Igor Golomstock (1929–2017) was a distinguished Russian art historian. He spent 12 years working as researcher and curator at the Pushkin Museum in Moscow and published books on Cézanne, Picasso, Hieronymus Bosch and the art of ancient Mexico, as well as the seminal study of 'totalitarian art'. His translations of *Darkness at Noon* and *Animal Farm* circulated widely in *samizdat* among the Moscow intelligentsia in the late 1950s. After emigrating to the UK, Golomstock taught at the universities of St Andrews, Essex and Oxford, and worked for the BBC Russian Service and Radio Liberty.

Sara Jolly is a literary translator. She has also worked as a freelance documentary filmmaker and edited two episodes of the BBC's prize-winning series about perestroika, *The Second Russian Revolution* and Sally Potter's documentary about women in Soviet cinema, *I'm a Horse, I'm an Ox*.

Boris Dralyuk is a literary translator and the Executive Editor of the *Los Angeles Review of Books*. He is the translator, most recently, of Isaac Babel's *Red Cavalry* and *Odessa Stories* and Mikhail Zoshchenko's *Sentimental Tales*.

'Igor Golomstock was a talented critic of Russian and Western art and he had an extraordinary biography, from childhood in Kolyma to dissident years in Moscow, followed by emigration to Britain. He writes about all this like a Solzhenitsyn character come to life, and the result is gripping, sad and often very funny. A must for anyone who wants to understand Russia and Russian culture.'

Catriona Kelly, Professor of Russian,
University of Oxford and author of *St Petersburg:
Shadows of the Past*

'Golomstock recounts in lively style his life in three separate communities: the Moscow art world of the 1960s, the human rights movement and the post-1970s émigré milieu of London, Paris and Munich. He is an observer with strong but discriminating opinions; seldom have the personalities who inhabited these worlds – and who in many cases hated each other – been so vividly portrayed. This is an essential study for those who wish to understand the cultural and political conflicts of the late Soviet Union and the Russian emigration.'

Geoffrey Hosking, Emeritus Professor of Russian History,
University College London and author of *Russia and
the Russians: From Earliest Times to the Present*

'*A Ransomed Dissident* is Igor Golomstock's most personal book and a perfect companion to his encyclopedic study *Totalitarian Art* (2012). In the past, some critics have argued that the term 'Totalitarian Art' was too vague and that its very vagueness made it too easy to apply the term to such different countries as Russia, Germany, Italy and China. Following Golomstock's dramatic journey through the circles of the Soviet totalitarian art and culture, however, readers of *A Ransomed Dissident* will see how the supposedly vague term acquired a very real existential meaning. This is important reading for anyone with an interest in the history and politics of Russian art.'

Vladimir Paperny, Adjunct Professor
of Slavic Languages and Literatures, UCLA

A RANSOMED DISSIDENT

A Life in Art under the Soviets

BY IGOR GOLOMSTOCK
TRANSLATED BY
SARA JOLLY & BORIS DRALYUK

I.B. TAURIS
LONDON · NEW YORK

Published in 2019 by
I.B.Tauris & Co. Ltd
London • New York
www.ibtauris.com

ISBN: 978 1 78831 295 0
eISBN: 978 1 78672 449 6
ePDF: 978 1 78673 449 5

A full CIP record for this book is available from the British Library
A full CIP record is available from the Library of Congress

Library of Congress Catalog Card Number: available

Typeset in Garamond Three by OKS Prepress Services, Chennai, India
Printed and bound in Great Britain by T.J. International, Padstow, Cornwall

The publication was effected under the auspices of the Mikhail Prokhorov Foundation TRANSCRIPT
Programme to Support Translations of Russian Literature.

For
Benjamin Golomstock
Flora Goldstein
Yulia Vishnevskaya

CONTENTS

LIST OF ILLUSTRATIONS

Maps

Plates

Plate 1 My grandfather Samuil Golomstock, my mother Mary, my grandfather's sister Lina Nevler and me, 1929. The left side of the photograph, where my father must have been standing, has been cut off. In those days, people habitually excised their arrested relatives from family photographs.

Plate 2 In the summer of 1943 we arrived in starving Moscow and in 1946 I became a student at the Financial Institute.

Plate 3 I travelled in the far north of Russia with the Sinyavskys. With Andrey on the river Mezen.

Plate 4 I was captivated by the way these local people lived, with their traditional, steady way of life, their enduring moral foundations, their readiness to help kith and kin.

Plate 5 With Sinyavsky and local inhabitants on one of those trips.

Plate 6 Explaining Soviet art to the public. Travelling Exhibition of Soviet Art, Chita, 1954.

Plate 7 Friends gathered on Thursdays in my 'studio'. We drank, discussed matters of art history, history and politics and, since then, alas,

I have never taken part in such high-powered intellectual discussions! Pictured here at a reunion in the 1980s from left to right: me, Villya Khaslavskaya, Slava Klimov, Yury Ovsyannikov, Gleb Pospelov.

Plate 8 Nina Kazarovets-Golomstock with our son Benjamin. 1968.

Plate 9 Waiting Game. With Rozanova outside our flat at Molodezhnaya shortly before Nina and I emigrated. 1972.

Plate 10 My university friend Alik Dolberg collected money for us.

Plate 11 With Robert Chandler, the translator of Shalamov and Platonov (centre) and Francis Greene (left). We lived in Francis's London flat for two years.

Plate 12 Galich invited me to work at Liberty not only during the summer holidays but also in the winter, both for company and to give me an opportunity to make some money. Munich, 1970s.

Plate 13 At the launch of my book, *The Camp Drawings of Boris Sveshnikov*, with close friends Flora Goldstein, Maya Rozanova, Yury Gerchuk, Lev Golomstock. Moscow 2000.

Plate 14 With Flora, Genoa, 2000.

Plate 15 Portrait of Igor Golomstock by Boris Birger.

Plate 16 Portrait of Igor Golomstock by Aleksandr Petrov.

TRANSLATOR'S NOTE

Igor's memoir teems with fascinating real-life characters – artists, writers, journalists, dissidents – many of whom would be household names to Russians but might well be unfamiliar to English readers. The most important of them have been included in the Dramatis Personae. Where someone is just mentioned in passing but needs explaining s/he is included in the endnotes.

I am grateful to Boris Dralyuk for allowing me to use his pre-existing translation of Chapters 2 and 3 which I could not have improved. Alexandra Berlina generously offered her marvellous translation of the lines from Brodsky's *Performance* which are quoted at the head of Chapter 2. Thanks to Alena Galich for permission to quote from her father's work and to Gerald Stanton Smith who has kindly allowed me to use his translation of some lines from Galich songs and poems. Thanks to Francis Greene for permission to quote from Graham Greene's *Getting to Know the General* and to the Brodsky Estate for permission to quote from his work.

Thanks are due to Kira Finkelstein, Irina Steinberg, Snejana Tempest and Olga Utrivanova for untangling knotty translation problems, to Melanie Mauthner, David Graham-Young and Simon Nicholls for feedback, suggestions on earlier drafts and friendly encouragement, to Helen Harris for help with the Yiddish, Masha Karp for feedback and additional information on the chapters on the BBC, to Brigitte Dugast for information on an elusive Parisian. I must express my gratitude to the Mikhail Prokhorov Fund for supporting the translation of the text and to my editor, Tom Stottor for his enthusiastic championing of this project. Finally, special thanks to Robert Chandler for his unflagging support and many suggestions for improvements and corrections. Any remaining errors are mine.

ACKNOWLEDGEMENTS

Thanks to *East-West Review* (Journal of the Great Britain-Russia Society) for permission to reprint extracts from Chapters 5, 6, 8 and 16. Thanks too to *Cardinal Points Literary Journal* for permission to reprint Chapters 2 and 3, both translated by Boris Dralyuk, and Chapter 7. Cover portrait by Anatoly Zverev reproduced by kind permission of Flora Goldstein.

At the publisher's request, some chapters from Part II have been abridged or omitted.

Igor Golomstock's memoirs were originally published in Russian as *Memuary Pessimista (Memoirs of a Pessimist)* by Znamya (2011) and AST (2014).

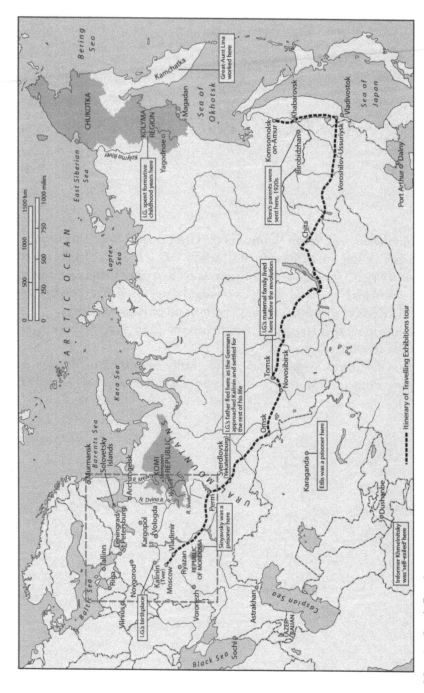

Map 1 Igor's Russia.

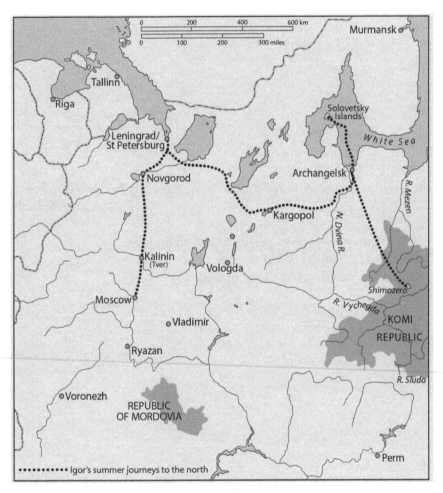

Map 2 Igor's summer journeys to the north.

The world is a comedy to those that think, a tragedy to those that feel.

Horace Walpole

The difference between a pessimist and an optimist:
Pessimist (gloomily) 'We'll soon be dead.'
Optimist (cheerfully) 'It's long overdue.'

Turning Point

As failures go, attempting to recall the past is like trying to grasp the meaning of existence.

Joseph Brodsky[1]

'That's a pastime for old codgers', my grandmother used to say. Of course she wasn't referring to the writing of memoirs, but her expression fits the bill perfectly. Now that I have turned 80, I have nothing particular to do in this world (a world that has changed so much in the past 20 years) except for sorting the wheat from the chaff in my memory, separating what might be interesting – for whom? – for my descendants, for readers, for historians? – from what has purely personal significance, and sitting down at my table to put onto paper the ghosts from the years gone by, a task now occupying many of my contemporaries who have a similar penchant for scribbling.

I don't remember my own life story very well. Memory requires a settled way of life, it attaches itself to place, but I never had this kind of stability. So, for example, I went to 10 or 11 different primary schools. Kalinin, then Moscow and various suburbs – Perlovka, Malakhovka, Rastorguevo – then somewhere else again, then Siberia, Khatynnakh Camp, Yagodnoe, Magadan – then Moscow again ... And then later, emigration: London, Oxford, Scotland (St Andrews), Munich, Paris, California, Cambridge (Massachusetts), Amsterdam and many other places. It is hardly surprising that with such a kaleidoscopic life, only fragments, scraps, little pieces of lived experience are preserved in my memory. It was partly for this reason that I swore long ago never to write my memoirs. But not only for this reason.

In Brodsky's reminiscences, the past is the process of the emergence of self-awareness, the forming of the personality – his own and that of his contemporaries. Suffice to say, this is a difficult, well-nigh impossible task. Brodsky, however, succeeded in this. My task is more modest.

I am very fortunate. During my life I have met a great number of well-known and in many respects outstanding people, and also many who are not so well known but who are also brilliant and exceptional personalities: Andrey Sinyavsky and Maya Rozanova, Yuly Daniel and Larisa Bogoraz, Aleksandr Yesenin-Volpin, Aleksandr Pyatigorsky, Rostislav Klimov, Yura Ovsyannikov, Miron Etlis, Georgy Shchedrovitsky, Georgy Costakis, Aleksandr Galich, Vladimir Maksimov, Vladimir Voynovich, Andrey Volkonsky, the artists Boris Sveshnikov, Anatoly Zverev, Volodya Yakovlev, Oleg Kudryashov, Boris Birger.[2] Many became my friends. I had a more casual acquaintance with others but every one of them left a trace in my life. So it is primarily about them that I would like to write, although it requires a literary talent beyond my modest capabilities.

As far as I myself am concerned, it seems important to show my relationship to the country in which I used to live, with its political regime, which, it seems to me even today, has remained essentially true to its origins, in spite of adapting itself to the course of history and constantly accepting new labels. Events conspired to give me a hearty dislike of the Soviet regime from very early on. I consider three of these events as turning points which shaped my outlook on life: the arrest of my father in 1934, my four-year stay in remote Kolyma (1939–43), and the Sinyavsky-Daniel trial (1966).

My friendship with the Sinyavskys began many years ago. We travelled together in northern Russia and Andrey and I co-authored a monograph on Picasso's work (published in 1960). Sinyavsky's arrest came as no surprise to me. I knew that he was writing and that he was publishing his work abroad under the pseudonym Abram Terts, and for several years we had been expecting the inevitable dénouement of this story. Sinyavsky was arrested in September 1965. Then my interrogation began and my home and office were searched. In February 1966, I was called as a witness to the Sinyavsky-Daniel trial and subsequently a case was brought against me for refusing to give evidence. In May of the same year I was found guilty and sentenced to six months' correctional labour. I was dismissed from my teaching post at Moscow State University, sacked from my job at the All-Union Scientific Research Institute of Technical Aesthetics, where I was working as a senior academic researcher, and the entire stock of my big book about modern European art, published by Iskusstvo, was pulped. I was barred from working, teaching or appearing

in print. There was only one solution – to emigrate (though in fact I had been dreaming about leaving the country for as long as I could remember). I spent 43 years in the Soviet Union and have lived about the same number in the West.

PART 1

Russia

Lord, lead me not into temptation and deliver me from purple prose.

<div align="right">Author's prayer</div>

CHAPTER 1

My Father's Arrest

I was born on 11 January 1929 in the town of Kalinin,[1] in the year of the Great Break,[2] when Stalin broke the backbone of the Russian peasantry and set the country on the road to collectivisation, industrialisation and terror. The first book I ever encountered was a short work by Arkady Gaidar about Malchish-Kibalchish (the Kibalchish Boy), with coloured illustrations. I don't remember the story, but the pictures of pot-bellied capitalists grimacing savagely as they tortured the heroic Boy, the instruments of torture, sizzling stoves, flashes of flame – all these images affected me like a terrible nightmare. The only time I have ever seen anything like this since then is in the representations of Hell by the artists of the Northern Renaissance and in miniatures in medieval religious books. Evidently, the writer's intention was to inspire children with a hatred of the enemies of the revolution, but the book only succeeded in inspiring me with an aversion to reading which lasted a long time.

When I was five, my father, Naum Kodzhak, was arrested – 'for anti-Soviet propaganda' as it said in his dossier. After that – only fragments, dribs and drabs from occasional family reminiscences, are stored in my memory. Naturally, my father had not been in any way involved in anti-Soviet propaganda. It was his misfortune to have been born into a rich Karaite[3] family in the Crimea. According to my grandmother, the Kodzhaks were closely related to the Katiks – the owners of the tobacco company, A. Katik and Co., which was known throughout Russia. Paustovsky, in his story *Kara-Bugaz*, writes about this family as *kulturtragers* – people with a civilising mission – who had settled to the north of the Caspian Sea.

My father's father (my grandfather) was a 'gabi' (a Karaite rabbi) in the Karaite synagogue in Shanghai. Evidently he fled there after the revolution.

My father studied at the Institute of Mining Engineering in Warsaw, he was an amateur musician, collected Tatar folk music and corresponded with the composer Reinhold Glière.[4] During World War I, he served as an ensign in the artillery, then (briefly, I think) joined the White Army. During the evacuation of General Wrangel's[5] troops from the Crimea, my father fell ill with typhus and was hidden from the Reds by friends or relatives and remained in Russia. Whether he stayed because of his illness, or because he actually wanted to, remains a mystery to me to this day.

I hardly know my relatives on my father's side. The large Kodzhak-Katik family was scattered to the four winds. Some emigrated, some went into the depths of Russia, and some, no doubt, went to the camps.

My relatives on my mother's side were Siberians. Most probably they came from a line of Jewish soldiers who, after serving in the Tsar's army, were permitted to settle outside the Pale of Settlement[6] on the borders of Russia. My grandfather, Samuil, an inveterate card player and drinker, worked as a commercial traveller for the well-known Czech shoe manufacturer, Bata. At weekends friends would gather at his house in Tomsk[7] to play *Preferans*,[8] and, so the family story goes, during the game they would calmly get through three litres of vodka, accompanied by snacks of *stroganina*[9] and *pelmeni*.[10]

The family was assimilated. My relatives only used a few Yiddish phrases – the ones I remember are *azokhenvey* (a plague on . . .), *kalten kop* (a head cold) and *kush mir in tukhas* (kiss my arse). My mother, Mary Samuilovna, studied at the Medical Faculty at Tomsk University and worked throughout her life in various places as a specialist in neuropathology. After the revolution the whole family moved from Tomsk to Kalinin. I don't know why.

The family – my mother, my father (until his arrest), my grandfather, his second wife (the first, my mother's mother, a well-known midwife, died before the family left Tomsk) and I – occupied half of a small rustic-style house not far from the hay market, with a tiny garden (which seemed enormous to me then), overgrown with raspberry canes. For some reason, there was a memorial plaque on the wall. Horses, carts, cows, chickens all filled the road. The first lorry to appear on our street caused quite a stir. My friends and I all rushed out to look at it. The other half of the little house was occupied by an old lady who seemed as poor as a church mouse. She often used to call on us, and my parents would give her a cup of groats, some bread, a few sugar lumps. One day she was found strangled in

her house and then lorries came and took away rugs, furs, crystal ware; obviously these valuables were being stolen. This was one of my earliest childhood impressions.

When I started school in Kalinin, Mama registered me under her maiden name, as she was afraid that my arrested father's surname would cause difficulties for me.

After an 'enemy of the people' was arrested it was awkward, to put it mildly, for his wife to go on living in the town where everybody knew her. This must have been why Mama and I went to Moscow and moved in to a small room with my great-aunt Lina Nevler (my grandfather's sister). She lived in a communal flat at number seven, Serov Passage (now Lubyanka Passage). Lina was an intrepid woman. She had once worked as a photographer in Kamchatka[11] and not long after we moved in with her she found herself a job as the director of a health resort in Sochi for workers from the Ministry of Food Production. Mama packed me off to Sochi as well.

It was 1937, and for me that year was accompanied by a particular song floating out of every loudspeaker. It began with the words: 'You can't help singing when you're happy', and ended with a quotation from Stalin: 'We live cheerfully today but tomorrow will be even more cheerful.' And life in Sochi really was cheerful for me. Sea, sun, mountains and a large garden where I fed 16 (or was it 18?) cats and two stray dogs. My acquaintance with a certain Andrey Ivanovich (I don't remember his surname; maybe I never knew it) meant a lot to me. He was tall, always neatly turned out, and had a little beard like the one Chekhov wore in middle age. He was a doctor and a colleague of my mother's, and I suspect he was rather sweet on her. He immediately took me under his wing. We went for long walks in the mountains, he taught me to collect and press wild flowers and to identify minerals in rocks. He showed me the stars and constellations and told me their names. Not long after I left Sochi he committed suicide by swimming far out to sea. Why? I don't know. It was the year 1937, the height of the purges, and there is probably no need to say any more.

When I returned to Moscow I discovered that I had acquired a stepfather. Iosif Lvovich Taubkin had been a Komsomol Party[12] worker in Siberia. He was singled out for promotion and sent to Moscow but he didn't go on to have a great career in the Party – he was a petty official, a sort of deputy director in the economic section of a couple of small factories.

We had nowhere to live. We rented tiny rooms in one place after another on the outskirts of Moscow and I moved from one school to another. My mother and stepfather didn't get on well – there were tiffs, rows, shouting matches. After one of their routine quarrels, Mama left for Moscow, taking me with her, and signed up for a two-year stint as a doctor in Kolyma with the Far North Construction Trust.[13] The job was very well paid, and, even more important, she was able to keep her Moscow residence permit. Mama had only the vaguest notion of what Kolyma[14] meant.

In the summer of 1939 we set off for Vladivostock. My stepfather got onto the train with us. Evidently, they had yet again managed to patch things up.

CHAPTER 2

Kolyma

Translated by Boris Dralyuk

In a space where no one ventures, where all living warmth is lost,
someone's jaw with golden dentures gleams in moonlit permafrost.
 Joseph Brodsky from *Performance* (*Predstavlenie*)
 translated by Alexandra Berlina

Kolyma, Kolyma, wonderful planet
Nine months of winter – all the rest is summer

 (folk rhyme)

It took us 12 days to reach Vladivostok from Moscow by rail. We then
spent another three days on board the steamer *Feliks Dzerzhinsky*, headed for
Nagaevo Bay. The steamer was famous: built sometime at the start of the
century in the Glasgow shipyards (according to a bronze plaque mounted
on the wall near the captain's cabin), its colossal cargo hold had transported
countless bands of prisoners to the camps. My stepfather had been assigned
to work in the Northwest Industrial Mining Administration of the Far
North Construction Trust in Magadan. He was to direct a sector called
Sportivny at the Vodopyanovo mine site.

The site was 700 kilometres to the north, in the direction of the Kolyma
River. We rode out in a lorry – which was, at the time, the only means of
long-distance transportation in that region. On either side of the road lay
low hills, draped with the sparse vegetation of the forest-tundra. Tall
mining towers for sifting gold stuck up in the hollows. Narrow wooden
planks ran up to the towers on every side – as if a gigantic spider had spun
its web between the hills. Hundreds of prisoners dragged wheelbarrows

laden with dirt along these wooden tracks, overturning them onto moving conveyor belts. The belts wound their way up the planks and dumped the dirt into large funnels atop each tower, where the soil mixed with water. The rocks and gravel remained on the grids, while the rarified soil rolled down the chutes along with the water. The gold, being heavier than soil, settled at the bottom. This desolate landscape was animated by rows of barbed wire and observation towers surrounding the camp. And so it was for the duration of the journey.

* * *

The Khatynnakh camp – centre of the sprawling Vodopyanovo mine site, where we arrived late in the summer of '39 – was a conglomeration of wooden houses and huts, occupied by the site's civilian employees and their families. The place my stepfather was in charge of, the Sportivny sector, with its three mining towers, was five kilometres from the village.

And all around it lay pristine nature, untouched by human hands: hills, overgrown with dwarf pine – that northern cedar which spreads its branches on the ground, bearing cones full of small, but very tasty pine nuts. In spring, the hills took on a pinkish hue, as entire fields of cranberries, which had survived the winter, emerged from the melting snows. And another recurring detail of this idyllic landscape: a glum little horse dragging an oblong object wrapped in a red blanket, flanked by the bent figure of the accompanying driver. That's how they carted back the corpses of prisoners who had fled in the spring and froze to death in the winter.

We young fellows had the run of the place. In the winter, when the temperature dipped to $-50°$ Celsius, school was cancelled and we were completely free. We skied, built caves in the hulking snowdrifts, and even heated them by burning paper and hay. I remember one time when the temperature dropped to $-69°$, but the air remained dry and the sun shone brightly. We had a snowball fight, but had to keep rubbing our faces with snow to avoid frostbite.

In the summer, our main occupation was digging for gold. There was a lot of it. When the rain washed a layer of soil from a mound of earth, gold flakes gleamed beneath it, and the same flakes glistened in rain puddles. We looked for gold in crevices of slate and underneath rocks, tearing up clods of earth. Once I found a nugget about the size of my little finger,

weighing 30 grams. But the primary method was panning. We used special trays, with bottoms bevelled on every side and grooves in the middle. We poured earth into them, mixed it with water using scrapers, and removed all the rocks and pebbles. When the only thing left was a layer of sand, we carefully washed it, and particles of gold remained in the grooves. There is something astonishing about the strange mystical force that attracts man to gold. Once, they blasted a big chunk of dirt and discovered a vein of gold in the crater. People rushed to the pit from all sides and, pushing and shoving, began clawing pieces of metal from the earth. Why, one wonders? We had to take the gold to the gold bank, where we were paid – if I'm not mistaken – a rouble per gram (10 kopecks for convicts). But the money had a purely symbolic value: there wasn't a thing to buy with it.

There were no shops. All the necessities – groceries, clothes, soap, cigarettes – were distributed not even by ration cards, but according to some list or another. The groceries consisted of dried potatoes, various grains, frozen apples (one had to dip them in cold water, and then they'd develop an icy crust), and, very rarely, meat – venison, horse, bear. Vitamin deficiency was mandatorily treated with a disgusting potion from pine needles, which seemed to me worse than castor oil. The potion supposedly cured scurvy. And this, when there was a heap of vitamins all around: lingonberry, cloudberry, blueberries, nuts, mushrooms. For some reason, though, no one was interested.

I was essentially left to my own devices. My stepfather spent most of his time at Sportivny, my mother worked in the camp clinic, and I wasn't their concern. My stepfather's position allowed him to take on an orderly – that is, a domestic servant selected from the ranks of criminal, rather than political prisoners. It was they who – if not directly, then indirectly – served as my teachers. There was nothing worthwhile that school could teach me.

The first was a Tartar named Yusein, a counterfeiter. Although he didn't manufacture forged banknotes himself, and engaged only in their sale, he got 10 years in the camps for it. He and I lived in perfect harmony. But one day my mother, returning home from work, discovered a horrible scene: the room was cold, I lay with a high fever, Yusein was snoring on the floor, and someone's feet stuck out from under the table. Yusein had found a bottle of alcohol my stepfather had hidden, called friends over, and made a feast. Apparently I was fast asleep and didn't notice a thing. For this offence, the poor soul was sent back to the camp barracks.

The second was Kostya – a handsome young man, modest to the point of shyness – who embroidered napkins and presented them to my mother as a sign of adoration. His entire family – father, mother, and brothers – were executed: the gang robbed cars on Altai roads. As a juvenile (he was not yet 16), Kostya was given 10 years. His sentence ended in 1940, and we parted with him as with a close relative.

And then there was Boris. He was a gang boss, a hoodlum, but had clearly turned 'bitch', since a real thief in law[1] wouldn't stoop so low as to work for a director. He wore silk shirts and enjoyed unquestioned authority among the thieves. When he'd left and our house stood empty, he simply propped a broom up against the door, and no thief dared come near. Such were the life and customs of that region.

My mother and stepfather's contractual terms were due to finish in autumn 1941. In order not to interrupt my studies, it was decided that I'd be sent to Moscow toward the start of the school year, along with one of our acquaintances, who was also set to return there.

We arrived in Magadan sometime in the middle of June, and a few days later war broke out.[2] Due to foolish inertia, we decided to continue our journey. But when we arrived in Vladivostok, it turned out that train tickets to Moscow were no longer available. We had no choice but to go back.

I spent several days in Vladivostok while awaiting the returning steamer. By comparison with Khatynnakh and Magadan, the city seemed a European capital. I ran from shop to shop, frittering easy money on all sorts of badges, quills, thermometers – from which we extracted mercury – and other trifles we couldn't get our hands on in Kolyma. I returned on the same steamer, the *Feliks Dzerzhinsky*, in a first-class cabin. Once back in Magadan, I found lodging in the barracks of a transit camp and arranged for my return trip with a lorry driver. I took great pride in my independence, and was sorely disappointed when I glimpsed my agitated mother, who'd found me after running around the barracks for hours. We returned together – not to Khatynnakh, but to a new location.

My stepfather had by then received a new assignment – directing the Chekai mine site. This site had been established very recently, after the discovery of a rich gold deposit. It was located 25 kilometres from the road, so one could only get there in the winter by sleigh – and in the summer, when rain eroded the soil, by tractor or horse. The site was small: around 5,000 prisoners and about a 100 civilian employees, including the guards (according to my very rough estimate at the time). And again – hills,

towers, barbed wire. I only write of what hasn't irretrievably fallen into nowhere through the leaky sieve of memory, and has instead lodged between the holes – of what now arises in the mind's eye like a vague phantom of things once seen.

Babushkin. He was a huge, radiant, good-humoured man, a former pilot. He'd served time for some criminal deed and, upon release, was hired as a camp guard. He'd drink a mug of denatured alcohol in one gulp, take me in his arms, toss me up to the ceiling, and I'd giggle with delight. Many years later, after my mother had died, my son was born, and my relations with my stepfather were somewhat restored, he told me about Babushkin: he was a bailiff, that is, an executioner.

Nekrasov. He was head of the camp guards. He'd tell how he and his buddies, dead drunk, would tumble into the barracks at night, lift some convict they didn't like from the plank bed, take him outside, and beat him mercilessly. I heard this story while pretending to be asleep, when a group of my stepfather's co-workers sat around our table, drinking.

One couldn't, of course, expect a school in Chekai. At the start of the school year, I trudged up to the road with Vitaly Kandinsky, the only other boy my age at the site. We then caught a lorry to the village of Yagodnoye – the centre of the Northwest Industrial Mining Administration.

The boarding school there was of the urban type. The students came from all those villages of the Administration's vast territory that lacked schools. The student body was a mixed bag. There were the children of civilian employees – like Kandinsky and me – and of prisoner-criminals, whose families decided to settle nearby. These latter determined the general atmosphere that prevailed at the school: life was regimented according to the laws of the criminal camp. Our dormitory, where about 20 boys slept, had its own gang boss – a hefty, overgrown fellow. A group of hangers-on bustled around him, 'spinning tales' for his entertainment and providing other services, including of the night-time sort. The staff were also mainly criminals, who got their jobs after serving their sentences.

The school's teachers were probably of a high calibre – doctoral candidates, PhDs, associate professors who had all been political prisoners. But school didn't interest me, and I was a hopeless student. It seems I didn't understand what relation all this book-learning bore to the reality – a reality beyond the pale of true human culture – to which my mother, my stepfather and I all belonged. Why do I need all these arithmetics, grammars, histories? Literatures?

I read little. There were no libraries, no bookshops, and besides, Comrade Gaidar and his Kibalchish had robbed me of any desire to read. At some point I got my hands on Dumas's *Three Musketeers* and didn't like it one bit. That fraternity of swashbuckling bandits seemed to be governed by a criminal code with which I was long familiar: the same strict moral precepts demanded by gang membership, the same smugly contemptuous attitude towards all outsiders, the same reverence for bosses (King Louis), and the same disregard for human life – which meant you could stick people on sabres as easily as chickens on a spit.

Someone slipped me a copy of Turgenev – *Torrents of Spring*, I believe. And once again – utter bewilderment. The nature, the life, the people – all of it was quite unlike what lay before my eyes. But first and foremost, the language: it seemed dry, pretentious and unnatural. People didn't speak that way. The people around me expressed themselves with obscenities. We children spoke in a half-criminal jargon, and profanity hung in the air. This seemed like normal human speech; without cursing, it would have lost its emotional pungency and eloquence. (Once, back in Moscow, in conversation with some of my classmates, I shot back with a filthy word; my civilised interlocutors gawped at me in amazement. I blushed and couldn't utter a single unprintable word for a few years thereafter.)

I'm probably modernising my recollections a good deal, projecting the results of later self-reflection onto the past. But in the cultural vacuum of my consciousness during that period, I could find nothing analogous to the things I'd read – there was nothing for them to latch onto.

My stay at the boarding school lasted a little less than a year. During this time, my family's life took another turn.

After one year of operation, the Chekai site, which, as I mentioned, was situated atop a rich deposit, came first in the extraction of gold – either in the Administration, or in the whole of Kolyma. The following year, the gold reserves had been exhausted, and production declined sharply. According to that era's rules, a culprit had to be found: my stepfather was relieved of his duty and his case was transferred to the judicial authorities.

So, in the spring of 1942, my mother and stepfather came to fetch me from Yagodnoye, loaded my meagre belongings onto a lorry, and we travelled down that same road to Magadan. Along the way, I threw my school report into a roadside ditch.

The capital of Kolyma region was then simply a large village, consisting mostly of two-storey wooden barracks. The main thoroughfare (the only one, I think) came up against a hill, and we settled in one of the barracks resting on the slope of that hill. This avenue served as the centre for the city's cultural and administrative life: a solid stone building housing various governmental institutions, a school, a hospital, the residences of Kolyma's senior officials. There was also a small shop, where crabs, sea sculpins[3] with heads two-thirds the size of their bodies, and all kinds of little fish were sold without ration cards. Fish plus American white corn bread – these provided a serious boost to the scarce food rations. Before the war, the small Magadan zoo was inhabited by two polar bears; then their meat was distributed by ration cards. In general, we didn't have the kind of famine they later had in Moscow.

My life in Magadan differed little from what came before. School still didn't interest me. When summer came, I ran down to the sea as soon as I could – thankfully, it was just about a kilometre from the city. I've never in my life seen such huge tides. They left behind entire lakes, entire lagoons of water that bustled with small crabs, stirring starfish, scurrying little fish, and jellyfish with undulating tentacles. As for the winter we spent in Magadan, nothing of interest remains in the memory but boring school lessons and skiing in the hills.

The city was chock-full of loitering criminals who'd been released from the camps.

Once, returning from forced volunteerism on Saturday (or Sunday), after the whole school was dispatched to harvest fodder turnips on a collective farm, I saw a tuft of smoke rising at the end of the street. A fire – interesting! I raced ahead, only to find a mournful scene: the smoke was coming from our own second-floor window. It later came out that a bunch of thieves lost a card game in the adjoining flat, and, having picked the place clean beforehand, torched it. Our flat burned down, too.

The next day at school, I was called to the blackboard. Naturally, I couldn't answer any of the questions assigned for homework.

'Report card!'

'It burned up', I answered proudly.

'Golomstock! Out of the class!' yelled the teacher, taking my response as an insult.

I left the class and almost wept at the injury: after all, the report card had really burnt up.

But most of all, I grieved for my burnt-up foreign stamps. I had pasted them onto the pages of some old, useless book. The collection was poor. But those places of origin – Great Britain, France, the United States, some country called Colombia, Tuva, Peru, Liberia, the Congo – were alluring signs of another world. That world was mysterious, strange, incomprehensible, but, in any case, different from the one in which I was forced to live, and from which I instinctively longed to escape from my earliest childhood.

The mournful episode with the fire also played a positive role for my family. Since the beginning of the war, all of my mother and stepfather's contractual terms of work in Kolyma were cancelled, and escape was only possible with special permission. The fire, which destroyed all our possessions, provided an occasion to seek permission for a return to Moscow. By that time, my stepfather's criminal case had somehow been resolved of its own accord, he hadn't received a new appointment, and, it seems, there was nowhere to settle us. In short, permission was granted. In the summer of 1943, we said goodbye to Kolyma, and left behind this 'wonderful planet, where there are nine months of winter, and the rest is summer'.

Despite the meagreness of the education I received there, the experience of Kolyma was, I believe, an important first stage in the formation of my character, my likes and dislikes, my outlook – that is, my personality. I won't describe all the terrible things I had witnessed in Kolyma: they've been described quite well without my input. Later, in Moscow in the '60s, the famed literary critic Leonid Pinsky, himself a former prisoner of the camps, lent me four typewritten volumes of Varlam Shalamov's *Kolyma Tales*, which he had compiled along with the author. I read them almost without pause, day and night. I remember the same places where Shalamov had spent his camp years (the Northwest Industrial Mining Administration, Yagodnoye, Suchan, Serpantinka), the same scenery, even the names of the camp directors that had stuck somewhere in my mind all this time, some of whom I even had the honour to behold firsthand. I saw much that someone of my tender age shouldn't have seen: fugitives baited with dogs, a guard shooting a prisoner he didn't like before my eyes, the legendary camp murderer Fomin[4] being led to his execution. Back then, of course, all this failed to form a coherent picture in my mind – failed to reveal the true essence of what was happening and, instead, settled into the recesses of my memory. I only grasped the political foundation of these events, their intimate connection with all that transpired in the country, later, in Moscow.

CHAPTER 3

Moscow

Translated by Boris Dralyuk

From Magadan to Vladivostok, we sailed on the American steamer *Stepan Razin*, given to the Soviet Union under the Lend-Lease Act. We then took a train to Moscow. Stations, remote halts, wild crowds of people – women, children, disabled veterans, some legless, some armless – storming the trains and cruelly shoved from the footboards by the conductors. All of this is intimately familiar to those who travelled by Russian railways during the war.

I fell seriously ill along the way, so we were forced to stop in Sverdlovsk. And here I met my father for the second time after his release.

My father had been sentenced to five years in the camps for 'anti-Soviet activities' in 1934 – when things were still rather 'vegetarian', as Anna Akhmatova put it. He served his time on the construction of the East-Siberian Railway, somewhere near the Chinese border. He was released in 1938 and dropped in to see us at my great-aunt's in Moscow on his way to Kalinin. I don't recall what we spoke about, then, but I've never forgotten the words, nor even the tune, of the song he sang to me:

We cannot work little by little,
And cannot love only a bit;
We lay the road ahead of schedule,
Pleased to be used as the State thinks fit.

I suspect he wrote it himself (I seem to remember that he played in the camp orchestra.)

To this day, my father remains a puzzle. What prompted this educated man, a member of the old *intelligentsia* and now a political prisoner, to say he was 'pleased to be used as the State thinks fit' and to sing (if not compose) a rousingly patriotic song about selfless labour in the camps? Fear, I think – fear inspired by his origins, his past, and the colossal state apparatus of destruction, which it was futile to resist. Fear had made him keep a low profile even before his arrest. And later, when the Germans were nearing Kalinin and he fled to Sverdlovsk, fear drove him to take up the discreet post of accountant for a bath and laundry trust. I remember that, shortly before his arrest, father burned a whole stack of tsarist bank notes in our stove. I bawled and begged him to give me those beautiful, brightly coloured pieces of paper, but got nothing. It seems that he burned that non-proletarian origin out of himself in much the same way, and with great success.

Our meeting in Sverdlovsk wasn't particularly warm. I hardly remembered him, and his paternal feelings had almost completely withered in the interval. We parted, to meet again only 29 years later.

* * *

In the summer of 1943, we arrived in Moscow, a starving city that had only recently fought off the German bombing raids. We again settled at Great-Aunt Lina's room in Serov Passage. In a few months, my stepfather, now a Major, was sent to Germany to help dismantle their factories. He disappeared until war's end, having started a fling with some woman over there. At various times, the little 16-metre-square room with a small cubbyhole – which was only large enough to accommodate my great-aunt's bed – housed up to seven people: my mother, my stepfather, his daughter Vera, my cousin Lev (whose parents had sent him from Grozny to study at the Petroleum Institute), Great-Aunt Lina, Grandfather Samuil and me. Each morning, Grandfather would open his copy of *Pravda*[1] and see letters from workers addressed to Comrade Stalin. He'd then utter the sacred words, 'I do not read other people's mail', pointedly turning the page. (To this day, I cannot open a letter meant for someone else, even my own wife.) I slept on suitcases pulled from under my great-aunt's bed. After Grandfather's death, I slept on sofa pillows, while Lev slept on the springs, or vice versa.

In the autumn of 1943, I enrolled in Year 8 at Moscow High School #312. The crowd here were more interesting than in Kolyma, and I immediately made friends with two of my classmates – Yury Kogan and Yury Artemyev. It may very well be that these friendships initiated my ascent from savage to *Homo sapiens*.

Among the three of us, Yury Kogan was the most intellectually advanced. He lived in the building adjacent to ours, No. 5, above Mayakovsky's former flat (now a museum dedicated to the great poet).[2] Kogan took a serious interest in contemporary history and politics, and pored over books on the history of diplomacy, intending to build a career as a diplomat himself (alas, it was known even then that the Institute of International Relations didn't accept Jews). He knew something about the situation in the country, told us about collectivisation and the famine in the Volga region in the early 1930s, about the political trials of 1937, about Comrade Stalin's personality, and many other things. (Where he'd found this information, I simply don't know.) In his case, all these horrors seem, by and large, to have been a matter of abstract, purely academic interest. In my case – they were superimposed on the experience of Kolyma, found emotional confirmation in that experience, and came together to form what one could call a three-dimensional view of Soviet reality. To some, this may seem implausible – a desire to demonstrate one's exclusivity – but it's a fact: even as a schoolchild, I'd already begun to hate Stalin, his entire camarilla, the Komsomol, the Communist Party, and the Soviet state as a whole.

Artemyev also lived nearby. His father had been arrested in 1937, disappearing into the camps, and Yury lived with his mother on Kirov Street, in a room at the former Hotel Lisbon that had been converted into a giant communal flat. Awkward, phlegmatic, and a bit on the heavy side, he looked like a typical young Russian landowner out of a Turgenev novel ('the hair, a colourless mess – and a pancake for a face', as I described him in one of the epigrams we exchanged from time to time). Often, when class was in session, one could glance through the window and see Artemyev slowly trudging to school through the yard. Confronted with the teacher's indignation, he'd just nod his head in repentance and set off for his desk.

Our shared love of music brought us even closer. Yury and I would spend our last kopecks on records and play them on an electric motor I'd inserted into an old phonograph case, which also served as our ashtray. The record hissed, the motor grunted, but I have rarely had such a keen experience

of music since. For Artemyev, music was also a scholarly concern. He'd befriended Mikhail Marutayev, then a student at the Conservatory, and together they worked out some theory of composition that I found completely incomprehensible. Marutayev would pick out a chord, then they would calculate what should follow, and then a second chord would sound. To my great surprise, something musical emerged from all this.

Artemyev and Kogan were a year older than I. In 1944, they reached the age of conscription, and, in order to avoid this, enrolled in the school for working youth. They intended to complete the last two classes in one year and go off to college, which then granted a reprieve from military service. Subsequent events brought about significant adjustments in our relationship.

Sometime in March or April of 1945, early in the morning, the telephone rang in the hallway of our communal flat. It was Artemyev. He suggested we go for a walk. There was nothing unusual in this, but something – either the tone of his voice, or the early hour – put me on my guard.

We wandered around Moscow for a few hours, passing along the Kitay-gorod Wall, the quays, and going as far the Sokol Metro Station. He talked the whole way.

The previous evening, he'd been summoned to KGB headquarters on Dzerzhinsky Square and offered the chance to cooperate – that is, to inform on his friends, including me. Yury played the fool, expressed doubts, put forward arguments. He was then taken to a window, shown the cars parked in the courtyard, and told that if he didn't comply, they'd go and pick everyone up straight away. 'You're a good Russian! What are you doing getting mixed up with Jews?' the KGB officer asked. Yury was forced to comply.

And then he told me about it the very next day!

In order to free himself from cooperating in this manner, at least in the future, Artemyev enrolled in Moscow State University's Geological Prospecting Department – although he was primarily drawn to philosophy. Upon completing his studies, he spent most of the year away on expeditions, far from the unblinking eye of the secret police. I never asked Yury about the nature of his activities, but, from time to time, he himself informed me of his reports: 'Golomstock expressed doubts about the validity of Marx's theory of surplus value ... Golomstock admires Ilf and Petrov's *The Golden Calf.*' Things of that sort. From the

authorities' standpoint, these were signs of disloyalty, but not serious enough to put someone away. Apparently, somewhere at the top, some official put a tick next to my name on the list of persons under reliable surveillance, and therefore posing no threat. I was not engaged in anti-Soviet activity, not involved in any secret student societies and circles. I just blabbed too much. And I was being monitored. Our yard-woman,[3] Martha – who was on the best of terms with Great-Aunt Lina – said that they'd come to her, asking who my associates were, who visited our flat, whether she'd heard me say anything anti-Soviet. One of my mother's patients also warned her of what a dangerous position I was in. And I'm convinced that if it weren't for Yury, I'd have spent many years in the camps.

For nearly 10 years, I lived in constant fear of arrest. For nearly 10 years, Artemyev's activities, which he despised and hated, placed him under severe stress. Only in 1954 or 1955 was he was able to declare to the KGB that, for whatever reason, he could no longer cooperate. I seem to have recovered, by then, and had got over my fears. Yury Artemyev didn't quite make it to 50; it turned out he'd had a weak heart.

Yury Kogan was also summoned, and also forced to cooperate. But he was offered a different field of activity. The school for working youth, where both Yurys studied, also provided an education to the children of certain prominent foreign communists (the son of Martin Andersen Nexø,[4] in particular). Lively and sociable as he was, Kogan had befriended these classmates, and now he was called upon to monitor them. He disappeared from my life after that point; we no longer saw each other. It seems he didn't want to involve me in his observations.

* * *

As in Kolyma, I studied poorly. The technical subjects – physics, mathematics, etc. – didn't interest me, while literature and history, as they were presented in school, inspired nothing but boredom and disgust. I couldn't even appreciate Pushkin until after I left school. During class, I would read Dostoyevsky, Leonid Andreyev and Andrey Bely under my desk. If these authors were mentioned in our textbooks at all, it was only in the notes, and only as 'reactionary' writers. In the last two years of my studies, I was excluded three times – for my very moderate successes and immoderate behaviour. My success was to work my way up from an F to a C. But my

behaviour was another story! I was a quiet boy, but somehow I drew the teachers' ire.

Once, during a chemistry lesson, I was reading Dostoyevsky under my desk, not bothering a soul – until someone launched a galosh[5] at me (our class was fairly boisterous). I calmly picked the galosh up off the floor, laid it on my desk, and was about to continue reading, when our chemistry teacher, turning away from the blackboard where she had been writing some kind of formula, saw the ill-fated footwear on my desk. She rushed to the head and announced that Golomstock had committed an outrage. I was excluded from school. My second exclusion took place under similar circumstances. During breaktime, as usual, an orderly entered the class with a tray bearing our prescribed breakfast (some sandwiches or biscuits, I don't recall); the boys all suddenly piled up on top of him. The teacher, entering class at that moment, seems to have been almost blinded. The only thing that seemed to leave an indelible imprint on her retinas was my figure, standing off to the side and taking no part in the pile-up. And again: the head ... my outrage ... expulsion. The third time was more serious. Our school was dispatched to aid a collective farm at harvest time. In the barracks where we were housed, someone stole something from somebody – and it seems that this very someone claimed I had done it. I felt slighted down to the very depths of my soul; I'd had enough. I got on the train, and went home – that is, I voluntarily abandoned my military post. And if Great-Aunt Lina, who had a good relationship with our head teacher, hadn't resolved these conflicts, I would hardly have made it to matriculation.

Once, our school's Komsomol activist approached me. 'Do you have Fs?'
'I do.'
'Will you improve on them?'
'I don't know.'
'That's alright. Write up a statement.'
Could I, in 1944, have said that I didn't give a damn about our Komsomol? Some could. I didn't dare.

* * *

I finished high school in 1946. Two options loomed in my future: college or the army. I had got to know something about the Soviet army during our school military assemblies in the summers of 1944 and 1945, and this fate seemed no better than the camps. They drilled us, 15-year-old boys, as if we

were adult soldiers. Night-time hikes over many kilometres, burdened with full equipment, digging trenches, crawling on our bellies through puddles and mud – all this exceeded my physical capabilities. But worse than the physical exercise and perpetual hunger, was the general human environment. At feeding time, a ravenous crowd would burst into the dining hall; everyone wanted to grab the seat closest to the cauldron and snatch up the best portions. I'd usually enter last and get the worst leavings, or nothing at all. And if not for the meagre parcels from home, I wouldn't have survived. One day, someone from our detachment lost a rifle – or perhaps someone had stolen it. The poor old sergeant advised him: 'Go and steal one from the neighbouring division.' In the real army, the loss of a weapon meant a date with a tribunal and firing squad. This was all strongly reminiscent of Kolyma.

Admission to college proved somewhat complicated. Anti-Semitism had not yet reached its apex, but was already gaining momentum, especially in institutions of higher learning. On my father's side, I was a Karaite, and this circumstance could have saved me from many later troubles. But when the time came to issue my internal passport, they determined my age by my teeth, as it were. The record of my birth, along with all the archives in Kalinin, had been burned before the Red Army retreated. In the passport application under 'parents' nationality', I listed my father as a Jew. Now I find it hard to explain why I did this. In his book *Babi Yar*, Anatoly Kuznetsov relates the following episode: on the morning that Kievan Jews were being led to the site of their extermination, the Karaites, who had spent the entire night praying in their synagogue, joined the doomed column. Perhaps the rejection of Jewishness would have been a betrayal of my mother and of the people to whom I myself (if only half-) belonged.

And so began my wanderings before admissions committees. The staff at Moscow State University's Art History Department simply refused to accept my documents, saying that, in this particular year, they would only accept medalists and veterans of the war (which was a bare-faced lie). At the Geography Department, they allowed me to take the entrance exam. Despite my fantastic ignorance, I knew how to get through exams. Once, on a physics test, I was asked about the laws of electricity; I hadn't the faintest clue. But I spiritedly began to expound on the caloric theory, and – not having had time to finish the historical portion and move on to a direct answer – was interrupted, receiving a positive mark for my efforts.

And here, too, I passed the history exam, geography exam, and something else. The only subject left was literature – about which I felt confident. I answered the questions quite reasonably, but the examiner (a certain Sorokin, as I now recall) disapprovingly shook his head at my every utterance. Finally, he asked me to recite a poem by Heine in German, which was, for some reason, the only work by a foreign author that had made it into the Soviet school curriculum. I began: 'Auf die Berge will ich ...' but faltered in the middle. Sorokin grinned with satisfaction and gave me a C.

A few days remained before the admissions process was to conclude. I was advised to apply to the Financial Institute. They accepted practically everyone. So I was forced to learn a profession which was deeply alien to all my inclinations and aspirations.

CHAPTER 4

Finances and Romances

The Financial Institute on Tserkovnaya Gorka was at that time a very down-at-heel establishment which mainly took students from the depths of the provinces (now, apparently, it is one of the most prestigious elite institutes in Moscow).[1] However, the teaching staff were quite well-qualified. It was the refuge of many academics with Jewish surnames, who no longer had access to more respected institutions. There were some interesting people among them. So, for example, the circulation of money was taught by Rubinstein, who later became a well-known Moscow collector. We were taught war economy[2] by Major Nevler. One day I was reading Renan's *Life of Christ* during the class. Nevler caught me unawares, took the book, read the title, set us some piece of work and buried himself in the book. After the class he returned the book to me without saying a word. A certain Agushevich taught us the foundations of Marxism-Leninism and gave us colourful descriptions of the first Party meetings: 'So then Axelrod[3] gets up on the platform', he intoned solemnly and with obvious sympathy for this Menshevik. At the beginning of the second year in a general assembly we were told that Agushevich had turned out to be an enemy of the people. Remarkably, some of the more unsophisticated among my fellow students at the meeting spoke out publicly, asking to know in what way Agushevich had been an enemy. Fortunately the affair was hushed up.

I had no interest in financial studies. At the Institute I continued to study in the same way I had done at school. During lectures I read novels, I tried (unsuccessfully) to teach myself how to read music and my overall grades went from D to C. True, I did once contrive to get an increased student grant (I think it was then called a Stalin grant). At the end of one semester there were only two exams – political economy and civil law. I mugged up – not without curiosity – on two volumes of Marx's *Capital*,

something by Adam Smith and something by David Ricardo, and got two As (the majority of my fellow students failed).

The dreary, monotonous days at the Institute are just a blurred memory. The only important event of those years was my meeting with Nina Kazarovets – my future wife. We were studying on the same course and I fell head over heels in love with her. She was a quiet, inconspicuous girl with the light blue eyes of a soulful mermaid and she seemed to me unusually beautiful. In the gymnastics class she effortlessly performed all the prescribed exercises while I was a general laughing stock – hanging like a sack from the horizontal bars and unable to lift myself up even once. My feelings were not reciprocated at the time and it was only 15 years later that we began our life together.

* * *

The longer my education went on, the less I wanted to make finance my profession, and the deeper I plunged into my real interests. I couldn't take up music, thanks to my complete lack of education in the subject. Art history was an alternative choice. I began unofficially attending lectures at the university and decided I must enroll in the university's evening department for art history. But how was I to do this? There was no hope of extracting my school leaving certificate, which I needed if I was to be allowed to sit the entrance exam, from the Financial Institute's personnel department. The only way round it was to get another certificate. And it was my old school friend Yury Artemyev who helped me do this.

His friend, Victor Pevsner, was an eccentric individual. A technology boffin to his very marrow, he was totally deaf to anything other than engines, transformers, wirelesses. When he had to sit oral exams in arts subjects for his school leaving certificate, the day before the examinations he and Artemyev locked themselves in his room and Pevsner built an ingenious device for transmitting and receiving. He wrapped a wire around his waist and passed one end, with a little microphone, down his sleeve and fixed the other end to a miniature wireless receiver which he had placed in his pocket. He gave a similar miniature transmitter to Artemyev. In the mornings, Artemyev, equipped with text books, would climb up into the school attic and Pevsner would dictate the exam questions up to him and

Artemyev would dictate the answers back down. Pevsner also possessed an entire set of stamps and seals from different state institutions, which he had probably made himself. Later on I sat his written essay, literature and history papers at the Radio Institute, using his examination card with my photograph. So, to enable me to enroll on the art history course, he made me a certificate with all the necessary signatures and seals, stating that I had completed seven years in some school I had never heard of.

This was the beginning of a real *Sturm und Drang* period in my life. In three months, I passed more than 50 exams: in all the subjects for school years 8, 9 and 10, a demanding set at the Financial Institute, including a state exam in military affairs, school leaving exams and five university entrance exams. In autumn 1948, I became a first-year student in the evening section of the Art History department in the Faculty of Languages and Literature at Moscow State University, and the following year I graduated from the Financial Institute with the title of Advisor on Financial Services, third rank (the equivalent of 2nd lieutenant in the army), and was appointed as a credit inspector in the Proletarian section of the Moscow City Bank (Mosgorbank). I was bored at the bank; I loathed it and found it rather scary. The campaign against cosmopolitanism which had been launched some time before, was now reaching its peak with the Jewish doctors' plot.[4] Every morning, the deputy director of the bank, Comrade Putintseva, would open the newspaper and read aloud (especially for my benefit) about the latest crimes of the killers in white coats. Meanwhile, the radio was broadcasting Shostakovich's song cycle, *From Jewish Folk Poetry*, and women's voices yelled from loudspeakers 'Doctors, Doctors, our sons became doctors, ayee!' Evidently the authorities wanted to some extent to use the song cycle as a fig leaf to cover the anti-Semitic Bacchanalia which had returned to the country. I myself interpreted the song cycle at that time as a wicked parody of what was going on.[5]

Putintseva, who was completely uneducated, hated us – the so-called 'young specialists' (apart from me, there was also a girl graduate working there). To make matters worse, a compulsory uniform was introduced for people working in the various branches of government service – for railway workers, lawyers, engineers ... The finance people were decked out in a green uniform and the women were embarrassed to wear it to the theatre

because people kept asking them one and the same question: 'Where's the toilet?', mistaking them for theatre staff. Financial advisors (i.e. the officer class) were supposed to wear a pin in their buttonhole with one, two or three stars (depending on rank), junior advisors (i.e. NCOs) had badges or other distinguishing signs. (I contrived to get out of wearing the uniform – which, to add insult to injury, you had to get made at your own expense.) Sergeant Putintseva couldn't bear such an injustice but, feeling sure of her position (it was said that she was the lover of some highly placed official of the Mosgorbank), she undermined us with every means at her disposal.

My duties included authorising credit for construction projects by regional enterprises – baths, laundries, landscaping schemes, cleaning projects and so on. People say that unlike the chaos in Russia today, there was order under Stalin. What a joke! I had to visit the establishments under my jurisdiction and make on-the-spot checks on the use of materials released for building projects. What didn't I see there! Money was released for the building of hothouses. Where are the hothouses? 'Well', they say to me, 'we burnt them down.' Inspection of the pay roll revealed that individuals serving prison sentences were continuing to receive their pay ... and so on and so forth. On 31 December all the regional bosses, led by the president of the regional committee himself, burst into our office and demanded that the annual accounts be completed by midnight so that the regional capital investment plan was 101 per cent fulfilled. What a nerve! They'd be lucky if the plan was 50 per cent fulfilled in some of the organisations. My clients tried to palm me off with bribes; they proposed various outings by car. I understood that someone would have to go to prison and that it would most likely be me. It was time to clear out, although I had not yet completed the two years of compulsory service required of a young specialist after graduating from the Institute.

I won't describe how I managed to extricate myself from the bank and avoid being sent by the bosses to work in a place 'that was not so remote'.[6] My memoir would read like a complaints book (without suggestions for improvements), which was in those days an essential fixture in shops, baths, toilets and similar public facilities.

* * *

My studies at the university relieved my dismal existence as a credit inspector. The lectures by Boris Vipper, Yury Kolpinsky, Andrey Guber, Aleksandr Gabrichevsky, practical museum studies, visits to Leningrad – all these activities led me from my unappealing and humdrum working life into the pure sphere of culture which I had been seeking, and which I knew about only through hearsay. New surroundings, new acquaintances, new friends. The student cohort on the evening course was a mixed bag. Prize winners weren't thick on the ground (of course the admissions panel had been lying when I tried to submit my documents two years earlier). War veterans were represented by three Sashas: Sasha Berdyugin from the military prosecutor's office, Sasha Borov from Smersh (counter-Intelligence), and Sasha Khalturin from the KGB. But there were also clever, educated, interesting boys and girls.

When I was in my first year, I met Maya Rozanova-Kruglikova, the future Maria (she changed her first name when she emigrated) Rozanova-Sinyavsky, and our close friendship continues until today. In the faculty there was a saying about her: 'Be as rosy and round as Rozanova-Kruglikova.'[7] She was lively, sociable, with a sharp mind and a sharp tongue and she always had a string of admirers in tow. At some lecture or other we happened to sit next to each other and she suddenly took my notebook out of my hands and started looking through it. I found this disconcerting, but that was her style – on first meeting you she would tweak your tail, so to speak, and observe your reaction. But I will say more about her later on.

The Art History department was then housed within the Faculty of Languages and Literature – (soon we were moved to History). Latin was a compulsory subject. It was taught by a man called Dombrovsky. His first lecture was about Academician Marr. The second lecture was again about Marr. In the third lecture, he began to explain Latin verbs. He failed to turn up for the fourth lecture and was not seen again in the faculty. We were puzzled, but the explanation was quite simple. This was exactly the moment when Comrade Stalin's little book, *Marxism and Problems of Linguistics*, appeared, and the idealistic theories of Academician Marr were criticised in it. Dombrovsky disappeared and our Latin classes were cancelled. So I remain to this day a linguistic ignoramus. Dombrovsky was not an isolated case. Professor Boris Vipper was accused of cosmopolitanism and expelled from the university, and

Vasilyenko, a lecturer in applied arts, was sent to the camps. This was just within our small department. In the History Faculty the situation was more extreme. A group of student Komsomols were denounced and sent to the camps. As a result of our fellow-student Khalturin's denunciation, Zhenya Fyodorov was sent to prison. Who else? Those who have an interest in the subject would do better to turn to the substantial literature devoted to such matters, rather than rely on my patchy memory.

* * *

The students in our evening department were for the most part rather long in the tooth. Mikhail Liberman was about 50. He is one of that group of absolutely exceptional people whom I have been lucky enough to know in my lifetime.

Liberman was a painter (a pupil of Petrov-Vodkin),[8] an architect, a restorer, a builder, a bibliophile. His main hobby at that time was art history, and that is what brought him to the university. He lived somewhere on the Novaya Meschanskaya, not far from Kolkhoznaya Square on the first floor of a small house which he himself had designed. Here he held seminars of a sort on the history of art, to which he invited the students from our university group and anyone else who wanted to come. His library included a unique collection of Russian Futurist publications which he had begun collecting at the beginning of the 1920s (later he exchanged books with the poet and experimental book artist Kruchenykh – also a passionate collector who became a friend, as well as with other avant-garde artists still alive at the time – after his death this collection was bequeathed to the Turgenyev library). Liberman also collected reproductions of art from all over the world. He photographed them or cut them out of old books and albums. He even taught me how to split the page if there were reproductions on both sides. This collection of his numbered thousands, if not tens of thousands of items. He slept for two hours a night, saying that this was all he needed. At the time when I met him, Liberman was working in the All-Union Scientific Research workshops for the restoration of architectural monuments. The workshops were housed in the premises of the former Visokopetrovsky Monastery on Petrovka Street. To my great delight, he invited me to work there as part of his team.

The work was absorbing. We compiled historical information about churches in Moscow and the Moscow region which had been identified as architectural monuments for future restoration. We rummaged in church archives, dug out tiny nuggets of information from old tomes and reference books, went to examine sites; I even learnt to decipher the church Slavonic lettering of sixteenth-century documents. We were paid piece-work rates, like those in a printers' – per printed page of excerpts and texts from historical documents. We didn't make much but it was enough to live on. I worked there for about two years.

On 9 March 1953, I walked to work as usual from Yauza, where I was then living, to the Visokopetrovsky Monastery. I went along Petrovsky Boulevard and a dense crowd of people was moving along the pavement to the House of Unions to say farewell to the beloved leader. The approach roads to the centre of Moscow were all closed but I was allowed through because of my work pass. There was a surprise waiting for me at work. On the noticeboard there was an announcement: some staff, namely Liberman, Zemtsov and my humble self, were to be dismissed in order to reduce the size of the team. Oh well, it was only to be expected.

I climbed up to the eight-bell tower of the Visokopetrovsky Monastery – the highest point in Moscow. From there I could see black ribbons of people, like the tentacles of an octopus, thronging to Stalin's coffin from all sides of the city. I went back home down the same boulevard. It was thawing, the ground was wet with melting snow and a vast number of galoshes were scattered all over the boulevard; some had already been heaped into a pile, some were hanging from tree branches, evidently put there as someone's idea of a joke. As I later surmised, these were the relics of the hundreds of people who were crushed in Trubnaya Square.[9]

I did not grieve for Stalin – 'He deserved to die a dog's death' I proclaimed boldly, in front of two of my fellow students who weren't shocked by my declaration – but nor did I get any special joy from it. My prospects looked no less dismal, and perhaps even more so than before. The day before the leader's death, on 4 March 1953, my friend Miron Etlis was arrested.

Miron and I had become friends in the junior reading room of the Lenin Library. We started college at the same time – I at the Financial Institute and he at the Third Moscow Medical Institute

which shortly afterwards moved to Ryazan, about 200 km south-east of Moscow. As well as studying medicine, Miron was at that time working on what he called the science of classification. As far as I understand it (and I don't understand much), this was something like cybernetics – which at that time was considered bourgeois and idealistic. This man was so full of energy that he didn't even drink vodka (very unusual among our set) – and he was in a constant state of creative excitement without any alcoholic stimulus. Every Friday evening he would board the train without a ticket (he didn't have any money), hide under a bench seat and travel to Moscow. By nine the next morning, he would already be in the Lenin Library and on Sunday evening he would return to Ryazan by the same means. He joined the student science society at the medical institute (perhaps he was even president?) and he was beginning to get his articles published, but

One day, a friend of Miron's asked him whether he believed in the doctors' plot. 'No', said Miron. 'Why not?' asked his friend. 'Well, if they were poisoners they would know who to poison.' 'Who?' asked the friend. 'The fat one', said Miron, for some reason thinking of Malenkov.[10] The friend turned out to be an informer, working for the secret police.

Sometime at the beginning of April, I received a summons to attend the Ryazan section of the KGB. I already knew that Miron had been arrested and I went to Ryazan convinced that I wouldn't be coming back. The Ryazan KGB questioned me for a whole day. The questions were mainly to do with Etlis's anti-Soviet attitude. Taking a leaf out of Artemyev's book, I mumbled something along the lines of – yes, he had doubts about the Marxist theory of surplus value, and I myself . . . But did he say anything about his terrorist plans? I indignantly rejected this proposition. Miron had in fact never said anything to me for the simple reason that he wasn't planning any acts of terrorism. They asked me about other people I knew, in particular about Liberman. His art history seminars were also of interest to the KGB.

But somehow they didn't seem to be taking my interrogation very seriously. An air of uncertainty and futility hung over this department. From time to time the interrogator went off somewhere; various people dropped in to exchange a few words which I couldn't make sense of.

They even brought me something to eat at lunchtime and in the evening they let me go and gave me my travel expenses.

These KGB types already knew what I was then unaware of. 3 April 1953 was the day the doctors' plot case was dropped, and Miron's case was closely connected with that. I was out of danger for the second time.

Nevertheless, in May Etlis was found guilty of 'planning the assassination of Malenkov' and sentenced to death. He spent 24 hours in the tower where they held the condemned prisoners in the Ryazan prison, after which they informed him that his sentence had been commuted to 20 years in the camps.

Miron served his sentence in the Karaganda[11] camps. Solzhenitsyn, in his book *200 Years Together*,[12] cited Etlis, whom he claimed had worked in the camp sanatorium, as an example of how the Jews in the camps fixed themselves up as trusties with cushy jobs. This is not true: Miron did heavy labour. It is true that the camps were no longer as they had been under Stalin and there were rumours about the possibility of rehabilitation and release. In the evenings, Miron would climb up onto the top bunk, closest to the electric light, and study medical text books in the hope of one day finishing his studies at the Medical Institute. His Majesty, Chance, helped him on his way. The head of the camp (or his deputy) was afflicted with boils and couldn't find any remedy to cure them. Miron had become seriously interested in hypnotism while at the Institute and offered to try this method of healing on the governor. The experiment was a success. In exchange, Miron was given the right to go out of the camp zone, a right that was given to certain categories of prisoner (drivers, auxiliary workers and so on). The first time he went through the camp gates after finishing work for the day, he climbed into a goods wagon, arrived the next morning in the town of Karaganda and presented himself to the head of the overall administration of the Karaganda camps. He introduced himself as prisoner number such and such, alluded to his previous training, and asked permission to sit his exams in the local medical institute. The head, a KGB officer in the new mould, with a university badge on his jacket, was astonished but eventually issued instructions which actually stated that camp inmates were to be allowed to undertake professional training. After a long paper trail, permission was finally granted.

When Miron returned to Moscow in 1956 under the amnesty,[13] he called in at Karaganda on the way, to receive his graduation diploma from the Karaganda Medical Institute.

* * *

Miron Etlis's arrest, the incident with the Ryazan KGB, my despair of finding any kind of work ... my mood was absolutely wretched; for some reason Artemyev and I called this a 'yellow jacket mood'. We were hungry, sombre, a bit frightened, but nevertheless we were often cheerful − youth prevailed. Moscow was waking up after the bleakness of the hungry postwar years. Food rationing ended, the shops stacked up towers of tins of cod's liver and crayfish (during the Khruschev era these sold like hot cakes), on the counters new kinds of sausage caused a stir and there were pot-bellied jars of red and black caviar, which cost just a kopeck more than the cheapest herring, but the majority of the population did not have this extra kopeck. On Gorky Street there was the then famous Cocktail Hall, where for a new rouble[14] (if you were lucky enough to have one) you could have a cocktail called 'Flying High' or a glass of punch, and stay there till midnight sucking it up through a straw while chatting to friends. On an empty stomach one was quite enough. As I remember, the Cocktail Hall was a place where the semi-disgraced creative intelligentsia spent their time. You could meet Mikhail Svetlov, Yury Olesha;[15] once a rather drunk man introduced himself to us as the well-known historian Pokrovsky (and it is perfectly possible that it really was Pokrovsky[16]). During the years of the struggle against worship of the West, the Cocktail Hall was deprived of its foreign name and it was converted to a simple cafe while witty people renamed it in suitably Russian style as the Booze Hut. The Balchug Hotel stood on the spot where the Detsky Mir (Children's World) toyshop is today on Teatralny Passage, and it had a wonderful pub, in the style of a traditional old Russian tavern, in the basement; there was sawdust on the floor and barrels instead of tables. They served soaked peas and salted black rusks with your beer and sometimes you could even get real crayfish. For some reason we called this place The Three Rascals. And you could find beer stalls on nearly every corner. I am writing so much about drinking establishments because all my friends and acquaintances in those days were essentially homeless, as I was myself, and pubs were the only places

where we could meet, mingle, chat and, well yes, get slightly drunk in order to cheer ourselves up. We could let off steam here and escape from our drab everyday existence and our feelings of hopelessness. And then there was the music as well.

* * *

The spring of 1953 was perhaps the most dismal period of my life. And not only of mine. The ominous figure of Lavrenty Pavlovich Beria loomed on the horizon, the man whose name was linked to some of the most terrible crimes of Stalin's regime.[17] There were rumours that transportation trains were already standing somewhere on the sidings of the Kazan Station and that in the Soviet far east, in Birobidzhan, they were building barracks to house a hundred thousand Jews who were about to be deported from Moscow. This was how the authorities intended to save these cosmopolitans and potential traitors from the just punishment of the people. On the other hand, on the occasion of Stalin's death the government announced an amnesty for prisoners with a sentence of less than five years. This meant freedom for criminals – political prisoners never got such paltry sentences.

'Klim Voroshilov[18] and Brother Budyonny[19] gave the gift of freedom and the people love them for it' – was sung all over Russia at that time.

There was a crime wave in Moscow. It became dangerous to walk down a dark alley in the evening and people reported seeing the most extraordinary goings-on in communal flats. Here's one story I was told. It happened in a large communal flat in Moscow. The tenants were mainly little old ladies from the intelligentsia, but a certain Uncle Vasya also lived there – an alcoholic hooligan who terrorised the other inhabitants. Once, having drunk himself senseless, he set fire to the kitchen and ran down the corridor with a knife, threatening to stick it in anyone who came out of their room. Finally, through their combined efforts, the old ladies marched Uncle Vasya off to the police station and he was put behind bars. And the following scene. 1953. The old ladies are in the kitchen, each one cooking supper on her own primus or gas ring. The door opens, in comes a drunken Uncle Vasya and announces: 'They put a red hot poker up me arse! But here I am again. Ain't you pleased to see old Uncle Vasya again? Just your bad luck.' The old ladies' jaws drop, and their false teeth fall into the soup.

The suffocating atmosphere of terror and gloomy forebodings lifted somewhat by the summer of 1953 — after Beria's arrest.

> 'Lavrenty Palich Beria
> Could not be trusted
> There's nothing left of Beria
> But fur and feathers.
> Cherry plums grow in the south
> Not for Lavrenty Palich,
> But for Kliment Yefremich
> And Vyacheslav Mikhailich'

they sang in Moscow at that time. But soon Vyacheslav Mikhailich and Kliment Yefremich[20] also got a kick up the backside.

And I finally managed to get myself a job — in the travelling exhibitions section of the Directorate of Art Exhibitions and Panoramas of the Ministry of Culture of the USSR. There was such an organisation in Moscow then. Works of art by members of the Union of Soviet Artists that had been commissioned and purchased by the state but which were not of sufficient quality to be exhibited in museums (i.e. second-rate works) ended up in this section. Selections were made from these acres of painted canvas, these thousands of tons of bronze and marble and the chosen works were sent off on travelling exhibitions to different cities in the Soviet Union. I was taken on to do guided tours for these exhibitions sometime in the summer of 1953. I held this post for two years.

My first trip was to Astrakhan, my second — with an exhibition of graduation works by students from art schools in the Soviet Union — included Leningrad, Vilnius, Tallinn and Riga and my third covered the towns of Siberia and the Russian far east. This last trip was under the aegis of the Ministry of Culture of the USSR and the Political Directorate of the Soviet Army. The exhibitions were to be held in the officers' quarters in various towns from Omsk to Vladivostock, including Tomsk, Novosibirsk, Chita, Voroshilov-Ussuriysk, Khabarovsk and Komsomolsk-on-Amur. I found this prospect irresistible, as our itinerary included Port Arthur and Dalny, which were on the territory of contemporary China — which, however you look at it, actually counted as 'abroad'.[21] Alas, by the time of our trip these towns had been transferred to the People's Republic of China. The exhibition was run by a team of two, the director and the guide (me).

The trip lasted a year and I remember the experience as variations on the theme of monotony. In nearly all the towns we had to go to, there were grandiose Stalinist buildings in the centre but the outskirts consisted of squalid hovels, footpaths made of planks laid across a sea of mud, all the ugliness of a squalid, somnolent, drunken existence.

As well as paintings and sculptures by Soviet artists, we took a large, five-metre high panorama, *The Battle of Stalingrad*, and in every new place we had to hire workers to install it and to hang the other exhibits. The available manpower consisted almost exclusively of tramps and assorted riff-raff – low life, drunks and criminals. They wouldn't work without vodka. In Chita, just before the actual opening of the exhibition, the crew announced that unless the director immediately gave them money to buy vodka they would down tools and then cut off his balls for good measure. The terrified director hid in his hotel room while I had to go and buy half a litre of vodka with my own money, have a drink with them and engage in edifying conversations which had some quite entertaining moments.

In Voroshilov-Ussuriysk the only solid building in the whole town was the Officers' House. The only restaurant in the whole town was next door. Here, for the first and last time in my life, I played my grandfather's favourite card game, *Preferans*. The director and I occupied adjoining rooms and in the evenings the officers would come and join us there. We played for high stakes and the games went on until the early hours. The next morning, either the director or I would attend the exhibition while the other caught up on his sleep. I played cautiously and as a rule stayed within my means. After dinner, a band – consisting of violin, accordion and hopelessly out-of-tune piano – played in the restaurant and the officers would start their raucous carousing. A touring troupe of midgets were on the same itinerary as us and they contributed greatly to the entertainment in the restaurant. The midget Petya, who was three feet tall, would be passed from one officer to another, given vodka to drink and jokingly clasped to the breasts of the waitresses. Petya would tear himself free, scratch and bite and then crawl up the stairs to his room, drunk as a lord.

On the other hand, when I went to give lectures at military bases, factories, schools and collective farms, I discovered the extraordinary scenery of Siberia and the Far East from the cabs of the lorries I travelled in. I had never before seen anything like the primordial Siberian taiga, untouched by human beings, or the landscapes of the Baikal region, with their wide horizons, with such extravagant blossoming and blazing of colours in the

vegetation. My lectures were basically about Russian and Soviet art, illustrated by slides, which astonished and delighted the audience.

Faint whiffs of the future thaw began to penetrate the stuffy atmosphere which enveloped the cultural life of those days and in my lectures and guided tours I tried to introduce the audience to the concept of an alternative approach to art.[22] The highlight of our exhibition was a painting by Laktionov,[23] *Moving in to the New Apartment*: a mother looking around at her new surroundings with tender emotion, and a young pioneer holding a portrait of Stalin. Using this painting as an example, I explained the damage that naturalism and varnished reality[24] could do to art. The public took this calmly. The groups of soldiers, schoolchildren, workers and collective farm workers who visited the exhibition didn't give two hoots about these ideas. There were only two categories of visitor who reacted indignantly to my seditious speeches – teachers and lieutenant-colonels. The teachers knew perfectly well what you could say about Soviet art and how you could say it, while the lieutenant-colonels, awaiting promotion, needed to display ideological vigilance. I kept a cutting of an article from *Literaturnaya Gazeta*,[25] in which Laktionov's picture was mildly criticised, for just such situations. 'Look', I would say, 'read it.' And their outrage would evaporate before the irrefutable menace of the printed word. What the hell, maybe the comrade from Moscow had new instructions on these matters.

When I wasn't travelling or giving guided tours, I spent most of my free time drinking with local artists. But I don't remember anything interesting from these encounters and conversations. Except for one occasion.

In Khabarovsk I was assigned a young Azerbaijani submarine lieutenant, whose name escapes me, as a room-mate. He had just finished a submarine voyage under the ice of the North Sea route from Murmansk to Chukotka. The submarine surfaced for the first time after many weeks (or months?) at Chukotka and here the sailors made up in full measure for their weeks of celibacy. According to the lieutenant, whenever any inhabitant of Chukotka saw sailors approaching he would simply throw himself down on the snow shouting 'I'm a male, I'm a male.' And now my new acquaintance was spending his official leave in a wretched hotel room in Khabarovsk. It seemed a bit odd to me that an officer in funds would spend his time like this. But, as he explained, it was simply that he was afraid to go back to Azerbaijan where he was in hot water with the ideological watchdogs

because of Shamil.[26] He considered that Shamil had been a freedom fighter but the official line was that Shamil was a bourgeois lackey and a traitor.

I spent a month under the same roof as this educated and well-read lieutenant. In the mornings we usually went to the exhibition together and in the evenings entertained ourselves as best we could. It was impossible to obtain vodka in Khabarovsk at that time; only champagne and brandy were available. My friend called the drink made from these two ingredients 'instant submersion'. Once, at about two in the morning, we rolled out of some restaurant or other and ran into three somewhat tipsy youths. We started chatting and they said they were students at the local naval college. 'They fill your heads with drivel there', said the submarine lieutenant. The students were indignant. 'What do you mean, drivel?' they asked.

'Well, tell me, who built the first submarine?'

'Who? Nikonov.'

'Yes, and it sank on its first trial. Fulton, an American, built the first one. And the steam engine?'

'Everybody knows it was the Cherepanovs.'

'Cherepanovs my foot! It was Stephenson, an Englishman. And the telephone?'

'Popov.'

'To hell with Popov. It was Marconi, an Italian.'

The students' faces were a picture of bewilderment and one youth abruptly threw open his pea jacket, revealing some bottles of vodka sticking out of the inside pockets. 'Let's go, lads.' We had a protracted leave-taking and apologised for not being able to join them. We were already in the somewhat more forgiving post-Stalinist era.

Khabarovsk was the penultimate destination on our itinerary. There was still Komsomolsk-on-Amur to come. I went there by train to check the premises that had been proposed for the exhibition. I took a jam-packed bus from the station to the town centre. It was early spring, the road was icy and an approaching dumper truck skidded and its steel side sheared off the rear part of our bus. A number of people had cuts and bruises but one woman sitting at the back by the window was seriously injured. We got her out of the bus and she lay on the snow, bleeding. I ran out into the middle of the road and tried to stop a passing car to take her to hospital. But the Moskviches and Pobedas filled with officers carefully skirted round me and continued on their way. I swore at them but it was like water off a duck's back.

I immediately felt a deep loathing for this military town, still a stronghold of Komsomol enthusiasm.[27] After a fleeting glance at the exhibition premises I said that the ceilings were not high enough for our panorama and that we wouldn't be able to install the exhibition there.

The railway station and the train I went back on were both infested with criminals,[28] newly released from the camps in Kolyma, which was only a stone's throw away. In my overcrowded carriage some lout turned an elderly woman out of her seat and took it for himself, threw his rucksack onto the top berth and went off with his pals to the restaurant. Behaving like a lout myself, I clambered up onto this top berth and went to sleep. I was awoken by the original lout shaking my shoulder and demanding that I move. I sometimes used to fly into blind rages, and despite my slight build and natural timidity I would be ready to seize my adversary by the throat. 'Do you want me to smash your face in?' I muttered now, through clenched teeth and to my own astonishment. Surprisingly, the lout retreated, sat down in his seat and then spent a long time abusing me to his neighbours. I was expecting reprisals when we arrived at Khabarovsk station, but nothing happened.

In Khabarovsk I discovered that the Pushkin State Museum of Fine Arts in Moscow, which had for the past five years been exhibiting paintings donated by Comrade Stalin, was to undertake a new project, an exhibition of pictures from the Dresden Gallery, and that the museum was looking for guides. A job in the Pushkin Museum would be a dream come true. I phoned Makarov, the head of the Directorate of Art Exhibitions, and asked permission to leave the exhibition and go to Moscow. After some hesitation, he agreed. I went back to Moscow fearing that there would be a huge fuss about my abandoning the travelling exhibition. But Makarov turned out to be a decent man. He confirmed our telephone conversation. Using my year's absence as an excuse, I didn't rejoin the Komsomol and threw away my membership card.

CHAPTER 5

The Pushkin Museum of Fine Arts

The exhibition of paintings from the Dresden Gallery created a sensation in Moscow. It was 20 years since there had been any exhibitions of art from abroad in the Soviet Union. In 1949 the State Museum of Fine Arts (The Pushkin Museum) – the only place in Moscow where you could see the works of the great European masters – was given over in its entirety to an exhibition of works presented to Comrade Stalin by those who toiled for all progressive humanity. But now you could see Raphael, Titian, Rembrandt, Vermeer, El Greco ... queues of a thousand people stretched all along the Volkhonka and down the next street and people waited all through the night in order to get into the museum the following morning. Exhibition guides were needed for these huge crowds and we were mostly chosen from amongst the students in the Art History department. I had an advantage: my two years' experience working on the travelling exhibitions. So that's how I landed up at the museum, where I worked for a total of 12 years with a five-year break in the middle.

After the restoration of the permanent exhibition of the museum's collection I worked as a museum guide, but I was soon appointed as the editor of the Pushkin Museum's scholarly publications. We were paid a pittance but I prayed to God that we wouldn't get a rise: there were rumours that the museum was to be given the status of a scientific research institute, with a corresponding rise in rates of pay. If this had happened, a whole crowd of bureaucrats and opportunists would have made a beeline for the museum and it would have been quite impossible to get any work done. As it was, this cultural backwater housed a group of people who were on the whole thoroughly decent – young art historians who were passionate about art and enthusiastic about their work, and elderly, highly cultured members of the old intelligentsia, sheltering in this tranquil backwater from the 'hostile whirlwinds'[1] of the Stalinist years.

The senior curator at that time was Andrey Guber. At the same time, he lectured in the art history department of Moscow State University on the culture of the Renaissance and he himself had the bearing and manners of a nobleman from the time of Lorenzo de' Medici. On one occasion he had set me and a couple of my fellow students an oral test. We were all sitting at a small round table in one of the university classrooms. One girl was getting her answers in a muddle and her friend kept giving her gentle kicks under the table to warn her that she was making mistakes. We all passed the test.

'Why didn't you react when I nudged you under the table?'

'What do you mean, nudged me?'

It was actually Guber's foot that her friend had been touching. Goodness knows what Guber thought of this forward behaviour. But both during the test and afterwards he remained imperturbable.

Mikhail Liebman was the academic secretary of the museum. He was born in Riga and had studied there. After the annexation of Latvia by the Soviet Union, he was conscripted into the Soviet army and served on the front during the war. Liebman was a walking encyclopedia and brought into the museum a breath of Western scholarly accuracy which was rare in Soviet institutions.

The distinguished oriental scholar, Vsevolod Pavlov, headed the department of oriental antiquities. This unassuming individual had once done time for some sort of anti-Soviet transgressions (evidently this was in the early 'vegetarian' days of Stalinism) and after his release he was hidden by well-wishers in the cellar of the museum's storerooms. He ran a course at the university on the history of Ancient Egyptian art and practically every one of his assertions about the particularities of ancient Egyptian culture invariably concluded with the phrase: 'But on the other hand, how can we know?' Both his students and his colleagues at the museum knew him affectionately as Vodya and I always think of him exclusively by that name.

Aleksandra Demskaya, the chief archivist, was the secretary of the Museum's Party organisation.[2] The bookbinding studio – a small basement room with a single occupant, Lev Turchinsky, came under her aegis. People from all over Moscow brought books and manuscripts to Lev for binding, and his room was full of illegal literature. It was piled from floor to ceiling with stacks of books from foreign publishers, complete sets of émigré journals, rarities published before the revolution, and, most important of all, *samizdat*.[3] Lev gladly made short-term loans of *samizdat* literature to his friends. It was in his studio that I first read the typescripts

of Solzhenitsyn's *August 1914*, Yuz Aleshkovsky's *Nikolay Nikolayevich*, Venedikt Yerofeyev's *Moscow to the End of the Line (Moskva-Petushki)* and many others.

Documents written by the museum's founder, Ivan Tsvetaev, and manuscripts by his daughter, the poet Marina Tsvetaeva, were held in Demskaya's archive. We managed to publish an article by Marina Tsvetaeva, 'The Opening of the Museum', in The Collected Reports of the Pushkin Museum. It was apparently the first work by her to appear in print since the 1920s.

Ksenya Yegorova succeeded Demskaya as Party secretary at the museum. She joined the Party in order to be able to do research in foreign museums, archives and libraries. She worked in the Western department and was extremely knowledgeable about art and many other things, but as far as everyday life was concerned she was completely unworldly. Once I went with her to have lunch in the dining room at the Prague Restaurant which was not far from the museum. Just at this time a major Dutch art historian was on a visit to Moscow and Ksenya was showing him round and taking him to plays and exhibitions. The previous day they had been to the theatre to see a production of Mayakovsky's *The Bathhouse (Banya)*. I asked Ksenya how she had managed to translate such a difficult play which included a lot of obscenities for good measure. 'Well, I myself don't understand them', she said in a loud voice which reverberated round the packed dining room. 'I saw the words "f****** c***" written on a wall, but I've no idea what they mean.' I nearly crawled under the table with embarrassment. She was, in fact, deeply devout, a fact that I only learnt much later, when she came to visit us in London and Amsterdam and advised me in letters to turn to the Lord to help me with all my troubles. You can imagine what kind of Party secretary she was.

I don't think it would be an exaggeration to say that, from the end of the 1950s, the museum turned into one of the few oases in the stifling atmosphere of Moscow where the culture of Stalinist Socialist Realism still reigned supreme, sturdily guarded by the Academy of Arts of the USSR. The museum was the only place in the capital where you could see not only the works of the great masters of the past, but also a small part of European art from the end of the nineteenth and beginning of the twentieth century. The Moscow Museum of New Western Art was abolished in 1948 and everything from Impressionism onwards was treated then as evidence of the decay and decadence of Western bourgeois society. And even classical art

from abroad in its entirety was overshadowed by the achievements of the great Russian masters. Kramskoy's pictorial qualities were deemed to far exceed Velasquez's, Hogarth's work seemed superficial and trivial compared with the social pathos in pictures by Fedotov or Perov. Bosch, Grünewald, J. M. Turner with his departure from realistic principles of representation, served the dark forces of reaction and all developments in world art were stimulated by the irreconcilable struggle between reactionary and progressive tendencies. However, whatever the ideologues said about aesthetics, our university teachers had willy-nilly inculcated in us a different attitude to worldwide artistic production. Indeed, the work spoke for itself. During our guided tours in the museum, we tried to sensitise our audience to an alternative response to the paintings of Claude Monet, Cézanne, Van Gogh and early Picasso.

We managed to convince the management of the importance of attracting young people to the museum and with this aim in mind we set up an Art History Club for senior school pupils (today the club occupies its own separate building attached to the museum with all the latest equipment and activities for school-children of all ages). In the museum galleries we provided classes in description and analysis of works of art, took pupils round architectural monuments of old Russia – in Novgorod and Vladimir – taught them the fundamentals of attribution – i.e. to look at reproductions and identify the date, the school and the maker of a particular painting. Stereotypical responses broke down, people developed a new attitude not just to art but to the whole regime.

During one such exercise I showed the students reproductions from the periodical, *Art of the Third Reich*, for the year 1938, covering up the titles written in Gothic script and asked them to identify the artists. (My colleague Mikhail Liebman had discovered this Nazi magazine in a heap of publications which had been confiscated from German libraries and had not yet been sorted out. He had tucked it away out of sight of the numerous censorship committees.) The students saw in front of them very familiar images: muscular young men, heroic warriors, enthusiastic workers on the factory floor, the flourishing of the nation, unanimous approval. The task seemed easy to the students. Gerasimov! Nalbandyan! Mukhina! They vied with each other to shout out the names of these Stalin prize-winners. In one of the reproductions, a worker's family listened reverently to the sounds coming from the painted radio. 'Laktionov!' 'Look carefully.' And then an expression of complete confusion appeared on the

faces of the young art critics. There was a portrait on the wall above the heads of the family listening to the radio. However, what they saw there was not the Leader's full moustache, concealing the smirk on his lips, but the Führer's Chaplinesque little toothbrush moustache.[4]

* * *

When I was appointed as editor of the Pushkin Museum's scholarly publications, the museum staff still included learned ladies of the previous generation who had been educated at pre-revolutionary high schools, at institutes for daughters of the nobility and at the Smolensk Institute: Nina Loseva, I. A. Kuznetsova, Ksenya Malitskaya, T. A. Borovaya. Well educated and fluent in foreign languages, they did not understand Soviet reality and shut themselves off from it, each within the framework of her own speciality. Thus, the woman in charge of Western Art, a Spanish specialist, the delightful Ksenya Malitskaya, dwelled somewhere in sixteenth-century Spain. Her great enemy was the Belgian writer, Charles de Coster, who, in his novel *Till Eulenspiegel* (extremely well known in the Soviet Union), slandered King Philip II, whom she saw as the noblest of beings. Nina Loseva was head of classical art. One day she brought her old nanny to the gallery of antiquities. When nanny saw Venus and Apollo naked she exclaimed: 'Nina! You should be ashamed of yourself. A spinster like you.'

These ladies from the *ancien regime* (brought up under the last tsar) had many intellectual and human qualities, and only one fault – they wrote badly. And how could they be expected to write well? A career in journalism was not available to them and the writing of diaries and the epistolary arts on which they had honed their literary style in their youth had become a risky business. I had to almost completely rewrite their scholarly articles. On the other hand, the stories they told offered glimpses into the unwritten, unofficial history of the museum, to which they were living witnesses. Unfortunately, only a few such glimpses have lodged in my memory – I recount those that have below.

Comrade Novikov

After the arrest of the museum's director in 1937, a certain Novikov was appointed in his place. He was a house painter by trade. At first he didn't

emerge from the director's office and only showed signs of animation when the museum was being renovated. Then he appeared in the galleries and gave instructions with regard to colours, putty, paints, and other fine points of his trade. After that he got a little bolder and appeared in the library. 'Why are all the book cases open?' Comrade Novikov asked the terrified staff. He was given an explanation: scholars were working there, specialists who were reading the books 'Well', said the director, 'Open one case, and when they've read everything in it, open another one.'

A certain Iranian communist was working at the museum then. He had fled from his capitalist motherland to the land of victorious socialism. Of course there was nowhere to put him and he was placed in the numismatic department since he would be able to decipher the inscriptions on Persian coins. His Iranian name and surname were difficult to pronounce and in the museum they called him by the sonorous nickname of Khrich Poganich.[5] Discipline was very strict in those days and people started to make complaints about the poor fellow. He kept coming back from lunch late; he would absent himself at odd times of day. Whereupon Khrich Poganich wrote a letter to the director to justify himself. He explained that he had a problem either with his bladder or his stomach and because of this he was obliged to go to a public lavatory because it was draughty in the WC at the museum. Whereupon Comrade Novikov gave him permission to use the women's lavatories.

November 1941, a few months after the Nazi invasion. A day was appointed for the evacuation of the museum collections. Our old ladies, who were then still young, took down the paintings, dismantled sculptures, nailed up crates ... all they were waiting for were the director's instructions. But on the appointed day he didn't appear. Nor did he appear on the following day, or the day after that. It was subsequently discovered that Comrade Novikov had already been evacuated as he was 'essential personnel'.

Abram Efros and André Gide

In 1936, the progressive French writer (he subsequently became reactionary) André Gide visited the USSR. Abram Efros, a brilliant essayist, critic and translator, was assigned as his interpreter. They came to the museum and the writer got a stomach ache. He was escorted to the lavatory, the entourage waited outside and suddenly an anguished cry rang

out from the cubicle. *'Papier! Papier!'* The following year, Efros was arrested and sent into exile. It is quite possible that his failure to provide the progressive writer with loo paper incriminated him as a saboteur.

The Museum of New Western Art

Another story I remember is about the abolition of the Museum of New Western Art in 1948. This was done on the initiative of the Academy of Arts of the USSR. Evidently, their management was pursuing two goals. First, they wanted to lance this boil of bourgeois decadence in art and, secondly, to get their hands on the museum's premises, the Morozov[6] mansion on Kropotkin Street. Indeed, they moved in there as soon as the abolition of the museum had been agreed. A meeting was arranged between Khruschev and the management of the Academy. When he learnt about this, Viktor Lazarev, the only art historian to be a full member of the Academy of Sciences of the USSR, rushed to the meeting to explain to the member of the Central Committee that the decision to close the museum was very ill-advised. He arrived late. When Lazarev went into the museum he saw that Serov, the president of the Academy of Arts, was saying something to Khruschev as they stood on the grand staircase of the mansion, and pointing at the large panel of Matisse's *Dance*. Khruschev was guffawing loudly. It was too late to do anything.

Exhibits from the abolished museum were shared out between the Pushkin Museum and the Hermitage and an order was given to prepare a list of all the exhibits to be sold abroad.[7] Lazarev tried to persuade the museum staff to drag out the process for as long as possible. And they did. After Stalin's death the sale was cancelled. And so this great collection of modern Western art (formerly the private collections of Shchukin and Morozov) were saved for the Russian nation. All except one exhibit. Soon after the war a powerful American businessman had arrived in Moscow to meet the members of the government. When they took him round the galleries of the Museum of New Western Art, Molotov took down from the wall Van Gogh's *The Night Cafe*, which the businessman had admired, and presented it to him as a gift. This painting now graces the art gallery at Yale University.

CHAPTER 6

The International Festival and Artists

The International Youth Festival[1] which took place in Moscow in 1957 played a significant role in the process of re-evaluation which was going on in the post-Stalinist Soviet Union. It is hard to overestimate the part it played in the subsequent history of Russia. The festival gave the Soviet public its first chance to become acquainted with contemporary art from abroad. Before Stalin's death, people had no such opportunity. The Museum of New Western Art had been abolished in 1948, university courses on the history of foreign art ended with the Impressionists, all museum exhibitions (at the Pushkin Museum, the Hermitage, the Tretyakov Gallery) stopped abruptly at the1880s, for beyond that date lay only 'reaction' and 'decadence'. It is true that there were progressive communist artists abroad, people like André Fougeron, Rockwell Kent and Diego Rivera, but even their work did not meet the exacting standards of socialist realism. Now a slight stirring began in this regard – Khruschev was clearly flirting with so-called progressive Western circles. Diego Rivera and Alfaro Siqueiros came to Moscow. Rivera was a Trotskyist and Alfaro Siqueiros an unbridled Stalinist who had led the first (unsuccessful) attempt on Trotsky's life and, although neither of them was a socialist realist by any stretch of the imagination, they were given a truly royal welcome in artists' circles. Out of all the work that was then called 'progressive contemporary art', the works of the Mexican artists were the furthest removed from the canons of socialist realism. This was precisely the reason why Inga Karetnikova (who had been at university with me and then worked with me at the museum) and I became very interested in Mexican art. We co-authored a long article in the collection *Contemporary Visual Arts in Capitalist Countries* (Moscow, 1961) and unexpectedly (for lack of others) became specialists in this field. At the major exhibition *The Art of Ancient Mexico* in 1963 – the first in the Soviet Union to have

government support – we were involved in curating the exhibition, we trained up the exhibition guides, I supervised the translation of the catalogue and Inga accompanied Mikoyan[2] round the exhibition.

I also took round someone from the Central Committee (either Kirilenko or Kirichenko[3]). In a narrow passage between display cases, I turned to my esteemed guest in order to let him go first and suddenly felt myself being lifted into the air; my head was turned in the required direction and I was deposited on the floor. Behind me stood a stony-faced bodyguard. I had breached protocol.

Working on contemporary Western art was still a risky business then. Very few art historians studied the twentieth century and those that did obviously didn't want to run risks. So I and a number of other colleagues from the museum were assigned to work on the installation of the exhibitions for the International Youth Festival. This festival prised open 'a window onto Europe' for us, and a host of foreigners poured into Moscow through this chink, together with the fresh air of freedom. Two young Englishmen sought me out at the museum and said they had brought me a present from my old friend Alik Dolberg, who now lived in London.[4] We went out into the Italian courtyard where there weren't many people about and they handed me two books: *Darkness at Noon* by Arthur Koestler and George Orwell's *Animal Farm* – books which were illegal in the Soviet Union at that time. We stood and talked by a cast of Michelangelo's David while a man in civilian dress hovered around listening attentively to our conversation. When I stopped to search for a pen so that we could exchange addresses, this citizen kindly offered to lend me his. I was so captivated by these books that I began to translate them straight away and then I read the translations to quite a wide circle of friends. After some time two boys came to see me. They mentioned the name of one of my friends to show that they were trustworthy and asked me to give them the manuscript of my translation of *Darkness at Noon* so that they could type it up. A few days later they brought me a typed copy. This copy of mine later disappeared due to the vagaries of fate but others circulated round Moscow. Many years later the great archivist, Garik Superfin, discovered a copy there – it is now lodged in the archives at the Research Centre for East European Studies at Bremen University.

Before we were allowed to start work on the festival exhibition, our team was called in for a briefing by Fyodor Kaloshin, the director of the Institute

of the History and Theory of Art of the USSR Academy of Arts. This was a serious matter. Works by young artists from 36 countries were to be displayed in three pavilions constructed in Gorky Park. And what a variety of work: surrealism, expressionism, formalism, abstractionism ... we must offer a rebuttal, oppose it ... explain the aggression ... the imperialist character of all these trends in art. (The same situation occurred the following year at the exhibition of contemporary Polish art, displayed in the Moscow Manege.) We were again sent there as consultants, to explain to the public the harmfulness of so-called formalism in art. It was around this time that the expression 'undercover art historians' was coined.

I worked in pavilion number one, which housed art from Argentina to Israel (however, the Israeli artists never actually got as far as Gorky Park: after the festival had ended the crates containing their work were discovered in some Russian railway station depot). I helped mount the exhibition and then acted as a consultant – in other words, I did not so much oppose the art as explain to the public, to the best of my ability, the principles of how to approach contemporary art. The public listened attentively, and although people didn't understand everything, some sort of change in their mind-set nevertheless occurred. I can judge this by the fate of Kaloshin, the director of the Institute.

He had been picked out by the Party for promotion from some remote backwater; he defended his thesis on Lenin's views on aesthetics, or something of this sort, and he signed his articles F. Kaloshin, philosopher. People made jokes about his pronouncements ('In England there was a crisis and the hired hands no longer had a leg to stand on.'). And his own story also reads like a joke. Clearly, this poor devil sincerely believed in the Soviet aesthetic clichés and in the things that he wrote. The revolution in his thinking occurred when he dropped into the festival exhibition. He then said to one of his staff – (someone I knew): 'Well, there is a whiff of decadence here, perhaps, but imperialism? American aggression? An international plot against the USSR?'

Instead of that he saw canvases covered with coloured blobs, distorted figures, strange landscapes ... he could not detect any ideology whatsoever in all this. The result was unfortunate. Kaloshin grew to hate his Academy, and complained that all these Soviet prize winners, the Nalbandyans,[5] Deynekas,[6] Kukryniksies,[7] were ready to tear each other's throats out for a State commission. He died soon afterwards. He cannot have been more than about 50, judging by appearances.

But it was our young artists who were most shaken up by what they saw. In one of the pavilions there was an open studio where the public could watch the foreign guests create their masterpieces. One of the painters, Harry Calman (or rather Colman;[8] I had never at that time come across his name in books or catalogues), an obvious disciple of Jackson Pollock, spread a large canvas on the floor, placed buckets of paint next to it and slapped the paint onto the canvas with a big brush. The result was stunning! Other visiting artists also demonstrated different creative techniques that we had never seen before.

For our budding artists all this was a complete revelation. They absorbed this new relationship to what they were painting (whether this was external reality or their own inner world), and these new methods of embodying such relationships, but then overlaid this with their own experience, their own reality. This gave their work a distinctive character and differentiated it from the work of Western painters and from those Western trends which were their starting point.

So, Anatoly Zverev – one of the most talented artists of his generation – assimilated the spontaneous creative method from Jackson Pollock (or Harry Colman) and then produced something that I would call figurative *tachisme* – an apparently incompatible combination. He would splash paint onto a canvas or sheet of paper then apply seemingly random, chaotic brush strokes – all this would take only a few minutes and the result was a perfectly recognisable landscape or a very accurate likeness of a person.

We became friends. When Zverev didn't have anywhere to spend the night he and his girlfriend, Nadya Rumyana, would come to our room (which measured just seven square metres) and sleep under the table. For all his down-and-out appearance, there was something gentlemanly about him. He would arrive in a ragged overcoat, fastened with an ancient scarf, but he always produced a clean towel and his own vodka glass from his pocket. Once he borrowed three roubles from me to buy a bottle, and then, every time he met me, would apologise for the fact that at that moment he was unable to pay me back. 'Never mind, Tolya, forget it!' I would say every time. One day we met at Boris Sveshnikov's and again he apologised but then said, 'I'll tell you what, I'll do a drawing of you.' He took a big sheet of paper and a piece of charcoal. Within no more than 30 seconds, without once looking at me or lifting his hand from the paper, he had created a sketch which was strikingly like me and captured my inner character. He didn't need to look at his model, he already had their general

image in his conscious (or subconscious) mind, and all he needed to do was transfer it onto paper or canvas. Sometimes Zverev put a few sheets of paper on the floor and in the course of a few minutes he covered them with paint. Of course this method (as with Pollock or Francis Bacon) did not always produce results.

Zverev was supported at that time by Georgy Costakis.[9] Every week, Tolya would take him whatever he had produced and receive some money to keep him going. He could hardly have survived without this. Much later, after Costakis had emigrated, he invited me to his home in Athens, in order to go through Zverev's work. He had dozens, maybe hundreds of sheets. We put them in piles, according to quality: brilliant, excellent, good, average. The thinnest pile was the first category, the thickest pile, the last.

I first met Volodya Yakovlev[10] early on. He was then working as a photographer for the publisher Iskusstvo. I asked him to photograph paintings for my diploma thesis. Volodya was already half blind then. When he came to the museum, he looked at the paintings by literally putting his nose to the surface. I often met him at the Festival exhibition. Soon after this he showed me his own drawings. The shape of the subjects had undergone some kind of cubist distortion. I took fright. How could someone who was half blind take up the analysis of form, which needs acute eyesight? I didn't visit him after that as I was afraid of showing my feelings about the kind of work he was doing. However, Yakovlev soon found himself. It was as if his bright, fantastical flowers and birds were radiantly lyrical emanations from the loneliness of the artist.

So each of the artists I knew – Oskar Rabin, Dima Plavinsky, Aleksandr Kharitonov[11] – interpreted the experience of the West in their own way. It can certainly be said that the 1957 Festival was a powerful spur to what came to be known in time as unofficial Soviet art.

I met Boris Sveshnikov – a remarkable man and a remarkable artist – at the end of the 1950s. One day I called in at the museum's restoration workshop and saw a painting on my friend Galya Erkhova's table: evening, a town square, a telephone kiosk, a girl ... At first the painting seemed to me to be the work of one of our homegrown surrealists. But the whole scene was penetrated with a mood of such piercing solitude that I got a sinking feeling in the pit of my stomach. Galya took me to meet Sveshnikov and we became friends. Sveshnikov's style had been forged long before the Festival. In 1946, as a 19-year-old student at the Moscow Institute of Applied

and Decorative Arts, Boris was arrested on the street, while on his way to a local shop to buy kerosene. He was sentenced to eight years in the camps for allegedly belonging to a group which was allegedly planning an assassination attempt on Stalin.

He spent two years doing heavy manual labour, after which he was written off as a 'goner' and sent to a camp for 'invalids'. Friends helped him to get a job as a night watchman at some sort of small factory within the Vetlosyan[12] camp where he remained until the end of his sentence. He would spend the nights drawing in his little box room.

His surviving works from the camps (more than a hundred drawings and a score of paintings) are unique not only in Russian art but in all twentieth-century art (I am absolutely convinced of that). Before his arrest Sveshnikov had not even heard the word 'surrealism'. But he saw in the reality of Stalin's camps in the 1940s what had been imagined in Parisian attics in the 1920s – the irreality of life, the fragility of human existence on this earth, the banality of evil.[13]

After he was freed, Sveshnikov, his wife Olya and her son lived on Usachevka Street in a tiny two-roomed flat, which he had taken over after his father's death. He was reserved, taciturn – as if he had still not completely thawed out after the camps – but he was nevertheless open to people, and very interested in the new developments in art. Once I took Sinyavsky to see him, and we – Zverev, Plavinsky, the Menshutins – often gathered round his hospitable table, drank, talked, and – most important of all – looked at his new works. They had an almost post-apocalyptic quality: it was as if the scroll of time had been rolled up and the artist were dispassionately contemplating and recording the capricious resproutings of human life.

It was the beginning of the period when there were exhibitions of unofficial art. When the nonconformist artists asked Sveshnikov for paintings to exhibit, he gave them some, but did not himself take part in the new movement. The cold of Stalin's era was still lodged within him and he knew that he would not survive a second term of imprisonment. Collectors began to show an interest in unofficial art. Costakis was one of the first to approach Sveshnikov with the aim of buying one of his paintings. Later, Costakis recounted their conversation:

'How much do you want for it?' asked Costakis.
'I don't really know.'

'A thousand roubles?'
'No, I won't sell it at that price.'
'Then how much?'
'Two or three hundred.'
They bargained and met halfway.

Sometime at the beginning of the 60s, Sveshnikov took me to meet an artist who was, according to him, amazing – Oleg Kudryashov. At that time Oleg lived in an old house in the Basmanny District in a room overlooking a large Moscow courtyard. He would stand for hours at his window, observing the inhabitants of the courtyard, and embodying what he saw in hundreds of grotesque drawings. For Kudryashov, each squiggled figure in his compositions had its own character and biography and as he showed us his drawings he would shout enthusiastically, 'That's Uncle Vasya – the alkie from number 12, and that's Petya, who's just got out of clink', or things of that sort. At the same time he was doing miniature abstract engravings. He engraved on a zinc plate, leaving metal shavings or 'burr', on either side of the engraved line. He impressed the image onto paper, and then painted over it with watercolour. The speckling of zinc burr imparted a kind of silvery gleam to the surface, which, in combination with the soft floating colours, gave the engraving an amazing elegance – as if a light scent of French Rococo had penetrated the leaden atmosphere of Moscow. These engravings were compiled in small folding books.

Kudryashov's only art education had been his attendance at an art studio belonging to the Pioneers' club. Nevertheless, by the beginning of the 60s Kudryashov was already gaining a reputation among the inner circles of the art world as one of the most technically innovative and serious graphic artists in Moscow. From time to time the engravings room at our museum or the Tretyakov Gallery would buy two or three works from him. Kudryashov was accepted as a member of the Moscow branch of the Union of Soviet Artists thanks to the efforts of fellow artists who recognised his creative promise. But highly placed art bureaucrats saw Kudryashov's work as pernicious rubbish. What exactly, they asked, was the aesthetic significance and authenticity of those alcoholics, cripples and wizened old crones skulking in the backyards of socialist Moscow? And what was the meaning of those pages of his covered with nothing but circles and zigzags?

For that matter Kudryashov himself, despite his new-found official status, was unable, and indeed unwilling, to subscribe to the creative ethos of the Artists' Union – either to its old socialist realist ideology or to its new, so-called progressive movement. He also remained on the sidelines with regard to the unofficial artists who were emerging at that time from underground and announcing their presence through exhibitions in people's apartments and in various venues outside the art world. He remained on his own, he felt at peace only when alone with his work and he avoided everything else like the plague. Taking such a stand absolutely guaranteed his creative independence but did not provide any means of making a living. When he had nothing to eat, Oleg would lie down on the sofa to conserve energy for his work. He could not carry on like this for long. In the summer of 1974, he and his wife Dina and their eight-year-old son were able to emigrate on an Israeli visa, thanks to his wife's Jewish origins.

* * *

Sometime in 1958, much to my surprise, I was appointed acting academic secretary of our museum. The director then was Aleksandr Zamoshkin – an art historian in the Stalinist mould who had previously played a part in the battle against formalism in Soviet art, but who was personally a mild and cautious man. His greatest fear was of any kind of unpleasantness either for the museum or for himself. Among my duties I had to reply to letters from museums abroad. When I took him the typed text of my reply in Russian he would read it attentively and invariably found something wrong with the punctuation. He would send it off to be retyped and then put the letter in his drawer and that was the last that was ever heard of it. But I gather that he also kept dossiers on us in the drawer, just to be on the safe side – ideology was constantly shifting at that time. And clearly, there were plenty of dossiers. I gave lectures on contemporary Western art in various cities, on behalf of the Society for the Dissemination of Political and Scientific Knowledge, and my unorthodox opinions provoked a natural reaction among Soviet citizens. The head of our personnel department, Nikolay Prokhorov happened to be the grandfather of Galich's stepdaughter, Galka Shekrot, who was also working at the museum and who was a friend of mine – it's a small world! Prokhorov summoned us to his department and warned us in a fatherly way that we were storing up trouble for ourselves.

I was compensated for the tedium of office work by the constant companionship of Boris Vipper. Vipper had been the main supervisor for my diploma thesis on the fifteenth-century art of the Netherlands which I defended in 1956. At the museum he was deputy director of the research unit and we shared an office.

From 1924 to 1941 Vipper had lived and worked in Riga and – unlike most of our academic art historians – had enjoyed access to all the major museums of the world. He had actually seen the originals of the works he wrote about. Of course he was obliged, like everyone else, to have recourse to the usual clichés, such as 'the battle between the realist and non-realist tendencies' in art from any given historical period and had to refer to the classics of Marxism-Leninism. However, this ideological shell concealed some brilliant analysis and a stream of original ideas. His exclusive preoccupation with West European art naturally attracted accusations of cosmopolitanism. In 1948 (or 49?) he was sacked from his university post where he was head of the department of Western Art. But his father's status saved him from any more drastic punishment. Academician Robert Vipper had won Stalin's special favour for his book about Ivan the Terrible, in which the tsar's cruelty was justified by his aim of creating the great state of Russia – Stalin was pleased by such comparisons. Boris Vipper was often called upon to verify the attribution of paintings which were up for sale. On such occasions he invited me along, ostensibly as a colleague, but actually so that he could give me a lesson in attribution. From these lessons I learned once and for all that only the act of looking at the actual object with the trained eye of the art historian gives any worth and meaning to what you write about – be it the history, theory, or sociology of art, or art criticism. I felt highly sceptical about the formalist, semiotic and structuralist approaches which became fashionable in the 1960s.

But now it's time to divert the course of these reminiscences away from the museum, for my future fate was to be shaped by events for the most part outside it.

CHAPTER 7

The Sinyavskys, Khlebny Lane, the Far North

When I returned to Moscow in 1955 after my year-long trip with the travelling exhibitions, I discovered that my old friend Maya Rozanova-Kruglikova had started a passionate love affair with Andrey Sinyavsky. They were very soon married and Maya moved in with Andrey.

They lived at Sinyavsky's place at number 9 Khlebny Lane: they had a room in a communal flat, plus a small basement which Andrey had turned into a study and where he hid from tiresome visitors. This is where Rozanova brought me and I stayed there for some time.

At first Sinyavsky and I were rather wary of each other; we were sniffing each other out, so to speak. This was only natural because we were living amongst people who were on the whole alien to us, often dangerous, and we could only recognise kindred spirits by using some sixth sense, by catching some fleeting signs. Joseph Brodsky writes in his memoirs that in his circle they chose their friends according to their preference – Faulkner or Hemingway? Our generation had to be guided in our choice by political signs as well as aesthetic ones. In both these areas Sinyavsky and I had much in common. Sinyavsky's father had flung his noble origins into the fire of the revolution, joined the Kadet party,[1] been imprisoned by the Soviet authorities (like my father), and was sent into exile and if anybody had asked us – Picasso or Gerasimov,[2] Platonov or Babayevsky[3]? – our answers would have been the same.

Sinyavsky was at this time an academic at the Gorky Institute of World Literature and was teaching in the theatre school of the Moscow Arts Theatre. In the evenings there would be convivial gatherings in Khlebny Lane. Volodya Vysotsky,[4] who was then Sinyavsky's student at the Moscow Arts Theatre School, would turn up with his guitar. Another of Sinyavsky's

students also came, and his old friend and colleague, Andrey Menshutin, with his wife Lydia, who was the soul of kindness. We sang prison songs and washed them down with vodka and simple snacks. I don't think Vysotsky had started composing his own songs yet. He sang old songs from the prison camps – 'The rivulet flows' and 'The steam engine flies' – but he sang with such drawling intonation, expressing these tragic stories with such anguish that the old songs acquired a completely new sound – the sound of his own – future – songs. And his improvised stories were even more extraordinary – a kind of one-man show – about astronauts, about the three bears – who 'sat on a golden branch, one of them was small, the next one swung his legs' and that one, the one swinging his legs, was Vladimir Ilyich Lenin, and the she-bear was Lenin's wife, Nadezhda Krupskaya. It was so funny that I almost split my sides laughing. I don't know if any recordings of these improvisations have survived – I never heard them again, but if they have disappeared it is a great loss for the art of performance. Sinyavsky was usually rather reserved and taciturn in company but on these occasions he relaxed and gave inspired renderings of 'Abrashka Terts grabbed a pile of dosh.'

Abram Terts was the pseudonym he took for his underground writing. Why? Well, Sinyavsky himself has written about this in his novel *Good Night* (*Spokoynoy nochi*).[5]

Somewhere around 1955 or 1956 he began to read his underground stories – *Pkhents*, *The Trial Begins* (*Sud idyot*), *The Makepeace Experiment* (*Lyubimov*) and others – to a very small circle of friends. But the fact that he was sending his manuscripts abroad was known only to the Menshutins, the Daniels and myself. Everybody knows what this led to, but I will come to that later.

* * *

Sinyavsky had many interests outside his literary research at the Institute. These included the schism in the church in the sixteenth century, Orthodox heresies, the avant-garde art of Russia and Europe and prison songs, a genre which he considered to be an integral part of popular folklore and which to a certain extent even replaced it in Soviet times. Maya Rozanova was then working in the field of architectural restoration, and was involved in the restoration of St Basil's Cathedral in Red Square. She was interested in folk arts and crafts and old Russian church architecture. Their interests, which

coincided for the most part, drew them to the Russian North, then untouched by Soviet civilisation.

The Sinyavskys made their first journey along the river Mezen[6] in 1957. The following year they invited me to go with them. We got hold of an outboard motor in Moscow, then we bought an old boat from a fisherman in the countryside near Vologda and we set off up the Mezen, constantly deafened by the din of the motor. Along the upper reaches of the river there were abandoned villages on the banks for hundreds of kilometres. Sturdy five-walled log huts,[7] all empty, half-ruined old churches which had been desecrated ... in some of these churches odd bits and pieces of the old iconostases were still standing but parts of them and the icons which had hung on the walls were strewn about the floor, covered with a thick layer of bird droppings. Maya cleaned off the dirt and dung and wiped their blackened surfaces with cotton wool dipped in turpentine and then images from the sixteenth or seventeenth century often emerged. Some of the original population were still living in the villages by the lower reaches of the river, but here too there were empty huts, churches with broken crosses and collapsed cupolas. Depending on the time of year, rain or snow poured in and covered any of the wooden icons that had survived there. The local people used these for their own domestic purposes. They patched holes with icons, chopped cabbage on them, used them as lids for their pickling barrels. (We had a friend, Kolya Kishilov, who worked as a restorer in the Tretyakov Gallery, and much later on he went off on an expedition to find icons. In one village he saw a window boarded up with an icon, its image facing outwards – under its thick black surface a thirteenth-century Christ the Saviour was discovered. This icon now graces the Russian Paintings of Antiquity room in the Tretyakov.) But the older generation, especially the old women, treated the icons with more reverence. For example, one day the Sinyavskys saw an icon, clearly very old, in one of the huts, and proposed to buy it. 'No', said the owner, 'If it's for a church, then you can have it for nothing.' 'It's not for a church', said Andrey, and we went away empty-handed.

At that time the icon 'Klondike', the current looting and pillaging of the whole expanse of what was ancient Rus, had not yet started. While I am on this topic I need to run ahead of chronology, and recount here the sad story of the Kargopol Museum.

This was during the early 60s. During one of our journeys to the North (without the Sinyavskys by this time), we went to the town of Kargopol.

The Museum of local lore, history and economy was housed in the former cathedral in the main square. Here there were collections of exhibits of folk art from places which had been centres of artistic production in the North before the revolution. Spinning wheels, embroidery, lace, painted trays, objects crafted from birch bark, icons ... I have never since seen such a cornucopia of folk arts and crafts. The museum director was a stocky fellow of about 50 (I think his name was Nikolay Ivanovich). We called on him in his office to get some advice about our onward journey. While we were talking two boys came in, clearly young pathfinders. 'We've brought some icons, Nikolay Ivanovich.' These were two large panels from a seventeenth-century iconstasis. 'Put them by the cupboard', said the director, without turning round.

Skip forward to December 1965, a couple of months after the arrest of Sinyavsky and Daniel: Aleksandr Yesenin-Volpin had organised a demonstration at Pushkin Square under the banners 'Respect the Soviet constitution' and 'We demand an open trial for Sinyavsky and Daniel'. Maya Rozanova was under great strain and we decided to take her to Kargopol for a time. There she would be far removed from the interrogations, from the attentions of the KGB, and from the sensation created by the trial. We wanted to give her a chance to recuperate. Four of us went. Maya, myself and our old friends Gleb Pospelov and his wife Masha Reformatskaya. Naturally, the first thing we did was go to the museum. What we found there was like our worst nightmare. There were no artworks whatsoever. One room was devoted to photographs of the Kargopol choir, which had won some sort of prize, another displayed a mammoth's tooth, a stuffed hare, a few other examples of local flora and fauna and so on. Maya, with her characteristic nosiness, dashed off to the director to find out what had happened. The new woman director became flustered. 'I know nothing about it. Go to the Culture Department at the town council.' We set off for the town council, which was luckily very nearby – on the other side of the square. The head of the Culture Department, Comrade Nosova, gave us a hostile reception. 'What icons? We never had any icons. What do you want and who exactly are you?' In response to these questions Gleb produced a little red book from his pocket, on the cover of which was printed in gold letters: Ministry of Culture of the USSR (Gleb worked in the Scientific Research Institute of the History of Art attached to the ministry). Comrade Nosova quailed at the sight of this document. 'Comrades ... actually, there was an

unfortunate episode ...' The story was indeed extraordinary. The former director was a simple man. He wasn't a drinker, but on the other hand he did send his children to study in Leningrad and had to support them there, and he earned a paltry salary. And Nikolay Ivanovich (let's call him that) began to sell off exhibits from the museum. At first one piece at a time, but then, later, wholesale. People came from Moscow, loaded up their vehicles and drove off with the items, either for their own collections or in order to resell them. The most striking thing about this story is the fact that the money from the museum sales did not even cover his fairly modest needs. But as well as being the museum director, he was also chairman of a hunting club, which was building some hunting lodges in the forest. So then he got mixed up in a scam with the hunting lodges as well. For some reason no one paid any attention to the misappropriation of the museum's collections. But now events turned from comedy to tragedy. Nikolay Ivanovich burnt all the inventory records, took an old pistol from a display case, went out of the museum and shot himself, leaving a note: 'I request that I be buried like a dog, and that my fur coat be given to the person who buries me.'

But it's time to go back to my travels with the Sinyavskys. Andrey's main interest was not so much icons as books. The Old Believers[8] who had once lived in these regions had constructed in their cellars so-called hidey holes. Here some monk who had withdrawn from the world and from the iniquitous (from the point of view of the followers of the old faith) church, would live and devote himself to copying books. The Sinyavskys had discovered one such hidey hole during their first journey and now they went there again, taking me with them. It was a large windowless space, as big as the whole area of the hut, with a low ceiling, and it was literally packed to the gunnels with piles of paper. Manuscripts of the Martyrologies,[9] the Apocrypha, early printed editions of the Bible, Lives of the Saints and Martyrs, Old Believer prayer books – all these were piled up in heaps on the floor like so much useless rubbish. The descendants of these bibliophiles, who still lived in the hut, had no interest in these books, didn't see any value in them and merely used them as cigarette papers.

'Give us a fiver and take as much as you can carry!' We loaded these treasures onto the boat, and then, as we were by now in the densely populated areas along the lower reaches of the Mezen, the Sinyavskys were able to post them to Khlebny Lane.

At that time I was more interested in fifteenth-century Netherlandish painters than in old Russian texts. Whenever we stopped in a place I went fishing, and I enjoyed listening to Sinyavsky's conversations with the old people in the villages – about the past, about their life and faith. I was captivated by the way these local people lived, with their traditional, steady way of life, their enduring moral foundations, their readiness to help kith and kin. It was as if we had gone from the Soviet Union into some miraculously preserved fragment of old Rus. When our engine broke down a good half of the men of the village would cluster round this dratted piece of machinery to get it working again. They refused to take any money. The same thing happened when we wanted to pay for our night's lodging (usually in a hayloft), or for milk or for the modest fare we ate. Maya had learned from her previous experience and brought a 'Moment' camera with her, which could take a snap and produce a print on the spot. One morning when we climbed down from the hayloft we saw a touching sight in front of us. All down the street people were sitting decorously on the *zavalinkas* (earthen ledges) outside their huts, with modestly lowered gaze; old women, in what were obviously their best black dresses, young married women in their finest clothes, some of them wearing their traditional head-dresses, children who had been washed, brushed and all dolled up. 'Take their picture' – our hostess dug Maya in the ribs with her elbow. As a rule, family photos were stuck up inside the huts, in the place where the iconostasis would have been in earlier times. Newly-weds, deceased relatives, gallant soldiers – snaps sent from the army. But Maya was the first photographer to have appeared in these places for many a year.

* * *

The Sinyavskys infected me with the North. After that, every summer – with rare exceptions – I would set off on a trip with various companions along various rivers – the Northern Dvina, the Vychegda, the Sluda. Once we got as far as the Solovetsky Islands[10] on board a rust bucket carrying a load of hay. That was the first year they lifted the ban on outsiders visiting this hellish spot. At that time it was a desolate and chaotic place. In the Cathedral of St Peter and St Paul we managed to get through a hole in the wall and go down to the lower rooms – there were corridors, piles of broken banners, placards, broken furniture, empty rooms – either investigators' offices or interrogation cells ... but what

struck me most of all was the loo: a long staircase ascended behind a small door, and at the top stood an enormous lavatory, like a tsar's throne. Evidently this facility was intended for the personal use of the head of the camp or, if not for him, then for one of the most senior staff.

In the last years before I emigrated, my favourite place for summer expeditions was the region of Shimozero (Shim Lake) in the Soviet Socialist Republic of Komi. We had to get off the Leningrad–Arkhangelsk train at some little halt (the name escapes me), and then walk 50 kilometres lugging heavy rucksacks of provisions. During the war, the route taking supplies to besieged Leningrad had passed through this region. The road surface had been pounded to bits and it had not been repaired since the war. Instead, the region had simply been abandoned. When we asked directions from the local people, they replied, 'Ah, Shimozero? There's no Soviet power there.' There really was no Soviet power there. No electricity, no radio, no post office, no shops – all communications with this area had been cut off. According to the locals, there was another reason for these measures. Somewhere around there were secret underground aerodromes. No trace of them was visible, but sometimes during the day a thunderous noise would roar from the sky, making the fish in the lake jump a foot out of the water. Evidently jet fighters were breaking the sound barrier.

The Veps lived here – an Ugro-Finnish people, with their own language and at one time their own system of writing. They had not been expelled, they had simply been deprived of everything necessary for life. The young people and their families had dispersed to various places, just a few old people remained. Only one old man lived in the big village where we usually stayed and on the other side of the lake, two old women whom he had taken under his wing. The old man caught pike in the lake – enormous fish, two metres long (I have never seen such fish since) – dried them in the stove and in the winter snow he would go by sledge to sell his catch. He would bring back salt, matches, tea, sugar, with which he supplied his old women, as well keeping them stocked up with fish.

Perhaps it was my childhood memories of Kolyma that kindled my love for the North. Although the natural environment in northern Russia is nothing like the wooded tundra of Kolyma, the same kind of unpeopled emptiness, the same kind of wide horizons evoked a sensation, if not of actual liberty, then of free will. Although there were camps and criminals aplenty in the republic of Komi too.

CHAPTER 8

Dancing Around Picasso

At the Twentieth Party Congress of the Communist Party of the Soviet Union (25 February 1956) Khruschev denounced Stalin.[1] His letter was read in institutions at closed Party meetings. Although I am not sure how 'closed' they were, as I was able to attend such a meeting at the museum. Some people cried. But we were already familiar with the content of this secret speech. Maya Rozanova's stepfather, Levitan, a major in the political department of the frontier troops – practically the only Jew who had survived in that department – had brought it home from work one evening and we had enjoyed reading Khruschev's invectives against the leader of all progressive humanity. In Moscow you could smell the thaw.

Sometime in the autumn of 1958, Velta Pliče, an editor at the Znaniye publishing house, approached me with a proposal to write a short monograph about Pablo Picasso. The French communist and celebrated peace campaigner had just been awarded the Soviet Peace Prize, and every year Znaniye had to publish a short book about the current winner. I was rather sceptical about Velta's proposal. The only acceptable way of writing about Picasso at that time was to praise his progressive ideology while censuring his art as bourgeois formalist ornamentation. Naturally, I didn't want to do either of these things. On the other hand, the idea of writing about Picasso was tempting.

I shared my doubts with Maya Rozanova and she suggested, with characteristic boldness, that Sinyavsky and I should co-author the piece. Sinyavsky and Andrey Menshutin were then writing *Poetry in the first years of the Revolution* (*Poeziya pervykh let revolyutsii*), published in 1964, and Sinyavsky was interested in the links between the Soviet revolutionary avant-garde and developments in Western art. He knew and loved Picasso's work and to my surprise he agreed to co-author the book.[2]

Realising that the chances of a book on Picasso being published were zero, Andrey and I decided to ignore censorship and prohibitions and write as if we were writing in the free world. We divided up the subject matter and set to work and by the summer the manuscript (approximately 100 pages long) was ready. Most likely this would have been the end of the matter, but for our editor, Velta Pliče. She sent it to Ilya Ehrenburg for an opinion, he reviewed it very positively and promised to write a foreword. Ehrenburg's review carried a lot of weight, the book was accepted for publication and an edition of 100,000 copies was printed. This only came about because the publishing house, Znaniye, which was directly attached to the Central Committee of the Communist Party, dealt solely with political subjects and had no clue about art. The management's idea of the work of Picasso was limited to the drawing of the Peace Dove, which in fact adorned the cover of our book. A scandal erupted when the ideologues of stalinist socialist realism from the Academy of Arts of the USSR found out about the book. They considered our little book as nothing more nor less than ideological sabotage, intended to undermine the foundations of socialist realist art. These Stalin Prize-winners had solid links with the top brass in the Party machine and these links paid off. A stream of correspondence began among the highest levels of the Party leadership. On 12 January 1961, Leonid Ilichev, the head of the Department of Propaganda and Agitation of the Central Committee of the USSR, reported to Mikhail Suslov, the chief ideologue of the Central Committee: 'The publishing house Znaniye, from the all-Soviet society for the dissemination of political and scientific knowledge, has produced a print run of 100,000 copies of *Picasso*, a monograph by I. Golomstock and A. Sinyavsky. [...] In this monograph the authors have not emphasised those aspects of Picasso's work which would situate him close to realistic art, but have instead concentrated on his formalist and abstractionist works [...] the monograph has been printed but distribution has been held back.' Suslov asked, 'How shall we deal with the monograph?' They soon found an answer. All 100,000 copies were to be pulped.

On the other hand, Ehrenburg – an old friend of Picasso and the president of the France – USSR Friendship Society – was very keen on getting it published and he began to pull strings of his own. As a result – clearly thanks to Ehrenburg's intervention – *L'Humanité*, the mouthpiece of the French Communist Party, published an article under the blaring headline: 100,000 COPIES OF PICASSO BOOK TO BE PUBLISHED IN

SOVIET UNION. (Picasso was actually the main financial backer of *L'Humanité*.) The order to destroy the copies was suspended but the books continued to languish in the warehouse.

However this was not the end of the affair. In the spring or summer of 1961, a delegation of top representatives of the French Communist Party visited Moscow. At the reception in the Kremlin, one of their leaders (maybe Maurice Thorez himself!) shook hands with Kosygin and congratulated him on the publication in the USSR of a book on the great French Communist-Artist.[3] On 5 May 1961 Ehrenburg sent a letter to Suslov: 'This year the French Communist Party and progressive French (and not only French) organisations will celebrate Picasso's eightieth birthday. It would be very awkward if information about the destruction of the majority of copies of this book published in the USSR was leaked to the West, and nowadays these things have a habit of happening.'

More correspondence began at the highest level and finally a judgement of Solomon was given. Out of the 100,000 copies printed, no more than 30,000 were to be put on sale. The sale of the monograph would be limited to a few book stalls in Moscow and Leningrad. The rest of the copies were not to be distributed. I don't know what became of these remaining 70,000 copies. In the summer of 1961 the book went on sale.

In essence, this was the first book on Picasso to be published in Russia since the revolution. Long queues formed at the few places in Moscow where it was available and it sold on the black market at ten times the cover price of 19 kopecks. Quite unexpectedly, I became a popular figure among the left-leaning Moscow intelligentsia. Complete strangers offered me tickets for plays that were impossible to get into and I was taken into the manuscript department of the Lenin Library where a copy of Bulgakov's then unpublished novel, *The Master and Margarita*,[4] was brought to my table, concealed inside the cover of another manuscript. Like a character out of Ray Bradbury,[5] I then narrated the contents of this novel to my friends. The reason our little book caused such a stir on both sides was because its appearance coincided with a brief period of relative liberalisation in the field of culture. A 'left wing' formed in the Moscow Union of Soviet Artists. In exhibitions the so-called 'severe style' of works by Pavel Nikonov and Nikolay Andronov competed successfully with orthodox socialist realism.[6] In March 1961 the sensational 'Exhibition of the Nine' opened. In this exhibition, Boris Birger, Vladimir Veysberg and others, all members of the Moscow Union of Artists, exhibited work which

went far beyond the official style, right up to the abstract work of Natalya Yegorshina. Finally, the exhibition '30 Years of the Moscow Union of Artists', opened on 1 December 1962 at the Moscow Manege, and there the public could see works by Robert Falk, David Shterenberg, Aleksandr Tishler and Pavel Kuznetsov, which had previously been gathering dust in museum store rooms.

In meetings, debates, discussions, people began to voice criticisms of the very dogma of socialist realism and of its chief disciple, Aleksandr Gerasimov. It should be noted that Stalin's favourite artist did not lack a sense of humour. At one of these meetings (which I just happened to attend), one speaker after another had a sly dig at the former president of the Academy of Arts of the USSR.[7] Finally, the chairman announced, 'A critic of the Members will take the floor.' 'A critic of wh-a-a-t?' asked Gerasimov, who had perched himself on one side of the presidium table. 'A critic of the Members.' 'As if I haven't had a big enough dose already', sighed the severely chastised socialist realist.

* * *

One day two ladies from the Critics' section of the Moscow Union of Soviet Artists came to see me. They proposed to make an immediate request for me to be admitted as a member. I hadn't intended to join this organisation, but I had housing problems. I had absolutely nowhere to live. I used to land up in the apartments of people I knew when the owners went away on holiday or on work trips, or I kipped at my friends' places, and would only spend the night in my great-aunt's overcrowded room in Serov Passage as a last resort. But now I had the prospect of joining a housing co-operative and having the right to the 20 square metres of living space designated for union members, in addition to the nine allotted to ordinary mortals. In December 1962 I was accepted straight away as a member of the Moscow Union of Soviet Artists and they even dispensed with the probationary period which was mandatory at that time. But in that same December Khruschev launched devastating attacks against the exhibition at the Manege[8] and against members of the creative intelligentsia when he met them at the Kremlin's Guest House on the Lenin Hills. This marked the end of the brief period of liberalisation.

At roughly the same time, Sinyavsky was accepted as a member of the Union of Soviet Writers. He had already won a reputation as an eminent critic

in the literary periodical *Novy Mir*, with his brilliant and acute critical articles about the poetry of Anatoly Sofronov, Yevgeny Dolmatovsky and Yevgeny Yevtushenko. But this was not sufficient for membership of the union. Writers were required to have had at least one book published. *Picasso* was Sinyavsky's first published book. Neither Andrey nor I had the least idea that this slender little book would bear such unexpected fruits.

* * *

The thaw was over and the crackdown began. At the museum, pictures from a Fernand Léger exhibition which was due to open the following month were removed one after another. Léger's widow, Nadya Khodasevich, made no objections. With the agreement of Yekaterina Furtseva[9] she filled a whole room, which had been emptied of Léger's paintings, with works by her new husband – the young French artist Georges Bauquier. I was sent to Ehrenburg to collect two works by Léger which he owned. I took Sinyavsky with me as he wanted to be introduced to the man who had written the foreword to our book. This was just after the meeting between members of the government and the creative intelligentsia, at which Khruschev had abused the cream of our writers and painters in unprintable language. People said that when the leader attacked him personally, Ehrenburg simply got up and walked out of the meeting. Now, at home, he was in a state of nervous excitement. The second volume of his memoirs, *People, Years, Life* (*Lyudi, godi, zhizn*), was soon to be published and he feared that this book, and indeed all his other work, would be consigned to oblivion.[10] 'Ilya Grigorevich', said Sinyavsky, 'write for the desk drawer.' Ehrenburg looked gloomy, kept quiet for a moment and then said (I am quoting from memory), 'I'm an average writer. I can't write for the desk drawer. I know that what I write today is necessary to people now, but tomorrow they won't need it.' This hit the nail on the head! Even in the most boring of the novels he wrote in the 1940s, Ehrenburg always went to the brink of the forbidden, just crossed that line, and was harshly criticised in the press a number of times because of this. I, at least, always found something 'necessary' in those novels of his.[11] And which of our masters of the pen would call himself 'average'? Ehrenburg immediately went up several degrees in my estimation.

Our *Picasso* also got a mauling by the press. The sixteenth session of the Academy of Arts of the USSR in 1961 was partly devoted to a riposte to the

hostile sortie by Golomstock and Sinyavsky. The heavy artillery was called up for this task. Boris Johanson, the president of the Academy, fired the first salvo. 'I am extremely angry with the authors – young Soviet art historians, educated in our Soviet universities – with the editor, Comrade Pliče, and with the management at Znaniye who permitted the publication of this deeply flawed brochure. I think our art critics will give a worthy reply to this brochure which Znaniye has published. They will elucidate the harmful nature of such attitudes and will give a correct evaluation of the work of Picasso.' The art critics did not hold back. Yury Kolpinsky devoted a significant part of his report to dissecting the incorrect attitudes of the monograph's authors, and of the foreword by Ilya Ehrenburg. The Stalin Prize-winning sculptor Zair Asgur detected in the monograph a tendency to deflect the Soviet artist from his concrete task. The old Stalinist hanger-on V. S. Kemenov[12] summed up this ideological pandemonium. 'On this occasion, Ehrenburg's article about Picasso, introducing the muddle-headed book by Golomstock and Sinyavsky, has done serious damage to the struggle for realistic art. It is not so much that the existence of such a book might make some young Soviet artists lose their heads. Working under the conditions of the building of socialist culture, they will eventually realise the truth, but the existence of such a book could also prevent many young progressive artists working in the capitalist countries from reorienting themselves onto the path of realism, for this book surrenders our most important positions: our understanding of realism and our conception that realism has real significance for the fruitful development of art.'

I sat in the gallery of the Academy's assembly hall and simply marvelled. It seemed that our little book, with its 60 pages of text and handful of poor-quality black-and-white reproductions, could be harmful not only to Soviet artists, but also to Western artists who, evidently through their own ignorance, had heard nothing about Picasso and could get the wrong idea about him from a little book published in the Russian language.

During a break between sessions, as I was coming down the grand staircase in what was formerly the Morozovs' mansion, but now housed the Academy of Arts, I heard a voice behind me. 'Hello, Igor.' Yury Kolpinsky was behind me. I greeted him and continued on my way. And suddenly from somewhere beside me a long arm reached out. 'Let's shake hands', whispered Kolpinsky. The poor devil thought I wouldn't want to shake hands with him. 'I didn't actually name any names', he said, once we'd

shaken hands. It is true that he had not mentioned the authors by name during his criticism of the Picasso book.

Poor Kolpinsky! He had been our university teacher, a brilliant lecturer, an art historian who sensed beauty and harmony in his very nerve endings . . . once he was holding a class with us on classical antiquity in one of the galleries at the museum and suddenly a fly landed on the plaster cast body of some nymph or other. Kolpinsky shuddered just as if the insect had touched his own nerve. In his youth he had succeeded in getting to Italy and since then he had secretly dreamt of seeing the hills of Tuscany at least one more time, and the treasures of the museums of Rome, Florence, Venice, the Vatican. The Academy of Arts had a country house somewhere near Rome which it had inherited from the pre-revolutionary Imperial Academy. The only possible way he could go abroad was to get himself invited to this country house belonging to the Academy. In order to do this Kolpinsky joined the Communist Party and became a member of the Academy, although he couldn't stand it or any of its members. Once in a private conversation he said, 'Kemenov? Well, if they told him to seduce his own daughter on Red Square he would do it!' (Kemenov was at one time president of the Academy.) I don't know whether Kolpinsky ever got to see Italy again.

Who would cast the first stone at such gifted scholars as him? They were obliged to make compromises and accommodations; they had to stifle their own consciences for the sake of their careers, or sometimes in order to save their lives. This is quite different from professional time-servers, who deserve to have stones thrown at them.

Boris Vipper liked our little book on Picasso. Although his own aesthetic tastes didn't go beyond the art of the eighteenth century, he perfectly understood the aspirations and innovations of the subsequent artistic culture. One day in the museum, I gave a lecture on modern sculpture in which I devoted a lot of time to Henry Moore and considerably less to Mukhina.[13] The lecture provoked some friendly discussion and Vipper added his voice to the general chorus. Then in our office he complained bitterly, 'How can you praise Moore – he's an arse!' The word 'arse' was not at all typical of Vipper's vocabulary, but accurately characterised one aspect of the forms moulded by the great sculptor: an attraction to the materially corporeal bottom (as Bakhtin put it).[14] For Vipper this was a minus, but for me it was a plus. And Vipper perfectly understood and appreciated our interpretation of Picasso's work. He even

proposed that I should go and work in the Institute of the History of Art, where he was head of the department of Western art. This was beyond my dreams! But after the scandal about our Picasso book erupted it was no longer possible. And in our office Boris Robertovich gave me friendly advice about how I should now proceed. He would tell me about how he had also been criticised in his time for his book *English Art. A Short Historical Outline* (*Angliyskoe iskusstvo. Kratky istorichesky ocherk*) – published in 1945 ... I vividly remember this 'criticism' which ended with Vipper being dismissed from the university. I was still a student then and chanced for some reason to be in the department at the moment it happened. The head of the department of Russian Art in our faculty, the talented but hot-headed Professor Fedorov-Davydov, who had at one time suffered persecution himself, now curried favour by denouncing his colleagues. When his 'criticism' of Vipper went beyond the bounds of decency, Boris Robertovich removed his spectacles, took another pair out of its case, put them on, picked up his briefcase and left the auditorium, with his human dignity completely intact ... and then he wrote his critical article about surrealism in the West. And now he was advising me to write something about Soviet art. I sincerely pitied my old teacher. He was still haunted by the terror of those times when such escapades could even get you a stretch in the camps. When Sinyavsky and I heard and read the abuse directed at us by the ideology monsters we simply laughed it off.

For the socialist realist artists – academicians, members of the management board of the Moscow Union of Soviet Artists – Picasso was perhaps their greatest foe. On the one hand, he was a Communist, a progressive activist, a peace campaigner, and it was dangerous to touch him; on the other hand ... it was not so much that from their point of view he was a 'bourgeois formalist', they could have reconciled themselves to that. The main problem was that he was a great master and, if you measured his works against all the great achievements of Soviet art, these dimmed in comparison and looked like rejects from the previous century. This was obvious to a trained eye at first glance – and to an untrained one at second. It was this that they couldn't stomach and the battle with Picasso took off in various directions.

On one occasion Ehrenburg's secretary, Natalya Stolyarova, phoned me. 'Ilya Grigorevich is very worried', she said. 'The newspaper *Sovietskaya Kultura* has an article ready for publication which includes an interview which Picasso gave to an unnamed journalist. In the interview the artist

allegedly confesses that his formalist doodles are simply done to fool the bourgeois public. He says that he is keeping his authentic – realistic – works hidden and he intends to reveal them some day to show the world his true face.' Ehrenburg was keen to know what this was all about. I got busy researching and through contacts among my friends I got to the heart of the matter. It turned out that the material in the interview had been taken from a book of 'imaginary interviews' by the Italian writer Poppini who was well known during Mussolini's time. In it the author presented his fictitious interviews with Picasso, Einstein, Freud and other great names. I can't now recall the name of this book or the exact name of the author. Nor do I know how faithfully these 'revelations' of Picasso had been reproduced in the article, because naturally I hadn't read it, since it was still lying on file at *Sovietskaya Kultura*. I don't know what action Ehrenburg took, but in any event, the article containing this interview never appeared.

CHAPTER 9

The Museum Again

My position at the museum was becoming ever more precarious. Irina Antonova had succeeded Aleksandr Zamoshkin as the director of the museum. She had always considered me – with my pronouncements about modern art – as an *enfant terrible*, but after the Picasso scandal it became decidedly awkward to keep me on as academic secretary. Very senior figures began to visit the museum. Even Mikhaylov, the Minister of Culture, would come in person. Once he came into the room where an important exhibition was being prepared. He was wearing a luxurious fur coat and a fur hat, and he democratically shook hands with the workers and the attendants while simply ignoring us, the academic researchers. I happened to see him in another incarnation. Apparently during a state visit to India a symphony concert was arranged in honour of the Soviet delegation. Khruschev asked Mikhaylov which composer they were listening to and received the answer, 'Tchaikovsky'. After the concert General Secretary Khruschev expressed his pleasure to the concert organisers that the great Russian composer was honoured in India. It turned out they had been playing Beethoven. The enraged General Secretary sacked Mikhaylov. Soon after Mikhaylov's dismissal, Khruschev and his entourage favoured the museum with a visit to an exhibition of modern Belgian art. He sat on a couch in the French room and told those present how once upon a time a donkey had painted such pictures with his tail.[1] Antonova, Vipper and Guber stood with their heads bowed with embarrassment. Suddenly, out of nowhere, the disgraced Mikhaylov appeared. He somehow got down on his haunches like a dog in front of the entourage and tried to attract Khruschev's attention with a beseechingly devoted gaze. Khruschev turned away. Evidently, this was typical of the relationships between the country's leaders. And I happened to see yet another such leader in the museum.

In 1958, an exhibition opened of works from German collections which had been seized by the Soviet army during the war and were now being returned to the German Democratic Republic. The ceremonial handover took place in our Italian courtyard. The Minister of Culture from the GDR spoke first. A cheerful, relaxed German, he exchanged bows with the Soviet leadership, happily poured forth a stream of witticisms, thanked the museum staff by name. Mikhail Liebman, our academic secretary at that time, interpreted. Then Kosygin[2] came to the microphone, looking like a mummy. He took out a sheaf of pages and began to read. Five minutes passed, ten … Liebman began to grow restless. He had no hope of remembering this torrent of words. After Kosygin had finished reading his speech he put it in his pocket and left the microphone. A tense silence followed. Nobody could bring themselves to approach Kosygin. I started to imagine that guards in plain clothes would appear and take Liebman away to God knows where. The situation was saved by Andrey Guber – the senior curator at the museum. He whispered something to Kosygin who took the pages out of his pocket and gave them to Guber. Liebman began translating from the printed text.

When we learnt of the proposed visit to the museum of secret agent Khalturin,[3] who was now head of the Department of Fine Art in the Ministry of Culture of the USSR (i.e. deputy Minister, according to the table of ranks of that time), I left our office early so as not to be an embarrassment by my presence, but also to avoid having to shake hands with him. Antonova suggested transferring me to the Western Art department, to which I happily agreed. Volodya Leonovich, who had previously worked in the numismatic department of the museum, took over my role as academic secretary.

All people are unusual, but, paraphrasing Orwell, some are more unusual than others. I include Leonovich, with whom I became great friends, in this last category.

Leonovich was an ardent follower of Steiner and anthroposophy.[4] Anthroposophy was the guiding star by which he lived; it formed the bedrock of his world view. From the exalted heights of anthroposophy the various Khalturins, Kemenovs and others of that ilk appeared as mere phantoms from the illusory Maya, the outer skin on the body of world order. Because of this, he could fulfill his duties by calmly talking with all such individuals and was an ideal academic secretary. Goethe's *Faust*, especially Part Two, was his bible. He read it in the original German.

His stories about Pasternak were a revelation to me. According to Leonovich, secret anthroposophical meetings were held at Pasternak's dacha, which he himself had attended. Volodya read me early poems by Pasternak, *Marburg* in particular, and decoded their hidden anthroposophical subtext.

I don't know if the literature on Pasternak mentions his links with anthroposophy, but I absolutely believe Leonovich. And he had yet another incarnation. Every summer he would take two months' leave (I deputised for him) and set off for distant corners of Russia where he studied and collected birds' nests. When I mentioned Leonovich much later in conversation with a professor at Oxford he immediately remembered, 'Ah, the famous ornithologist!' Volodya had never told me that he published his scientific articles abroad.

* * *

My private life also changed dramatically. In 1960, after 15 years of my being in love with Nina Kazarovets, we were finally united. She came from a simple working-class family. Her father worked as an engine driver on the Kazan railway. In the 1920s, his older brother had built up a thriving smallholding somewhere in Belarus. He was dekulakised[5] and like hundreds of thousands of peasants died in exile in Siberia. Nina's father worshipped his brother and apparently could not forgive the Soviet authorities for his death. He had seen life and understood a lot about what was going on. Obviously he had to drive trains full of prisoners to Siberia and beyond. In his own way he tried to protect his family (three sons and two daughters) from any political suspicion. So he forbade them to keep any books in the house apart from school textbooks. In October 1941 when people were fleeing in panic before the German army which was approaching Moscow, he drove his train to some place in Siberia but instructed his family to stay where they were, in Moscow. He would come back and sort everything out. Evidently he was waiting for the Germans to arrive.[6] When we were going to emigrate and had to get permission from our parents he was in hospital. He listened silently to Nina's request and then took the document and simply asked where he needed to sign it.

After graduating from the Financial Institute, Nina worked in a bank, but a career in finance didn't appeal to her any more than it did to me. She enrolled in the extramural department of the Biology Faculty at Moscow

State University and then worked first at the biological station at the Rybinsk reservoir, and then in some Moscow institute connected with biology in space, fortunately not secret work.[7]

We rented a room with a shared kitchen in the semi-basement of a house on Petrovsky Boulevard. It measured seven square metres. The tiny entrance hall next to it was almost totally occupied by a large trunk, on which our landlady, Avgustina, slept whenever she came from her village – she was elderly, lame and angry with God for her lameness. Our room contained nothing but a writing desk with a chair facing it, and a folding divan bed which also served as a seat for guests. Life was hard but fun. We – the Sinyavskys, the Menshutins, the Pospelovs – started a light-hearted 'gluttons club' and took turns, once a month, to produce a slap-up banquet. We patted each other's tummies as a masonic ritual. As many as 20 people squeezed into our little room. How we managed it, I simply can't imagine now.

* * *

Even though I had been removed from the position of academic secretary, I was still a thorn in the side as far as the management were concerned. Obviously they had to get rid of me somehow and a succession of reprimands began to appear on my personal file. The first was a reprimand for being late – nothing out of the ordinary, so to speak. A second, much more interesting one, followed. On the eve of a national holiday, our museum closed two hours earlier than usual. I was called to the service entrance where a professor of Art History from Columbia University was asking to be let in to the museum. He was desperate to see our Impressionist collection, but he was flying back to America the following day. It just so happened that I was on night duty at the museum and, according to the rules, had to make three rounds of inspection of the rooms together with the head guard, a policeman, a fireman, a locksmith and two or three more arms of the law. The main object of these rounds was to check whether water was coming in from the somewhat dilapidated roof and, if it was coming in, to put a bucket under the leak. So I suggested to the professor that I could take him with me on my rounds. The next day a denunciation was received. I had taken a foreigner round the museum and he could have scattered anti-Soviet leaflets there. In her office, Antonova tore a strip off me. I said, 'Irina Aleksandrovna, how on earth could someone

scatter leaflets in front of six of the museum staff?' But rational arguments were no help.

And a third episode.

Once, during the summer, when I was deputising for Leonovich, I needed to go to the library for some reason. It was hot and I had left my jacket in the office. The policeman on duty at the library door asked for my pass. I had done the night rounds with this policeman more than once, he knew exactly who I was, and I tried to reason with him. He insisted, I lost my temper and told him not to stand there like a dummy. It turned out that this was Soviet Police Day and that I had insulted a representative of this honourable profession.

I realised that I would have to leave the museum. Legally, a fourth reprimand was automatically followed by dismissal without any leaving benefits. Just at that moment I received an offer to go and work as a senior researcher at the recently formed All-Union Scientific Research Institute of Technical Aesthetics (VNIITE). It was a tempting offer and yet, if the situation hadn't been so difficult, I wouldn't have left the museum. But afterwards I had no regrets. My work at VNIITE turned out to be very interesting.

CHAPTER 10

VNIITE

The founding of The All-Union Scientific Research Institute of Technical Aesthetics (VNIITE) in the very early 60s was an attempt to correct the gross mistakes of the Stalinist past. Yury Solovev, who had been appointed director of the Institute, managed to convince the top men in the government that categorising design (and equally genetics and cybernetics) as reactionary sciences had seriously damaged the national economy and continued to do so. Although, because the term 'design' sounded suspiciously 'bourgeois', it was replaced by the more cumbersome and vague 'technical aesthetics'.

VNIITE was established on the site of the former Agricultural Exhibition,[1] and answered to the Committee for Science and Technology at the Council of Ministers of the USSR, i.e. to an organisation that wasn't specifically ideological, and this was its greatest advantage. Because of this, people from a wide variety of professions made a beeline for this place, people whose creative potential had been constrained by the in-house ideology of the institutions where they had previously worked. Our department (The History and Theory of Design) was a veritable Noah's Ark. Karl Kantor and Georgy Shchedrovitsky were philosophers, Galya Demosfenova, Larisa Zhadova and I were art historians, Vyacheslav Glazychev and Vladimir Aronov were architects, Aleksey Dorogov was a historian with a very wide range of interests, Leonid Pereverzev was a jazz musician who studied cybernetics, the young Oleg Genisaretsky could turn his hand to anything, and so on. The department had to work out a theory of technical aesthetics (design) and establish its history. Nobody, least of all our superiors, had a clear idea of how to do this or what would be needed to achieve it. To all intents and purposes we had *carte blanche* — freedom of action. Under the pretext of writing about design, Larisa Zhadova published articles on Malevich, El Lissitzky and constructivism

in the Institute's digest, *Technical Aesthetics* — articles which no newspaper or publisher would have accepted for publication at that time. I made a study of the German Bauhaus and the historical links between art and design (these articles of mine were only published 40 years later in the 'archive' section of that same digest). Shchedrovitsky and Genisaretsky[2] worked on what they called methodology. They would debate with each other for hours at a time, scribbling diagrams with arrows and tables with numerical symbols on the blackboard. It was all Double Dutch to me.

Shchedrovitsky, who, in addition to our sessions, held philosophy seminars at home nearly every day, said that, as was only to be expected, a young undercover agent from the KGB had joined these seminars. The lad was over-conscientious. He made excruciating efforts to understand what people were discussing. It was not long before members of the seminar group were taking turns to take him parcels in the loony bin. I wasn't so conscientious; I didn't attempt to understand the intricacies of their theories, but I felt that there was something dangerous hidden behind their ideas of global planning, global design, disseminated throughout society. The architect Vyacheslav Glazychev,[3] who participated in these discussions, wrote many years later in his article, 'The Evolution of Planning':

> Igor Golomstock ... shouted at us, 'Don't go there, you rhinoceroses!' He felt that we were wrong and he was invoking Ionesco's play which had just been published in a magazine.[4] Golomstock felt that this juggernaut was going in the wrong direction, but he didn't have the language to prove it.

This was because we spoke different languages. I spoke in the dialect of intuitive art criticism; they in the dialect of rational philosophy. I didn't understand but neither did our superiors and they left us in peace. I don't know what it was like in other departments of VNIITE, but in ours the atmosphere was like the Bauhaus at the time of Gropius, except that Schoenberg and Kandinsky didn't drop in on us and there was no Paul Klee helping arrange concerts of avant-garde music. On the other hand, young specialists in various fields of knowledge did come to our meetings, for example Sasha Rappaport, who became a great theoretician of architecture. Technical aesthetics itself, with its orientation mainly towards the laws of form, came into sharp conflict with the dogmas of official Soviet art theory. It was a convenient means (at least for me) of introducing an unorthodox

approach to the problems of artistic creation. And even for the management of the Institute, the ideology of socialist realism was a serious obstacle to practical activity. Thus, one day I received for review B. Brodsky's manuscript about modern European architecture, intended for his doctoral thesis. Boba – that's how he was known in Moscow – was the author of popular books about art, and for some unknown reason he enjoyed the right to travel abroad. Having travelled throughout Europe and popped into Latin America, Brodsky, full of fresh impressions, wrote his dissertation. This turned up on my desk, typed on vellum paper and bound in Morocco leather. It was full of what was then new information about modern architecture, in particular about Oscar Niemeyer's work in Brazil, and was written in a clear and lively style.

The question of whether to recommend it for defence as a doctoral thesis was considered at a meeting of Academic Council at the Institute. I said that art criticism was not a science, and that a dissertation on art required different criteria of evaluation; if Boris Johanson could be awarded a doctorate in Art History for his painting, *Lenin's Speech at the Third Congress of the Komsomol*, then why shouldn't we recommend Brodsky's well-written book as a doctoral thesis? The Academic Council agreed to recommend it and I am convinced that not a single scientific establishment in the USSR would have given such a recommendation.

Legends abounded about Boba Brodsky's adventures and flamboyant behaviour in Moscow. He lived in grand style. Sometimes he came to the Pushkin Museum, booked and paid for a guided tour, but then chose a guide and took her to a restaurant instead. But the story of his dissertation was probably the most striking of his adventures. Of course Brodsky knew perfectly well that he hadn't a hope in hell of getting his doctorate and he decided to turn the defence of his thesis into an entertainment. Anticipating all the arguments of his learned opponents, he pre-recorded his answers to their objections on a tape recorder at home. And the rest of the comedy was played out at the Institute of the History of Art in Kozitsky Lane. Nedoshivin embarked on a diatribe. 'Just a minute, German Aleksandrovich', said Brodsky and switched on the tape recorder. 'Sorry, Ivan Ludvigovich', and pressed the button again. It must have been hilarious. Unfortunately I wasn't there to witness the scene. It happened during the summer and I was on my wanderings somewhere in the north.

* * *

At departmental meetings Georgy Shchedrovitsky and I were opponents, adversaries (I remember that in the heat of a passionate argument I called his theories 'fascist'), but outside the bounds of debate we were friends. This was possible because of his amazing tolerance, his ability, characteristic of a great scholar, to listen to any opinion opposite to his own and take note of it. We met regularly, either at my house or at Galya Demosfenova's studio, drank, argued, exchanged information ... I had never met anyone with such a powerful intellect. It was as if his brain was charged with a high tension current and the voltage of his thought processes never dropped in any circumstances – whether in heated discussions, at festive social occasions, or while simply walking and chatting ... This is not to say that he didn't relax among friends: the life of the intellect and the business of everyday human relations somehow flowed in parallel in him, not interfering with one another. During his lifetime Shchedrovitsky published about 200 books, monographs, articles, not to mention the miles of reels of tape preserved in his archives, with recordings of his lectures, reports and speeches at the countless seminars he gave. And, as often happens, such incandescence of thought is not without cost. The lamp burns out and consciousness sinks into darkness. Georgy Shchedrovitsky died in 1994.

Oleg Genisaretsky came to the institute when he was 22 or 23. He was a youth with a Martian head, crammed with such a quantity of knowledge of various kinds that I regarded him as an alien from another planet. One episode was particularly striking. The leader of our group, Karl Kantor, who was at that time a liberal Marxist, invited a venerable philosopher to one of our sector's meetings, to give a talk about Marx's theory of labour. After the lecture, Genisaretsky got to his feet. 'What definition do you give to the word "labour"? In various works Marx defines it as ... in the first volume of Capital ... in the second ...' One might well have thought what does Oleg care about Marx?

He was then working on the methodology of a plan that was not in the least Marxist, on art history and religious questions; later he worked with Father Aleksandr Men.[5] Evidently his phenomenal memory retained things from even the most marginal of his interests.

Nowadays, Shchedrovitsky has been accorded his rightful place among leading scholars and thinkers and Genisaretsky is not far off such status, I believe. Unfortunately the same cannot be said of Aleksey Dorogov, although his intensity of thought was perhaps even greater than

Shchedrovitsky's. Dorogov was a phlegmatic, awkward individual, always absorbed in some project of his own, and he reminded me of a much older version of my childhood friend, Yury Artemyev.[6] He was probably the oldest among us. I believe that his hero was the legendary Russian philosopher, Nikolay Fedorov,[7] who was (according to Dorogov) a man with no material ties. Dorogov himself found shelter in a little room at a hostel where he had lived since his days as an undergraduate (or as a post grad). I have never met anyone more erudite. He gave dozens of lectures about the history of science, art, technology, philosophy; he drew up chronological tables, compared developments in different fields of material and spiritual activity and constructed from all this a monolithic pyramid of human culture. And yet he was scarcely capable of writing. Once he complained to me, 'I don't understand Toynbee.[8] How can someone who knows such an enormous amount also manage to write so much?' Academic researchers were required to submit four of five printed pages of scholarly research per year and Dorogov's lectures were counted as part of his output. But when he forced a short article out of himself, it was – unfortunately – just a compilation of commonly known facts. Dorogov was not the first case of this kind that I have come across. For a scholar of this type, every idea of his own, every concept and insight, seems dubious and imprecise, in comparison with the enormous quantity of facts he knows, or else he thinks it has already been expressed in other academic work. It seems that his only serious publication – a short article about Bakhtin – was written with three or four co-authors. In the 1950s Dorogov went to Saransk, where Bakhtin had been living since he was exiled there in the thirties.[9] I like to think that he would have been able to converse with the great scholar on equal terms.

While I was still at the Pushkin Museum I had begun working on a book with the long-winded title, *The Aesthetic Character of Artistic Trends in Modern European Painting.*[10] It developed into a sizeable book – between 300 and 350 pages. In 1964 it was submitted to the aesthetics section of the publisher Iskusstvo. It passed successfully through the reviewing process and was signed off for printing. During the summer of that year, Viktor Lazarev – the only art historian who was a full member of the Academy of Sciences, invited me to deliver a course of lectures on modern Western art in the Art History department of Moscow State University.

In my time, lectures on the history of art had ended at Impressionism or thereabouts. After that, Professor Valery Prokofiev, my good friend and well-wisher, took his lectures as far as Picasso and Expressionism, but a whole course on twentieth-century art simply didn't exist. The only thing that Lazarev asked me, when he gave me the job, was not be too enthusiastic about abstract art. I replied that I myself was not a great admirer of this trend. I had always been attracted by the idea of teaching and I set to work enthusiastically.

Ensuing events put a nail in the coffin as far as my work at the university and at VNIITE were concerned; I will write more about this in other sections of this book, but I have to break off for now. The relatively smooth course of events was rudely interrupted by the arrest of Andrey Sinyavsky and Yuly Daniel.

CHAPTER 11

Great Expectations

Somewhere around 1955 or 1956, Sinyavsky had begun reading his stories and tales to a few friends – *Pkhents*, *The Trial Begins*, *Icy Conditions* (*Gololeditsa*), *The Makepeace Experiment* and others. But the fact that he was publishing them abroad under the pseudonym Abram Terts was known by very few people. It was inevitable that all this would end badly.

The hunt for the real author of the anti-Soviet works written by 'Abram Terts' and published in the West had begun long before and the noose was gradually tightening. We became increasingly aware that we were being followed; police spies lurked in doorways, hardly bothering to conceal themselves, our telephones were tapped. Once I called Lev Turchinsky[1] from the Central Post Office. After finishing the conversation, I picked up the receiver to make another call and – hey presto! I heard my whole conversation with Lev, replayed on tape. Something had clearly gone wrong with their equipment. Shortly before Sinyavsky's arrest two characters turned up at our communal flat to install a telephone. They explained that the previous resident had applied for a telephone some years earlier and now his request had got to the top of the waiting list ... later they used this very telephone to summon me for questioning. The cream of literary critics, experts, specialists in crime detection and KGB agents, both inside the country and abroad, were roped into the search for the authors who had been published abroad under the pseudonyms Abram Terts and Nikolay Arzhak.[2] Once, at a departmental meeting at the Institute of World Literature, a highly respected practitioner in this field, Rurikov, presented a paper on the topic, 'The Real Identity of Terts'. He reported that, according to the conclusions of textual analysts, the style of these works showed that they had not been composed by any contemporary Soviet writer, that they were clearly the work of some old anti-Soviet émigré who no longer had a firm grasp of the Russian language. It is hard to know

whether this was an attempt by the KGB to lull the suspect into a false sense of security or pure stupidity on the part of these highly expert text analysts. Andrey's ears must have been burning as he was actually present at this meeting.

In spite of the prolonged strain of living under the constant expectation of arrest, Sinyavsky continued to write and send his work abroad. Alcohol helped him to bear the stress. Even when he was younger, Sinyavsky had been no slouch at downing quantities of booze at parties, but now he said that in the mornings he could not sit down at his desk and begin to write without a shot or two of vodka. Like Joseph Brodsky, who, after his second heart operation in America, used to cadge cigarettes from me, saying that he couldn't work without his nicotine fix. For both of them, their creative work was more important than life itself (Rozanova had a different opinion on this matter. Perhaps she was right. In the camp, where alcohol was prohibited, Sinyavsky wrote *Strolls with Pushkin* (*Progulki s Pushkinym*), *In Gogol's Shadow* (*V Teni Gogolya*), and *A Voice from the Chorus* (*Golos iz khora*).)

I once asked Andrey what we should do and how we should react if he were arrested. He didn't give any answer because he understood better than us that it was impossible to anticipate what would happen and plan ahead. Everyone would act according to their own conscience. Sinyavsky had long been fascinated by the world of prisons and camps because of his interest in the language of criminals and convicts. The camps, either directly or indirectly, wove themselves into the literary fabric of his early stories and he even took his pseudonym – Abram Terts – from a prison song. We once argued about the merits of Soviet versus Nazi camps. Andrey had a preference for the Soviet ones. Here you could somehow or other get out of trouble, live on your wits, hold out. I preferred the Nazi ones. There was order there and, as a Jew, I would know why I was heading for the gas chambers; but even anti-Semites could end up in Soviet camps.

Many years later, when I was living in London, Anatol Goldberg – known in Russia as a legendary BBC commentator – who had escaped to London from the Nazis, told me a story which could have served as an argument in my debate with Andrey. He had a friend in Berlin – someone with Communist sympathies. When the Nazis came to power in 1933 he was arrested, put on trial and given a five-year sentence. Anatol was sure that this man must have perished, but after the war his friend phoned him and they met up. In 1938, exactly five years to the day since he was sentenced, he had been released. As he was leaving prison, the policeman on

duty in the lobby said to him, 'Don't go home. You'll be arrested straight away. Go to any port, get on any ship and leave the country.' Which is exactly what he did. The German police had their own scores to settle with the Gestapo. Could such a thing have happened in Stalin's Russia?

* * *

On 8 September 1965, I stayed until late at Inga Karetnikova's place. She was an old friend and colleague of mine and we were writing something together on modern art. It was nearly midnight when I returned home to Petrovsky Boulevard. My wife, Nina and Lydia Menshutin were waiting for me outside: Andrey Sinyavsky had been arrested. Three days later Yuly Daniel was arrested. I spent the whole night going through my papers. I tore up anything compromising and flushed the pieces down the lavatory and picked out the books and manuscripts which needed to be hidden in a safe place.

Andrey Sinyavsky's arrest did not come as a surprise either to us or to him. The following evening I set off for their apartment in Khlebny Lane. Here, as I expected, they had only just finished searching the place. A whole team of KBG men were sitting at the table and they were delighted to see me. As the saying goes, talk of the devil and he'll appear. I left Maya something to eat and went home. She was surprisingly self-possessed in such a difficult situation. She thoroughly checked the lists of what had been confiscated, argued about individual books and tape recordings, then demanded that they be returned.

Some action had to be taken. I rushed off to see Alik Yesenin-Volpin, who passed among us for a great lawyer, an expert in every sort of civil and criminal code, thanks to the fact that he had already personally had a taste of them. 'Listen', I whinged, 'these wonderful people have been arrested.' 'I don't care how wonderful they are', said Yesenin-Volpin, 'what's the charge?' I liked this. He straight away diverted my emotional outburst into the practical realm of legal defence.

After thinking about the problem, Yesenin-Volpin arranged a 'civil appeal' and a rally at Pushkin Square, where, on Constitution Day, 5 December 1965, a group of protesters appeared with a banner, 'Respect your own constitution' (which guaranteed freedom of speech) and a demand, based on this guarantee, for an open trial for Sinyavsky and Daniel. The police instantly broke up the rally. This is taken to be the beginning of the human rights movement in the Soviet Union.

We didn't take part in the rally. Maya Rozanova and Sinyavsky considered that they had done their work, and that protesting, letter-writing and getting up demonstrations was for the wider community to do. It was at this point that we took Maya to Kargopol, first, so that she would not be wrongly implicated in the protests, and secondly, to give her some respite, as detailed in Chapter 7.

Rumours about the arrest of Sinyavsky and Daniel quickly spread through Moscow and reached the West. I am not going to describe how the various circles within the country and abroad reacted to their arrest. This affair long ago went beyond the bounds of personal reminiscence and became a shared public memory. (Anyone wishing to acquaint themselves with the details can refer to *The White Book*[3] which was compiled by Alik Ginzburg hot on the heels of the trial, to the collection *The Price of Metaphor*[4] and to many other sources.) I will just mention that among the hundreds of foreign and Soviet writers and scholars who protested against the arrests to various highly placed authorities in the USSR were Graham Greene, Saul Bellow, Alberto Moravia, Hannah Arendt, André Breton, Louisa Mumford, Louis Aragon, Ehrenburg, Chukovsky, Kaverin.

I also wrote a letter of protest, addressed to the Supreme Soviet, to *Pravda* and to various other places. I wrote that I was familiar with the works of Abram Terts which had been published in the West, and did not detect anything anti-Soviet in them. I analysed Terts's works from this standpoint and, of course, I tried to show that his arrest was illegal. Unlike the well-known Soviet and foreign activists, those of us who wrote such letters (including Yura Gerchuk, Kolya Kishilov, Yura Levin and others) hadn't the least expectation of influencing the decision of the powers that be. We simply wanted, through *samizdat*, to inform people about what was actually happening in their country. The texts of the letters circulated widely and the long arm of the law reached out for me too.

At the beginning of January I had a phone call from the Lefortovo Prison.[5] Special Investigator Khomyakov required me to present myself at the prison at 10 am on the following day for questioning. Khomyakov, a drab-looking individual in civilian clothes, was sitting in his office. If I had met him in the street the following day I wouldn't have recognised him. The main thing Khomyakov was interested in finding out was whether Sinyavsky had read me his anti-Soviet works or had given them to me to read. The fact was that the clause of the criminal code under which Sinyavsky was charged ran as follows: 'the preparation, dissemination and

possession of anti-Soviet literature'. As far as preparation and possession were concerned, Sinyavsky had not denied them. But dissemination still had to be proved. And the interrogator wanted to obtain this proof from me. I lied, of course. No, he hadn't read them to me or given them to me to read. The follow-up question was, 'In that case, from whom did you get these books?' What could I say? That I had bought them on the black market? That I had found them in the street? That I had got them from friends? (Then the logical question, 'from which friend in particular?' would have followed.) I realised that I would not be able to lie my way out of it. As far as telling lies was concerned, the KGB were professionals. So I simply refused to answer the question. A few days later I was again summoned to Lefortovo for questioning. The same Khomyakov kept harping on about the same thing over and over again. Had Sinyavsky given it to me or not, was it Soviet or anti-Soviet . . . finally, Khomyakov took me to an empty room, ordered me to wait and left me there.

I must have waited an hour or more. Suddenly the door opened and in came Sinyavsky and his interrogator (also a special investigator), Pakhomov. Sinyavsky and I embraced. 'A meeting of friends', said Pakhomov with false bonhomie. Confronting us with one another had the same aim: to prove that Sinyavsky had read me his manuscripts, i.e. disseminated anti-Soviet literature. Pakhomov read out an excerpt from Sinyavsky's statement under questioning where he admitted that he had read something he had written to a few friends, including me. 'Yes', I confirmed, 'he did read something to me, and I read something to him' (I had read him my translations of Koestler's *Darkness at Noon*, Orwell's *Animal Farm* and the stories of Franz Kafka). 'However', I said, 'when I first came across his books which had been published abroad, I didn't recall having heard anything about their subject matter from the author.' '*Pkhents*', Andrey whispered to me. 'Oh, yes', I 'remembered', 'he did read me *Pkhents*.' *Pkhents* was an early story by Sinyavsky – perhaps the first – he had read it to a fairly wide circle and precisely because of this had not sent it abroad. There was nothing incriminating in this science-fiction story. With this our confrontation reached an impasse.

All this happened in a highly civilised atmosphere. Andrey was calm and restrained and his jailers were not aggressive. And there was good reason for this. In January 1966 the sensation caused by the arrest of Sinyavsky and Daniel was at its height, both in the West and inside the country and the high command had evidently not yet decided whether to

avoid international shame and back down, or to save face and carry on with the case. We were even allowed to talk for a little while about personal matters and I told Andrey that his son Yegor, who was then only a few months old, was in good health and that Maya was fine . . . after this we parted.

* * *

I felt like K. in Kafka's novel, *The Trial.* After the interrogations I would dash home to prepare for my lectures at the university and the Stroganov Institute, where I was running a course on the history of design, and I had other things to do for VNIITE . . . in the evenings I gave my lectures and then met up with friends to exchange news and discuss future developments. This shuttling between the unreality of prison and the reality of academic life did nothing to lift my spirits. I was weighed down by great and alarming expectations of our future prospects, which hardly promised to be rosy.

CHAPTER 12

The Sinyavsky-Daniel Trial[1]

The Sinyavsky-Daniel trial opened on 10 February 1966 in the Moscow district court and I was summonsed to appear as a witness for the prosecution. During the morning session, while the accused were being cross-examined, all the witnesses were kept in a room put aside for that purpose. There were eight of us: Daniel's friends, Garbuzenko and Khazanov; Sinyavsky's friends, Andrey Remizov and E. Dokukina; Sasha Petrov who was Rozanova's student at the Abramtsevo College of Design and Applied Arts; Duvakin, who was a former teacher of Andrey's at Moscow State University, and Sergey Khmelnitsky. We were all admitted to the court room for the afternoon session which was devoted to the questioning of witnesses. The questioning began with the chief 'accusers' so to speak. The session opened with the examination of Remizov. Like Daniel and Sinyavsky, he had also published his manuscripts abroad, under the pseudonym Ivanov, for which he had been hunted by the KGB. When he learnt of Sinyavsky's arrest, he himself went to the authorities and confessed about his own publications and their anti-Soviet content. He ascribed a similar anti-Soviet character to Sinyavsky's works. During questioning he only confirmed his previous statement, which he said needed to be followed up. Remizov was pardoned. He got off with a mere public reprimand at a general meeting in the Library of Foreign Literature where he worked. The examination of Daniel's old friend Khazanov didn't go so smoothly. I never saw anyone in such a state of moral collapse. He was literally dripping with sweat which seemed to ooze out of his eyes and his nose and to trickle from his forehead and his cheeks. Poor devil! Before the trial had begun he had obviously been terrified and had written some sort of letter to the KGB denouncing his friend. And now he was aghast at being exposed. 'You wrote this letter?' asked Judge Smirnov, holding up a piece of paper. 'Come up to the desk!' Instead of this, Khazanov moved towards the exit

like a sleepwalker. And it was only after he had been shouted at two or three times that he presented himself in front of the judge and muttered something inaudible in reply to the questions put to him. The last one to testify at the afternoon session was Khmelnitsky. Sergey Khmelnitsky, a school friend of Sinyavsky and an architect by profession, had been recruited by the authorities at the end of the 40s. Two of his close friends had been sent to the camps thanks to his denunciations. In 1964, while he was defending his thesis at the Institute of the History of Art, one of these friends, who had by then served his sentence, asked to speak and related the extra-curricular activities of his former friend. After this unmasking Khmelnitsky cleared off from Moscow and went to Dushanbe [in Tajikistan]. In the witnesses' room where we waited to be called into the courtroom, everybody ignored him, except for Duvakin, who was unaware of his background. Khmelnitsky immediately sat down next to him and they had a lively conversation. Khmelnitsky knew nothing about the fact that Sinyavsky and Daniel had published abroad and his appearance in the courtroom was a completely unexpected turn of events for those sitting on the defendants' bench. We were equally amazed by his testimony. He asserted that he himself had given Daniel the idea for his main 'anti-Soviet' novella, *This is Moscow Speaking or Open Murder Day* (*Govorit Moskva ili Den otkrytykh ubiystv*). He said that one day he had happened to hear a summary of the novel on Radio Liberty. He had been unable to restrain himself and blurted out in front of a whole lot of other people that the author of this novel must be Daniel! He acknowledged that this was a mean trick on his part. All this made him look very high-minded.

Why, you might ask, did the KGB find it necessary to call this witness all the way from Dushanbe? To vindicate their valuable colleague in the eyes of the intelligentsia? The subsequent activities of Khmelnitsky, even after he had emigrated, support such a hypothesis. But more about this later.

In the courtroom the wives of the accused, Maya Rozanova and Larisa Bogoraz, tried to note down the proceedings in as much detail as they could. I also took some notes. In the breaks between sessions we gave these notes to our friends who were waiting outside in the freezing cold. It was a closed trial, only certain privileged people selected from a state-approved list were allowed in, no one else was admitted. It was from these notes of ours that *The White Book* was born.

The next day of the trial, 12 February, began with my cross-examination. And again, as during the investigation, they were mainly interested in the source of my knowledge about the works of Sinyavsky-Terts. 'Who gave you these anti-Soviet books to read?' inquired the counsel for the prosecution, Temushkin. 'No,' the 'liberal' judge, Smirnov, interrupted him. 'You are wrong to call them anti-Soviet. It is up to this court to decide whether they are anti-Soviet or not. Therefore you (he was addressing me), may mention the names of your friends.' All I could do was repeat what I had said to investigator Khomyakov. 'I refuse to give their names, because, although I do not consider these works anti-Soviet, the fact is that my friends are being held under article 70.[2] I don't want to implicate anyone else in this.' Whereupon Temushkin made an application to the court to indict me for refusal to testify. The application was granted and I was ordered to remain in the court room until the end of the trial. Sinyavsky declared from the defendants' bench that Golomstock had given exhaustive answers to all questions but that the question about what he had done with the books after his arrest had nothing to do with the matter in hand. Daniel said the same thing. But the court was not interested in such judicial niceties, nor were they interested in my replies to questions about Sinyavsky's philosophy, his political opinions, his attitude to Russian culture ... Both the verdict on the accused and my own punishment had been decided beforehand.

After calling upon Sinyavsky and Daniel to make their final speeches, the court pronounced sentence: seven and five years, respectively, in hard labour camps. A decision was also taken to charge me under article 182 of the criminal code for refusing to testify.

Maya Rozanova and Larisa Bogoraz remained in the court room, clarifying some formalities with the servants of Themis, Goddess of Justice. I waited for them in the corridor. When the three of us left the building we were applauded by the large crowd which filled the courtyard of the Moscow District Court.

* * *

The consequences of my indictment were not long in coming. The prospect of my own trial loomed over me. My case was conducted by a lieutenant-colonel in the KGB, Georgy Kantov. He was a complete blockhead, a crude

and loud-mouthed military type. I can't remember clearly what we talked about during my interrogation. Obviously the discussion was all about the same thing – where I had got hold of, or who had given me the works of, Abram Terts. One morning during a regular meeting of our section at VNIITE, the door flew open and three people burst in. The senior man introduced himself: 'Lieutenant-colonel Georgy Petrovich Kantov', and announced that they would now conduct a search of Golomstock's possessions with the aim of finding anti-Soviet literature. The appearance of Kantov and his comrades both stunned and amused my colleagues. Shchedrovitsky (an expert in Kant's philosophy), asked them to explain what was meant by anti-Soviet literature and wanted to see a list of books which fell into this category, if such a list existed. Blockhead Kantov mumbled something indistinct in reply. The KGB men began rummaging in my desk. When they were about to disembowel my briefcase, Dorogov, who sat at the desk next to mine, moved it to his desk and said that it belonged to him.

What did the KGB hope to achieve with this action? Could they really and truly think that I would keep anti-Soviet literature at work? Although they obviously did have this idiotic idea in their heads. Many years later the director of VNIITE, Solovev, told me that they had shown him an arrest warrant which they would use if they found anything incriminating. Probably they wanted to compromise me in my colleagues' eyes. The result was the exact opposite.

After failing to find anything anti-Soviet at work, Kantov announced that he had a search warrant for my apartment on Petrovsky Boulevard and that we would now go there. I said that I no longer lived there: recently Nina and I had finally got hold of a one-roomed apartment in a new building on Elninsky Street not far from the Molodezhnaya metro station. The fact that the address on the search warrant did not match my actual address had the team temporarily stumped (the letter of the socialist law had to be strictly observed) and Kantov asked whether I would consent to the search being conducted, despite the fact that the addresses didn't match. I consented.

What happened next was like a cross between Kafka and Bulgakov. We piled into a large black six-seater vehicle – the three KGB men, myself and a heavily tattooed[3] driver and set off for Molodezhnaya. On the way it became obvious that we were going in the wrong direction and when Kantov questioned the driver he said that first he had to go to the Kazan

railway station to meet his colleague. We stopped outside the station, the driver left, the KGB lieutenant-colonel and the major set off to find something to eat and I remained in the vehicle with second lieutenant Ekonomtsev. He introduced himself as a student (or graduate) of the Classics department of the Faculty of Languages and Literature at Moscow State University. We waited for a long time. The major and the lieutenant-colonel had already returned from lunch when we heard a loud crash behind us. The driver was shoving his colleague's boxes and suitcases into the boot of the car. Off we went again, and again in the wrong direction. The driver had to take the things to a house somewhere at the other end of Moscow. 'Why didn't your friend come with us?' asked Kantov, pointing at the empty front seat. 'I thought it wouldn't be ethical', answered the tattooed individual. We reached the house and the driver, together with Kantov and the major, unloaded the suitcases from the boot and dragged them up the stairs. Such breaches of rank among KGB personnel struck me as rather odd. But later I gathered from the remarks they exchanged amongst themselves that the car, and therefore the driver, were under the authority of KGB General Abramov and I came to the conclusion that they themselves were not sure who had seniority in this situation – the lieutenant-colonel, the general's driver (maybe he was a colonel?!) or even the lieutenant.

It was afternoon by the time we reached Molodezhnaya. There was complete chaos in the flat, where we'd only just moved in. Our friend Sasha Petrov was building bookshelves, books were piled up on the floor, the table was snowed under with papers. Our tattooed driver and someone who was apparently a neighbour acted as official witnesses to the search. The KGB men rummaged in our dirty linen, inspected the dustbin, examined manuscripts, leafed through books. Lieutenant Ekonomtsev found a volume of Plutarch in a heap of books and delightedly declared that he was actually studying Plutarch at that moment. To my surprise, I realised that he obviously wanted to help me. So, when Kantov happened to pick up the typescript of Kornilov's poem 'After Midnight' – which was blatantly anti-Stalinist – Ekonomtsev took it from the lieutenant-colonel, said that it was an old thing with nothing incriminating in it, and tucked it under a pile of books (evidently he was the KGB's literary expert). He did the same thing with my translations of Kafka and when he came across some manuscript that he didn't know, he gave me a questioning look and hid it out of sight, just to be on the safe side.[4] At about 7 pm – again in strict

accordance with the regulations – the team left, without having had time to look in the right-hand drawer of my desk (in any case, they wouldn't have found anything of interest to them in it).

As my mother told me later, a simultaneous search was being carried out by another team at their apartment. After a long search which didn't turn up anything incriminating, they suddenly noticed a concealed built-in cupboard, blocked by some piece of furniture. The piece of furniture was moved, the cupboard was opened and in it they found an enormous trunk, locked with a giant padlock. The KGB men's eyes gleamed. They sent to the building management for a locksmith, who was naturally not on the premises, but was expected to turn up shortly. There was a long wait. Finally the senior KGB man shrugged, opened his briefcase, which contained a full set of burglars' lock-picking equipment, and set to work. The trunk was opened, but instead of a cache of illegal literature, they found an assortment of clothes, a saucepan with a hole in it, some old frying pans. Miron Etlis,[5] who had returned from the camps and then left Moscow, had asked me to store some of his mother's things (she had recently died).

* * *

The interrogations and searches, regardless of their results, led to their inevitable conclusions. Somewhere around the beginning of May, I was tried for refusing to give testimony at the Sinyavsky-Daniel trial. I don't remember the exact date or place of the trial. But I vividly remember the actual legal proceedings. The protests against the writers' sentences, both at home and abroad, had not yet died down – in fact, rather the opposite – and Judge Gromov was particularly afraid that my case would attract the attention of the foreign press and cause a new wave of protests. He went to inordinate lengths to deny any links between my case and the preceding one. At any mention of Sinyavsky's name he interrupted me, alleging that my case had nothing to do with Sinyavsky and Daniel's. But his fears were groundless. My trial was conducted in the most modest of circumstances. Only our closest friends and a few supporters were present in the little room. There were no foreign correspondents. As contradictory as it might seem, the witnesses for the prosecution were my wife, Nina Kazarovets, and Maya Rozanova. Both of them confirmed, in reply to the judge's questions, that yes, Golomstock had read the works of Abram Terts. The court found

me guilty on the basis of their testimony. I was sentenced to six months' correctional labour under article 182 of the criminal code of the Russian Soviet Federal Socialist Republic for refusing to testify. This article was designed to punish those who refused to speak at their friends' trials — petty thieves, hooligans and similar antisocial elements. Parasites[6] were exiled, workers were sent back to their place of work to be punished by the collective, who cut their pay by 20 per cent and forced them to give a written undertaking that they would not leave their place of residence. It appeared that I was the first senior staff member from a research institute to be sentenced to correctional labour. All this was akin to madness, but evidently this was the logic of the Soviet legal system.

The ideological repercussions were much more serious for me than the legal punishment. My book, *The Aesthetic Character of Artistic Trends in Modern European Painting*, had been submitted to the publisher Iskusstvo three years earlier. It had been signed off for printing and had even been typeset but now it was cancelled. The type was all broken up.[7] *Technical Aesthetics number 2*, a digest of research papers from VNIITE, which included a long article by me about the historical interrelation of craft, art and design, was pulped and reprinted without my article. Someone took a few copies of the original digest from the typesetters and I still have one of them. Contracts for a book on Hieronymous Bosch with Iskusstvo and for an album of paintings by Cézanne with the Aurora Press were cancelled. My name was banned in all the newspapers, periodicals, and collections where I usually published.

For the staff at VNIITE this was a very worrying time. There was a threat of staff cuts and many people feared for their future. Only I was calm. The management did not have the right to dismiss someone who had been sentenced to correctional labour. But I didn't stay there much longer.

In January 1967 Alik Ginzburg was arrested and a new wave of protests began. Boris Shragin and I sat together in my apartment and composed one such letter of protest which was signed by more than a hundred people. Our letter was not the only one. Shchedrovitsky and another VNIITE colleague were among the signatories. This was the straw that broke the camel's back, as far as the management was concerned, and we were dismissed on the pretext of staff cuts and our department of the history and theory of design underwent radical restructuring.

The Moscow Union of Soviet Artists also began a critical review of members accused of antisocial activity, as the act of signing protest

letters was called then. I was among those summoned to a general meeting. D. A. Shmarinov chaired the meeting and he seemed to feel awkward, which is more than could be said of the other members of this distinguished commission. The tattooed Stepan Dudnik,[8] the painter of the Stalin Prize-winning picture, *Thank you Comrade Stalin for our Happy Childhood*, and the Party secretary (I don't remember his name), wanted to know why we were standing up for anti-Soviets who had been justly convicted. I said something about the Stalinist repressions which were starting to happen again in our time, at which point someone asked an unexpected question. Didn't we mean the repressions against enemies of the people – like Bukharin, Kamenev? I was so flabbergasted by this turn of the discussion that I answered impulsively with sincere indignation: 'I wish I had your problems ... my friends are in prison and according to you I am supposed to worry my head about Bukharin.'[9]

Finally, there was a judgement of Solomon. I was turned from a full member of the Union into a probationary member, but then the category of probationary membership was promptly abolished. I was not formally excluded from the Union, but in practice I turned out to be in a membership category that didn't exist. At any rate, when I subsequently went to the Union for some information about my housing situation, nobody knew if I was still in the organisation or not, and to be on the safe side they didn't give me any information.

* * *

Ripples spread out from this wave of repression and even threatened the careers of our most distant acquaintances. People were sacked, publishers removed books from their lists, manuscripts that had been printed were pulped. People reacted to this in different ways. Rita Wright-Kovaleva, a translator friend of Daniel, came to see us. 'Ah', she lamented, 'It's a disaster! My translation of Kafka's *The Trial* was about to come out!' As if the world could not get by without her translation.

Once, Maya Rozanova, Vika Schweitzer and I were queuing for a taxi outside the Union of Soviet Writers where Vika worked as a secretary in the translation department. I needed cigarettes and I ran across the road to buy some. When I came back a large, corpulent man was standing in the queue behind us with a lit cigarette in his hand. I rummaged in my pocket but couldn't find my matches so I politely asked him for a light. The man

looked at me with glazed eyes. 'You should shave off your beard', he said. It always got on my nerves when strangers made remarks about my beard so I replied cheekily, 'And maybe you should grow one?'

After this the atmosphere grew rather tense. Vika whispered something to the people who were with this man and Rozanova observed the proceedings with a malicious smile. We needed to clear the air. 'Please do give me a light.' The man held out his cigarette with a trembling hand and then his colleagues led him away. The man was Tvardovsky.[10]

But we were already in the post-Stalinist era and people didn't cross the street to avoid meeting us. Vysotsky[11] continued to bring his guitar to Rozanova's house. Once he sang his new song, 'The Wolf Hunt', dedicated, I believe, to the hunt for Sinyavsky. Not only did my old circle of friends remain loyal, but I even acquired new ones.

Boris Birger also signed the protest letters and also got a grilling from the Moscow Union of Soviet Artists. This gave us something in common but I was also drawn to Boris because of his creative work. Birger started at art school straight after he returned from the front and, at first, he dedicated himself to formalist research, then burnt all his early work and began the quest for his own style in the field of figurative painting: little Moscow streets, landscapes, portraits ... I was struck by the mismatch between his character and the emotional tenor of his paintings. He himself was dynamic, sharp in his movements and his judgements, but his work ... During my visits to his studio on Tsvetny Boulevard, while Boris nipped out to buy vodka, I would be left contemplating his works, immersed in the world of peace and silence which emanated from his paintings. Even in the large group portraits of friends, in which Okudzhava, Voynovich, Balter, Iskander and Chukhontsev[12] are posed round a table, decked out in fantastical costumes and fools' caps, an atmosphere of quiet concentration unites the group, instead of the usual cheerful ambiance of a booze-up among friends. He created a whole gallery of portraits of the outstanding personalities of that era, including Sakharov, Sinyavsky, Lev Kopelev and Nadezhda Mandelstam. We often met in Moscow; I visited him in Bonn, where he lived after emigrating and he stayed with us in Oxford and London when he had exhibitions in England; our friendship continued right up until his death in 2001.

* * *

My mother and stepfather had spent many years living in my great-aunt's room in Serov Passage, but their turn had finally come to get an apartment. According to the norms of those times, each ordinary Soviet citizen had the right to nine square metres of living space, which meant that my mother and stepfather could only aspire to a minute one-roomed dwelling. I saw in this yet another manifestation of socialist democracy. Mama, who had worked as a doctor for almost 50 years, received a pittance from the state, but any member of the Moscow Union of Soviet Artists, who had got admittance thanks to some lousy little book or pamphlet, was entitled to 20 square metres in addition to the usual nine, and a studio as well, which people often converted into very comfortable living quarters. I was very annoyed by this and so I made a joint application with them and as a result my mother and stepfather received a decent little two-roomed apartment on Kostyukova Street.

As mentioned previously, Nina and I bought a co-operative one-room apartment on Elninsky Street near the Molodezhnaya metro.[13] By this time the opportunity of a luxurious flat in a Union of Artists' co-op in the centre of Moscow had been rudely snatched away from me. A few days after the Sinyavsky trial we were due to move to the new place. Our artist friend Boris Sveshnikov phoned and offered to help us move. We loaded our things onto a lorry and drove to Molodezhnaya. This was my first sight of our new place – an eight-storey tower constructed as part of Khruschev's solution to the housing problem.[14] It was still unfinished. Wires dangled from the stairwell like black entrails. Dirty stains were coming through the damp, unpainted plaster . . . We stowed our stuff as best we could and went down to have lunch in the cafe opposite. Here Sveshnikov told us a story: he had had a dream the previous night. For some reason he had come to this building, had entered the hall and seen these black entrails. He had gone up to the third floor (where our apartment was), turned to the right . . . his dead mother opened the door to him. . . in the empty room women were washing the windows. Shortly after this he gave us a drawing which he had done not long before we moved in. If you removed a few surrealistic details, it was the view from our window. If artist-clairvoyants really exist, then Boris Sveshnikov was one of them.

And there were more encounters. Nadezhda Mandelstam – a wise woman surrounded by a swarm of young admirers of the poet, Osip Mandelstam; Varlam Shalamov, like a great old cracked wardrobe (I met him at Nadezhda Mandelstam's), Natalya Stolyarova, Ehrenburg's secretary, who had been born in France and spent many years in Stalin's

camps. During one of my meetings with Natalya Stolyarova, she took me out onto the balcony and and read me a note from Solzhenitsyn, expressing his approval of my conduct at the trial. At the end of the short message was a postscript: 'burn after reading' which Natalya then did in my presence.

* * *

Despite all the punitive measures and prohibitions against me, Viktor Lazarev renewed his invitation to me to deliver a course on the history of nineteenth- and twentieth-century European art to the full-time and evening students in the Art History department at Moscow State University. He repeated this invitation the following academic year (1967–8) as well.

I began my first (and last) lecture with Louis David and recounted how, in his huge composition, *The Tennis Court Oath*, this bard of the French revolution painted out the faces of the participants at the meeting as soon as they were guillotined and replaced them with others. The analogy with Soviet painting was too blindingly obvious. The following morning I had a telephone call from the university and was ordered to appear in the faculty at 10 am. I was met by Professor Grashchenkov, who regretfully informed me that my lectures had been cancelled and that I should not set foot in the department again. Either someone had denounced me or the top brass suddenly got cold feet, but that was the end of my university career.

So that's how I landed up among the dissidents.

CHAPTER 13

Dissidents

The truth is beyond our reach, we would settle for facts.

Aleksandr Pyatigorsky

Now, nearly 50 years after the events described, writers often use the very term 'dissidence' rather loosely. All those who spoke out against the regime in one way or another were dissidents: they signed protest letters, attended demonstrations, were sent to the camps or were exiled. However, the movement was composed of many different types and it is necessary to make distinctions, if only in order to define the position of those whom I considered like-minded people.

Towards the end of the 1960s the dissident movement branched off in many directions: human rights advocates, political reformers, religious believers, Zionists, campaigners for the restoration of 'Leninist norms', for socialism with a human face, for the right to emigrate, for freedom of speech and creativity, campaigners for the return of the Tatars to Crimea,[1] nationalists and people who simply jumped on the band wagon in order to earn some political capital before their departure abroad. Groups, associations, societies were set up, each with their own leaders and hierarchies. Over time, and especially in the émigré communities, these different ideologies went into battle with one another: the Russian nationalists hated the Westernisers, die-hard socialists hated the supporters of an alternative social system, the keepers of the one and only truth (and there were more than enough of those among the dissidents), considered spineless pluralists as traitors to the idea, and so on.

I did not join any of these groups although I felt sympathy for them all, without exception. We were all oppressed by a single totalitarian power and I considered that resistance was natural and right. But I didn't believe in the possibility of remaking Soviet power by means of political speeches.

I didn't go to Red Square with the group headed by Larisa Bogoraz (after this she was given the title of grandmother of the Russian revolution) to protest against the invasion of Czechoslovakia by Russian tanks.[2] The Soviet invasion seemed to me to be the reflex reaction of a totalitarian organism, like the automatic response of an octopus, shooting out its tentacles in pursuit of an escaping prey. And I didn't have much faith in socialism with a human face either.[3] On the day when a rally had been planned at our Institute in support of the Soviet invasion, the party secretary of the Institute came and asked me whether I had any work to do and, if not, wouldn't I like to go home. I was happy to agree. He was afraid that I would make a political speech at the rally. He was mistaken in this. I had no intention of attending such a shindig.

Roughly speaking, we weren't protesting against the regime, but against the lies of the regime. 'You can die for your country but you mustn't lie for your country' was a popular catchphrase in our circle. The songs of Okudzhava and Galich also taught us this, and Brodsky's poems, the stories, and later the novels of Voynovich, not to mention the Russian classics from Pushkin to Mandelstam, Tsvetaeva, Platonov. I must confess that I was not a patriot. Doctor Johnson's pithy adage, 'Patriotism is the last refuge of a scoundrel' made an early impression on me. And the trumpeters of Soviet patriotism were indeed for the most part great scoundrels. Probably, I thought to myself, somewhere there might be homelands worth dying for, but Stalinist Russia, in which I had contrived to be born? I understood the Russian soldiers – simple workers and *kolkhozniks* (collective farm workers) – who went over to the German side in order to fight against their communist motherland, and if I had been a couple of years older, and found myself on the front, I would most likely have surrendered at the first opportunity and been hanged on the first poplar tree. I didn't believe the Soviet press reports which referred (in very measured and restrained terms) to Hitler's policy with regard to the Jews and we didn't have any other source of information. The word 'Motherland' (in those days it had to be written with a capital letter) meant no more to me than an address on an envelope. I am writing about myself and how I remember my own mood in those days, but it was characteristic of many people of my generation – or at least among many in my circle of friends and acquaintances – who had not fought in the war and who shared a similar attitude either consciously or unconsciously.

As far as our position towards the regime was concerned, we (like many others who opposed it), considered it not as a political confrontation but as a moral opposition, as an opposition to the lies which penetrated through all the pores of society and all the realms of professional activity. This is how it was understood by Sinyavsky, Daniel, Yesenin-Volpin and the many thousands of professional people who sang songs to guitar accompaniment, wrote books for *samizdat* and *tamizdat*,[4] who filled young minds with unorthodox ideas about art, science, philosophy, morality, the norms of social behaviour, who defended the persecuted and supported those in prison. Did they consider themselves dissidents?

Obviously, it was this divergence in moral and political positions which brought about the ensuing schism in the general opposition movement known as dissidence. There was even a schism within our group. As always in such situations, wounded pride, aspirations, ambition played their part – (I don't want to go into these things) – but the main reason for the split was the differing attitudes of Sinyavsky and Daniel towards what had happened. For all their very warm personal relations, they had totally different characters, temperaments and interests. Yuly Daniel was a talented poet and translator who had gone through the war and been wounded at the front. He seemed to be living life in the fast lane in the entertaining company of the literary set, fellow writers, friends and drinking companions. He was what you'd call a happy-go-lucky sort, friendly, sociable and not very discriminating in his choice of friends. During his trial some of them were pretty badly behaved, to be frank. He was a dazzling storyteller. At the dinner table he would come up with ever more brilliant tales. It seems he didn't write them down and it's a shame if they haven't been preserved. I remember two of them.

The first one was told to him by a comrade from the reconnaissance unit in which Daniel served during the war, a young Komsomol from a little town in the back of beyond, somewhere in Ukraine. He came from a large and very poor Jewish family. Before a feast day on which goose was traditionally eaten, the family patriarch, Uncle David, set off with a pair of geese to the Kosher slaughterhouse in the neighbouring town. One of the geese died in the crush on the bus and the butcher refused to ritually slaughter a bird that was already dead. Back home at the dinner table, Uncle David took the dish and to everyone's amazement, polished off that whole goose himself.

What happened next:

This was at the beginning of the war. A reconnaissance group was moving in a westerly direction and encountered a stream of Jewish refugees travelling east. And suddenly this friend of Daniel spots his own family among the crowd. He rushes up to Uncle David. Where are you going? What for? How? Why? Uncle David doesn't answer, but just keeps repeating, 'I should never have eaten that goose.' He takes this whole nightmare as the Lord's retribution for his breaking of the Law.

And here is another scene, this time witnessed by Daniel himself. Members of the reconnaissance unit were settling down for a bite to eat on a little hillock not far from the road. A tank stopped in view with some kind of engine problem. The mechanic climbed out and got underneath it, so that only his legs were sticking out. A staff car came up and stopped. Out got a general and began asking the mechanic something, at which point the mechanic started effing and blinding in reply. The general promptly shot the poor beggar and set off in his car again. The tank commander's head appeared from the hatch. When he realised what had happened he dived back inside and the turret began swivelling. Bang! The general's car was blown to smithereens. The tank commander reappeared. 'You saw what happened?' he asked the reconnaissance troops. 'No, we didn't see a thing.'

Daniel and Sinyavsky shared a love of literature, a hatred for the ugly side of Soviet life and a preoccupation with the common problems of creative work. But during the trial their lines of defence diverged. Sinyavsky did not admit his guilt, either wholly or partly. Yes, I am different, I am an idealist, yes I am not with you, but nor am I against you, he said in his closing speech. At that time this might have seemed like a ruse, an attempt to defend himself from accusations of having an anti-Soviet attitude, but it was Sinyavsky's sincerely held conviction, which he had repeated on more than one occasion.

Daniel was not so consistent in his defence. At the end of the trial he admitted that yes, they were guilty of sending their work abroad, yes, there was a lot of political tactlessness in their books, a lot of bragging and insults. Yes, he said, they were no angels and they did not deserve to be sent home in a taxi at the court's expense. Later he himself realised his mistake, and regretted what he had said in the courtroom, and I think that to a large extent this conditioned his behaviour in the camp.

I was shocked when Larisa Bogoraz and her small son returned from a visit to Daniel and she told us about how heroically he was behaving, how

he was participating in strikes, signing petitions and about how, once, he jumped up on a table and lashed out at one of the screws. She herself had thrown some potatoes over the fence to the miserable prisoners and had argued with the camp authorities. This position was attractive to some of our politicised dissident friends. They saw in Daniel a leader, under whose banner they could rise in a common political struggle.

Sinyavsky offered them no such banner. He considered that he had done his work and now he must serve out his sentence with dignity. Rozanova saw it as her task to preserve Sinyavsky, and in that I wholeheartedly supported her. In the camp Andrey did the heaviest kind of manual labour and in his free time wrote letters to his wife. Prisoners' correspondence was limited to two letters per month, but it didn't occur to the authorities to specify their size. Andrey's letters were fat. The camp censors didn't detect anything incriminating in them. No complaints about the grub, or about the rudeness of the authorities, or about how hard the work was, just some sort of discussion about Pushkin and Gogol, some entertaining fragments of camp folklore ... Later Sinyavsky's books, *Strolls with Pushkin*, *In Gogol's Shadow* and *A Voice from the Chorus* would emerge from these letters. Such a divergence of outlooks between the two men had fateful consequences for our circle.

After he emigrated, Sinyavsky once declared that his only quarrel with the Soviet government was about aesthetics, a statement which aroused a storm of indignation among former dissidents, causing him no end of trouble. I think that the aesthetic position is far broader and more serious than the political position, for it includes in it the idea of beauty, moral and aesthetic standards, the representation of good and evil, justice and lawlessness – everything that a politically orientated person might disregard for the sake of achieving higher (from his point of view) goals, all the things that for Sinyavsky (and indeed for me) were the main cause of our differences with the Soviet authorities. Political opponents can come to an agreement, reach a compromise, eventually change their outlook. It is more difficult for people with different political and aesthetic orientations to come to an agreement. I came to this conclusion after becoming all too familiar with dissident squabbles.

Our dissident friends strongly supported Daniel's position. We wouldn't have objected if it were not for the old Soviet cliché lodged in their politicised brains: 'Whoever is not with us is against us.' Daniel's heroic position was contrasted with Sinyavsky's compliant behaviour. Sinyavsky

was blamed for not joining in strikes, not signing protest letters, not doing time in a punishment cell. Maya Rozanova was accused of not letting Andrey join in the common political struggle. Our encounters were accompanied by quarrels, abuse, insults to Maya. And yet Sinyavsky and Daniel themselves continued to respect, love and have faith in one another to the end of their days.

* * *

I accompanied Maya a number of times on her visits to Andrey. He was then in Mordovia [some 600 kilometres south east of Moscow] in a camp which was situated in a settlement with the sinister name of Yavas.[5] The landscape was equally dreary: barbed wire, watch towers, fences, columns of prisoners accompanied by guards with dogs. Alik Ginzburg was a prisoner in the adjacent camp. I would meet his wife Arina at the station when she came to visit him, and arrange for her to stay with some local people who earned a little extra from such enterprises. We were all still friends then. The settlement lay on high ground and if you climbed up you could see the layout of the camp from the porch of a house which had been built up there. The barracks were laid out round a central square and had a neat appearance. Once – it was a Sunday, a non-working day – Andrey came out onto the square, obviously by previous arrangement with Maya, with two of his fellow prisoners. I took this as a personal recommendation. These fellow prisoners were Misha Nikolaev and Rofalovich. From this time onwards our 20-square-metre apartment in Moscow turned into a kind of staging post when prisoners were released from the camps.

The first one to appear at our house was Lenya Rendel. Lenya had been arrested in 1957 together with a group of Komsomols from the History Faculty of Moscow State University who had been fighting for the re-establishment of 'Leninist norms'. Their goal had been to fight their way to power and form their own – fair-minded – government. Rendel was some kind of shadow minister of foreign affairs. During his illegal excursions to Moscow from his 101-kilometre exclusion zone,[6] Lenya stayed with us. In the mornings he read the papers, and then nervously paced the room. 'Lenya, what are you upset about?' I once asked him. 'A hundred million Africans are starving.' 'Lenya, take a look at yourself in the mirror!' He had emerged from the camp looking as if he had just been dragged out of the

gas chambers at Majdanek. He was nothing but skin and bones and his teeth were growing at right angles to his gums.

The next one to be released was Misha Nikolaev. Rendel met him at the station. Accommodation had to be arranged for Misha and Lenya suggested two alternatives. The first, a humble abode where they ate off newspapers – (he meant Pyotr Yakir's place) – the second – an aristocratic house, where they served food on plates (i.e. our apartment). Practical Misha chose the second option. Mikhail Nikolaev didn't know his real name and didn't remember his parents. Evidently they had been members of the powerful Party leadership who had been arrested and had then been shot or had disappeared in the camps. Misha had fetched up in an orphanage for the children of enemies of the people, where he was given a new name, patronymic and surname. When the war came the orphans were sent for medical inspection; two years were added to their age and they were sent to a trade school. Thus, at the age of 15, Misha was called up and sent to the front. After the war he worked on building sites somewhere in the Urals and was arrested for anti-Soviet propaganda. After his release he tried to cross the border to Turkey, was caught and sentenced to be shot. His sentence was commuted to 25 years in the camps and then reduced to 10 years. In total he served 15 years. But there were longer sentences. He said that once he had seen a powerfully built old man in the camp baths, with a large wooden cross on his chest. 'How long have you been in, Grandpa?' asked Misha. 'Well, I've just finished my 43rd year.' 'So you've never seen Soviet power!' 'God is merciful', said the old man.

The old fellow was a member of one of those sects that believed the Soviet authorities were the devil incarnate, and every official seal the stamp of the Evil One. When he was released he threw away his internal passport and was again imprisoned for anti-Soviet activities and vagrancy.

Unlike Rendel, Nikolayev appeared to be in rude health when he turned up at our house. Solidly built, with a big black beard, he looked like a gypsy, and in the camp he had chosen to sit out his sentence in a punishment cell, rather than ruin his health with heavy manual labour. He read a lot – books from the camp library, literary journals, art periodicals, to which prisoners were allowed to subscribe and which they exchanged among themselves. I was struck by his erudition, his inner intelligence, so at odds with his outward appearance. Misha could talk cleverly and knowledgeably about poetry, about literature, about Tsvetaeva, about Picasso.

One day Rozanova brought her friend Vika Schweitzer to see us. Vika worked as the secretary of the translators' section in the Union of Soviet Writers, and after Sinyavsky and Daniel's arrest she collected signatures in their support from among members of the union. Her speciality was the work of Marina Tsvetaeva. 'You know', said Misha as we sat down to dinner, 'there's a fellow called Schweitzer who writes brilliant stuff about Tsvetaeva.' 'And that fellow is sitting right opposite you', said Rozanova, pointing at Vika. So began a love affair, which led to their marriage and emigration to the USA.

CHAPTER 14

Pen Portraits of My Friends

Friendship is the Wine of Life.

James Boswell to Samuel Johnson

Socrates is my friend but truths are ten a penny.

Moscow paraphrasing of Plato[1]

After the momentous events of 1966 I was left without employment, without money, without any means whatever of earning a living. And I was not the only one. Many of those who had protested, spoken for the defence, signed letters, ended up in the same boat. This raises the question, how could such renegades survive under a totalitarian regime?

When my students, whose houses had also been searched, came to see me, soon after Sinyavsky's arrest, and asked the traditional Russian question, 'What is to be done?'[2] – I could only give one answer – stick together with your own people. 'Your own people' meant your own circle of friends, acquaintances, like-minded people. Moscow society was made up of such circles, formed by a community of interests, and people's mutual need of support. 'We don't need first aid, slow aid would be fine'... sang Galich.[3] The more the government oppressed us, the stronger these links of friendship became. And this worked in our favour.

My friend Valery Prokofiev signed a contract with Iskusstvo for my book on Hieronymus Bosch which had been cancelled. The book was published under the pseudonym G. Fomin.[4] Anna Barskaya, who worked at the State Hermitage, did the same thing. She lent her name to my large-format album of Cézanne pictures in Soviet collections after Aurora Press cancelled my contract.[5] The whole advance, 50 per cent of the fee, went straight into my pocket, of course. (I never got the balance because both books, alas, were only published after I had emigrated.)

We all survived in different ways. Rozanova, who had also been sacked from her various jobs, started to learn jewellery-making, alongside her student Sasha Petrov. Maya worked with her head, Sasha with his hands – she came up with the ideas and he brought them to life. Artist friends shared their studio space with them. They sawed, chiselled, ground ... cornelians, jade, simple stones ... copper, silver. The style of their pieces was reminiscent of Russian baroque. They started to show them at craft exhibitions. Petrov became a member of the Moscow Union of Soviet Artists. Their brooches, necklaces and rings were in demand among the ladies of Moscow and this enabled them to survive.

* * *

Aleksandr Kamensky, one of the leading critics in the Moscow Union of Soviet Artists, let me have his 'studio' on Little Lubyanka Street – a semi-basement room where the pipes and the lavatory froze in winter. This is where I worked and where friends gathered on Thursdays. Yura Ovsyannikov, Sasha Pyatigorsky, Slava Klimov[6] were permanent members of this group as was Sasha Kondratov[7] whenever he came to Moscow from his home in Leningrad. Lenya Batkin,[8] Nathan Eidelman,[9] Georgy Shchedrovitsky came and brought their friends. We drank, discussed matters of art history, history and politics and since then, alas, I have never taken part in such high-powered intellectual discussions!

Characters are jostling inside my head, demanding to be let out and set down on paper. What shall I do with them? Sit quietly! I'm your writer aren't I? Don't push! Come out one by one.

* * *

I first met Yura Ovsyannikov after he had returned from the front and was working as head of the book editing section at Iskusstvo. We subsequently signed a contract for a large album of Picasso drawings and I set to work. After Sinyavsky's arrest the project seemed to me to be doomed. But a few days later Ovsyannikov came to see me and said that I must continue working on the album and that he would try to keep my name as author on it, although he couldn't guarantee it. He didn't succeed. The album came out with a foreword by Mikhail Alpatov[10] and without the name of the compiler and writer of the accompanying text. I gave copies to friends with the inscription, 'from an unknown author of the mid-twentieth century'

and for Sinyavsky I signed it, 'from anonymous to pseudonymous'. It was Ovsyannikov who arranged the redrafting of the contract for the Bosch book in Valery Prokoviev's name. He sent the manuscript for review to Sergey Averintsev.

Averintsev at that time described himself as 'acting theologian', for there weren't any others in Moscow. In his review, he pointed out Golomstock's errors, in particular with regard to medieval heresies, where the author had confused opposition to the church with opposition to Christianity ... for, 'Christianity is the totality of all the living, all those who have lived and all those who will live.' It was as if he was writing this review not for a Soviet enterprise but for a theology college. But he was very appreciative of the manuscript and recommended it for publishing. In general he managed, in defiance of Marxism-Leninism, 'to live in society and be free from society'.[11] Once, at an academic conference in the Institute of Philosophy, Averintsev suddenly stood up and declared in his squeaky voice, 'The previous speaker referred to some kind of Leninist theory of the two cultures. I don't know what that is ...' People started gesticulating at him. 'Sit down', they said, 'and stop lowering the tone of this academic meeting.' (Any Soviet school child knew about the theory of two cultures.[12]) As a religious believer, Averintsev understood and sensed the spiritual essence of culture better than any of us. Once, talking about Aleksandr Kazhdan,[13] whom he considered his teacher and revered for his learning, he said to me, 'A. P. (Kazhdan) looks in a puddle, sees a reflection and thinks that it is the sky.' When Averintsev gave public lectures about the Middle Ages at the Pushkin Museum he would sketch the outlines of a Gothic cathedral with gestures, stand to one side and contemplate the building in the air that he had conjured from his imagination, point to its various parts and explain their sacred meaning. It was quite extraordinary, as if he could actually see the church in front of him.

Yury Ovsyannikov was a born publisher. As far as typographical layout and standards of scholarship were concerned, the series he created, *Cities and Museums of the World, A Concise History of the Arts, A Life in Art*[14] and others, were the best of their kind. He had one brilliant idea after another. He commissioned me to prepare a multi-volume series on the history of world civilisation. It was an absolutely fascinating task. I put together a plan for the series and invited the participation of scholars whom I considered the leading experts in their fields. Sevastyanov, the director of Iskusstvo, called a meeting in his office to discuss the project.

The projected authors of individual volumes came to the meeting: Averintsev, Aleksandr Kazhdan, Aleksandr Pyatigorsky, Shimon Markish,[15] Lev Gumilyev.[16] We discussed the structure of the series and its contents. Averintsev spoke about the necessity of introducing a separate volume on the Jewish diaspora, without which it would be hard to make sense of medieval history. Pyatigorsky put the case for an additional volume about the history of Buddhism. It was obvious that Sevastyanov was hearing words such as 'ethnos', 'diaspora', 'eschatology', for the first time in his life. After the meeting, he summoned Ovsyannikov and reprimanded him: 'Why didn't you lay on any brandy for such an exceptional gathering?'

Sevastyanov had previously been an instructor in the Party Central Committee and, following Khruschev's lead, fulminated against the Soviet intelligentsia. During the thaw he was transferred to the post of director of the Iskusstvo Press, which he ran in a relatively liberal manner, but when the thaw ended he sacked all the liberals from the publishing house and manoeuvred himself back into his post as a Central Committee instructor. Yura Ovsyannikov was among those who were sacked.

Ovsyannikov never told me the reasons for his dismissal from the publishing house. But his friend Boris Bernstein, one of our greatest art historians, writes in his memoirs, 'Ovsyannikov began to have problems: the story about the Bosch book became known. And then the benefactor himself lost his job.'[17] Ovsyannikov was not just my benefactor. He kept the wolf from the door for many renegades by giving them manuscripts to review, and clearly I was not the only one who published under a pseudonym with him. For some time he was unemployed, he sold off books from his library in order to eat and wrote books about Russian architecture and about the history of St Petersburg. Then the publishing house Soviet Artist took him on. And here he again showed his talent for publishing. He created the annual, *Soviet Art Studies* (*Sovetskoye iskusstvoznaniye*), the first edition of which came out in 1973. I was already in the West by then, but Bernstein writes that 'there was nothing else like it in Soviet publishing'.[18]

Ovsyannikov was a head taller than me, with a shock of grey hair and he had great personal charm and an inner nobility. Sometimes, after our meetings at my 'studio' on Little Lubyanka Street, we would set off to 'refuel' in some tavern. Once we were sitting in the Metropole bar. A beautiful young woman at the counter, already rather the worse for wear, got into an argument with the people next to her and began cursing the

Soviet authorities. The atmosphere became very heated. Ovsyannikov led her out of the bar, accompanied her home in a taxi and reappeared after half an hour.

After perestroika began, Ovsyannikov came to see us in Oxford and London, sometimes on his own, sometimes with his wife, the charming and clever Irina, and their son. I introduced him to my friend Andrew Nurnberg – the owner of a major literary agency in London – and at the end of the 80s, an extremely difficult time for Muscovites, Ovsyannikov was able to earn a living in Nurnberg's Moscow office. We remained firm friends until his death in 2001.

* * *

I knew Aleksandr Pyatigorsky for about 50 years. In Moscow we saw each other nearly every day, then our paths diverged. Can I really say that I knew him well? A philosopher and orientalist, he soared in the rarified atmosphere of Buddhist metaphysics and European rational philosophy which were a closed book to me; from such an elevated standpoint our everyday life evidently wasn't something he took very seriously. That is how I see him now and it is not easy to write about him.

After graduating from the philosophy faculty at Moscow State University, he joined the Institute of Oriental Studies where he worked in the office of George Roerich[19] whose disciple he considered himself. Pyatigorsky became a Buddhist scholar but for some reason also considered himself a Buddhist. At dinner, before knocking back a glass of vodka, he would dip his fingers in the glass and sprinkle those around him, pronouncing as he did so some clearly sacred Buddhist mantra – 'mahama ... mahama' – and something else we couldn't catch. I was not clear what his Buddhism consisted of, apart from this. For me, a consummate agnostic, all this was 'hokypoky' as James Joyce called it[20] but this didn't prevent us having a very warm friendship. He became a leading scholar of Buddhism. And not only of Buddhism. His mind worked with clockwork precision, and I was struck by his ability to write in any surroundings – in the kitchen, in a bar, at the dinner table, resting his paper on his knees. In collaboration with Yury Lotman,[21] Pyatigorsky developed semiotics – then a totally new field of study. I attended the first Semiotic Congress which was held in Moscow in 1961. I was not terribly interested in semiotics per se, but I was drawn to the unorthodox approach

to problems of scholarship, so far removed from Marxism, which was voiced by all the speakers at the conference. A group of orthodox thinkers appeared at the last session. They intended to deliver a riposte to the advocates of this idealistic bourgeois pseudo-science. The speech by their leader, Meylakh, was aggressive in content, boorish in tone and ended with a threat of the kind 'We'll discuss this further with you in another place.'[22] Whereupon Vyacheslav Ivanov[23] (Koma, as he was known to his friends), stood up, scarlet with rage and shouted in his squeaky voice which went up an octave with every phrase, 'As a semiotician I classify Meylakh's speech as that of a vile! political!! informer!!!' Pyatigorsky, who was chairing the session, reacted instantly. 'Objection! I request Vyacheslav Vsevolodovich to withdraw the word "vile".' Ivanov nodded his agreement and the orthodox group left the conference room in high dudgeon, indelibly branded as informers. As far as I know, the conversation 'in another place' never happened. At numerous supper parties, then so common in Moscow, Pyatigorsky entertained us with legends and tales from oriental folklore. I remember one particular legend about a wise old Buddhist which Pyatigorsky repeated on several occasions. When the old man's son was killed he said nothing. When his wife was raped he said nothing. And so on. Because for this sage, life's ups and downs were merely a little ripple on the illusory surface of existence in comparison with the transcendent Buddhist harmony in which he dwelt. The moral of such a story could be the occasion for serious reflection, but as time went on I began to suspect that in some way it defined Pyatigorsky's own behaviour.

Pyatigorsky did not participate in the dissident movement – I don't say this in a spirit of reproach. But when a famous Buddhist monk, Dandaron, was arrested he came to his defence. The authorities began making life difficult for him; his situation in Russia became very precarious. By then I was already in the West and helped him to emigrate. I arranged his visa and official invitation to England and helped secure his appointment to fill a teaching vacancy in the School of Oriental Studies at London University, where he continued to work right up until he retired. I organised temporary accommodation for him and his family. I had to go to quite a lot of trouble to do all this. But when he arrived in London in 1974 Pyatigorsky shook the dust of the past from his heels, as it were. In the émigré feuds, which were extremely unpleasant for us, his former friends, he took up a position of strict neutrality. Like that old man in the Buddhist parable, he said nothing when Sinyavsky was persecuted, or when his

former friends were branded as Russophobes. On the other hand, in his lectures and speeches, or when he appeared on television, he poured forth paradoxes, got irritated, shouted, preached at his opponents. His philosophical eccentricities attracted disciples to him. He gradually turned into a guru, a cult figure in his own way. I didn't like this and we rarely met during the last 20 years of his life.

* * *

Rostislav Klimov (Slava as he was known to friends) lived not far from Sretensky Boulevard, in the building of the former insurance company, Rossiya. He was two years above me in the Art History department at the university. A student of Boris Vipper, he was the star of his year and should have gone straight on to do a PhD, but the Party bosses within the university opposed this – he didn't do any community service, wasn't a member of the Komsomol, had no grounding in politics . . . From this time onwards until the end of his days Klimov worked as the chief academic editor at Iskusstvo. Slava had suffered from epilepsy since childhood and was under doctors' supervision. Medical treatment kept the illness in check. He only once had a fit in my presence – after the death of the doctor who had always looked after him. I then introduced him to Miron Etlis.[24] When Miron left for Magadan, he handed Slava's care over to Yura Freydin, one of the most gifted psychiatrists in Moscow, and apparently there were no more fits after that. Slavochka worked from home and only went to the office to get paid. This was permitted not just because of his illness. As academic editor he was irreplaceable. Iskusstvo's most prestigious books came out under his editorship: the six-volume *A General History of the Arts*, the four-volume *Monuments of World Art*, and many others.[25] He worked at night and slept during the day. I often dropped in on him after finishing work at the Pushkin Museum, around 7 or 8 pm. Slava found it very difficult to wake up. 'I feel ghastly in the mornings', he said.

But Klimov considered his life's work to be a project on the evolution of the whole of world art 'from the bison to the Barbizon'[26] and further. Sometimes we sat up all night and he would lay out his conception of the development; cycles, stages, phases, periods . . . charts, tables, diagrams. All in all, he worked at this project for almost 40 years. Slava worried about how slowly he was progressing. He was afraid that his ideas would be realised by someone else, somewhere else. I reassured him. His ideas were so

original and individual to him that it was impossible that anyone else – even if he were a genius – could think them up. I sincerely believed this.

I would not call Klimov a great scholar. He didn't derive his ideas from books. He looked and he thought. In the main he looked at reproductions. He wasn't able to see the originals in museums abroad. He was only able to go to the Netherlands with a group of art historians on one occasion and once, I think, to Italy. But he had such an eye, such an understanding of what he saw (not what he read!). Only he and Vipper had this ability, in my experience. Unfortunately he wrote very little. But his articles about Breugel, Raphael and Matisse were classical examples of deep critical analysis which were studied by the following generation of art historians. In his appearance, manners, and attitude to people there was something of the democratic aristocrat, evidently inherited from his forbears. It was entirely fitting that he kept an opera hat (a folding top hat) as a relic. He would occasionally wear it and then he resembled an English gentleman out of a Chesterton novel. Murochka Beker, whom he married when they were still students, was the illegitimate daughter of the Metropolitan of the reformed church in Vvedensk, but there was nothing pious about her. She worked as an editor at the Aurora Press and she and I produced that large format album of Cézanne's pictures from Soviet collections which I wrote about earlier. It was Murochka who kept the household going. The place teemed with youngsters, friends of their daughter, Masha. Slava was a kind of 'uncle' to them, and he accepted this form of address as his due. On holidays they held lively parties with drinking, dancing and, most important of all, conversation. Friends came – Valery Prokofiev, Zhenya Levitin, Rimma Sobko. Yury Zolotov came.

Zolotov had studied with Klimov at university and was a party (or Komsomol) activist there. He was actually one of the people who had blocked Klimov's path to a PhD. He himself had an academic career and became a professor, specialising in French art of the eighteenth century. When he was still working for his doctorate he gave his first lecture at our evening course. During the break he had the misfortune to come up and ask whether we were enjoying the lecture. 'No', said one of my very mature fellow students, who then turned his back and continued his interrupted conversation. I think that Zolotov was traumatised by this for the rest of his life.

At the Klimovs' parties Zolotov would meekly sit in a corner and Slava would dismantle his dull essays in soothing academic tones, and explain to

the author that he had no grasp of what he was writing about. Zolotov would despondently nod his head. Clearly, he understood that he was no match for Klimov's academic ability and he was sick at heart. Before I emigrated I went to say goodbye to Slava at Koktebel[27] where he spent every summer. 'I hope it all collapses, even if it falls on my head', he said then, referring to the regime, which kept forcing us to part with our friends forever (as we thought then). After perestroika I would see Klimov every time I went to Moscow. Year by year his situation became more and more dangerously unstable. After Murochka died Slava's life fell apart. He was helpless as far as everyday life was concerned and Rimma Sobko looked after him. When I was teaching at the university she was a student on my course, and I never came across a more talented student. After getting her doctorate she herself became a popular teacher in the Art History department. Rimma retyped and edited Klimov's manuscripts, kept his academic archive at her place, kept him supplied with books . . . we all thought that they would marry. But 'there's no fool like an old fool': Slava fell in love with someone else, married her and the marriage turned out to be an absolute disaster. The collapsing Soviet regime did indeed fall on his head. Thanks to the crazy inflation at the end of the 80s, his salary at the Press became almost symbolic. Slava was literally half-starving. Nevertheless, he did manage, on one occasion, to benefit from the abundance of perestroika. An architect of his acquaintance who had become a highly successful and wealthy interior designer asked him if he would be willing to give a course of lectures on art history to his wife. 'You know', he said, 'I love her very much but she's stupid and we have absolutely nothing to talk about.' Slava thought it over and then told me, 'Perhaps I can give her a crash course on my theory on the development of art.' It seems that with the fee he received Klimov was able to make one last visit to his beloved Koktebel.

In 2000 I heard that Slava was seriously ill and wanted to see me. I took a flight to Moscow. He was lying in a general ward of the Botkinsky hospital. He was like a skeleton. He recognised me but hardly showed any reaction and simply ate the food his daughter Masha brought him. He died the following day. He was being treated for double pneumonia but he died from cancer.

Sasha Kondratov lived in Leningrad and stayed with us when he came to Moscow. A graduate of the Lesgaft Institute of Physical Culture and Sport,

Leningrad, he became a journalist and popularised widely differing fields of scientific knowledge. He worked with Thor Heyerdahl[28] to decipher the script of the Easter Islands, he studied the language of the ancient Mayans with Y. V. Knorozov,[29] the problems of mathematics with Academician Kolmogorov[30]... I never met anyone with such a capacity for becoming instantly absorbed in any idea and then putting it down on paper. After a serious drinking bout, when no one else was capable of coherent speech, Kondratov could whisk the plates and leftovers off the table, set up his typewriter in the space he had cleared, and type his next article at breakneck speed. He published about 30 books, not to mention his numerous articles and publications about linguistics, cybernetics, ancient civilisations, biology, paleontology, mathematics, geology. We planned to write a book together about the development of twentieth-century European art from Marcel Duchamps to minimalism (under the title 'From Nought to Nought'), based on my concept of its development. His surrealist poems and stories appeared in *samizdat* and made a strong impression on me at the time. But in my opinion, his greatest achievement in the field of scholarship was the new science which he founded – udology. Contrary to Marr's theory,[31] Kondratov showed that at the root of Slav languages lay only one first element – UD.[32] This element became the root of all words with a positive meaning (sUD – *court*; pUD – *Russian measure of weight*; mUD(rets) – *wise man*; chUDo – *miracle*; UDa, UDochka – *fishing rod*; prUD – *pond*; xolU(o)D – *cold* (taking care of their 'ud' is the favourite activity of Slavs during the freezing winter months), blUD – *dish* (*in the sense of something tasty*) and so on). Kondratov backed his theory up with a dictionary of 200 words in the Russian language with this root. It would be a great pity if this hasn't survived.

For us Sasha Kondratov was a kind of networking agency. He put interesting people together. He introduced Ovsyannikov to Boba Brodsky, Knorozov to Pyatigorsky, it was he who first took me to the Klimovs (or the Klimovs to us – I can't remember which). He was the fourth permanent member of the group that met at my 'studio' on Little Lubyanka Street. I remember one of Kondratov's stories which went back to his time as a journalist, when he did an interview with Academician Eugen Varga[33] who related one extraordinary incident in his life.

Varga was the director of the Institute of World Economics and World Politics and was some kind of consultant to Stalin on these matters. In 1947 the storm clouds began to gather above him, as they did over

many others. The telephone stopped ringing, friends and colleagues avoided meeting him. And one fine day a major and a lieutenant from the KGB appeared at his apartment with an arrest warrant. Varga had a direct line to Stalin and he asked permission to make a call. Stalin himself picked up the receiver. 'Iosif Vissarionovich, they have come to arrest me', said Varga. Stalin said nothing for a moment and then ordered him to pass the receiver to the major. Varga only heard the major's end of the conversation.

'Yes, Comrade Stalin ... understood, Comrade Stalin ... exactly so, Comrade Stalin ... affirmative, Comrade Stalin ... No, Comrade Stalin ... I can't, Comrade Stalin ... the serial number of the revolver ...' and he gave the revolver and the receiver to the lieutenant. The conversation with the lieutenant went as follows: 'Affirmative, Comrade Stalin ... understood, Comrade Stalin ...' and he shot the major. The lieutenant summoned the driver, they took a carpet off the wall, rolled the major's body in it and departed. Clearly the poor devil of a major thought that he had no choice but to obey the orders of his immediate superior and paid for it with his life. Whether this story was fact or fiction, whether Varga invented it or Kondratov embellished it, I think it is worth preserving as a testament to that era.

I only know about Kondratov's later life from what his friends have said. He undertook an inventory of the oriental antiquities in the museum of atheism in the Kazan Cathedral, performed tricks based on yoga at the circus. Sasha died in 1993, before he was 60.

* * *

A sad individual called Sasha Morozov lived for a time in my 'studio'. Contemporary moralists would not have put him last in the long line of Moscow cranks. After graduating from the Classics department of the Faculty of Languages and Literature at Moscow State University, Morozov found a job in the aesthetics section at Iskusstvo. He was assigned to edit a volume called *Marx and Engels on Art* (*Marks i Engels ob iskusstve*) under the general editorship of M. A. Livshitz. Sasha grumbled, 'Of course I'm not a Marxist but we can't distort quotations from the classics.' (He read Marx in German.) A dispute arose and Morozov left the press. He did some part-time work at the Moscow Patriarchy, doing translations from ancient and modern languages but he could not get a permanent job in any Soviet establishment (nor, indeed, did he want to), but with his

university degree no one would take him on as a watchman, a janitor or a boiler man. Finally, through the combined efforts of his friends, he managed to get fixed up as a driver at a transport depot. Here Morozov also failed to observe the commonly accepted rules. He didn't fiddle his mileage, didn't sell off petrol, didn't grease the bosses' palms, and thereby earned the hatred of this flourishing collective. As time went by the drivers realised that they had a holy fool in their midst, and holy fools have been venerated in Rus from time immemorial. They began to help him and protect him from the bosses and invited him to go and drink a bottle or two with them. And then Morozov left the job. Why? 'I couldn't respond' (i.e. reciprocate their feelings), was Morozov's answer to this legitimate question. It was then that the homeless Morozov was installed in my 'studio'. For his own interest Morozov was making a study of Mandelstam. It was he who reconstructed the authentic text of the great poet's essay, 'Conversation about Dante' (using various surviving copies of the manuscript and oral accounts.[34] Together with Zhenya Levitin, Yura Freydin and Yura Levin he was a member of the commission for the archive and heritage of Mandelstam, under the direction of Nadezhda Mandelstam, the poet's widow. But here too his hypersensitive nature could not endure some instances of injustice and he broke with the commission.

The last time I saw Sasha Morozov was in the autumn of 1990 at the rally in Dzerzhinsky Square dedicated to the inauguration of a stone[35] brought from the Solovky Gulag.[36] This was only my second return visit to Moscow after a 16-year break. The square was literally filled to overflowing. Around the large boulder, next to the bronze statue of Dzerzhinsky,[37] the founder of the concentration camps and the secret police, a platform had been erected. Former Solovky inmates and the leaders of perestroika delivered speeches from this platform, condemning the bloody regime of the Soviet Communist Party and the KGB. The daylight was going and as it grew darker lights came on in the building opposite. By the end of the rally the whole enormous KGB building blazed with lights like a Christmas tree. Regardless of the wave of anger, the KGB continued to work. This was even then seen as a sinister symbol of the times. Sasha Morozov appeared on the platform. He read poems by Mandelstam and wept.

* * *

And there were acquaintanceships, encounters, sometimes fleeting, sometimes lasting several years, which have left traces on my life. They too are knocking inside my head and asking to be put down on paper.

Towards the end of the 1950s, Andrey Volkonsky and his ensemble gave a concert of baroque music in the French room at the Pushkin Museum. I think that was our first meeting, although our close friendship began much later.

I don't know what attracted this scion of Rurik[38] and leading musician to my humble personage. It must have been my receptiveness to music.

I became passionate about music as a seven-year-old, when I heard Grieg's 'Dance of the Gnomes' on the radio. After that a long break interrupted my enthusiasm. Our endless moves around Moscow did not allow for music, at Kolyma radio broadcasts were banned, and the only sounds which emerged from the black gramophone records of those days were Soviet songs and folk music from the peoples of the USSR. When I came back to Moscow at the age of 14 my passion re-ignited with new force. I began going to concerts at the Conservatoire and attending Professor Zukkerman's classes there, which were intended for people like me, uneducated music-lovers. He explained to us the meaning of musical terms, analysed sonata form and illustrated it with excerpts from the great composers which he played on the piano. It was marvellous! Mama was working in a polyclinic for old Bolsheviks in Staropansky Passage where local heroes of the revolution who had lived through the Terror could get treatment. One of her patients worked as an usherette in the gods at the Bolshoy Theatre and let me in without a ticket. We stood and queued all night to get tickets for concerts by foreign musicians on tour – Willy Ferrero, Leonard Bernstein, Isaac Stern. When we couldn't get tickets or didn't have money to buy them, I forged them. A lucky ticket holder was admitted, then handed their slightly torn ticket back to me across the barrier; I stuck it together on the underside with transparent stamp glue, gave it to the following person, and so on, several times over. I loved music as one can love a woman – without understanding anything about her.

Volkonsky was a brilliant composer, harpsichord player and the founder of 'Madrigal' – the first ensemble of early European music in Russia. He also had a quality which is rather unusual in professional musicians: he had a passion for making music accessible to amateurs like me, and he enjoyed sharing the experience of listening to music with us. This was what drew us together in the first place.

I remember his sparsely furnished room, which contained nothing but shelves of books and records. It was here that, late into the night, he would play me recordings of Mahler, Schoenberg, Shostakovich, and explain the principles of atonal music. We listened and drank vodka. Once Volkonsky took me to see a friend of his, a blind musician (I don't remember his name) who had, according to Volkonsky, the biggest collection of recordings of twentieth-century composers in Moscow. And again – Schoenberg, Poulenc ... this was how I discovered modern music. Volkonsky had come from France with his parents after World War II and he introduced a European breath of freedom and liberation into our musty Soviet atmosphere. His genuine, instinctive, democratically aristocratic style was attractive to many people. He had absolutely no class or national prejudices. He was equally at home with bohemian Moscow, with the intellectual elite, with high-placed Soviet officials, with drunkards. He once told me that he was surprised by the respectful attitude of the Party high-ups towards him. And in fact they didn't harass him in the way they did many other modernists in the fields of music and fine art. In 1964 his famous *Mirrors Suite* was performed to a packed audience in the small hall at the Moscow Conservatoire and 'Madrigal' toured the cities of the Soviet Union. It wasn't the case, of course, that the authorities had changed their attitude to contemporary music. The party high-ups, with their celebrated 'class sensitivity', had already sensed the wind of coming ideological changes: it was not so much the common people as the nobility, the aristocracy, who were the pillars of the greatness of Holy Russia.

When Volkonsky decided to emigrate at the beginning of the 70s, I introduced him to some of my former women students who were planning to go to Israel, and who were willing to enter into a paper marriage to get an unhappy goy out of the land of Victorious Socialism. Volkonsky took advantage of one of these opportunities. He could not bear any snobbery about one's origins or bloodline. One event which happened after he emigrated illustrates his character better than anything else.

This happened in the early 1980s, when Sinyavsky started to be persecuted by various émigré factions as a Russophobe and a Jew (?!). A certain Madame Rozhkovskaya sent a letter to the editors of *Sintaksis*, the periodical published in Paris by the Sinyavskys. The letter branded various Sinyavskys, Amalrikovs, Paustovskys and other representatives of their nation as enslavers of the Russian people. Volkonsky in turn sent a reply to her letter to *Sintaksis*. I reproduce it in full.

Madame Rozhkovskaya!

Your letter to the editors of Sintaksis caught me off-guard. It obliges me, a direct descendant of Rurik to the thirtieth generation, to reveal a great family secret: Rurik was not a Varangian at all, he was just an ordinary yid. That's how long ago we started to enslave you, the Russian people!

I acknowledge that some of our people, Ivan the Terrible, for instance, were particularly successful at this.

After your brilliant revelations it makes no sense for me to remain in the cellar with all those Sinyavskys and Amalriks. Now that I've been unmasked it will be easier for me to continue my forefathers' work, simultaneously corrupting both the Russian and the French people. I consider it an honour to be in the same company as that young Jewish ignoramus, Brodsky. Although to be honest, I don't know if I deserve to. He's done a seven-year stretch, and I haven't.

Prince Andrey Volkonsky

My memoir seems to be turning into a sort of catalogue of martyrs. Most of those I am writing about are no longer alive.

* * *

Perhaps I ought to get back to the tale of the life and extraordinary adventures of my friend Miron Etlis.[39]

In 1956 Etlis returned from the camps. While he was still at medical school in Ryazan he had married a simple, uneducated woman, Shura, who worked in a kindergarten for children with learning difficulties. While Miron was serving his sentence, Shura moved to Moscow under the quota system,[40] worked as a plasterer on building sites and got lodgings somewhere on the outskirts. She used to come and see us but when the rehabilitation era began[41] she went to Kazakhstan to the Karaganda camp, found work as a waitress in the officers' mess and contrived to get Miron's name moved from somewhere near the bottom to the top of the list of candidates for release (prisoners were rehabilitated in alphabetical order).[42] Miron was in fact not rehabilitated but released under the amnesty.[43] The case accusing him of 'planning the assassination of Malenkov' was still hanging over him. His situation in Moscow was illegal – he had no papers, no work, no means of survival. But the story continued to unfold as if fate had scripted it especially for him. When he read in the newspaper the resolution of the Central Committee of June 1957 on the Anti-Party group of Kaganovich, Molotov, Malenkov and additionally Shepilov,[44] Miron

rushed off to the KGB headquarters at Dzerzhinsky Square and wrote a declaration on a page of luxury Whatman writing paper, the gist of which was, 'Why did you bang me up, you scum!' Within a day this document had gone through every department and a decision was taken to rehabilitate him (as if they thought that an assassination attempt on a subject who was subsequently convicted of a crime absolved the would-be assassin!). Miron then began working as a duty psychiatrist for Moscow city. In the evenings he often came to visit us on Petrovksky Boulevard and told us stories from his medical practice: about the time he was called to the Vagankovo Cemetery[45] to treat a woman who had gone there with a spade and started to dig up her husband's grave (he had appeared to her in a dream and asked her to bring him a few things which he needed for his life in the hereafter). Her documents identified her as a lecturer at the Society for the Promulgation of Political and Scientific Knowledge and the subject of her lectures was sleep and dreams. On another occasion he was called to the Kazan Railway Station where an Uzbek man was simply sitting and refusing to answer any questions. He was taken off to a psychiatric ward where he remained silent, until Miron had the idea of bringing a Tatar caretaker to see him. When the Uzbek heard someone speaking a language he understood he burst into tears and started to talk. He was a peasant from a remote mountain village in the Caucasus and he had decided to come and visit Moscow for the first time in his life. But when he fetched up in the hurly-burly of the station he thought that he had landed in hell and decided that he wouldn't speak, come what may. Money was collected to send him back home. Another time Miron was called to the Skryabin Museum where the deputy director was in the habit of holding nocturnal sexual-mystical gatherings with his female staff, apparently following the instructions of the great composer.[46] The fellow, who was as strong as an ox, greeted Miron with a knife. Miron told us about the time he saved the life of a female student who was standing on a ledge on the tenth floor of the new Moscow State University building talking to the stars and planning to fly up to join them. Miron climbed out of the adjacent window, casually made his way along the ledge and pushed the girl back inside. Dr Etlis's heroic feat even got into the newspapers.

As well as working as a duty psychiatrist, Miron took part in all sorts of commissions, consultations, examinations of patients in clinics. We once calculated his working hours – they amounted to 25 hours in a 24-hour day! The fact was that Miron made his diagnoses in record time. I once sat

in on one of his consultations. A factory nurse brought in a youth who had just tried to hang himself. The lad was like a zombie and showed no reaction to what was going on. Miron asked him something that I couldn't make head or tail of, and suddenly the patient came to his senses, began to speak and Miron immediately arranged for him to be admitted to a psychiatric hospital. When I asked what was the matter with him Miron answered that he had sexual problems with his wife. All this took no longer than five minutes.

Practical psychiatry could not entirely fulfill the intellectual needs of someone aspiring to scientific research work. But during Miron's time inside, science had made enormous advances. While he was still a student in Ryazan he had been working on what, at that time, he called the science of classification. This had now obtained official status as cybernetics (a term which had formerly been rejected). And Miron realised that he had been hopelessly left behind. He sought consolation with women, as the saying goes. This sort of thing could happen to anybody, but Miron kept a diary – the Russian intelligentsia were inveterate diary writers, even in the Stalinist era – and his wife Shura read this diary. One day she lay in wait for me at the doors of the Lenin Library and created a terrible scene. She shouted that she was going to kill 'that waster' and me as well. For some reason she considered me as an accomplice to his romantic escapades. It all ended in tragedy. One fine summer evening, after Miron had arrived home and gone to bed, Shura burst in with a razor and slashed his chest three times. Miron managed to get to his feet, go downstairs to the neighbours and call an ambulance, before he passed out. At the trial he blamed himself and Shura was given a suspended sentence. Miron could no longer remain in Moscow. I advised him to go to Kolyma. The region had been very little studied and offered many possibilities for scientific research. Ever since then Miron has lived in Magadan. Not long ago I received a bibliographical index of the works of Miron Markovich Etlis, published in Magadan to mark his 80th birthday. What hasn't Miron worked on in these past 50 years! He was one of the founders of the Institute for the study of Biological Problems in the North, he worked on education, on architectural planning in northern conditions and on curing alcoholism by adding a chemical to vodka. After this, vodka consumption in the north went down by a third (this project remains the experiment of the twentieth century in the study of addiction). He was the chairman of the Magadan branch of the Memorial Society;[47] he helped the sculptor Ernst Neizvestny

erect local memorials to the victims of the Soviet regime;[48] he published hundreds of articles, essays and papers on a huge range of subjects ... notwithstanding all this I don't know whether he ever got his PhD.

Shura still came to see us on Petrovsky Boulevard, full of rage and indignation. We would try to calm her down: 'Shura, dear, have a drop of vodka and some pickled cabbage.' But she continued to fume: 'I swear I'll kill him, the filthy dog' then in the next breath, 'I've sent him warm underpants so he won't freeze to death like a dog.' Yes, there are still women in Russian villages![49]

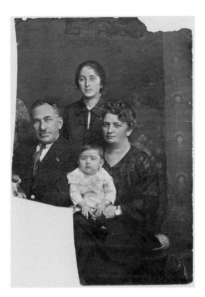

Plate 1 My grandfather Samuil Golomstock, my mother Mary, my grandfather's sister Lina Nevler and me, 1929. The left side of the photograph, where my father must have been standing, has been cut off. In those days, people habitually excised their arrested relatives from family photographs.

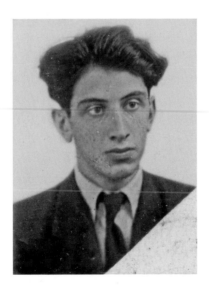

Plate 2 In the summer of 1943 we arrived in starving Moscow and in 1946 I became a student at the Financial Institute.

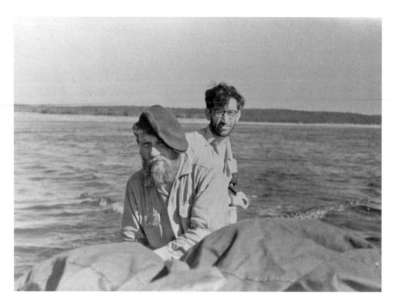

Plate 3 I travelled in the far north of Russia with the Sinyavskys. With Andrey on the river Mezen.

Plate 4 I was captivated by the way these local people lived, with their traditional, steady way of life, their enduring moral foundations, their readiness to help kith and kin.

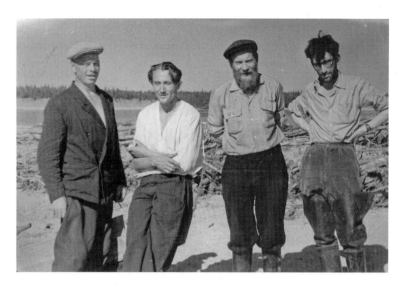

Plate 5 With Sinyavsky and local inhabitants on one of those trips.

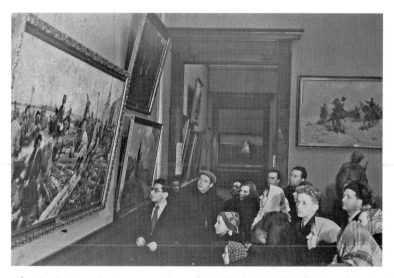

Plate 6 Explaining Soviet art to the public. Travelling Exhibition of Soviet Art, Chita, 1954.

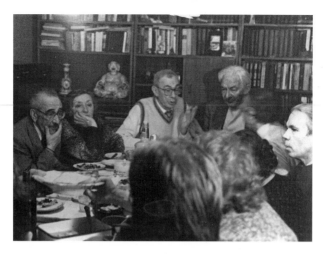

Plate 7 Friends gathered on Thursdays in my 'studio'. We drank, discussed matters of art history, history and politics and, since then, alas, I have never taken part in such high-powered intellectual discussions! Pictured here at a reunion in the 1980s from left to right: me, Villya Khaslavskaya, Slava Klimov, Yury Ovsyannikov, Gleb Pospelov.

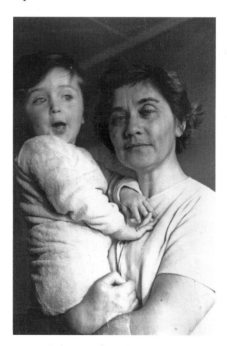

Plate 8 Nina Kazarovets-Golomstock with our son Benjamin. 1968.

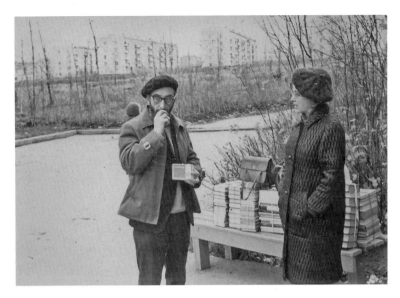

Plate 9 Waiting Game. With Rozanova outside our flat at Molodezhnaya shortly before Nina and I emigrated. 1972.

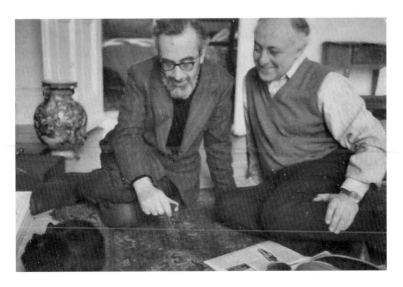

Plate 10 My university friend Alik Dolberg collected money for us.

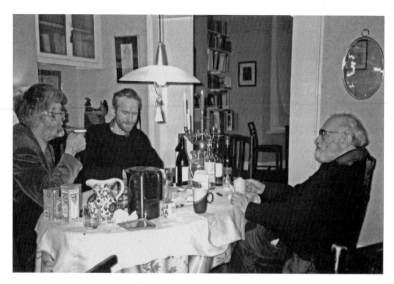

Plate 11 With Robert Chandler, the translator of Shalamov and Platonov (centre) and Francis Greene (left). We lived in Francis's London flat for two years.

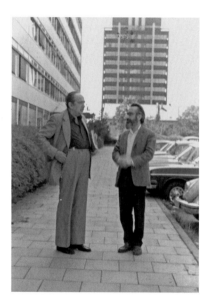

Plate 12 Galich invited me to work at Liberty not only during the summer holidays but also in the winter, both for company and to give me an opportunity to make some money. Munich, 1970s.

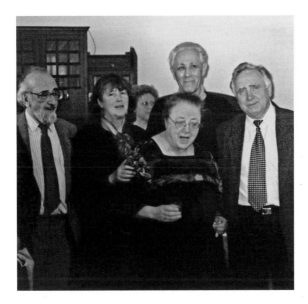

Plate 13 At the launch of my book, *The Camp Drawings of Boris Sveshnikov*, with close friends Flora Goldstein, Maya Rozanova, Yuri Gerchuk, Lev Golomstock. Moscow 2000.

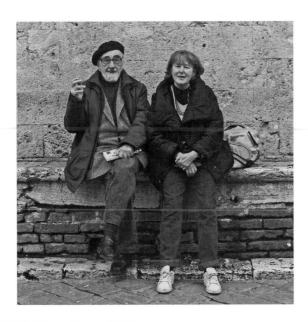

Plate 14 With Flora, Genoa, 2000.

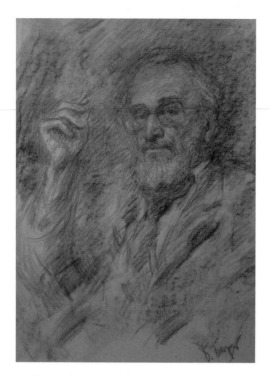

Plate 15 Portrait of Igor Golomstock by Boris Birger.

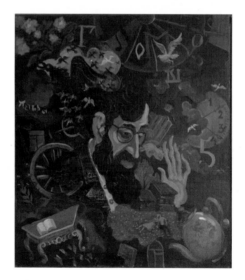

Plate 16 Portrait of Igor Golomstock by Aleksandr Petrov.

CHAPTER 15

Questions of Faith

In the 1960s young people began turning to the church in droves. Solzhenitsyn proclaimed that this was the spiritual regeneration of Russia. During my years of teaching I had plenty of opportunities to observe the newly converted. Many of them crossed themselves simply as a form of dissidence, protesting with this very gesture against the politics of an atheist state. Some picked up the scent of Orthodox Russophilia[1] which, three decades later, would define the official ideology of Putin's Russia. These neophytes hardly put their baptism to good use. Ignorant about matters of faith, they immediately began preaching the kind of ideas which would have sickened a true Christian. And there were a few, of course, who found faith at their heart's prompting, or observed it because of family tradition. Andrey and Lydia Menshutin, old friends of Sinyavsky who had become my friends as well, had been brought up as believers. They sincerely believed in Christian salvation, and out of the goodness of their hearts they tried to share this blessing with their friends, including myself, through the act of baptism. Once they took me to see Father Dmitry Dudko who lived not far from them, near the Shchelkovskaya metro. It was the priest's birthday and a large crowd — for the most part newly converted young people — thronged the spacious entrance hall. It so happened that I was standing near the closed door to the dining room. When we were invited to the table I was the first to go in; I moved forward and found myself standing right in front of the iconostasis. Suddenly everybody fell to their knees, fastened their gaze on the iconostasis, i.e. on me, and began to sing some sort of hymn. As a non-believer I could not kneel down and so I stood like an idiot, with bowed head. I don't think I have ever been more embarrassed in my life. Several times we left the table to go

and smoke in the stairwell, and I talked to the new converts. They seemed to me to be a thoroughly dubious bunch.[2]

* * *

Somewhere around the beginning of the 60s my young friends took me to the village of Semkhoz, about 40 miles from Moscow, where Father Aleksandr Men had his parish and from then onwards I used to go and visit him. Father Aleksandr let me read his then unpublished manuscripts – one about the books of the minor and major prophets[3] in the Bible and one about the history of the Old Testament.[4] I was struck by the brilliance of their literary language and by his vivid reconstruction of the landscape of Ancient Judea, the background to the events described in the Bible. But, most of all, I was struck by the idea – new to me – that there was no justification for the rupture between Judaism and Christianity. Father Aleksandr considered this rupture an annoying historical error. At the beginning of the 60s (as he told me) he was planning to go to Israel to preach Judaeo-Christianity; after some years he came to the conclusion that the time for this was not yet ripe.

I was not religious by upbringing, but my work as an art historian meant that I had to take questions of faith seriously. I responded to Father Aleksandr's ecumenicism in a heartfelt way. Maybe the genes of my forbears – secular Jews and Karaite rabbis – had something to do with this. Perhaps the Bible itself, which I read quite early in life, also played a role. In the Old Testament what attracted me was not the idea of God made man in the form of Christ, but the idea of God the Creator, without face or form, prescribing the rules of conduct for his people without giving rational explanations about why these rules must be observed. Why was it forbidden to mix milk and meat, why was it only permissible to eat the meat of animals with cloven hoofs,[5] what was the point of circumcision? But it is not your business to understand; do as you are bidden, otherwise – retribution will follow. (This is exactly the manner in which I, for the first – and probably the last – time, spanked my son Benjamin, when, as a one-year-old, he tried to put his little fingers in an electric socket. For how could I have explained the nature of electricity to him, even if I had understood it myself?) But even if you are rewarded for good behaviour in this life, you still don't know what will happen in the afterlife. The set phrase for death is: 'and he joined his own people'.[6] No more, no less.

I found rather obscure mentions of heaven and hell only in the later prophets. If God exists, I decided, then his relations with mankind must be like those of a wise elder with a foolish infant. And I began to feel like a sort of Judaeo-agnostic, if such a category exists.

At home Father Aleksandr was like a hospitable man of the world. We talked about everything under the sun; I mainly listened, he talked and told me a lot about himself.

His father was an orthodox Jew, his mother belonged to the orthodox catacomb church[7] and they brought him up in both denominations. He told me that he had experienced two miracles in his life, as a result of which he became a priest. While he was studying at the Moscow Fur Institute he also attended church, for which he was duly punished (I think he was expelled from the Institute). He left Moscow, entered the Irkutsk Agricultural Institute but was again expelled for his religious beliefs. And after that, predictably enough, he was called up for military service. Aleksandr Men presented himself and quite openly, as if making his confession, explained his situation to the military commissar. And this typical military bureaucrat thought it over and unexpectedly advised Men to leave Irkutsk immediately, and said that as far as his next call up papers were concerned, he himself would get them postponed. This was the first miracle. When he arrived back in Moscow Men went to some member of the clergy (I don't remember his name or his status), and asked to be admitted to a seminary. They talked for a whole night. In the morning the priest said that with all the knowledge he already had, Men didn't need to go to a seminary and that he was ready to ordain him there and then. Which he duly did. Father Aleksandr counted this as the second miracle.

In the course of our conversations I asked Father Aleksandr: how could he baptise people who were clearly not ready to lead a religious life. 'I cannot refuse baptism', he replied (I am quoting him from memory), 'but I don't have time to set them on a moral path ... as far as the church inspectors are concerned, when they come to check on the legality of a baptism, I simply put vodka on the table and they leave with bottles of brandy in their pockets.'

Men's ecumenicism was considered a heresy by the Orthodox church, and heretics, not just in the religious sense, but also in the spheres of ideology and politics, are considered by the pillars of orthodoxy to be more of a threat than outright opponents. Recently I read in the newspaper that Father Aleksandr's books had been burnt in the courtyard of some Moscow

monastery. And I have no doubt about who was behind the incident on 9 September 1990, when an attacker smashed Father Aleksandr's head in with an axe. The killer has never been found.[8]

* * *

Aleksandr Men never tried to convert me to any faith, unlike some of my well-wishers, including the Menshutins. I never succumbed but their missionary zeal did bear fruit. Sinyavsky was baptised in the early 1960s. I was surprised. Why Christianity, why the Orthodox church? Andrey replied that had he been a Jew or a Turk, he would have embraced Judaism or Islam; for him faith was a matter of tradition, the wish to 'join one's own people', so to speak, a matter of deep internal conviction, with no need to attend church services. I never once saw him cross himself or say any prayer; I don't think he went to church often in Moscow, if ever. Was Sinyavsky religious by nature? He had been brought up with a neutral attitude towards matters of faith. But if one takes this expression to mean not going to church services, but some sort of moral imperative, then yes. His whole life, his years in the camps, his years as an émigré all bear witness to that.

The Menshutins also played a role in the baptism of Stalin's daughter, Svetlana Alliluyeva. She had a job at the Gorky Institute of World Literature where Menshutin and Sinyavsky also worked. After Khruschev's denunciation of Stalin her colleagues began to avoid her. Once, in the Institute's cloakroom, Sinyavsky, who was innately courteous, handed her her coat. She burst into tears. From then onwards they began to see a bit of each other. I met Svetlana once at the Menshutins. She wanted me to give art history lessons to her son Osya. While we were having dinner she exuded such powerful waves of gloom that it gave me the creeps. Maybe it was an aberration on my part but I couldn't help seeing the ghost of her father rising up behind her. I turned down the job, pleading that I wasn't qualified for it.

CHAPTER 16

A Waiting Game

I had wanted to leave my country for as long as I could remember. In the middle of the 1960s a trickle of emigrants reached Israel, but I couldn't join it because, in the first place, I was afraid that my departure would cause more problems for Sinyavsky and, secondly, I wanted to be there when he was released from the camps.[1] So I had no choice but to wait. At the end of 1968 my mother died of leukaemia. I had run from one doctor to another, tried to get hold of various drugs from abroad that were impossible to obtain at home. At the funeral I got thoroughly drunk and in the presence of my stepfather's colleagues – Party economists – I abused the Soviet authorities with all my heart. Although what had the Soviet authorities to do with it? During my adult life I had not had much contact with my mother. Until the very day before she was admitted to hospital, Mama had worked one-and-a-half or two shifts at her clinic and then treated her friends, relations, acquaintances, neighbours. She wouldn't take money from them but sometimes a box of sweets would appear in the apartment and on the dresser there was a white china bear with an inscription in gold: 'To Dr Mary Samuilovna Golomstock from her grateful patients.' I was busy about my own affairs and rarely made an appearance at my great-aunt's apartment. Mama didn't try and impose her own values on me. Naturally she feared for me and simply tried her best to put me on the right path from which I constantly strayed. She didn't understand my quirky intellectual enthusiasms. I was often rather prickly with her. When I became passionate about music and hoped to get a new record for my birthday, she gave me a shirt. When I grew a beard (or, more accurately, stopped shaving), she presented me with an electric razor.

The year after my mother's death Nina gave birth to our son. We had only decided to have a child after making an irrevocable decision to leave

the country. For I couldn't take on the responsibility of bringing up our son in the conditions which prevailed in the land of Victorious Socialism. What could we teach him there? Should we make him anti-Soviet, thereby putting his name down for a stretch in prison, or tell him lies and close his eyes to reality, as many parents did with their children at that time?

They say that as the child develops in the mother's womb it is very influenced by what the mother-to-be sees around her. During Nina's pregnancy I was writing my book about Hieronymus Bosch and the apartment was strewn with reproductions of the paintings of this great seer: fantastic monsters, grotesque beasts, sinners undergoing hellish torments. Perhaps this explains Benjamin's taste for horror, fantasy and thrillers on television, in movies and in books, which he developed in early childhood.

I made ends meet in those years by doing book reports for publishers, by receiving advances for contracts agreed with third parties on my behalf, and by publishing articles under other people's names. Until one day, at some conference or other, Irina Antonova came and asked me if I would like to return to the museum. I don't think she made this proposal on her own initiative. Clearly, somewhere higher up they had decided to fix things up for their brother. Otherwise, they must have reasoned, a dissident like him will sit at home pounding away on his typewriter and what, one wonders, will he come out with? It was cheaper and easier to have a collective enterprise keep an eye on him, than to put a tail on him and bug his flat. So it was that in 1968 I started work again in the Western Art department at the Pushkin Museum of Fine Arts.

There had been few changes during my five-year absence. The new deputy research director (appointed after the death of Boris Vipper), I. A. Danilova, was a respected expert on the Italian Renaissance and she attracted leading scholars to our lectures and conferences. Averintsev, Mikhaylov,[2] Gurevich,[3] Gasparov[4] and Etkind all gave brilliant papers ... we also broadened our exhibitions policy and made useful contacts with museums abroad. But the omnishambles characteristic of the USSR at that time even spread to our modest activities at the museum. In 1970 we were to put on a major exhibition of Van Gogh paintings from Dutch collections – the first international collaboration between the Netherlands and the USSR. I had to go and take delivery of the paintings when they arrived at the airport. Strictly speaking, all I had to do was sign the papers to say we had received the paintings and accompany the cargo to the museum. All the rest – the

loading, the transport, the unloading – as is usual in such cases – was to be carried out by the Directorate of Art Exhibitions and Panoramas of the Ministry of Culture of the USSR.

On the morning in question, Mr Hannema, the cultural attaché from the Dutch embassy, came to the museum. He was a very charming and cultured man. We set off for Sheremetyevo airport in his car, and on the way we enjoyed high-flown discussions about art, in particular about Bosch (there was a Bosch exhibition going on in Amsterdam). At three o'clock sharp, as per schedule, a specially charted aircraft carrying the Van Gogh paintings landed. A police vehicle with flashing lights, which had been assigned to escort the cargo, drove up to the plane. An hour went by, then another and there was no sign of the car bringing the workmen from the Ministry of Culture. A bus with passengers for the return flight drove up to the aircraft; the pilot grew exasperated and said that he would now have to fly back to Amsterdam with the cargo still on board. I rushed round the airport in search of workmen and vehicles, and finally clinched a deal on a beaten-up 30 hundred-weight lorry which I directed to drive up to the plane. It was March, there was slush everywhere, and I, with the help of the director of the Dutch museum, Mr Kröller-Müller, who had flown from Holland with the paintings, dragged the crates of canvases through the melting snow and puddles and then loaded them onto the lorry to transport them to an airport warehouse. At last a man from the ministry appeared with one tipsy workman in tow. They had no transport with them. I kept ringing Antonova. She kept ringing the Ministry and embassy limousines and ministerial Volgas began to turn up. I cannot imagine how all this would have ended, were it not for the manager (or director) of the Amsterdam airline – a shrewdly practical Dutchman – who providentially turned up and pointed out to us an unloaded postal van which was parked nearby. 'Where to?' asked the van driver. 'Follow the police car.' The lad's jaw dropped. The ensuing sight was worthy of the brush of Van Gogh himself:

The police car with its red light flashing headed the convoy, a cavalcade of embassy cars brought up the rear and in the middle was the postal van, driven by someone with no idea where he was going, while inside the van I braced my back against the side and used my feet to stop the crates of paintings being jolted about.

It was nearly 10 pm by the time we reached the museum. Ministry and museum officials were lined up at the entrance. 'You've got to be joking', said the drunken workman, 'if you think I'm going to drag all this stuff

upstairs ... to hell with you all.' The officials modestly lowered their gaze. So my old friend and museum colleague, Leonovich, the Dutch museum director, Kröller-Müller, and I lugged all the crates up the grand staircase. The driver of the postal van was scared out of his wits and refused point-blank to take any money.

As well as my normal duties, I fulfilled two other roles at the museum. On the one hand I was in charge of the funeral team – i.e. I accompanied our old colleagues on their last journey – and on the other hand I was responsible for organising the museum's entertainments. When a conference organiser, after announcing the names of the participants, proclaimed 'Director of Entertainments – Golomstock!' this, for some reason, never failed to provoke guffaws of mirth from the audience. This is as far as I got in my managerial career.

* * *

Yuly Daniel's term of imprisonment in the camps was due to finish in 1970 and we waited impatiently for his release. At that point I suddenly started getting summonses from the military enlistment office. As a second lieutenant in financial services (my rank when I had left the bank), I was instructed to report for a six-month (or three-month?) officer training course. The first thought that struck me was that they simply wanted to remove me from Moscow as a precautionary measure, because Daniel was due to return there. I ignored these summonses until I was caught at work and served with a notification which I had to sign for. I then had to report to the enlistment office.

I didn't find any of the usual signs of the military training camps to which hundreds of people are routinely called up. An officer with pale blue epaulettes was sitting behind a desk in empty premises. I explained to him that my son had just been born, that my wife didn't work and that I was the only breadwinner and added that I had had nothing whatsoever to do with finance for the last 20 years. He merely gave me a fish-eyed stare but finally said that I must appear the following day before the chief military commissar in Moscow.

I duly presented myself and produced the same arguments to a colonel. Upon which I received a stern warning. If I did not report at 1000 hours the following day, with my kit, at the training camp, I would be handed over to the courts and I would get seven years in the camps (he was exaggerating) for evasion of military service.

I hesitated for a whole day. To be honest, I was afraid. I had left the world of finance 20 years earlier (and even before that I had understood precious little about it); if I were sent to a military unit I was capable of muddling their finances to such an extent that I would be guaranteed to end up in the camps. I decided not to turn up and began, yet again, to make preparations for my arrest. On her own initiative and against my wishes, Nina managed to obtain a meeting with the military commissar, at which she got the same answer. Friends took me to the lawyer Kasparov at the college of lawyers. He had been due to defend Daniel at his trial but was denied access to him by the KGB. Having listened to my story, he said that this was all nonsense, that I had a legal basis for asking for a postponement of my military training and that he would defend me. But when he heard my surname the lawyer shrugged helplessly. The KGB was clearly behind the whole business and so there was nothing he could do to help me. The story ended in a most unexpected and rather fantastic way.

My old friend from VNIITE, Galya Demosfenova was a close friend of Igor Sats, who worked at *Novy Mir*, and she told him my troubles. Sats was at that time helping some important marshal, an elderly veteran – probably one of Zhukov's aides during the war – to write his memoirs. Having heard my story from Sats, the marshal was indignant. Either he had his own scores to settle with the KGB – as often happened between the army and the secret police – or maybe he simply had time on his hands, but he arrayed himself in his full marshal's uniform, pinned on his decorations and medals which reached right down to his navel, got in his car and drove over to see the military commissar. I don't know what was said, and I am not going to try and explain the underlying cause of this incident and why it ended the way it did. In any case, the enlistment office didn't trouble me anymore.

* * *

Sinyavsky's release date was approaching. I believe that his stay in the camps had imposed a heavy burden on the KGB. The Sinyavsky-Daniel trial, conceived as a crackdown and deterrent to the liberal intelligentsia, had been a failure. Protests inside the country had been ongoing, Soviet delegations abroad continued to be obstructed; some agents found that their penetration into the consumerist paradise of the West became difficult. The head of the KGB, Semichastny was dismissed and Andropov,

a more pragmatic and carefully calculating man, was appointed as head of the secret police.

Rozanova wrote impudent (as I saw it) letters and declarations to the authorities, demanding Sinyavsky's release. I tore my hair and shouted that such tactics would ensure Sinyavsky never got out. But clearly Rozanova understood better than I did how to deal with the brute force of an iron grip that was already losing its strength. The authorities were ready to compromise. But then everything came to a standstill due to the position taken by Andrey himself. In the first place, Sinyavsky refused to enter into any discussions whatsoever, as long as Daniel was still imprisoned, but the KGB were settling scores on account of Daniel's provocative behaviour in the camp. In the second place, he, Sinyavsky, would have to request early release, a so-called pardon, which entailed acknowledging one's guilt and repenting one's sins. This was a step Andrey could not take. He was released six months early, after serving six and a half years in very difficult conditions.

Andrey reappeared in Moscow in June 1971. He was gaunt and seemed to have shrunk and his squint and his bushy beard made him look like an old, shabby gnome. The family rented a small house at Dinkovo on the outskirts of Moscow. Sinyavsky polished the texts which he had sent his wife in letters from the camp. The books *A Voice from the Chorus, Strolls with Pushkin* and *In Gogol's Shadow* emerged from these texts. Rozanova designed her rings and brooches and was the breadwinner. Seven-year-old Yegor started school and already showed evidence of his father's genes. He began writing stories. Sinyavsky did not see many people. Only close friends went to Dinkovo, drank vodka, discussed *samizdat* news and shared opinions about books, films and exhibitions. At that time all editions of Solzhenitsyn's *One Day in the Life of Ivan Denisovich* were being surreptitiously withdrawn from public libraries. I remember Sinyavsky's opinion about that book which went more or less like this: It's his masterpiece, he'll never write a better book, because he is only capable of describing what he sees; he lacks a creative imagination. I think that this is where the 'stylistic divergence' between Sinyavsky and Solzhenitsyn had its origins.

Sinyavsky's situation in Moscow remained precarious. He could not get any teaching or research work and he was banned from publishing any of his literary works in Russia. I tried to persuade the Sinyavskys to emigrate, but they hesitated: what was a Russian writer to do in a foreign country,

without a close circle of friends, without language, without a familiar way of life to serve as the pivotal material for literature?

Once Andrey had been released there was nothing to hold us back: in May 1972 Nina and I gave notice to the visa and registration department that we intended to emigrate to Israel. At the museum I went to Antonova and told her that I was going to emigrate. I said that since I didn't want to make things awkward for the museum I was handing in my notice. Antonova made an angry speech while pointing at the ceiling of her office. Then we went outside and wandered around the museum building for a long time. She asked only one thing of me: not to denigrate the museum. I think she meant that she didn't want me to spread information in the West about the museum's secret store of artistic treasures which had been looted from German collections during the war. I promised, and I kept my word.

In the course of her official duties Irina Antonova caused me endless problems; nevertheless, I have a lot of respect her. She not only kept the museum going, she significantly broadened its remit, turning it into a real cultural centre in the capital. Whenever I returned to Moscow on visits, after emigrating, we always met like fond relations.

CHAPTER 17

Departure: An Obstacle Race

Farewell forever, unwashed Russia!
O land of slaves, of masters cruel!
And you, blue-uniformed oppressors!
And you, meek nation whom they rule!

Lermontov tr. by Guy Daniels, revised by Robert Chandler

Forgive me for the banality of the epigraph, but these lines ran constantly in my head as I made preparations to leave. In households all over Moscow bitter quarrels broke out: to stay or to leave? Shchedrovitsky did not approve of emigration. He said that we must create a cultured layer at home. I said that the authorities would use this cultured layer to cover up the uncultured chaos underneath. Who was right? I think that everyone has their own idea of what is right and everyone has their own way of being true to their beliefs.

The summer of 1972 was unusually hot. Moscow was shrouded in smoke. The Kashirsky peat bogs were burning. While waiting for a reply from the visa and registration department we stayed in our friends' dacha at Domodedovo. We walked in the woods, read and were able to listen to broadcasts from the BBC, thanks to our proximity to the airport which made it more difficult for the authorities to jam enemy voices. One day Nina went to Moscow to buy supplies. She had hardly had time to open the door to our flat when there was a telephone call: 'This is the visa and registration department. You have been granted permission to leave for Israel. Get a pencil and take this down.' A list of what we were required to produce at the department followed: passports, military service certificate, professional references, references from the housing department …'and in addition: reimbursement for your education.' 'How much?' asked Nina. '29,000 roubles.'

It turned out that in April of that year, i.e. before we had put in our application to emigrate, a law had been passed making emigrants liable to reimburse the state for their education. Nobody had the foggiest notion about this law and it seemed that we were the first to hear about it. Maya Rozanova remembers how I went to their place and announced with an idiotic smile that I had been given permission to leave but wasn't going anywhere. The sum of 29,000 roubles was completely beyond our means (we would also have to pay for our renunciation of citizenship, for visas, tickets and other bits and pieces). I calculated that in 23 years of work, including all my book royalties, fees for lectures and articles, I had not earned such a sum. Our hopes of leaving had collided with the immovable wall of the state's arbitrary rule and been smashed to pieces. But Rozanova had other ideas.

With her characteristic energy and passion for untangling the most critical, apparently hopeless situations, she set about collecting funds to pay our ransom. Friends came, acquaintances and people we had never met, some brought 10 roubles, some 100; Yevgeny Pasternak[1] came and said that he wanted to redeem 100 grams of Golomstock. But how much could the impoverished Moscow intelligentsia raise? Sinyavsky sold a sixteenth-century icon, I began to sell off books, spinning wheels and an icon brought back from the north and we got back 2,000 roubles for our co-operative apartment. By the autumn, as a result of all these sales and donations, we had collected more or less 10,000. It seemed unlikely that we could raise any more.

There were rumours going around Moscow about some kind of foreign funds, about help for Jews intending to return to their historic homeland. But where were these funds? How could one get one's hands on them? I didn't know any foreign correspondents and I had no links with any Jewish organisations. The only option was to look for information among dissident circles.

In the roughly two years since Jewish emigration had started, new dissident groups, the so-called refuseniks, had sprung up in Moscow and elsewhere. The Soviet state did not just create material barriers to emigration. Many people who were technical specialists were immediately refused permission to emigrate on the pretext that their work was confidential. It was natural that such refuseniks formed groups to fight for the right to emigrate. Like some other dissident associations they took on the character of organisations with their own structures, hierarchies,

leaders, group interests and channels of communication which they preferred to keep to themselves. A Moscow group of refusenik-academics founded a typewritten magazine, *Jews in the USSR*, and sent it to Israel for publication via their own channels. The head of this group was our old acquaintance, the leading physicist, Aleksandr Voronel. I turned up to see this group with the traditional Russian question – 'Who is to blame and what is to be done?' We all knew who was to blame, but what was to be done, i.e. how to find practical help to emigrate, was for me a mystifying question of vital importance. They clapped me on the shoulder, advised me not to worry, said that they had possibilities, connections, channels, but to my questions – how? where? whom shall I go to? – they replied that it was not for me to worry about. Everything would be done. Nothing was done. One of my acquaintances went to a similar organisation and when she asked for help for me they said: 'Golomstock has done nothing for the Zionist movement.' I couldn't argue with the truth of this. Unfortunately mine was not an isolated case.

* * *

Our financial problem was unexpectedly solved. As autumn approached I had a call from distant London from my old university friend, Alik Dolberg. He had learned about our difficulties in the English press. On the telephone he bamboozled me (or rather the KGB) with stories about how Picasso himself was going to give the money for our departure and said that some English publisher was prepared to pay me advances for future works. Of course all this was a complete fabrication. In fact, Alik began collecting money for us, but it would not have been easy to obtain such a sum, even in the West, if it were not for his friend Bayard Osborn-Lafayette. Bayard came from old and very rich American stock. He personally wasn't rich, because his forbears had bequeathed all their money and property to a trust fund but, as with many estimable American funds, there was a statute about charitable gifts. Bayard simply called his accountant and got us a cheque for 5,000 dollars. Dolberg also guaranteed to get us British visas.

So then I was faced with a choice: London or Jerusalem?

Since childhood I had felt myself to be a Jew, even though the family was assimilated and the only anti-Semitism I experienced was from the state – nobody taunted me at school, nobody insulted me in the street, nobody oppressed me at work. But even state anti-Semitism was enough to make

one want to get out at all costs. In our debates in Moscow I stoutly defended emigration to Israel. Indeed, despite my agnosticism, I felt closer to the Old Testament than to any other doctrine. On the other hand, as far as culture was concerned, I was an anglophile. My favourite writers then were Sterne, Fielding, Dickens, and later Chesterton, Huxley, Orwell, Koestler, Joyce (excerpts from *Ulysses* were published in the periodical *Internatsionalnaya Literatura* during the 1930s).[2] I first saw the paintings of the English masters in the original at a major exhibition of the art of Great Britain at our museum. During the time when socialist realism held sway in the Soviet Union the story of European art was told according to the French model. David, Delacroix, Ingres, Courbet, revolutionaries and realists, were the leaders of artistic progress, and in our university lectures the only thing we heard about Turner and Constable was that Delacroix repainted his *Massacre at Chios* after he saw their paintings in London. (Although in comparison with the innovations of the English painters, his famous *Liberty on the Barricades* looked like a political poster.) 'France after 1789 was a revolutionary nation with a conservative culture while Britain after 1789 was a conservative nation with a revolutionary culture', writes the British art historian Andrew Graham-Dixon. The official Soviet interpretation was the exact opposite. From little pieces of history gleaned from books (from Carlyle and, again, Dickens) I formed the picture of a country which had developed smoothly over the course of 300 years without dislocations or revolutions, a country where the private is set above the public and the rights of the individual above the interests of the state, concepts encapsulated in that mysterious little word '*privacy*' which cannot be translated literally into other languages. This was all very different from what they had drummed into us at school and university.

And so, England or Israel?

I was 43 years old. I wasn't capable of physical labour and feats of arms, and it seemed to me then that this was what Israel required above all else. And what were the prospects for a historian of Western art who had not seen a single Western museum? I had no desire to become dependent on state benefits. Moreover my linguistic idiocy meant that it would be very difficult for me to master Hebrew.

It was not only my cultural interests which drew me towards England. I considered it my duty to pay back the money I had received from then unknown sources, and to show my gratitude to those people who had helped us emigrate. In the end all these things shaped my decision. On the

Moscow metro, as the train approached a station three-year-old Venka (Benjamin) would announce, 'Next stop – England!' But England was still a very long way off. I still had obstacle courses to negotiate before I could obtain the right to emigrate.

* * *

In order to complete the documentation for leaving the country I had to go through a whole series of procedures, to jump over a succession of hurdles that the authorities placed in the path of aspiring emigrants. For me, the necessity of having parental permission to leave was one such insurmountable hurdle. Mama was already dead, my father, who was over 80, was living in Sverdlovsk, 1,500 kilometres from Moscow. I had to catch a plane and see my father for the first time since 1943. My father was living on the outskirts of the town with his wife – a sweet, simple woman. He reacted to my idea of emigrating as if it were a farfetched fantasy, as if I had decided to fly to Mars. 'Why are you going?' he asked repeatedly. 'Our country is producing such and such a quantity of steel per year, is building so and so many aeroplanes.' 'But Papa, have you ever flown in a plane?' 'No, never.' So why was he bothered about it! He was still living with the Soviet notions of the 1930s. Nevertheless, he signed the document giving his agreement. This was not the end of it. His signature had to be verified at the housing department or by a lawyer. The housing manager, having lectured me about how immoral it was to abandon my aged parent, refused to verify his signature. My father hobbled after me from one notary to another through the puddles and potholes of the Sverdlovsk suburbs, but the servants of the law, when they read the word 'Israel' on the document, refused point blank to verify the signature. We even went to the local party committee but we got nothing there except abuse and a moral lecture. I went back to Moscow empty-handed.

At the Moscow visa and registration department I gave a lengthy explanation of the situation in Sverdlovsk to the top man, Comrade Zolotukhin, but the only answer I got was: the document is invalid without the notary's signature and seal. However, this invalid document did not affect the final, positive decision about our emigration. It seemed to me that at that time there were two forces at work simultaneously: centrifugal and centripetal. One was flinging us out, the other was dragging us in. One force was under the control of Andropov and the KGB

and strived to purge the country of dissidents, while the other was under the Central Committee of the Communist Party which detested any emigration whatsoever. There was no consensus between them. When these forces were in equilibrium we found ourselves suspended, when the balance tipped one way or the other we either went up or came down, painfully awaiting the new relationship of these two forces.

One day I was called in to the Moscow branch of the Union of Soviet Artists on the pretext of checking some data in a questionnaire. The secretary fetched a file, leafed through some papers and suddenly asked, 'Aren't you leaving the country?' 'Yes, I am', I answered. 'Well then, write a declaration, fill in the questionnaire ...' she said with obvious relief. Evidently centrifugal forces operated here, while Zolotukhin from the department of visas and registration was part of the centripetal force.

It is interesting that the most penetrating Western writers and political observers had already grasped what was in the air at the time, what we felt on our own skin. Thus, long before perestroika, Graham Greene wrote, 'a favourite theory of mine [was] that one fine day the KGB would be in control ... the KGB recruited the brightest students from the universities, they learnt foreign languages, they saw the outer world, Marx meant little to them.'[3] Shchedrovitsky said the same thing to me. The most able students from his philosophy course in the Faculty of Languages and Literature of Moscow State University joined the KGB. Fifteen years later that is exactly what came to pass. The people overthrew the master and put his dog on the throne.

* * *

In October the money arrived from London – 5,000 dollars. The state exchanged dollars for some sort of currency roubles, taking a cut of 60 per cent for themselves. These special roubles were highly valued on the black market because you could use them to buy unobtainable goods and foodstuffs in the currency shops – 'Beriozkas' – that had sprung up all over Moscow at that time. For one currency rouble you could get six or seven ordinary roubles on the black market. Within a few days we managed to sell them all off among our acquaintances at a rate of three roubles for one. I don't remember the exact amount we ended up with, but it was more than enough to pay off the remaining part of the ransom (about 20,000 roubles). We crammed the great heap of bank notes into a briefcase and I set off to

pay them into a bank in Moscow, accompanied by two friends, Dima Silvestrov and Misha Shtieglitz (both of them under six feet tall).

All that remained was to buy the plane tickets and fly out on our chosen route. But even this turned out to be complicated. There was one more hurdle to jump. At the international booking office at the Kazan Railway Station I was informed that they didn't sell tickets to London and that I, like all the rest of the Jews, had to fly to Vienna. But in order to fly to Vienna one had to have either an Israeli or an Austrian visa and without either of these I would not be able to buy any tickets at all. So our plans to leave had again run up against a brick wall.

For the umpteenth time I ran to Rozanova, bewailing our fate. Maya literally managed our departure – solved the money question, untangled all the knotty problems. Through some of her connections she got me a hearing with General Vereinov, the head of the all-union department of visas and registration. I went there boiling with indignation, intending to fling a previously prepared sentence in the face of the authorities: 'I haven't asked what you did with the money you took from us, and it's none of your business to ask me where I'm going.' But in the chief's office I had the wind taken out of my sails. A relatively young and intelligent-looking man with a university badge on his jacket sat behind the desk. 'Ah, Golomstock. Maria Ivanovna', Vereinov addressed a woman sitting at her typewriter, 'phone the booking office and tell them to sell Golomstock tickets to London.' This time the booking office treated me like a VIP. Obviously they interpreted the phone call from the all-union department of visas and registration as an indication that I was being sent abroad on some secret mission.

One last thing remained. The Dutch embassy at that time acted as an intermediary between the USSR and Israel (the USSR had broken off diplomatic relations with the latter). For reasons which were not entirely clear to me, the embassy would take belongings from Jews who were leaving and forward them to their destination. Friends asked me to take advantage of the opportunity and take a number of their documents to the Dutch embassy. In the main these were physics treatises written by Voronel and his colleagues. I packed them in a suitcase and set off for the embassy. I arrived during the lunch hour and there was a long queue standing in front of the cultural attaché's door. Half an hour went by and I saw my old acquaintance, Mr Hannema, attempting to make his way along the corridor to his office, not looking at anyone and repeating over and over again, 'I can't work in this zoo.' It was easy to understand why this civilised

Dutchman thought the crowd standing outside his office looked like a menagerie. These people had gone through a series of excruciating processes, they had been humiliated and robbed. They hoped to take with them into the unknown at least a small part of their former goods and chattels, their everyday life, their memories. In the queue in front of me I overheard conversations about sundry gold watches, brooches, dollars, exchange rates ... It's not hard to imagine what extravagant requests these people, brought up in Soviet lawlessness, made to the unfortunate cultural attaché, and what they proposed in return. My turn came and I went in with my suitcase. 'What's in the suitcase? Open it', ordered Hannema, very curtly. 'Actually, we know each other. You remember the Van Gogh exhibition?' 'So you're leaving as well', he said sadly. 'Why?' I lost my temper and raised my voice. 'Why? This ugly scene alone is enough to make one clear out of this country.' 'Maria Ivanovna' (for some reason the Dutch cultural attaché also had a Maria Ivanovna in his office), 'take the suitcase.'

Before I left, Viktor Lazarev – on his own initiative and in his own name – gave me a written reference, stating that I had taught in the art history department of Moscow State University in such and such years and delivered lectures on modern European art. Alas, this reference was to be of no benefit in my new life.

* * *

Almost all our friends came to the farewell party. The table groaned with food and drink. Scotch whisky, Dutch pink gin, French wine, ketchup, tonic, different sorts of sausage – all bounty unavailable to the ordinary Muscovite and bought from the Beriozka shops with the currency rouble. I think that for the first time in my life I didn't drink at a party. Maya, Andrey and I stayed in the kitchen discussing things. Andrey had received an invitation from his former French students, now eminent Slavist scholars, to take up a permanent professorship at the Sorbonne in Paris and the Sinyavskys were thinking about leaving. The manuscript of Abram Terts's *A Voice from the Chorus* had already been sent abroad. It was to be sent on to me from Israel and I was to try and get it published by some small press which was not too blatantly anti-Soviet. We came up with a code I would use when writing to tell the Sinyavskys what was going on.

We separated long after midnight. In the early hours there was a knock at the door. Andrey Volkonsky, Nikita Krivoshein and another friend they had brought with them asked whether there was anything left to drink and I found some bottles with dregs of alcohol in them.

On 5 November 1972 a crowd of friends accompanied us to Sheremetyevo airport. As we mounted the steps to board the plane I turned and gave them a farewell wave with Benjamin's potty which I happened to be carrying. I had the feeling that I would never see any of them ever again.

PART II

Emigration

Translator's Note to Part II

The Golomstocks were among the earliest 'third wave' emigrants to arrive in London from the USSR in 1972. Thanks to his role in the Sinyavsky trial and his being 'held to ransom' for the right to emigrate, Igor was a minor celebrity dissident and his arrival was mentioned in the British press.

In his immigration interview he was advised to apply for political asylum, which would have guaranteed the family somewhere to live, social security benefits and the right to work. Igor refused, as he did not consider his emigration a political act. Some of his friends later reproached him with making an irresponsible and impractical decision.

However, various influential people set about assisting the family to settle in London. The Golomstocks were invited to a number of glamorous parties to be introduced to people who might help them. Francis Greene, the son of the novelist Graham Greene, offered them a flat at the top of his house in Notting Hill Gate for a peppercorn rent. Paddy O'Toole, the head of Slavonic Studies at Essex University, offered Igor a post teaching Russian conversation to undergraduates. Igor was touched by the tactful delicacy with which all offers of assistance were made; it was as if the Golomstocks would be doing their benefactors a favour by accepting their help. English good manners and reticence were also in evidence whenever cultural misunderstandings occurred. At a smart party in Chelsea Igor helped himself to a handful of black, salty rusks from a saucer which had been placed on a low table. He assumed they were *zakuski* – snacks – to accompany his tankard of beer. When the household cat came up and also started tucking into the 'snacks' Igor chased him off. The cat settled nearby, watching balefully as Igor munched its treats, but none of the well-bred guests or indeed the hosts batted an eyelid or dreamt of enlightening Igor as to his faux pas.

Although Igor read English fluently he discovered that speaking the language was an entirely different skill, one that he never really mastered.

He began attending language classes but left after the third week, daunted by the facility with which his much younger fellow students from all over Europe cheerfully bandied about English phrases among themselves and confidently answered the teacher's questions. He was also distracted by numerous problems of his own: getting the manuscript of Sinyavsky's *A Voice from the Chorus* sent from Israel and placed with a London publisher; chasing up royalties owed to Nadezhda Mandelstam who was living in penury in Moscow; preparing the ground for the Sinyavskys' emigration to Paris.

However he also found time to enjoy the abundance of pubs, parks, libraries and galleries in a London already familiar to him through his wide reading of English literature. Waterloo Station was exactly as he had pictured it from reading *Three Men in a Boat*; setting off in the mornings from Liverpool Street Station to go to the University of Essex he was delighted by the sight of city commuters in bowler hats; as often as not, when he reached Colchester he would discover that there was yet another student sit-in at the university which was famed in the seventies for its left-wing staff and students. Igor listened wryly when a couple of his students who were locked up for 24 hours after committing criminal damage at the university complained about the quality of the food they had been given – the meat was greasy.

In his next teaching post at the university of St Andrews the surrounding landscape seemed to him to be straight out of the pages of Walter Scott. After St Andrews came a similar post at Oxford under Professor John Fennell. As well as conversing with students in Russian, Igor taught translation from English to Russian and gave lectures in Russian to post-graduates on the development of contemporary Russian literary language.

In parallel to this modestly paid but tranquil way of earning a living Igor was constantly preoccupied with the more turbulent business of émigré life. He was instrumental in settling the brilliant but difficult graphic artist, Oleg Kudryashov, and his family in London. He was involved in organising two exhibitions of Soviet unofficial art, one in London and one in Paris. Once the Sinyavskys settled in Paris in 1974 Igor became embroiled willy-nilly in the famously quarrelsome émigré community there. Unlike London, Paris had a substantial population of Russian exiles, representing the three great waves of emigration: post-revolution, post-World War II and now the latest flood

of dissident intellectuals in the 1970s. Ideological disagreements, professional and personal rivalries flourished and were fought out in literary and socio-political journals, one of the most influential of which was *Kontinent*, founded in 1974. Igor became closely involved in the birth of the magazine although he had his reservations about the wisdom of doing so.

CHAPTER 18

The Journal *Kontinent*

Many writers and dissidents in the émigré community were obsessed with the idea of founding their own journal. Vladimir Maksimov was no exception. He managed to persuade the German newspaper magnate, Axel Springer,[1] of the benefits of investing in a political journal which would unite the whole Russian emigrant community. The proposed journal would be a thick one (400–500 pages in paperback format), the contributors were promised European rates of pay and the staff would get a decent salary. Maksimov enlisted the Sinyavskys and the Sinyavskys enticed me to join. I had already had more than a taste of émigré squabbles so I was at first sceptical about the idea: gathering sheep and goats under one roof seemed hopelessly utopian. However I found the idea of working with Sinyavsky, Galich, Viktor Nekrasov[2] and Naum Korzhavin[3] very attractive.

The Sinyavskys and I were invited to Vienna, where Ullstein,[4] one of Springer's publishing houses, was based, to discuss the proposed journal. We were given a royal welcome. We stayed in an old Austrian castle with suits of armour in the corridors and a gallery hung with portraits of the former owners. We were taken to museums and artists' studios; I was presented with an edition of the multi-volume Propyläen *Kunstgeschichte* (*Art History*) – the very book which I had used at university to study art history.[5]

At an initial meeting, which was attended only by George Bailey from Ullstein Press, Maksimov, the Sinyavskys and me, we formally agreed to start the new journal. I was appointed editorial secretary.

So began the story of the journal *Kontinent*, a story with an unhappy ending, at least for us.

* * *

In Vienna, Maksimov had told us that he had access to practically the entire *samizdat* output from Russia and Eastern Europe. But when I arrived in Frankfurt in the summer of 1974 to put together the first issue, which was to be printed at the Posev Press,[6] it turned out that Maksimov had almost no material. He telephoned Solzhenitsyn and managed with some difficulty to talk him into sending a word of welcome to the journal.[7] Sakharov sent something similar. He got a contribution from *Posev*, the journal of the most active anti-Soviet émigré organisation NTS[8] (National Alliance of Russian Solidarists), and something from the East European dissidents. I took a suitcase full of manuscripts to Frankfurt. I had been given most of them by Professor van het Reve, who was at that time the editor of the Herzen Press. I had made a special visit to Amsterdam to meet him. I myself had other manuscripts. I took Sinyavsky's article, 'The Literary Process in Russia', Pyatigorsky's 'Remarks on the Metaphysical Situation' and my own article on the exhibition of unofficial Soviet art at Grenoble Museum.[9] I also took three poems by Brodsky.

I had already met Brodsky back in Moscow and the first time I went to New York I called on him at his apartment in Greenwich Village. He invited me to a Chinese restaurant and ordered marinated pigs' ears, obviously wanting to test my Jewishness. But I'm a bad Jew and enjoy eating pork. The following summer Brodsky came to London where we met up and I persuaded him to contribute some poems to the new journal which was then in preparation. He gave me three poems: 'On the Death of Zhukov'; 'The End of a Beautiful Era'; 'In the Lake District'.[10] But a few days later he rushed over to see me in a state of indignation and demanded the poems back. He didn't like the fact that the journal was called *Kontinent*. I spent a long time trying to get him to change his mind and ended up saying I was sick to death of dealing with geniuses. At that point he calmed down. So these three poems were first published in the opening issue of *Kontinent*.

At first our relations with Maksimov were entirely cordial. On one occasion the Sinyavskys, Maksimov and the newly-arrived Galich[11] all gathered at our flat in London – at that time we were still living in Francis Greene's house. We talked about the journal's prospects, had a few drinks, and Galich played his guitar and sang. At three o'clock in the morning I couldn't resist waking my five-year-old son Benjamin (Venka) so that he could see the living Galich.[12] Galich sang his 'Lullaby' to him.[13] 'And when the Bogeyman comes, he'll lock you in a cell ...' Venka burst into tears.

Our differences with Maksimov began in Frankfurt as soon as I read the introductory editorial for the first issue — a kind of ideological manifesto. Its aims and principles were formulated in the following manner: 1. UNCONDITIONAL RELIGIOUS IDEALISM with a prevailing Christian tendency ... 3. UNCONDITIONAL ADHERENCE TO THE PRINCIPLES OF DEMOCRACY ... 4. UNCONDITIONAL NON-PARTY ALIGNMENT ... The address finished with one of Maksimov's favourite sayings: 'He that hath ears to hear, let him hear!' It sounded as if anyone who didn't listen to Maksimov had no ears.

I asked Maksimov: 'Why religious idealism, especially unconditional? You know that even the contributors to this first issue are very far from all being religious idealists of the Christian persuasion.' An indignant Maksimov rushed off to ring up the Sinyavskys and complain about me. Why had they landed him with this atheist? Andrey, who also found such declarations from Maksimov objectionable, asked me to make allowances for the overexcitable temperament of our editor and have a little patience. The conflict was temporarily allayed but other serious differences began to arise.

Maksimov was one of a kind and his qualities and defects of character all stemmed from that. He was born into a simple working class family and ran away from home at a young age. He lived on the streets, was brought up in children's homes and centres for juvenile delinquents, was charged with some criminal offence and spent some years in the camps. His joyless youth and the Soviet milieu in which he ended up (as a member of the Union of Soviet writers), shaped his character. He was dogged, tenacious in attaining his goals, mistrustful of others, intolerant and scornful of his opponents. However he had an unusual gift for languages, and a naturally sharp intelligence. Having made up his mind to wage war on the Soviet authorities he armed himself with their own age-old slogan: whoever is not with us is against us! As time went on he began to seem to me more and more like a sort of busy regional committee secretary, the sole possessor of the truth, high-handedly distributing bagels to some, and the holes in bagels to others.

He himself was not a nationalist or an anti-Semite but for the sake of expediency he listened to the opinion of authorities such as Solzhenitsyn, Shafarevich and the ideologues of the old emigration. The staff 'collaborating' on the journal therefore included, alongside Robert Conquest, Eugene Ionesco, Milovan Djilas, Saul Bellow and other leading intellectuals from the West, such people as the editor-in-chief of the

newspaper *Russkaya Mysl*, Zinaida Shakhovskaya, who had already succeeded in souring relations with us, more recent émigrés. When we asked Maksimov why he had included her he shouted, 'As soon as we've finished issue number so-and-so I'll boot her out! But for the moment she's essential, essential.' Naturally, we couldn't agree with this way of going about things.

And there was another catch in the way the journal was organised which we didn't notice at first. Maksimov included the editor-in-chief (himself), and the editorial secretary (me), on the editorial board. The list of personnel on the cover, which in any other magazine would have been called editorial advisors or colleagues, in *Kontinent*'s case were designated as 'collaborators'. So Maksimov kept for himself sole control of the journal, since 'collaborators' didn't have the right to vote and I was unable to influence the policy of the journal which the editor-in-chief implemented.

The list of 'collaborators' expanded from one issue to the next and turned into a kind of icon wall of celebrities. Many of them, who had at some point agreed to contribute to the journal, quickly forgot about its very existence. The list was merely for show. And soon the purges began. Maksimov dropped anyone whom he thought left-wing. Saul Bellow, Viktor Nekrasov, Wolf Zidler, Lyudek Pachman, Mikhaylo Mikhaylov and other well-known East European dissidents – supporters of 'socialism with a human face' – were all got rid of. The editorials, which appeared in each issue, became ever more aggressive in tone as did Maksimov's articles, in which he pounced on left-wing intellectuals. The words 'pluralism' and 'tolerance' sounded to him like swear words. Solzhenitsyn felt the same.

After the nightmare of the Third Reich, left-wing attitudes were widespread among German intellectuals and Springer, who was bankrolling *Kontinent*, was considered by them to be on the extreme right. Heinrich Böll and Gunter Grass warned Maksimov about the danger of landing in the camp of right-wing extremism. Maksimov's response was to accuse them in print of being rhinoceroses[14] and he practically called them Soviet agents.

The disease of political intolerance intensified among our circle of dissidents too. Valery Chalidze came to London. He came up to me in the large hall where he was to speak and asked whether there were any members of NTS or journalists from Radio Liberty there so that he could avoid shaking hands with them. And even my friend Borya Shragin cursed *Kontinent* for being too right wing. We spent a whole night quarrelling and remained fixed in our previous opinions but also stayed close friends.

For me the division between left and right didn't make sense now, nor had it before, in Moscow. What mattered was whether a person was a decent human being. Once in Paris two young French men sought me out to ask my help in organising an exhibition of unofficial Soviet art. They shyly confessed that they were Trotskyists. I said that it didn't matter to me. If someone, regardless of their politics, was trying to do something useful, I was ready to help them. I became friends with Boris Miller — an active NTS member and a good man, and I also had good relations with the NTS leadership in Frankfurt, where *Kontinent* was published, even though I had no sympathy with their political programme.

The division of people into left- and right-wingers was just as alien to Sinyavsky as it was to me. In his monograph on the philosopher V. V. Rozanov, whom he considered a kindred spirit, he quoted his statement: 'There's a grain of truth in the Revolution and a grain of truth in the Black Hundreds.'[15] This couldn't simply be called tolerance, it was an objective, non-ideological attitude to history. Naturally, with such a philosophy, Sinyavsky was a thorn in Maksimov's flesh. For Maksimov there was only one truth and that truth must gleam like gold while everything else had to be painted black as pitch. Sinyavsky could not simply be removed from *Kontinent* without creating a scandal. He was too powerful a figure, both in Russia and among the émigrés. So Maksimov took a different approach.

In issue number five of *Kontinent*, Sinyavsky's brilliant article on Vladimov's novel, *Faithful Ruslan*, appeared with a preamble informing the reader that the editorial board did not agree with the article's content. What was there to disagree with? And who was it who disagreed — Maksimov and I? All this was simply stupid and it was clearly impossible to compromise with Maksimov. After issue number five Sinyavsky was no longer listed among the 'collaborators'. When I opened that issue I saw someone else's name published as editorial secretary. Maksimov didn't even deem it necessary to inform me that I'd been sacked! 'And the brother-in-law, Mizhuev, as well!' as Gogol wrote.[16]

'People are so oversensitive nowadays. If you tell someone to get lost he'll start a fight with you.' Maksimov often liked to intone. But I had no intention of getting into a fight.

CHAPTER 19

The Anthony Blunt Affair

When I first arrived in Britain, the case of the Cambridge spy ring seemed to me like a pure whodunnit. A number of Cambridge graduates who had held important posts in British Intelligence and in the Foreign Office, and who had therefore had access to top-secret information, had been unmasked as Soviet agents in the early 1950s. In Britain this was considered the greatest act of treachery in English history.[1] Three of the spies – Guy Burgess, Donald Maclean and Kim Philby – had defected to the Soviet Union. The fourth man remained undiscovered and in the early 1970s the press was full of speculation and innuendo. I half-jokingly told my friends that I knew who the fourth man was: Sir Anthony Blunt. The facts were as follows.

Back in 1965 Yury Ovsyannikov, who was then editor-in-chief for the publisher Iskusstvo, sent me a manuscript by Anthony Blunt on Picasso's *Guernica* for my comments. He told me that the manuscript had come directly from the Central Committee with instructions to publish it straight away. The manuscript was approximately 100 pages long, had already been translated into Russian and was lavishly illustrated. I knew of Blunt only through his short monograph on Picasso's early work and naturally my review was highly favourable.

This was, I repeat, in 1965, the point at which (as I learnt later in England) British Intelligence had unmasked Blunt as a Soviet spy.[2] The publication in the Soviet Union of a book by a well-known progressive English art historian who was 'undergoing persecution in his own country', was clearly intended to pave the way for his resettlement in Moscow. However, British Intelligence promised Blunt to keep the matter secret, even from the Queen and the Prime Minister,[3] in exchange for a full confession and they kept their word.[4] Instead of vegetating in Moscow, Blunt preferred to keep his position in London as Director of the Courtauld

Institute and Surveyor of the Queen's pictures and to preserve his reputation as an art historian of world renown. So there was no longer any reason to publish his book in the Soviet Union and it never came out there.[5]

This 'undercover art historian' continued his double life for 14 years. In 1979 a second investigation was launched and the Anthony Blunt affair was made public. There was a huge scandal.

Blunt had been recruited by Soviet agents while he was a student at Cambridge or shortly after he graduated. In those days the majority of the Cambridge elite (members of the Apostles[6] – a group to which Blunt and Burgess belonged) were Marxist sympathisers. Steeped in ancient Greek literature, many of them, including Blunt, took to heart the ancient sages' idea that love between men was superior to love between the sexes. Naturally this cocktail of Marxism and homosexuality made Cambridge a prime target for infiltration by Russian agents. Young disciples of Marx could easily be turned into friends of the Soviet Union while homosexuality, a criminal offence in England until 1967, was a useful tool for blackmail and recruitment.

In 1940 Blunt began working in British counterintelligence and had access to highly secret documents. He knew about the top-secret plans to land allied troops on the Normandy beaches in the summer of 1944. He took part in Operation Double Cross which involved double agents from Germany and the Soviet Union. He carried out surveillance in foreign embassies in London, including the Polish, Czech, Lithuanian and Estonian embassies and others which had shown themselves hostile to Stalin's regime. He handed over all his information to his KGB handler, Anatoly Gorsky, who was the Second Secretary at the Soviet Embassy in London. Who knows how many people were eliminated by Stalin's terror machine thanks to Blunt's information.[7]

During his second investigation [in 1979] Blunt testified that he had broken off all relations with the KGB after 1945. British Intelligence had no evidence to the contrary. I had in my possession incontrovertible proof that he was lying – the Central Committee's decision to publish his book in the Soviet Union in 1965.

Packs of journalists combed London, picking up whatever crumbs of information they could about this sensational story. I could not go to the press with my revelations without causing my friend Ovsyannikov major headaches. When I told him about all this some time later he said it made

him break out in a cold sweat. I phoned my Oxford friend, Professor John Fennell,[8] explained the situation and asked what I should do. 'Don't worry', said John, 'I'll contact MI5.' During the war Fennell, in common with many of his peers, had served in British Intelligence. He soon rang me back. 'They said, "Tell him to keep quiet."' Naturally it was not in the interests of British Intelligence, who had concealed Blunt's crime for 14 years, to give wider circulation to my story.

Anthony Blunt was stripped of his knighthood and dismissed from his posts as Director of the Courtauld and Surveyor of the Queen's Pictures. But he remained a free man and even continued as a member of the British Academy.[9] 'We elected him for his merits as a scholar, not as a spy', said the wise men from the Academy.[10]

CHAPTER 20

Radio Liberty, Galich

While in London I began making some programmes for Radio Liberty.[1] When Galich joined the station he persuaded the management to invite me to come to Munich and cover for Boris Litvinov, Head of the Department of Cultural Programmes, while he was on leave for two months in the summer. From then on I spent part of every summer in Munich for a number of years. As well as paying me a very decent salary as acting Head of Department they also paid me for any programmes I made myself, so that when I returned to Oxford we were able to take out a mortgage on a three-storey house with a little garden. So we put down roots in Oxford, where my wife Nina lives to this day.

The staff at Radio Liberty in those days were a motley crew. The majority were descendants of the first (post-revolutionary) wave of emigrants or members of the second (post-World War II) wave but there was also an influx of new, third wave, emigrants from the Soviet Union. The first wave émigrés, brought up with a nostalgic love for an illusory Russia which had long ago ceased to exist, were not very welcoming towards us, to put it mildly. We were firsthand witnesses of what had happened to the country, we had personally had our collars felt by the Soviet regime, we knew our target audience, and so the old guard saw us as dangerous competition. Among the postwar emigrants, who included people who had fought on the German side, there were strongly nationalistic and anti-Semitic sentiments. Of course most of us, the third wave, were Jews who had left the Soviet Union to escape exactly that kind of nationalism. But there were also former Soviet agents who had defected. All these disparate elements combined to produce a potentially explosive mixture.

The situation was exacerbated by the fact that Radio Liberty had adopted the American system of high salaries and an elaborate hierarchy of

grades. There were at least 15 grades or skill categories which dictated the pay rates and professional prestige of individual staff members. This system was obviously normal for Americans working in their traditional enterprises but completely alien to uprooted emigrants who for the most part had no particular professions, and for whom Radio Liberty offered the only opportunity of earning a living. So they scrambled up this promotional ladder, elbowing each other out of the way, plotting and scheming against one another, telling tales to the management, cooking up scandals and squabbles ...

The head of Radio Liberty, Francis Ronalds, could not cope with this chaos. He was a highly cultured man who knew Mandelstam's poems by heart, but the main thing was that he understood that this torrent of creative intellectuals from the Soviet Union was an invaluable resource for Radio Liberty. It was Ronalds himself who invited Galich to join the team. Unfortunately, Galich's presence only exacerbated the already tense atmosphere at the station.

The first time I went to Munich to cover for the Head of the Department of Cultural Programmes there was a programme called 'To the Sound of Strings', which broadcast songs by Soviet bards and guitar poets. The programme was produced by Galina Mitina, one of the second wave emigrants. I listened to some tapes of the programmes and was horrified. Instead of Okudzhava, Galich or Vysotsky performing their own songs, these were sung by crude imitators.[2] Since Galich was actually present at the station in person we decided to cancel the programme. This provoked a new round of squabbling which was orchestrated by the earlier emigrants and had a distinct taint of anti-Semitism, aimed particularly at Galich.

Here I need to clarify something. Despite all our disagreements and skirmishes, the last thing I want to do is make a blanket condemnation of the earlier emigrants. I had occasion to meet highly cultured individuals who had escaped or been expelled from Russia in the 1920s but who understood our problems. One such person was Boris Litvinov, the Head of Cultural Programmes for whom I deputised. Apparently he was born in France, received a good education, spoke several languages fluently and yet was also an active member of NTS.[3] We enjoyed the most harmonious professional and personal relations. He complained that our wave of emigrants had brought with us a Soviet spirit of suspicion and surliness and there was a grain of truth in this. But he also understood that if the third

wave had its share of pushy characters and tricky customers then it was no worse than the first two waves with their quota of idiots and anti-Semites.

Even so, the only person with whom I became really friendly in Munich was Yulia Vishnevskaya (whom I had already met when I lived in Moscow). A pure soul with a foul dissident mouth, she was the pupil, admirer and lover of Alik Yesenin-Volpin. While she was still a schoolgirl she had taken part in dissident gatherings, joined the demonstration in Pushkin Square calling for an open trial for Sinyavsky and Daniel, and skirmished with the police. She was sent to prison and then to a psychiatric ward. At Radio Liberty she was a quiet presence in the research department which was mainly staffed by Western Soviet watchers and she kept out of all the broadcasting squabbles. Probably she and I were the closest friends Galich had there although he often entertained large numbers of guests at his house. We were his admirers, his appreciative listeners, a splinter, as it were, of the Moscow audience whom he by then missed so much.

Sometimes Galich was invited to perform in the grand houses of some of the earlier emigrants (not all Russian aristocrats drove taxis in Paris; there was Nabokov-style emigration and Gazdanov-style emigration).[4] The guests sat in armchairs in a dignified manner, holding lyric sheets – some even had them in German translation. Galich felt awkward and left out words or phrases which he thought either indecent or incomprehensible to the audience, and it was only when he was at home having supper with his friends that he relaxed and sang as the spirit moved him.

Galich had listeners in Moscow and all over the world. When he got back to Munich from his first tour of Israel he was absolutely elated. His concerts in various towns there were a triumph. He played to packed houses and great box office returns. He even toyed with the idea of moving to Israel permanently. But his second tour was less successful: the impresarios set the ticket prices too high for the Russian emigrants who couldn't afford to go and hear their favourite bard for a second time.

I didn't fully understand the senior position that Galich held at Radio Liberty, which had been created especially for him in a shrewd move by the management then in post. It seemed that Galich more or less ran the cultural programmes department on behalf of his boss, Litvinov. Galich began inviting me to work at Liberty not only during the summer holidays but also in the winter. As far as I could make out this was because he wanted my company but also to give me an opportunity to make some money.

Aleksandr Galich's chief characteristic, I see now, was kindness. He was constitutionally incapable of refusing anything to anybody. When he first emigrated he mixed in earlier émigré circles. They asked him to join NTS: he joined. They suggested he should get baptised: he got baptised. When I went to his office with the scripts of programmes which for various reasons I thought not fit for broadcast he said, without even reading them, 'Just put them in the bin.' All these things were of little importance to him. He was, above all else, a poet. His gentle character and his inability to say no finally led Galich to the brink of disaster.

One fine day a certain Mirra Mirnik turned up at the station. All I can say about her is that she was a very attractive woman. But here it is more appropriate to hear what Yulia Vishnevskaya has to say. She worked at Liberty for 25 years and knows this story better than I do.

I don't know where Galich picked up this girl, Mirra. People said that she was temping as a typist at the Russian Service but I very much doubt if she was capable of typing a single word without making five typos in every six letters. However that may be, Mirra left her husband Tolik for Galich, taking her and Tolik's son Robik with her for good measure. Tolik completely lost the plot. He careered around the radio station waving a gas pistol, loudly accusing Galich of having wrecked his marriage and saying that he, Tolik, wouldn't stand for it. He burst into the office of our wise head of station, Ronnie, still waving the pistol and shouting that he would do whatever it took to fight back against such blatant abuse of his sacred rights. First he would kill Galich, and then take his grievance to the appropriate *channels. Namely:* Pravda, Izvestiya, *Academician Sakharov, Solzhenitsyn. Apparently* Pravda *and* Izvestiya *took his grievances very seriously and even managed to use them for their own propaganda purposes. History is silent about whether he succeeded in reaching Sakharov, but, if Tolik is to be believed, he did manage to get through to Solzhenitsyn in Vermont and the writer listened to him attentively and with great sympathy. The unfortunate Galich marked the arrival of Mirra and her son in his life with a ditty:*

> *'Robbie, oh Robbie,*
> *You'll be the death of me.'*

The reaction to all this at the radio station was entirely predictable. Irina Khenkina came running to Galich repeating titillating details about what he got up to between the sheets, which was a matter of common gossip

among those fine people who belonged to the Liberty team. Galich promptly collapsed on a sofa with a heart attack. In the end I went to Ronalds and convinced him to cancel Khenkina's entry pass to the station (she hadn't yet been taken on to the permanent staff). I have no doubt that the situation at Liberty was stoked up by our homegrown KGB. It is quite possible that this girl, Mirra, was put under Galich's nose with the help of the KGB. As I wrote earlier, there were KGB defectors working at the station. After the Americans had bled them dry of all their Soviet secrets they offered them a sinecure at Liberty. Some of them, however, were still working as Soviet agents.

A gloomy individual called Morev used to hang around our corridor. He was a Soviet agent who had handed himself over to the Americans. Some time later he went back to the Soviet Union and started writing newspaper exposés about hostile voices. In one of these articles, which appeared in *Literaturnaya Gazeta*, he listed staff from Liberty who were 'fascists and traitors who had collaborated with the Gestapo during the war'. Among the names was one Igor Golomstock.

Once a fellow called Zlotnikov turned up, presenting himself to the management as a journalist with clout. He was immediately given a senior position. Some time later, someone from the research department rushed in with a stack of articles from the Soviet press in which comrade Zlotnikov welcomed the Soviet invasion of Prague. But there was no way of sacking him under German law. The management only succeeded in booting him out when they discovered his failure to disclose on his application form that he had once served a prison term. After that he apparently got a job as an interpreter for the Soviet delegation at the United Nations.

Maybe I was suffering from spy mania, but when I wandered the corridors of Radio Liberty it was hard not to catch a whiff of the KGB office which was all too familiar to us.

Kirill Khenkin had a senior position at Liberty. He had formerly worked in the Secret Police and had taken part in the Spanish Civil War. He made no secret of his past; he openly alluded to his knowledge of the inner workings of the KGB, particularly with regard to the processing of emigration applicants' documents at the visa and registration department. He wrote an article for the Israeli Russian language journal *22*, entitled 'The Russians are Coming', which asserted that 60 per cent of emigrants' dossiers contained a written promise by them to 'work honestly with

Russian Intelligence'. Following that logic, I once said to Maksimov, two out of every four contributors to *Kontinent* must definitely be KGB agents. Whether it was Khenkin's intention or not, such revelations could only ratchet up the mood of suspicion in the already tense atmosphere among the emigrant community.

All this KGB activity culminated in a bomb attack on Radio Liberty's premises in Munich on 21 October 1981. The bombing was organised by agents from the Stasi (the East German secret police), with the help of the notorious international terrorist Ilich Ramirez Sanchez, known as Carlos the Jackal. A 20-kilogram bomb destroyed part of the building. The explosion was so powerful that it blew the windows out of houses within a one-kilometre radius of the station. Fortunately, it happened at night and very few people were injured. But by then I was no longer working at Radio Liberty.

* * *

Galich's position at the station had become increasingly untenable, both for him and for the management. To make matters worse, his flat was burgled. The thieves took all the money he had earned in Israel and saved from his salary. It was decided to move him to the Paris office of Liberty. At Munich railway station, where we were seeing him off, he told us that some men had approached him and threatened to beat him up.

I went to visit him in Paris. It seemed that now that he was removed from the Munich squabbles he was himself again. He had calmed down and started to write. Unfortunately, this relatively happy state of affairs didn't last long.

His wife Angelina told me about how he died.

Galich had bought himself some sort of new American radio set and had opened it up to have a look inside. Angelina went out shopping and when she got back she saw her husband lying on the floor. His head was covered with strange lacerations. The emergency doctor got stuck in a traffic jam and by the time he arrived Galich was already dead. He had been electrocuted. People who knew about this sort of thing said it would be a simple matter for an experienced electrician to get into the electricity supply in the stairwell and tamper with the voltage supply.[5]

* * *

At the end of one of my usual stints at Liberty, Ronalds called me in and proposed that I should take over Litvinov's job as head of Cultural Programmes. One of the strange arguments he produced in favour of my appointment was that the staff would be less foul-mouthed in my presence (I think he was mistaken in that belief). I turned the offer down for three reasons. In the first place, I considered Litvinov better suited to that post than I was and I didn't want to take the place of someone whose position had been undermined by constant plotting from every quarter. Secondly, I had absolutely no desire to immerse myself in the vituperative atmosphere that flourished at Liberty. And thirdly, I would have been sorry to permanently exchange my beloved London for Munich.

CHAPTER 21

At the BBC

'Every evening after tea
We Russians tune to the BBC.'

(popular saying in the USSR)

By 1979 I had completed four years teaching at Oxford – the maximum term for 'native speakers' as we were designated. When the four years were up, a freshly arrived foreigner was taken on to fill this post. However, John Fennell, Statutory Professor of Russian at Oxford, hired Nina although she could hardly be described as 'freshly arrived'. So I found myself at a loose end.

Radio Liberty was no longer a possibility. Francis Ronalds, who had been so well disposed towards us, had been ousted as a result of long drawn-out and elaborate plotting. Maksimov and Solzhenitsyn began to have ever-increasing influence over the agenda at Liberty and access was denied to us – the pluralists whom Solzhenitsyn termed 'pseudo-intelligentsia'.[1] There was still the BBC. I started making freelance programmes for them and was then taken onto the permanent staff of the Russian Service, where I worked until I retired.

My first impressions of the BBC after my experience at Liberty were as follows: I found myself back in the familiar atmosphere of a traditional British institution. There was a very great difference in the way of working at the two broadcasting companies. The BBC had no elaborate hierarchy of pay grades and positions. All programme-makers were on the same salary, with the exception of heads of departments (of which there were only a few) and if the management wanted to incentivise someone with a pay rise then

this was done discreetly so as not to upset other people. It was left up to the individuals concerned to tell their colleagues, if they so wished.

I was struck by the importance the Russian Service accorded to the selection of staff. The criteria for selection were: excellent Russian; good general cultural knowledge; professionalism in all relevant fields. They took a benign view if an applicant's English was less than perfect – 'They'll pick it up as they go along.' Programmes were made by experts in their field: Seva Novgorodtsev[2] made broadcasts about music, Dr Edik Ochagavia[3] covered medicine, Valery Lapidus, an engineer by training, made programmes about technology, the writer Zinovy Zinik covered theatre and literature, the legendary Anatoly Goldberg was our political commentator. The selection process included thorough political vetting. Any candidate who could be shown to have worked for the official Soviet press was rejected. It goes without saying that the same applied to anyone who could be linked to Soviet intelligence. I cannot remember a single former Soviet journalist among my colleagues in those days. Of course there were attempts to penetrate the Russian Service and I must mention one of them.

In 1983 a leading journalist from *Literaturnaya Gazeta* who was also, rumour had it, a high-ranking KGB officer, Oleg Bitov, was sent to Europe on matters which were somehow connected to the attempt to assassinate Pope John Paul II a couple of years earlier.[4] He then 'chose freedom', as the saying goes, and turned up in London. Either he botched his assignment and was scared to return home, or he thought he could have a glittering career in the West. People thought he was genuine; the BBC was even on the point of offering the eminent journalist a good position in the Russian Service.

By this time Nina had finished her stint in Oxford and our son Benjamin had started at Westminster School. We had bought a large house in Camberwell and at this particular moment the writer Yuz Aleshkovsky was staying with us. In Moscow, Yuz had been a close friend of the writer Andrey Bitov, used to visit him at home and of course knew his brother Oleg. Oleg now phoned Yuz and asked if they could meet up. I invited Oleg to come over to our house. He was already the worse for wear when he arrived. During dinner he talked mainly about how many dollars per line he was getting paid in the West, and then as he got more and more drunk he started to tell us about how he had defected. I couldn't believe my ears. Bitov recounted how White Guards[5] (he insisted on using this term,

obviously meaning NTS people) had kidnapped him, drugged him and brought him to London in an unconscious state. The next morning I asked Nina if I'd dreamt all this in a drunken stupor or had Bitov really said those things? Clear-headed Nina confirmed that I had heard correctly. I went to the management at the BBC and told them that I thought Bitov was planning to return to Moscow. This is exactly what happened some time later. In Moscow Bitov described his adventures in exactly the same words he had used at our dinner table. It's my proud boast that I saved the BBC from huge embarrassment.

There was another difference in the way the stations worked. At Liberty the scripts were read on air by presenters with trained voices. At the BBC we read our own scripts and, as we didn't have any voice training, we just spoke in our usual manner, as if we were talking to friends. Anatoly Goldberg had a rather squeaky, nasal voice which was in marked contrast to the standardised delivery of Soviet broadcasters. I think this was one of the reasons for Goldberg's extraordinary popularity with listeners in the Soviet Union. Real human voices burst onto the Soviet airwaves. They were instantly recognisable and trustworthy. The Estonian composer Arvo Pärt came to visit us at the Russian Service. He was a regular listener to the BBC and asked to 'touch the hem of Goldberg's garment'. As we went along the corridor, we could hear snippets of conversation from the open doors of different offices and Arvo, with his exceptional ear, immediately identified the voices. 'Ah, that's Zinik, that's Ben, that's Novgorodtsev.'

Our bosses were for the most part Slavonic specialists, graduates of Oxford, Cambridge, St Andrews, who spoke excellent Russian and understood the situation in the Soviet Union. The broadcasting policy of the Russian Service was primarily to present all aspects of British life – its culture, everyday life, institutions. But the definition of British life was very broad.

For example, I was very impressed with Aleksandr Zinoviev's book *The Yawning Heights* (*Ziyayuschiye vysoty*), which was published in Russian in Britain. I wanted to make a series of programmes exploring the ideas it contained.[6] But I hesitated. How could I justify such programmes as shedding light mainly on the British way of life? I went to take advice from the most senior manager – Baron Alexander Lieven – who was, I believe, head of the whole East European section which included the Russian Service. 'Is the book available in British libraries?' asked the

Baron. 'If that is the case, then it counts as part of British life.' All limits could be got round in similar fashion and political considerations took a back seat.

I remember a similar occasion. In 1985 it was decided to mark the approaching anniversary of the end of World War II with two programmes about life during the war in Russia and in Britain. I made the programme about Russia and my colleague, Tanya Ben, made the one about England. Naturally I began with the Ribbentrop-Molotov pact[7] and finished with the huge losses suffered by the Russian people in the war. Barry Holland, the head of the Russian Service, read my script and said pensively, 'The timing's rather awkward. The programme will go out on Victory Day, people will be celebrating with lovely food and drink but the radio will be serving up Ribbentrop and Hitler.' 'Let's broadcast Tanya's programme about Britain first and mine the following week', I suggested. So that's what we agreed. But on 9 May I got an urgent call to go and see Holland. 'We're putting your programme on air today', he bellowed indignantly. It transpired that Gorbachev, making the traditional leader's speech on Red Square, had accused Britain and France of having started World War II. No Englishman was going to stand for that.

All these factors guaranteed on the one hand that there was a harmonious working atmosphere within the service, and on the other, ensured the huge popularity of the BBC among Russian listeners. The Russian Service's budget was minuscule compared with the budget of the American combined station Radio Liberty/Radio Free Europe. But according to all international research data, including that of Liberty itself, the BBC had the biggest audience share of all the foreign 'voices'. This was the golden age for the Russian Service.

CHAPTER 22

The Second Trial of Andrey Sinyavsky

For four years I had to shuttle between London and Oxford, where Nina was still working. In 1983 her job there finished, we moved to London, and life gradually began to run smoothly. All would have been well except for the breeze from the continent which continually brought news of émigré squabbles to ruffle our peaceful London atmosphere.

Here I'll allow myself a short digression which will explain the underlying reasons for what happened later.

Since the early 1920s, Paris had been the main destination for Russian émigrés. Russian newspapers and books were published there, there was a chain of Russian restaurants, there was even the Rachmaninov Conservatoire. Paris attracted political refugees of every hue from revolutionary Russia, from monarchists to socialists. London was completely different. There was an odd belief in Russia (and perhaps it still holds today), that British society was much more closed than French society. But it's the exact opposite! It is true that the number of Russian emigrants who came to Britain was considerably smaller than the number who went to France. Nevertheless, over time the Russian population was thoroughly assimilated into British society. I was struck by something from the first moment I arrived in London. There were clubs for all the different countries and states that had been under Soviet domination: There were restaurants, reading rooms, meeting halls for Poles, Lithuanians, Czechs, Ukrainians, Georgians. The Russians had no such places for the community to gather, apart from the Orthodox church in Ennismore Gardens. Granted, there was the Pushkin Club, founded by early emigrants. The premises consisted of two small, interconnecting rooms where lectures were held once a week. As a new arrival I was invited to give a talk there. Five people turned up: two Poles, a Czech, an English woman ... they simply wanted to hear the Russian language.

In Paris access to French society was very difficult for the émigré community and they were left to stew in their own juice. (All this is described in detail in the memoirs and stories of Berberova, Teffi,[1] Gazdanov and many other Russian writers who lived in Paris.) This situation was fertile ground for political wrangling and suspicion to flourish. In time Sinyavsky became a victim of this atmosphere. Maya Rozanova dubbed the continual persecution of her husband 'the second trial of A. D. Sinyavsky'. I myself was dragged into this second trial, very much against my wishes. But I had no choice – we had to make a stand.

Hints of this second trial were already beginning to surface among the émigré community when Sinyavsky and I were working together on *Kontinent*.

In the very first issue in 1974, Sinyavsky wrote an article called 'The Literary Process in Russia'. It contained the following passage: 'Mother Russia, Russia-Bitch, you will have to answer for every child you suckled and then shamefully threw onto the rubbish heap.' The 'children' he was referring to here were the third-wave emigrants, not only those of Jewish origin but of every nationality, who had to escape from Russia. This passage aroused wild indignation among patriots, nationalists and anti-Semites: how could a Russian writer call Russia a bitch? Igor Shafarevich, a friend and close colleague of Solzhenitsyn, was an extreme nationalist and the author of the intensely anti-Semitic book *Russophobia*. He called for writers who had abandoned Russia to be struck out of the annals of Russian literature. That was when they first stuck the diamond-shaped label[2] signifying 'yid' and 'Russophobe' on Sinyavsky's back. The voices of some of the first-wave émigrés joined the chorus of patriotic indignation. They considered themselves keepers of the flame of Russian literature and regarded newcomers like us with suspicion. The journal *Vestnik*[3] and the newspaper *Russkaya Mysl*, both published in Paris, and *Novy Zhurnal*, published in the USA, not to mention the Russian-language tabloids, generously offered column inches to the malcontents. Neither Sinyavsky nor his defenders were allowed to reply.

The Sinyavskys came up with the idea of starting their own journal so that alternative views could be expressed. In 1978 Rozanova bought a printing press and set up at home as a publisher. The Sinyavskys funded the journal *Sintaksis* entirely out of their own pockets; sometimes Rozanova took on printing jobs for other organisations and individuals to offset some of the running costs. Right from the beginning I argued passionately with

Rozanova about the wisdom of this project; I thought that the appearance of yet another journal would only fan the flames of émigré quarrels. I was partly right but there was also a more positive outcome. Rozanova succeeded in attracting many leading writers, both from the Soviet Union and from abroad. *Sintaksis* had on its editorial board (or in its 'league of supporters', as we called them), Alik Yesenin-Volpin, Yulia Vishnevskaya, Yefim Etkind, Y. Mekler, Valentin Turchin, Aleksandr Pyatigorsky, the Sorbonne professor Michel Aucouturier and my humble self. In its 37 issues it published work by Aleksandr Zinoviev, Lev Kopelev, Leonid Pinsky, Grigory Pomerants, Dmitry Furman, Yefim Etkind, Semyon Lipkin, Zinovy Zinik, Louis Martinez, Heinrich Böll and many other well-known writers, poets and scholars. Of all the Russian journals published abroad, *Sintaksis* was the most politically independent. It was equally opposed to both Soviet ideology and nationalist bigotry.

* * *

The wave of indignation first aroused by Sinyavsky's unpatriotic 'Russia-Bitch' remark reached new heights in 1986 when an article by the KGB informer Sergey Khmelnitsky[4] appeared in the Israeli journal *22*.[5] Khmelnitsky had sent two of his friends to the camps with his denunciations and he did not deny his collaboration with the KGB and in his article, 'From the Belly of the Whale', Khmelnitsky asserted that Sinyavsky, his childhood friend, was also a KGB informer.[6] Earlier that year Khmelnitsky had arrived in Vienna on an Israeli visa; it so happened that when he went to KhIAS, the organisation for Jewish refugees, our mutual acquaintance Vadim Maneker, who was very well informed about goings-on in Moscow, was sitting on the other side of the desk. As soon as Khmelnitsky caught sight of Maneker he fled and soon afterwards popped up in West Berlin. It was rumoured that he was touting round a manuscript that he wanted to publish but no respectable Western firm would touch it. Evidently that manuscript was the origin of the article 'From the Belly of the Whale'.

I had known about Andrey's relations with the KGB for a very long time – both from what the Sinyavskys themselves had told me and also from Hélène Peltier,[7] an unwitting participant in these events. Hélène was the daughter of the naval attaché at the French embassy in Moscow. She was a student in the same year as Sinyavsky in the Philosophy Faculty at MGU (Moscow State University) and they became friends. One fine

day Sinyavsky was called in by the KGB who wanted him to marry the French girl. Previously they had suggested this to Khmelnitsky but Hélène hadn't responded to his overtures so nothing came of it. The KGB hoped to use Hélène's marriage to a Russian citizen as a means of snaring the attaché himself. Sinyavsky had no choice but to agree but he immediately warned Hélène and they then put on a show of breaking up. Later Hélène Peltier (who subsequently married the Polish sculptor August Zamoysky) wrote in *Le Monde*, 24 October 1984, that Sinyavsky had tricked the devil, rather than join hands with him and that he had risked his life in so doing. She also made it absolutely clear in other newspaper articles and in private letters that Andrey had saved her life.[8] Sinyavsky told this story in his novel *Good Night*, in his characteristic fantastic-realistic style.[9] People who had it in for Sinyavsky claimed that this was simply a smokescreen to obscure the true facts of the case.

And now Aleksandr Voronel, in his introduction to Khmelnitsky's opus in *22*, was essentially putting a professional informer who had turned in two of his friends in the same moral category as a man who had saved his girlfriend from ensnarement by the KGB. 'Unfortunately', wrote Voronel, 'the times are such that we can no longer divide people into righteous men and sinners. We can only talk about degrees and methods of depravity.'

Now, re-reading my collection of cuttings from the mass of rabble-rousing articles which appeared in the Russian press, and my own correspondence with various editors and individuals who joined in stoking up this shameful campaign, I ask myself a question to which I have no answer. Why did our former friend, the major Russian physicist and now editor-in-chief of *22*, Aleksandr Voronel, who had at one time severed all relations with Khmelnitsky, now feel the need to publish this article, this public breast-beating written by an informer who had been unmasked and was now flaunting his guilty conscience?

I actually wrote and put this question to Voronel. I received a lengthy missive in reply with arguments about the relativism of moral criteria and about how it was wrong, when considering such matters, to be ruled by 'group interests' – (that's what he called supporting one's friends!).

Lev Kopelev, Professor Etkind, Yury Bregel (who was sent to the camps thanks to Khmelnitsky), and many others, among them Voronel's close friends Yuly Daniel and Larisa Bogoraz, sent outraged letters to *22* and to Voronel personally. Larisa wrote,

You wanted to mislead your readers by tarring all shades of opposition with the same brush. But let's remember what Galich said.

In this world not all's in vain

(Though it mayn't be worth two bits!)

Just so long as there are weights

So you can *see* the level of the shit.[10]

Probably you people in your highly civilised world have given up using a simple shitometer but haven't yet come up with anything better. So carry on in your own sweet way for the time being.

But no such arguments were effective.

They're leaving, they're leaving, they're leaving – my friends;

Some on their way down, others in the ascent . . .

as another Galich song has it.[11] And the departure of my friends has been the greatest sorrow of my old age.

In his story 'Administrative Grace', Leskov wrote about one of the characters that 'he experienced the supreme happiness possible for a leading intellectual: he dug up some dirt about his nearest and dearest'. And in certain Russian émigré circles there was great rejoicing at Khmelnitsky's libel. It provoked another wave of 'revelations' about Sinyavsky.

Maksimov gave free rein to his hatred of Sinyavsky. He sent photocopies of Khmelnitsky's article to every press outlet and asked *22* for permission to reprint the article in *Kontinent*.[12] When Natalya Gorbanevskaya,[13] who was now the editorial secretary of *Kontinent*, happened to turn up in our office at the BBC my colleagues and I pounced on her with the direct question: was *Kontinent* planning to publish this filth? She replied diplomatically, 'not publish, just re-publish'. Another moral authority, Feliks Svetov, broadcast from Moscow that 'there's no more disgusting "stink" than the whiff of any kind of collaboration with the KGB, whatever the circumstances.' He was clearly referring to Sinyavsky.

I found this hounding of Andrey very painful indeed and not just because I felt sorry for him, though indeed I had never before seen him in such low spirits. I kept thinking about my childhood friend, Yury Artemyev: thanks to his 'denouncements', not one of our common circle of friends and acquaintances had ended up behind bars.[14] I could have tried to demonstrate or prove from Yury's case that not every collaboration

with the KGB, whatever the circumstances, smells disgusting. But nothing I could say would have convinced these people. They didn't even sniff out the fact that by persecuting Sinyavsky they themselves were acting as willing or unwilling tools of the KGB. A fact that will become clear, I hope, as I explain the further course of events.

* * *

Although none of this dirt rubbed off on me personally, I nevertheless felt spat upon. Delving into this sewer is repulsive and I find it difficult to write about. But it can't be helped. We had to make a stand.

In 1991 a document was leaked from the Presidential archive: a letter from Andropov to the Central Committee on 26 February 1972 in which Andropov, then head of the KGB, approved the decision to allow Sinyavsky to leave for France by private invitation.[15] It was widely circulated and was first published in the Israeli (Russian-language) journal *Vesti* in 1992. But, as it later transpired, the version received by the publishers had been distorted. Whole paragraphs from Andropov's original letter had disappeared. For example the following sentence was missing: 'Sinyavsky essentially remains true to his former idealistic position; he does not accept the Marxist-Leninist line in literature or art and therefore no new works by him can be published in the Soviet Union.' The phrase, 'a positive decision about this matter (the exit visa) would lessen the likelihood of Sinyavsky undertaking a new anti-Soviet campaign' had been omitted. As had the lethally frank paragraph stating that 'Thanks to our measures, Sinyavsky's name has definitely been compromised among those elements of the creative intelligentsia who formerly sympathised with him. According to our sources, some of his associates think that he has links with the KGB.'

Rozanova, as meticulous as ever, went to the President's special commission on the archives[16] and asked them to check the authenticity of the document which had been published in *Vesti*. She was officially informed that 'the published document appears to be a forgery, fabricated by collaging photocopies together. Paragraphs one, two, three, six, seven and nine were cut out of a copy of the original document, then glued together and recopied in a xerox machine.'

The first person to swallow this fake bait was Maksimov. In an editorial in the first issue of *Kontinent* for 1992, he wrote that this document shed

light on Sinyavsky's 'privileged' conditions in the camps, on his early release on compassionate grounds and even on the trial itself.

A few months later Rozanova acquired another document which had also been leaked from the same presidential archive. This time it was an excerpt from the minutes of the KGB Fifth Chief Directorate's plans for 1976.[17] The document runs 'continue the measures to compromise the target [i.e. Sinyavsky – (author's note)] and his wife in the eyes of their circle and their contacts who have remained in the Soviet Union, by portraying them as having secret links with the KGB... Time frame for the activity: one year. Responsible for implementation: comrade Ivanov E. F.'

But in the interval between the appearance of these two documents there was a complete orgy of 'revelations' about Sinyavsky.

I am not going to make a detailed investigation of this campaign in these memoirs. I am not going to enumerate all the lying, insulting and libellous articles aimed at the Sinyavskys. I will stick to one particular episode which graphically illustrates the way the campaign was promoted and the ethical level of this 'debate'.

Russkaya Mysl (RM), which was published in Paris, and *Kontinent* were behind this campaign. In the RM issue of 5 February 1993, the editor-in-chief, Ilovayskaya-Alberti,[18] wrote an article entitled 'Moral Twilight'. She spun the usual yarn about the Sinyavskys' links with the KGB, about their alleged pretensions to be the leading figures in the history of dissidence and much more besides. I wrote a reply to Ilovayskaya-Alberti and in order to spare the reader quotations from her invective I will just give some extracts from my reply.

Moral twilight and the rewriting of history, which you discuss in your article, seem to me to be typical not so much of contemporary Russia, as of the all-out campaign against Andrey and Maria Sinyavsky which is unfolding in the pages of your newspaper. Indeed your article forms part of that campaign. You write about people who 'even today claim to have been the founding fathers of dissidence or opposition in Russia' meaning the Sinyavskys. But of course the Sinyavskys have no need to make any such claims. All serious research by writers who are not involved in émigré squabbles shows that the Sinyavsky-Daniel trial was a catalyst for much that has happened in Russia since then. For some reason you want to strike this fact out from the pages of history; you object to the very

phrase, 'the Sinyavsky-Daniel trial' and so you add to it, scathingly, 'as people are pleased to call it even today' (and what else would you suggest calling it?).

You have used the tried and tested method of rewriting history to turn an honourable character into a moral monster. To achieve this, journalists in your newspaper have quoted and commented on extracts from KGB documents. But your readers are unaware that these documents have been doctored. And for obvious reasons, none of these investigative journalists have included this crucial sentence of Andropov's which comes from those very documents and which damns your whole enterprise: 'Thanks to our measures, Sinyavsky's name has definitely been compromised among those elements of the creative intelligentsia who formerly sympathised with him. According to our sources, some of his associates think that he has links with the KGB.' ...

In the same issue of RM you have published next to your article a literarosophical (I don't know how else to describe it) essay by a certain Inna Rogachiya, in which she attempts to blacken Sinyavsky's name by selectively quoting from the text of *A Voice from the Chorus*, this book which was born in the gulag.[19] She quotes: '*I'm getting porridge again and have visibly put on weight.*' And with the perspicacity of Hercule Poirot she notes that this was exactly two months after Andropov's secret note. In the mind of the innocent reader this gives rise to the idea (and that is clearly the intention) that Sinyavsky got porridge in return for some services to the KGB. Then Rogachiya comments on my afterword to *A Voice from the Chorus*:

'*Oh please!*' she says. '*Was the esteemed author of the afterword perhaps getting his dates mixed up, and painting a picture of hard labour in Tsarist times? When were Soviet political prisoners ever allowed to write 15 or 20 page letters? And regularly, at that? Letters about literature?*' She seems to be implying that Sinyavsky was writing these letters with the special blessing of the camp authorities while no-one else was allowed to.

But everything goes into this soup which you are determined to cook up, everything is grist to your mill, so that even if you can't prove the impossible, you can at least throw doubt on what is patently obvious. And then we really do end up in a moral twilight...

In order to preserve the appearance of objectivity, RM printed a very small extract from my letter (20 lines out of a four-page letter). The editor issued

no apology for publishing misinformation. To add insult to injury, in the April issue of *RM* I was astonished to see a reply to my unpublished letter from my acquaintance Igor Shelkovsky. In it he made out that Sinyavsky had been attacking not only Solzhenitsyn but also Sakharov – a preposterous accusation.

* * *

I was always struck by the fact that opponents of the Soviet authorities adopted the very same methods that the Soviets themselves used. These tactics – sticking insulting labels on people, blackening their names, denouncing them – were not the exclusive province of Russian political émigrés in Paris and nor was Sinyavsky's case unique. The same sort of thing happened to our old friend Alik Dolberg.[20]

Unlike most of us, Dolberg came from a well-off family: his father – a major in the NKVD – had been responsible for building bridges somewhere in the Dalstroy system[21] and from his earliest childhood Alik had been taught both good manners and foreign languages. He graduated from the Romano-German department of the Languages Faculty at Moscow State University with a remarkable knowledge of ancient and modern languages. In 1956 he succeeded in joining a tourist group to the German Democratic Republic. In East Berlin he boarded an underground train and got off at the first stop in West Berlin (this was before the wall had been built). He managed to bypass official checkpoints and asked for political asylum from the Americans. He had told me of his plans before leaving Russia and had advised me to do the same. I replied that I was too old for such reckless ventures (I was 25 then – five years older than him). Dolberg was tried *in absentia* for betraying his country and sentenced to 15 years in the camps. Even though he had emigrated his problems were far from over. The Americans were immediately suspicious of him. As well as being surprised by his perfect English, they were struck by the way he ate his peas at dinner time from the back of his fork. Where could he have learnt Western manners and such brilliant English, if not at Spy School? A document which fell into American hands seemed to provide the answer to this mystery: it revealed that Aleksandr Dolberg was none other than the nephew of the unmasked Soviet agent Abel[22] who would in due course be exchanged for the American pilot Gary Powers.[23] It wasn't difficult to guess where this document had come from. Nevertheless, Alik

was sent to a camp for displaced persons along with real spies and agents – and he only got out of this camp with great difficulty. This was quite a shock to him.

When I arrived in London in 1972 I was the first person who could confirm that Aleksandr Dolberg was not a cover name for a spy but actually Alik's real name and surname. But for the 17 previous years doubts about his reputation had bubbled away in the cauldron of emigrant squabbles. As usual, Russian emigrants took a delight in abusing their nearest and dearest. In 1974 Aleksandr Glezer came to London to arrange an exhibition of unofficial Soviet art.[24] He stayed in Alik's flat but when he got wind of the rumours about Dolberg he immediately began to put people on their guard against him.

The situation Dolberg found himself in was partly due to his own stupidity. With his mastery of half-a-dozen European languages and his knowledge of Russian and foreign literature, he could have had a decent academic career in Britain but the poor devil was attracted by the idea of political journalism, a field already oversupplied with anti-Soviets who were well past their sell-by date. He co-authored the first English-language biography of Solzhenitsyn with an English journalist. I read this opus as soon as it came out and was astonished by the apologetic and obsequious tone in which the great writer was discussed. We didn't have to wait long for a reaction to come from Moscow. The hero of the biography thought it was a grubby concoction and a hodgepodge of unsubstantiated rumours. Solzhenitsyn had appended his signature.

* * *

I could to a certain extent understand the position of Ilovayskaya and even Voronel: as newspaper editors they were under pressure to cover sensational stories, disputes, controversies; they had their proprietors and their readership to consider. But what to make of Alik Ginzburg, who had compiled *The White Book*[25] about the Sinyavsky-Daniel trial, Bukovsky, who had demonstrated for that trial to be open to the public, what to make of Kuznetsov, Chukovskaya, Livshitz – all these heroic dissidents and activists who were now joining in the persecution of Sinyavsky? How on earth could one explain such a phenomenon?

CHAPTER 23

Politics versus Aesthetics

In 1988 I was working at the Hoover Institution at Stanford University in California. I was writing my book on totalitarian art[1] and my friend, Vladimir Bukovsky, who had graduated from Cambridge in neurophysiology and had got a grant to do research at Stanford, was dissecting rabbits. From time to time we met up.

Once we stayed up all night in his apartment, drinking and arguing. Maksimov was cranking up his campaign against Sinyavsky at that time and I wanted to be clear where Bukovsky stood. I was shaken by what he came out with in the early hours of the morning. 'I'm not interested in Maksimov', he said. 'I just need to screw a quarter of a million dollars out of the Congress or the Senate and that'll be the end of Soviet power.' Those were his exact words. Towards dawn we rolled out of his apartment still arguing, right up to the moment when Bukovsky, practically tearing his shirt off, shouted, 'I have the right to do what I like! How many years did I do in prison?' To which I replied, 'Volodya, I respect you because you graduated from Cambridge, not because you spent time in the camps.'[2]

At an Oxford dinner I had once happened to sit next to Bukovsky's tutor from Cambridge, a distinguished biologist (I think he was a Nobel prize winner but I don't remember his name). He was amazed that someone who had spent so many years in prison could master mathematically based developments in biology that were completely new to him. Bukovsky got his place at Stanford in spite of, not because of, his dissidence, but instead of cutting up rabbits he spent his time pestering the life out of newspaper editors, senators and congressmen.[3]

Naturally, for someone with a great political goal, however illusory it might be, everything else was of secondary importance, including considerations of basic morality; anything which stood in the way must be

swept away by any means necessary. In these circumstances the political took precedence over the aesthetic.

After he emigrated, Sinyavsky said, somewhat tongue-in-cheek, that his differences with the Soviet authorities were aesthetic rather than political. This aroused a storm of indignation among former dissidents – a storm that caused him a great deal of pain. For them, the precedence of politics over aesthetics was indisputable. For Sinyavsky the question of aesthetics was much broader and deeper than politics. Aesthetics included the traditional categories of goodness and beauty as well as an understanding of the truth. In other words, it included within it a conception of moral and aesthetic norms about good and evil, about justice and arbitrary power – everything that people who focused on politics could easily neglect in the interests of what was (for them) a higher aim.

A political opposition always needs a leader. When, at the very beginning of this story of Sinyavsky's persecution, Alik Ginzburg came to Oxford, I asked him the same question I put to Bukovsky and got a straightforward and honest answer: 'I'm playing for the other team.' There was no need to ask who was the captain of this other team. The *leitmotif* of the campaign to 'unmask' Sinyavsky was his supposed hatred of Solzhenitsyn, the assertion that it was Sinyavsky himself who started the persecution of the great Russian writer. To say that people got this wrong would be an understatement.

I had been a witness over many years to the relations between the Sinyavskys and the Solzhenitsyn family. Back in Moscow Rozanova had been friendly with Solzhenitsyn's wife, Natalya Svetlova – the two women took their children to the same playground; when the Solzhenitsyn children needed a doctor it was Rozanova who took our friend Emile Luboschitz, the well-known Moscow paediatrician, to their house, and he was the only doctor that Solzhenitsyn trusted. Not long before Sinyavsky emigrated he and Solzhenitsyn met (at the latter's suggestion and apparently for the first and only time) in a wood on the outskirts of Moscow. Solzhenitsyn tried to persuade Sinyavsky to write a historical novel about Russia. It was a completely misguided suggestion. On the day Solzhenitsyn was arrested I was in the Sinyavskys' apartment in Paris and I saw the efforts Rozanova made, telephoning friends and organisations, giving advice to Natalya, preparing a campaign in defence of Solzhenitsyn. And when Solzhenitsyn was expelled to the West she invited him and his family to stay in her house.

When *One Day in the Life of Ivan Denisovich* had appeared in *Novy Mir* in 1962 we all eagerly devoured the story. Sinyavsky at that time was highly appreciative of the artistic qualities of the work, but he did say that it was Solzhenitsyn's masterpiece and that he would never write a better book: he was only capable of writing about what he himself had seen – he lacked a creative imagination. The 'stylistic differences' between Sinyavsky and Solzhenitsyn stemmed from this remark.

Misha Nikolaev writes in his memoirs that when he came to our house for the first time after he was freed from the camps, there were people sitting on the floor reading and passing around pages from a typescript – this must have been either *Cancer Ward* or *The First Circle*. We took great pleasure in both these novels.

Then *August 1914* appeared in *samizdat*. Boris Shragin invited people over to discuss the book. Sergey Averintsev, Valentin Turchin and some others came (I don't remember exactly who). The general reception was rather lukewarm. Solzhenitsyn had no direct experience of the events of World War I and his customary vivid descriptions of real life and his precision of detail were replaced here – with the exception of a few successful pages – by woolly descriptions and a very one-sided portrayal of the events of that war. Sinyavsky was right. This was the beginning of a falling-off in quality (the following 17 volumes of *The Red Wheel* were simply unreadable).

Soon after our arrival in London, Nikita Struve[4] invited me to dinner and naturally we talked about *August 1914* which had recently been published by *Vestnik RSKhD* (*Herald of the Russian Christian Movement*). I told Struve about our meeting some years before at Shragin's place and our criticisms of the book. As I found out later, my remarks were interpreted as expressing the categorical opinion of Sinyavsky and we were straight away counted among the 'denigrators' of the great writer.

It was not Sinyavsky who started the dispute with Solzhenitsyn but Solzhenitsyn who set in train the hounding of Sinyavsky. Yefim Etkind, who had been a very close friend of Solzhenitsyn in Moscow, testified to this (*Russkaya Mysl*, 5 March 1993). At the beginning of 1975, Etkind, who had already emigrated, received the typescript of an article sent from Moscow, signed with the initials 'S.O.'. There was a note with it asking Etkind to deliver the typescript to *Russkaya Mysl* and to mention that Solzhenitsyn was taking a personal interest in it. It was a very badly written

article. The author, S.O., did more than disagree with Sinyavsky; he denounced and defamed him. Etkind sent the article to Solzhenitsyn in Zurich saying that he considered it unpublishable. He received a reply which expressed approval of the article and demanded that he send it straight to *Russkaya Mysl*.

Etkind's testimony was like a voice crying in the wilderness. *Russkaya Mysl* not only continued to ramp up the theme of the hostility between Sinyavsky and Solzhenitsyn but also found a rational explanation for it in the pronouncements of a certain Viktor Lupan (who later became editor of *Russkaya Mysl*), which were published in the weekly magazine *Moskovskie Novosty* on 24 January 1993. Lupan's opinion was that the Sinyavskys had been 'broken by the KGB and despatched to the West with the primary aim of conducting a campaign against Solzhenitsyn'. And after the publication in *Vesti* of the doctored letter from Andropov, it became obvious to the émigré community (primed by Solzhenitsyn) that Sinyavsky was an 'agent of influence'. Thinking it all over now, I am increasingly convinced that the boot was very much on the other foot. It was Solzhenitsyn who was the 'agent of influence'.

I am not for a moment – I must emphasise – accusing Solzhenitsyn of working for the KGB. What I am saying is that I have a theory, perhaps too daring a theory, but one which deserves consideration.

Andropov, as head of the KGB, was able to create a kind of think-tank in his office. In place of the usual thugs he enlisted professionals – psychologists, sociologists, 'politologists'... Georgy Shchedrovitsky told me that the brightest students from the Philosophy Faculty at Moscow State University went straight to the KGB after graduation. There they had ample opportunities to work in intelligence, informed by classified sources unavailable to mere mortals. In the case of Solzhenitsyn these people must have understood perfectly whom they were dealing with. His anti-Western stance, his nationalism disguised as patriotism, his contempt for pluralism and the liberal dissidents, the 'intellectuals', the 'demis', as Solzhenitsyn sneeringly called the democratic movement – all this had much in common with the KGB's outlook. Solzhenitsyn's views could not fail to divide the émigré community, provoking the opposition of the liberal intelligentsia on the one hand and the enthusiastic support of patriots and nationalists on the other. Solzhenitsyn's arrest in Moscow and subsequent bundling (in handcuffs) onto a plane bound for the West served

as a ringing endorsement of his status as a martyr and the number one enemy of the Soviet Union. He was accepted as such in the politicised émigré community. Andropov had made a very clever move. Unleashing Solzhenitsyn on the West was like sending a fox into the henhouse. He duly wreaked havoc.

From his lonely vantage point, the hermit of Vermont kept a steely eye on émigré activity in Europe and nudged it in the direction he wanted it to go. As a result all the main émigré publications – from the Russian Orthodox-patriotic *Vestnik RSKhD* to the unbuttoned *Russkaya Mysl*, from the hidebound *Kontinent* to the worker-peasant *Posev* – were heavily influenced by Solzhenitsyn. Ilovayskaya flaunted her friendship with Solzhenitsyn and his close links with her newspaper, *Russkaya Mysl*. Nikita Struve published Solzhenitsyn's works in his YMCA Press, Solzhenitsyn kept his eye on Maksimov, and Maksimov took his cue from Solzhenitsyn. Thanks to their combined efforts, the original managing director of *Kontinent*, George Bailey, was appointed head of Radio Liberty. Sinyavsky's publication of his *Strolls with Pushkin*, written in the gulag, was the final straw which finally convinced Solzhenitsyn of Sinyavsky's malicious intention to throw mud at the sacred name of Pushkin and undermine the foundations of Russian culture.[5] So a new orgy of revelations about Sinyavsky began.

I don't know what the relationship between Voronel and Solzhenitsyn was like at this time. Clearly there was some kind of contact. Solzhenitsyn followed the Israeli journal *22* and made use of material published in it for his own essays. After Solzhenitsyn returned to his native land, Voronel and his wife visited him in Moscow to pay their respects and published admiring and enthusiastic articles about him. Solzhenitsyn's poisonous hints about Sinyavsky's supposedly privileged living conditions in the gulag and his early release were fleshed out by Nina Voronel in her memoirs. In her article, 'Yuly and Andrey' in *Questions of Literature* (*Voprosi literatury* 5, 2002), she put forward the 'unlikely but intriguing', as she put it, hypothesis that even the Sinyavsky-Daniel trial was merely a stage show aimed at establishing Sinyavsky's reputation as a leader of the dissident movement prior to sending him to the West as an agent of influence. And Aleksandr Voronel himself is still harping on this theme: in his 2011 miscellany, *Jewish Antiquity* (*Evrayskaya Starina*), he published an article, 'The Trial', in which he repeated old arguments and proposed new ones (all completely far-fetched) to support such 'hypotheses'.

All this caused Sinyavsky to fall into a deep depression. I kept saying, 'Andrey, why do you give a damn about the pathetic Russian press? Just focus on what all the major European critics, writers and scholars say and write about you.' This had no effect whatsoever on Andrey. His great reputation in the West as a writer, as a human being and as a fighter against the Soviet regime meant little to him. On the other hand the insulting absurdity of every new dig at him in the Russian language left him sadly bewildered.

For all his respect for the West, Sinyavsky lived within Russian culture, and all his own creative work was dedicated to that culture. He didn't find much satisfaction in his teaching post at the Sorbonne. He delivered in-depth lectures on Kuzmin,[6] Mayakovsky, Russian civilisation, Vasily Rozanov. He developed these lectures into books. But the only people who attended the lectures were a few conscientious PhD students and a bunch of elderly Russian ladies who wanted to hear their native tongue. Sinyavsky began to drink heavily.

When Maksimov saw the second archive document, the minutes which made clear the KGB's intentions to compromise Sinyavsky in dissident circles, he felt sufficiently guilty to apologise to the Sinyavskys publicly, in the pages of *Kontinent*:

> For many years vested interest groups in the West and behind the Iron Curtain have asserted that the Sinyavskys had dealings with the KGB. 'Galina Borisovna'[7] disseminated false information which found fertile ground and had consequences which we can only regret today ... therefore I consider it my duty to apologise to Andrey and Maria Sinyavsky for the suspicions I publicly expressed about their voluntary or involuntary links with the KGB.

After Sinyavsky's death, Ilovayskaya had the bare-faced cheek to assert in an interview with *Corriere della Sera* that he had in fact been recruited by the KGB and had more or less died of remorse after admitting his guilt.

I would have liked to be able to ask Solzhenitsyn's former admirers what they thought about his returning to live in the Russia of Putin and the KGB? A Russia where the prison-guard culture has spawned magnificent offspring in every nook and cranny of the country. Of course Solzhenitsyn's anti-democratic, anti-Western stance, his nationalism, his Russian Orthodoxy – all those things that were opposed by the Sinyavskys and

the liberal intelligentsia — became the cornerstones, if not the actual foundations, of the ideology of the current incumbents of the Kremlin. Solzhenitsyn was heaped with new, exalted honours, Putin went to pay his respects to him, and it was decided to introduce extracts from his *Gulag Archipelago* as set texts in schools (maybe this has already happened?). Putin and Medvedev lit candles over his coffin while the descendants of the guards from that very same gulag joined in singing 'With the Saints give Rest, O Christ'.[8] Unfortunately, nearly all these admirers have already joined their idol in the other world so there's no one left to ask.

CHAPTER 24

Sinyavsky's Last Years

Andrey's last years brought him no peace. The KGB minutes which clearly demonstrated that the information about Sinyavsky's apparent collaboration with the KGB had come directly from their own headquarters had already been published, and Maksimov had already apologised in print for his earlier attacks on Sinyavsky. Nevertheless, the émigré community refused to be appeased, and the persecution of Sinyavsky continued. He was also depressed by the situation in Russia where, following the collapse of communism, complete chaos was setting in.

Shortly before Maksimov died, he went to see the Sinyavskys and they co-authored some articles pointing out the cost of Yeltsin's[1] reforms. Maksimov consulted Rozanova and humbly agreed with everything she said. It was as if the author of *Saga about Rhinoceroses*[2] was a changed man. Soon after Yeltsin's storming of the White House,[3] Sinyavsky, Maksimov and Pyotr Yegides[4] met under one roof and wrote an article for *Nezavisimaya Gazeta* (*The Independent Newspaper*) entitled 'Under the Sturdy Protection of Law' in which they judged Yeltsin's action as a violation of the main principle of democracy – the rule of law. Yet again, in certain circles this article was taken as a confirmation of the Sinyavskys' pro-communist convictions. These people were perplexed by the question of how these former sworn enemies – the pluralist Sinyavsky, Maksimov, the rabid scourge of the left and Yegides, the socialist-with-a-human-face – could sit round the same table? Rozanova wittily commented on this perplexity so typical of the Soviet mind-set: 'when there's a forest fire, all living creatures run for their lives side by side, and no animal eats any other. They have more important things on their minds. And we certainly had a forest fire on 21 September. Perhaps that's why these old foes sat round the same table, to show, by the highly unlikely combination of their names, how very serious this event was.'[5]

About a year before Andrey's death, at a regular émigré gathering in Paris, which was attended by the unrepentant Madame Ilovayskaya and various émigré writers, Sinyavsky was again accused of mortal sins. He left the hall and collapsed. The hospital diagnosed a heart attack. He was forbidden to smoke but after six months he was found to have lung cancer which rapidly metastasised in his brain.[6]

During the years after my retirement from the BBC I often went with my second wife, Flora, to Fontenay-aux-Roses, the Paris suburb where the Sinyavskys lived. Andrey was usually depressed. I got the impression that as a result of all the attacks, accusations, insults, all the intrusive visitors and needless conversations, as a result of all this reality weighing down on him, he sank deeper and deeper inside himself. He retreated into his work. He worked on his last novel, *The Cat's House* (*Koshkin Dom*) and re-read his favourite books. Instead of human society he preferred communing with his cat Kaspar Hauser or with his feathered friends: 'I settled on my favourite bench to feed buttery crumbs to the sparrows and pigeons ... I could already recognise individual birds. I told them off when they squabbled over my crusts. I taught them manners. I recited poetry...and those birds also learnt to recognise me', he wrote in his marvellous last essay, *A Journey to Chernaya Rechka* (*Puteshestvie na Chernuyu Rechku*).[7]

Rozanova called all this 'a game of self-abasement', but it wasn't a game; he was being true to his nature. For example, Sinyavsky was constitutionally incapable of going first into a stranger's house, and towards the end of his life he would get very annoyed if people insisted on ushering him in ahead of them.

When people came to dinner he sat for the most part silent, and nursed his glass. In the old days alcohol had helped relieve the tension of constantly waiting to be arrested in Moscow. Now it could be counted on to help drive obsessive thoughts out of his head and enable him to leave reality for the bright world of the imagination (nowadays I myself have recourse to the same remedy). His illness also played its part.

Rozanova took him to see all sorts of doctors and healers. Sometimes there would be a temporary improvement, followed by a setback. For the last few months of his life Sinyavsky hardly left his bed. He was fed with a spoon, not allowed to drink, and suffered from thirst. Sometimes I smuggled in a glass of 'water' for him. Where was the harm!

Sinyavsky died on 25 February 1997. His last words were, 'To hell with the lot of you!' This unconventional parting remark was not just addressed

to his nearest and dearest but to all of us who were fussing round his bed and distracting him from some final, obviously very important, thoughts. 'What the artist needs is a melancholy feeling of freedom and luminous solitude', he wrote in his essay about Boris Shveshnikov. It was what Sinyavsky himself needed more than anything else and which fate had always denied him. He was persecuted in Russia and hounded as an émigré, and I believe that with his last breath he was damning that whole reality which oppressed him throughout his life.

Sinyavsky was buried in the local cemetery at Fontenay-aux-Roses in a ceremony conducted by the Moscow priest Vladimir Vigilyansky (the *padré* as Rozanova called him). Friends of the Sinyavskys came from Moscow – Andrey Voznesensky, Vitaly Tretyakov (at that time the editor of *Nezavisimaya Gazeta*). Voznesensky threw a handful of Russian earth into the grave.

Many people turned up to the funeral. Their French neighbours, casual acquaintances, the woman who ran the local cafe where Andrey was a regular, the Mayor of Fontenay-aux-Roses, who said in his graveside address that the town was proud of its famous fellow citizen. There was not a word of official condolence from Moscow.

CHAPTER 25

Perestroika

I was at Harvard[1] when I was surprised to learn of the start of the Gorbachev thaw. I had no faith in the possibility of any radical change in the Soviet system. I thought that it would be a repeat of what had happened in 1956: after a temporary relaxation everything would go back to normal. I was mistaken – something considerably worse happened. The history of Russia took a leap, not a leap forwards, however, but sideways. The epoch of chaos began.

I went back to Moscow for the first time in 1988 and stayed in the apartment of our friends, Ada and Oleg Gorbachev, on Lenin Prospekt. There was a feverish mood in Moscow. On the one hand people were euphoric about the hope of imminent changes; on the other they feared they would soon go hungry thanks to the empty shelves in the shops and the depreciation of the rouble. The streets were thronged with markets where people were selling their last possessions so that they could at least buy some bread, and the metro stations and underpasses were full of beggars. My first impressions of Moscow were ambivalent. Once when I was coming out of the University metro station in broad daylight I witnessed an unbelievable sight. A man was pressed up against a pillar with his hands raised. Another man was holding a gun to the back of his head; a third was patting him down from head to foot while a fourth kept a lookout. A dense crowd of people streamed out of the metro and no-one took the slightest notice of this outrage. Clearly, Muscovites were accustomed to such things.

Another time I was standing among the crowd on the platform of the Lenin Library station. I don't have extra-sensory perception but on this occasion I suddenly became aware of a wave of malicious hatred directed towards me. In order to escape this wave I even moved to board a different carriage. A man of about 30 followed me in. He was wearing a tracksuit top

and looked like a typical Russian football fan. He placed himself by the doors and stared at me. We both got out at University. There weren't many people around and he immediately came up to me.

> 'Want me to cut yer throat?' He gestured with his hand as if he were opening a tin.
> 'Go to hell.'
> 'You're a Jew, aren't you?'
> 'Go to hell.'

He seemed a bit taken aback. He didn't say anything else, just spat at me and ran off. That was the sum total of our conversation.

On the other hand, when I met Leonid Bazhanov I believed, albeit briefly, in the positive possibilities of perestroika.

In my day, Bazhanov had some unskilled job at the Pushkin Museum, then he graduated in Art History from Moscow State University and worked for Yury Ovsyannikov in the editorial offices of the magazine *Questions of Art History* (*Voprosi iskusstvoznaniya*). I hardly remembered him but he had always sent me greetings via Yury and when he later visited England himself we finally got to know one another. Bazhanov was obsessed with the idea of founding a centre for contemporary art in Moscow and had already taken the first steps towards realizing this goal. And now he showed me his domain.

A little backstreet somewhere in the old Zamoskvoreche district of Moscow. Across the street a sign projected from the wall of a residential building – *Hermitage Gallery*. In a shabby, two-roomed Moscow apartment there was a private view going on for the exhibition of some abstract artist. Cheerful faces, speeches, toasts, a friendly, enthusiastic atmosphere. Photography exhibitions in two former district palaces of culture ... Here were fresh shoots, piercing through the dried-up bark of official culture.

A year later, when I made my second return visit to Moscow, Bazhanov's Centre had expanded significantly. Now he had a whole square of houses round a large courtyard somewhere on Pyatnitskaya Street. There were already three functioning exhibition spaces, in one of which Zlotnikov had a show going on.[2] There was the sound of hammering; the space was being partitioned into a printing press area, a library, a guest room. Then it all went to pot. Bazhanov never told me why it collapsed. I think that, as was usual at that time, his colleagues privatised it all. After this, Bazhanov joined the Russian Ministry of Culture as head of the Department of Arts. He had a

single aim in mind – to somehow get hold of state funding for a centre of contemporary art. He thought it would take three years; in fact it took five. But the result was that the centre was given the former estate of the artist Polenov,[3] not far from Moscow Zoo, with three buildings which in time were equipped as exhibition spaces, reading rooms and research laboratories, a library, archives. Nowadays it is the major non-commercial cultural centre in Russia with branches in Yekaterinburg, Kalingrad and various other towns. For me, it was for many years the only cultural oasis in Moscow where one could meet old friends, acquaintances and young enthusiasts who were selflessly devoted to art.

These were the impressions I got from the surface layer of post-perestroika Russia. I discovered firsthand what lay in the depths when, in autumn 1990, friends invited me to participate in a public ceremony to unveil a commemorative stone brought from the Solovetsky Islands[4] to Dzerzhinsky Square.

At six o'clock in the evening we all gathered at the Krasniye Vorota (Red Gates) metro station and a huge crowd streamed along Kirov Street to Dzerzhinsky Square. Demonstrators carried placards and banners – 'The Communist Party's hands are covered in blood!', 'Down with the KGB', 'Long Live Democracy!' and so on. As we passed offices and residential buildings the windows opened, women waved handkerchiefs and called out greetings to the demonstrators. People ran out of doorways and joined us. Dzerzhinsky Square was jam-packed. A platform had been erected near the large Solovetsky boulder and right next to the bronze statue of Feliks Dzerzhinsky, the founding father of the gulag system and the creator of the Soviet secret police.[5] Former inmates of the Solovky camps and leaders of perestroika made threatening speeches from this platform; they waved their fists and cursed the blood-stained regime of the Communist Party and the KGB. Dusk was approaching and as it got dark lights began to come on in the offices opposite us. By the time the demonstration ended the whole of the huge building occupied by the KGB was lit up like a Christmas tree. It resembled a scene from a Fellini film but it engraved itself in my mind as a symbol of what was happening in the country. The KGB was hard at work. Implacable Chekists[6] were going about their business, preparing for regime-change, for the day when they would replace the Communist Party. Which is exactly what happened.

* * *

Since leaving Russia I have had a recurring dream: I arrive in Moscow and walk among the crowd (through the airport?) past a glass wall. Through the glass I can see the faces of my friends who stayed behind in Russia. They are smiling at me but I am afraid that a glance or gesture from me will betray the fact that I know them. Just such a barrier, but a psychological one, stood between my friends and me after my 17-year absence.

As soon as I arrived we met up in the Gorbachevs' apartment. Villya Khaslavskaya, Galya Demosfenova and Natasha Razgon were all dog-lovers and the conversation straightaway turned to dogs. One anecdote followed another about the doings of their four-legged companions.

'Friends,' I implored eventually, 'that's enough about dogs! After all, it's 17 years since we've seen each other.'

There was a short pause and then they went back to the subject of dogs. At the time I found this very odd. Later I realised that for them my life as an emigrant was shrouded in mystery and it was no easy matter to cut through this fog to the important questions of existence. And I myself could only vaguely imagine the reality of their daily existence during all these years. I had brought various provisions with me to half-starved Moscow and I proudly produced from my bag a very long object, wrapped in paper.

'Sausage!' they all shouted delightedly. 'Cucumber,' they all chorused with disappointment when I unwrapped it.

In my time a fresh cucumber in winter had been a highly prized item, but by now this hothouse product had lost its novelty. Fortunately, I had in fact also brought sausage. There was a barrier between us and it took time for it to come down.

Since the 80s I have hardly been back to Moscow. Everything that has happened in Russia under Yeltsin and since has rid me of any desire to breathe the air of crime and corruption or to hear the smug rhetoric that vaunts the Motherland as a great power surrounded by enemies – all this is familiar to us from the old days. Of course my friends are still there, but now many of them are able to travel to the West. And that has been one of the rare benefits of perestroika.

CHAPTER 26

Family Matters

In 1989 I was 60 – the age at which BBC employees had to retire in those days. Retiring didn't make much difference to me. I continued to make programmes as a freelancer, covering the cultural scene in Britain, contemporary art and prominent people, past and present. However, the BBC Russian Service itself became completely different.

When perestroika began in the Soviet Union reforms also started at the BBC. Many people at that time believed that the collapse of the communist regime in Russia would usher in an era of genuine democracy. They thought that the Communist Party and the KGB were now only relics of the painful past. As time went by such illusions dissipated, but they had already taken root among the management of the World Service at the BBC. This had devastating consequences for the Russian Service.

From the mid-eighties, the strategy, organisation and character of the broadcasts underwent fundamental changes. The political vetting of new entrants was practically abolished. The main selection criterion now was the candidate's fluency in English (presumably to make it easier for the new management, who didn't speak much Russian, to communicate with their subordinates). The question has to be asked: which people in Russia at that time could get high-level training in foreign languages, and where? You don't have to look far for the answer: the children of the nomenklatura,[1] employees of the state propaganda organs, broadcasters on international affairs, foreign correspondents who had studied at specialist language schools, not to mention actual spies. That's the sort of crowd which started to find its way into the Russian Service at the beginning of perestroika. The problem was not so much a matter of these people's previous professions as of the general mind-set they brought with them. For them, the interests of contemporary Russia counted for more than the objective presentation of events which was traditional at the BBC. Some of these professionals

occupied senior management posts in the Russian Service and it was precisely these people who implemented the new reforming strategy.

The only vestiges of the old Russian Service were to be found in our features department which had been headed for many years by Masha Karp, a talented translator of English literature. She held onto the old broadcasting principles. So, shortly after the Litvinenko scandal[2] in 2006 Masha made an in-depth programme about him. It was suspected that the former FSB colonel, Aleksandr Litvinenko, who had been fiercely critical of Putin's regime, had been poisoned by Russian special agents in London, where he now lived. This shocking story was being widely discussed in the British press. But for the Russian Service this topic proved to be off-limits. The Litvinenko programme was banned from the airwaves,[3] and Masha received a reprimand. It was not long before the features department was disbanded on orders from senior management and Masha Karp and nearly all the old team had to leave.[4]

The BBC subsequently cut the number of staff in the Russian Service in London and increased numbers in its Moscow bureau. The phenomenon of journalists of Russian nationality, broadcasting in the name of the BBC from Moscow, under the eyes of the Russian state – in the old days this situation could only be imagined in your worst nightmares. People in Moscow at that time said that you couldn't distinguish the BBC broadcasts, either by their slant, or by the voices and intonation of the presenters, from a dozen homegrown Russian stations. And impartial observers describe the content of these broadcasts by the Russian Service as 'pro-Kremlin'. And that's the saddest thing of all: the BBC lost its identity.

My freelance work also dried up. Actually, I wasn't too upset by this, although I had enjoyed my work and the programmes I had made gave rise to my books, *The Camp Drawings of Boris Sveshnikov* (2000), *Avant-garde Art in Europe and America* (*Iskusstvo avangarda v portretakh ego predstaviteley v Evrope i Amerike*) (2004) and *English Art from Hans Holbein to Damien Hirst* (*Angliyskoye iskusstvo ot Gansa Golbeyna do Demiyena Khersta*) (2008). But I simply could not have gone on working at the BBC under the new regime.

* * *

My private life went off the rails after I emigrated. As I've made clear earlier in this memoir, I didn't really have a home or a family life until I was 40. I was that rare thing, a Jew without relatives. Work, friendships, cultural

interests had been more important than worries about domestic life. I fell in love from time to time but the objects of my passion suspected that I was not good husband material and didn't reciprocate my feelings.

'Of course, a woman is also a human being', my friend Sasha Pyatigorsky used to say, and then, leaning over confidentially, would add, 'But you and I both know that that can't really be the case.' Clearly, I loved women as I loved music, without understanding anything about them. So I was in love with Nina for 15 years before we began our life together. I didn't even think of getting married. A ceremony in a Soviet wedding palace seemed to me ugly and pointless. I didn't realise that for a woman marriage is the bedrock of a stable existence.

Thank goodness Nina didn't suffer from nostalgia, but the tensions of our earlier life in Moscow were not without consequences. Moreover, Nina was already 43 when she had our son Benjamin and perhaps she suffered some psychological shock while giving birth. I was unaware of it at the time. When we went to the registry office to get Benjamin's birth certificate, Nina suddenly decided to register him under her surname. As she explained later, she had been afraid that having my surname might cause him harm, and she had made up her mind not to leave Russia. This was a blow to me. Then everything changed; we did emigrate, but a trace of mutual resentment followed us into our new life. For several years we were to all intents and purposes living separate lives. When I came back from America I rented a room in London and Nina continued to live in our house in Oxford. And then Flora appeared on the scene and I fell in love with her. And, just like Nina before her, she spent eight years hesitating, doubting, before we finally got together.

I had first met Flora at the Pushkin Museum not long before I emigrated. After graduating she went to work there, first as a guide and then as a researcher in the archeology department. We only knew each other slightly but there was some sort of mutual attraction. When the male staff were electing 'Miss Museum' it was Flora who got my vote although the museum had a whole array of pretty young women working there.

In 1981 I got a letter from Vienna. Flora informed me that her husband, a conductor and violinist from Moscow,[5] had been invited to work in the Netherlands and they were leaving the USSR. Shortly after their arrival in the Netherlands they separated. Flora was left alone in a strange country where she didn't speak the language and only her perseverance and strength of character enabled her to master the Dutch language and find herself a job

in a travel bureau. She took tourists around the Netherlands, France (she spoke very good French), and Belgium. She used to visit London (where our love affair began), gave lectures at Amsterdam university, taught at a summer school in Bavaria, wrote articles for Russian-language newspapers; in a word she did all the usual things that émigrés with arts degrees did to keep body and soul together in a foreign land.

Her family history was typical of many Jewish families who came to the Soviet Union from the outposts of the former Russian empire. Her father, Mikhail Goldstein, traced his origins to the shtetl of Loshits[6] near Warsaw; her mother, Berta Iosifovna came from a similar shtetl not far from Pinsk in Belorussia (now Belarus). At the beginning of the twentieth century both families had escaped from the pogroms to Argentina, where Flora's future parents met. Like many Jews from the borderlands of Russia they sympathised with socialism. Berta was somehow linked to the Bund[7] when she was young and Mikhail wrote articles for left-leaning newspapers. Towards the end of the 1920s, they left Argentina and travelled to the Soviet Union to help build the socialism they longed for. They were received in Leningrad as honoured guests but were soon sent to build this same socialism in Birobidzhan.[8] Conditions there were harsh and there was not even a whiff of socialism. Their baby daughter perished – she simply froze to death in the unheated shack they were living in. Two years later the family resettled in Moscow. Mikhail Goldstein got a place at the Literary Institute. Their second daughter, Karma, was born in 1933 and Flora in 1937. In that same year Mikhail was arrested on suspicion of spying for some unspecified foreign power. He spent two years in prison, but after the fall of Yezhov[9] he was released along with a small number of other prisoners. Then he went down on his knees and begged Berta to forgive him for bringing her to the Soviet Union. In 1941, Mikhail volunteered for the front as a German-Russian interpreter. In 1943 he perished at Smolensk.[10]

Berta Iosifovna was left alone with her two small daughters. She didn't speak Russian, she had no one to help her. Clearly it was only her strength of character that allowed her not only to survive, but to successfully bring up her daughters. The girls went to music school to learn the violin. Karma became an orchestral player and violin teacher. Flora studied archaeology at Moscow State University.

Nina, for reasons best known to herself, wouldn't give me a divorce. So Flora and I live in sin.

Instead of a Conclusion

The Benefits of Pessimism

In these difficult days if you are a pessimist you can easily pass for a prophet. I have to admit that no one thinks I'm a prophet; but as far as political developments are concerned, my most pessimistic premonitions and speculations always come to pass. I was never a Leninist or a Stalinist, I didn't believe in socialism with a human face or in democracy as a panacea for all the social ills and injustices in this world. I didn't fall under the spell of the highly politicised democratic movement. I had no faith in the thaw of the 1960s or in the perestroika of the 1980s because I understood that in Russia everything will always find a way back into its usual rut. I never became disenchanted because my pessimism had never allowed me to become enchanted. And so, in my old age I don't suffer from insomnia, I sleep peacefully and my conscience doesn't torment me, as it does many of my contemporaries who regret the errors of their youth.

For the pessimist life is hard, but death is easy.

London – Amsterdam 2009–12

Afterword

Robert Chandler

On 11 January 2018, on what would have been Igor's 89th birthday, we held a memorial evening for him at Pushkin House (London). Anyone who wished to speak – to tell a story about Igor, to express their gratitude to him in any way – had the opportunity to do so. It was only a week or two afterwards that I realised that all the speakers had, in their different ways, said essentially the same thing: that Igor, without any flag-waving, was always uncommonly sure of himself and true to himself. If only because he was unable to do anything else, he always acted in accord with his principles.

It was, perhaps, Yulia Vishnevskaya who articulated this most clearly. She lives in Israel and was unable to attend the evening. I have translated part of what she sent me a few days afterwards:

In the late 1960s, Igor and I both lived on the same branch of the Moscow metro. We happened to meet quite often. And this was unforgettable. In the metro – as if this were a perfectly normal thing to do – Igor used to read émigré publications of books by banned Russian writers – Russian-language editions of Nabokov, for example, published in the USA by Ardis. In Leningrad or the Ukraine, this would have got him arrested. In Moscow, at this time, it might not have been enough to get him arrested, but it could have had serious consequences – dismissal from work, a room search, and certainly confiscation of the books themselves. {. . .} Almost all of my friends at this time were dissidents. Many of them were men and women of desperate, even legendary courage – but none of them would have read Ardis publications in a public place, making no attempt to hide what they were doing. {. . .} What is most interesting in all this is that Igor was not in the least a bravado. He was not a man of desperate courage. He was simply without fear. He was a rock – a man one could always count on. If called, he would always come.

Igor's reading Nabokov in the metro may have impressed and inspired a younger friend, but there were occasions when Igor's consistent adherence to a clear moral code was not merely life-changing but – literally – life-saving. During the 1980s, Frank Williams, the head of the features department, was Igor's immediate boss in the BBC Russian Service. During the memorial evening, after emphasising how much Igor had taught him about the Soviet Union, he recounted the following story:

Igor had very stubbornly held beliefs, and one of his central principles was that writers should not be sent to the camps for views their characters expressed in works of fiction. Sometime in 1982 or 1983 Igor heard from the Posev representative in London that one of their authors, Leonid Borodin, had been sentenced to 10 years in a labour camp on the standard charge of anti-Soviet agitation and propaganda. Because this was his second offence, he would be sent to a strict regime camp near Perm, and he was not expected to survive.

Something, Igor said to me, had to be done.

Borodin was a strong Russian nationalist, and he was not a particularly brilliant stylist. He did not naturally fall into the group of writers we liked to promote on the Russian Service, and Igor would certainly have had no sympathy with his ideology. As for me, I had never even heard of Borodin until then. But that was beside the point. Writers should not be sent to a labour camp for the content of their stories, regardless of what we thought of them.

Igor wrote the standard-length half-hour biographical programme about Borodin and we ran a short series of extracts from his stories. We had no idea whether it would have any meaningful effect, but we had done what we could.

Borodin was one of the last writers to be sent to a camp, and he was released after serving four years. As glasnost and perestroika gathered momentum and the Soviet Union opened up, it became possible for me to get a work visa to visit Moscow myself. Either in 1987 or 1988 I visited Borodin in his home. He was visibly unwell. He was very thin, and he moved with some difficulty, but at least he was alive.

I wasn't sure what to say, but Borodin spoke first. He thanked the BBC: we had saved his life. When he went into the camp, his work norm was impossibly high, his food rations were inadequate, and he was not allowed any food parcels from home. He knew the authorities wanted him dead. He began to lose hope.

Then one day, things suddenly changed. The work norm was reduced to a more realistic level, and his food ration went up. Even better, food parcels from home began to come through. It seemed that the authorities no longer wanted to kill him.

The timing of this change, Borodin told me, coincided with Igor's programmes. They had been noted by the authorities. Borodin's case was on the international community's radar, and the last thing Moscow needed was yet another scandal about a murdered writer.

Principles can sometimes, it seems, save lives.

* * *

I myself have many reasons to feel grateful to Igor. I shall mention just one. In 1980 he showed me a copy of the first Russian edition of *Life and Fate*, recently published in Lausanne. If I wanted to establish myself as a translator, Igor said, I should translate this novel. I laughed, saying I did not read books of that length in Russian, let alone translate them. A month later, Igor – with his usual quiet persistence – sent me the transcripts of four radio programmes about the novel he had just made for the Russian service. Igor may, perhaps, have known me better than I knew myself. At the time, only in my late 20s, I thought I had little interest in the traditional novel; I read mainly poetry and more modernist prose. Igor, however, seems to have trusted me to be able to respond to the depth and truthfulness of Grossman's perceptions and not to be put off by the novel's old-fashioned structure and style. And Igor was right: I was immediately gripped. Very soon, I was translating a brief extract. With Igor's help, I published an article about *Life and Fate*, along with this extract, in the journal *Index on Censorship*. Collins Harvill then commissioned a translation. And a few years later they also published my translation of *Totalitarian Art*.

* * *

Igor's life would, of course, have been a great deal easier if he had been more adaptable. Another speaker at the memorial evening mentioned Igor quarrelling with his friend Alexander Pyatigorsky. Pyatigorsky had criticised him for not making more effort to assimilate into English society, and this had evidently angered Igor. Igor was a passionate Anglophile – he loved Dickens and Trollope as much as Leskov and Dostoevsky – but his

grasp of conversational English was extraordinarily poor. He had no wish to assimilate. Nor would he have known how to go about this. He was who he was and that was that.

* * *

Obstinacy often goes with arrogance. Igor, though, was unusually modest. He was a poor public speaker and he did not like to put himself in the foreground. One of our few disagreements while I was translating his *Totalitarian Art* was when, struggling to simplify an awkward and rather impersonal passage, I introduced the pronoun 'I'. Igor quietly explained that he couldn't bring himself to write in the first person. It wasn't that he thought there was anything reprehensible about this; it was simply something he was unable to do.

He was, unsurprisingly, deeply reluctant to write an autobiography. I tried several times to persuade him, but without success. Other friends also failed. Fortunately, Leonid Bazhanov eventually succeeded, winning Igor round by pointing out that he had known many gifted and important figures and that it was his duty to write about them, to save them from oblivion or misrepresentation.

Igor's conscious focus in this memoir is indeed on his friends and his times. But, since his friends were such an important part of his life, the memoir also gives us a very clear sense of Igor himself. Nevertheless, there is one crucial moment in his life that remains mysterious.

In Chapter 3, Igor skates over a remarkable change that took place in him when he was around 15, soon after his family's return to Moscow. He describes his young self as a foul-mouthed, barely-educated child without the least interest in literature or any of the arts. And then, all of a sudden, he is excitedly reading Dostoevsky. Igor recounts all this rather casually, as if such a transformation is a commonplace matter. I questioned him about this several times but was unable to get him to say more than what he had already written. Even 70 years later, he appeared to see nothing surprising about his suddenly developing the capacity to respond to Dostoevsky with such passionate enthusiasm.

Most people with a particular artistic gift can point to at least one teacher or family member who did something to awaken this gift. In Igor's

case, however, the interest in art and literature seems to have come almost entirely from within, with only the slightest prompting from a friend. He was, in a sense, a self-made man. It is not surprising that he always remained unshakeably himself.

Robert Chandler, February 2018

Notes

Turning Point

1. These are the opening lines of Brodsky's autobiographical essay, 'Less than One', the opening essay in his collection of selected essays, *Less than One* (Viking, London, 1986) see also Dramatis Personae.
2. See Dramatis Personae for nearly all the above mentioned.

Chapter 1 My Father's Arrest

1. Kalinin (now Tver) is on the Volga, 150 km north-west of Moscow.
2. Stalin wrote an article 'The Year of the Great Break' (God velikogo pereloma: k XII godovshchine Oktyabrya), published on 7 November 1929, the 12th anniversary of the October Revolution. In it he announced a radical change in the economic policy of the Soviet Union, specifically the abandonment of Lenin's New Economic Policy (NEP) and the acceleration of collectivisation and industrialisation.
3. The Crimean Karaites are an ethnically Turkic community whose members adhere to a unique form of Judaism that originated as early as the seventh century. Unlike Rabbanite Jews, Karaites were exempt from oppressive anti-Semitic laws during both the Imperial and Soviet periods.
4. Rheinhold Glière (1875–1956) was a Russian composer of German-Polish ancestry best known for his music for the ballet *The Red Poppy* (*Krasny Mak*), 1927, later retitled, to avoid the connotation of opium, as *The Red Flower* (*Krasny tsvetok*), 1955. *The Red Poppy* was praised as 'the first Soviet ballet on a revolutionary subject'.
5. After battles in which he lost half his standing army, and facing defeat in the Crimea, Wrangel organised a mass evacuation from the shores of the Black Sea. Wrangel gave every officer, soldier, and civilian a free choice: evacuate and go with him into the unknown, or remain in Russia and face the wrath of the Red Army. Wrangel evacuated the White forces from the Crimea in 1920 in ships that were remnants of the Russian Imperial Navy. They became known as Wrangel's fleet. The last military and civilian personnel left Russia with Wrangel on board the *General Kornilov* on 14 November 1920.
6. The Pale of Settlement was the term given to the region of Imperial Russia in which Jews were allowed to live. Jewish permanent residency was generally prohibited beyond the Pale. It extended from the eastern *pale*, or demarcation line, to the western Russian border with the Kingdom of Prussia (later the German Empire) and with Austria-Hungary. After the Revolution of February 1917 the provisional government abolished the Pale of Settlement along with the rest of the anti-Jewish restrictions.
7. Tomsk is one of the oldest towns in Siberia, famous for its university and wooden architecture.

8. *Preferans* is a 10-card plain-trick game with bidding. It became popular in Russia in the 1830s and is still played today.
9. *Stroganina* is a Siberian speciality – thin slices of raw, frozen fish or meat.
10. *Pelmeni* – Siberian dumplings – are similar to ravioli.
11. The Kamchatka Peninsula is a 1,250-kilometre-long, fish-shaped peninsula in the Russian Far East, with an area of about 270,000 km^2. It lies between the Pacific Ocean to the east and the Sea of Okhotsk to the west. The volcanic landscape is known as 'the land of fire and ice'.
12. The Komsomol was the Young Communist League which actively helped inculcate Party values in the younger members of the population. Membership was open to people aged from 14 to 28 but Komsomol functionaries could be older. Younger children joined the Young Pioneers. While membership of the Komsomol was nominally voluntary, those who didn't join found it very difficult (if not impossible) to pursue higher education and lost access to officially sponsored holidays. Active members benefited from privileges and promotions in their careers.
13. The Far North Construction Trust (also known as Dalstroy) oversaw the road construction and gold mining in the Kolyma region of the Russian Far East using forced labour. Over the years, the Far North Construction Trust created some 80 prison camps across the area. The town of Magadan was the base for these activities.
14. For those who did know, Kolyma was synonymous with a chain of brutal prison camps.

Chapter 2 Kolyma

1. 'Thief in law': an elite member of the Soviet and post-Soviet criminal underworld, who follows and enforces a more or less formal set of laws by which career criminals must abide.
2. The Soviet Union only entered World War II after Hitler broke the Molotov–Ribbentrop non-agression pact by invading the Soviet Union on 22 June 1941 in Operation Barbarossa.
3. Sea sculpins: Gobius – a small fish found in the Black Sea.
4. **Author's note:** Fomin had already stacked up such a long sentence for a series of murders, that he had nothing to lose. Without the death penalty there was nothing to stop him killing again. The death penalty in Kolyma was sometimes abolished, sometimes reintroduced. For political prisoners this law was irrelevant. They were shot regardless of the presence or absence of the death penalty.

Chapter 3 Moscow

1. The newspaper *Pravda* (*Truth*) was the official mouthpiece of the Communist Party of the Soviet Union from 1918 to 1991.
2. Vladimir Mayakovsky (1893–1930) was a leading Futurist poet, playwright and artist. He joined the Bolsheviks at the age of 15 and was initially enthusiastic about the revolution. His suicide in 1930 is sometimes attributed to his disillusionment with the Soviet Union.
3. A yard-man (*dvornik*) or yard-woman (*dvornichikha*) is a concierge-cum-caretaker who tends to the pavement and yard in front of an apartment house. The police and secret services often used *dvorniki* and *dvornichikhi* as informants.

4. Martin Andersen Nexø (1869–1954), Danish novelist. The first of the four parts of his great novel, *Pelle the Conqueror*, appeared in 1906.
5. Galoshes are waterproof overshoes, usually made of rubber.

Chapter 4 Finances and Romances

1. The Financial Institute (which became the Financial University under the Government of the Russian Federation in 2010) is ranked 150 in the 300 best universities in BRICS countries (Brazil, Russia, India, China and South Africa). https://www.topuniversities.com/ university-rankings/brics-rankings/2018 (accessed 17 January 2018).
2. 'War economy' was the study of logistics and the financial organisation of the army.
3. Pavel Axelrod, 1850–1928. At the Second Congress of the Russian Social-Democratic Labour Party in London in 1903, Axelrod sided with the Menshevik faction against Vladimir Lenin's Bolsheviks. The Mensheviks subscribed to an Orthodox Marxist view of social and economic development, believing that socialism could not be achieved in Russia due to its backward economic conditions, and that Russia would first have to experience a bourgeois revolution and go through a capitalist stage of development before socialism was technically possible and before the working class could develop the necessary consciousness for a socialist revolution. In 1917, after the February Revolution, Axelrod returned to Russia. By then some Mensheviks had already joined Kerensky's Provisional Government and supported government war policy. Despite all his efforts, Axelrod failed to gain Mensheviks' support for a policy of immediate peace negotiations with the Central Powers (consisting of Germany, Austria-Hungary, the Ottoman Empire and Bulgaria). After the Bolshevik victory, which Axelrod called a 'historical crime without parallel in modern history', he toured the world rallying socialist opposition to the Bolsheviks.
4. The Jewish doctors' plot: in 1952–3, a group of predominantly Jewish doctors in Moscow were accused of conspiring to kill off Soviet leaders. Many doctors were dismissed from their jobs and arrested.
5. In 1948, Shostakovich acquired a book of Jewish folk songs, and from this he composed his song cycle *From Jewish Folk Poetry*, Op. 79, originally for soprano, mezzo-soprano, tenor and piano. He initially wrote eight songs that were meant to represent the hardships of being Jewish in the Soviet Union. However in order to soften this, Shostakovich ended up adding three more songs meant to demonstrate the good life Jews had under the Soviet regime. Despite his efforts to hide the real meaning in the work, the Union of Composers refused to approve his music in 1949 under the pressure of the anti-Semitism that gripped the country. Stalin had originally warmed to the idea of Israel as a Jewish state. In 1947, the Soviet Union joined the United States in supporting the partition of British Palestine into Jewish and Arab states, and supported Israel in the 1948 Arab–Israeli War with weaponry supplied via Czechoslovakia. Despite Stalin's willingness to support Israel early on, various historians suppose that the anti-Semitism of the late 1940s and early 1950s was motivated by Stalin's possible perception of Jews as a potential 'fifth column' in light of a pro-Western Israel in the Middle East.
6. This was an ironic way of referring to the camps which were in fact always very remote.
7. The name Kruglikova contains the adjective 'krugly' – meaning round.
8. Kuzma Petrov-Vodkin (1878–1939) was the son of a poor cobbler who rose to become a famous painter and the first president of the Leningrad Regional Union of Soviet Artists

(1932). One of his best-known paintings is *Bathing the Red Horse*, 1912, which seems to prefigure the coming revolution.

9. Stalin's body was put on display in the Hall of Columns in the House of Unions in the centre of Moscow and hundreds of thousands of weeping mourners came to say goodbye to their leader. On the first day of mourning the crush in Trubnaya Square resulted in the deaths of dozens, possibly even hundreds, of people.

10. Georgy Malenkov was one of Stalin's right-hand men. Following Stalin's death, Malenkov temporarily assumed leadership over both the party and the ministries comprising the nation's government. After he organised a failed coup against Khruschev in 1957, he was removed from the Politburo and exiled to Kazhakstan (1957) before ultimately being expelled from the Party (November 1961).

11. Karaganda, in Kazakhstan, was one of the largest labour camps in the Soviet Union.

12. *Two Hundred Years Together* (*Dvesti let vmeste*) was a two-volume historical essay by Solzhenitsyn on the Jews in Russia. It was published in 2001–2 and stirred much controversy. Some critics considered it factually unreliable and opinion was divided on whether it was anti-Semitic. For more about Solzhenitsyn see Dramatis Personae.

13. The government started a mass amnesty of the victims of Soviet repression after the death of Stalin. In 1953, this did not entail any form of exoneration. The government released the amnestied prisoners into internal exile in remote areas, without any right to return to their original places of settlement. The amnesty was applied first for those who had been sentenced for a term of at most five years and had been prosecuted for non-political articles in the Soviet Criminal Code (for example, children of those repressed on political grounds were often prosecuted as 'antisocial elements', i.e., on the same grounds as prostitutes). In 1954, the government began to release many political prisoners from Gulag labour camps. After Kruschev's secret speech denouncing Stalinism in 1956, the government accompanied the release of political prisoners with rehabilitation, allowing them to return home and reclaim their lives.

14. Following World War II, the Soviet government implemented a redenomination of the currency (decreed on 14 December 1947) to reduce the amount of money in circulation. Old roubles were revalued at one tenth of their face value. This mainly affected paper money in the hands of private individuals. Amounts of 3,000 roubles or less in individual bank accounts were not revalued, while salaries remained the same. This revaluation coincided with the end of wartime rationing and efforts to lower prices and curtail inflation, though the effects in some cases actually resulted in higher inflation. From *An Economic History of the U.S.S.R.* by Alec Nove.

15. Mikhail Svetlov (1903–64) was a poet and playwright. The main theme of his works in the 1920s was the civil war. Probably the best-known poem written by Svetlov is *Grenada*, published in 1926. He was the the the author of the lyrics for the famous film song, Song of Kakhovka which was very popular among Soviet soldiers during World War II. Yury Olesha (1899–1960) was a novelist who is sometimes grouped with his friends Ilf and Petrov, Isaac Babel, and Sigismund Krzhizhanovsky into the Odessa School of Writers. He is credited with coining the phrase, 'writers are engineers of human souls' which was subsequently taken up by Stalin.

16. Mikhail Pokrovsky (1868–1932) was a Russian Marxist historian. One of the earliest professionally trained historians to join the Russian revolutionary movement, Pokrovsky is regarded as the most influential Soviet historian of the 1920s. After his death in 1932,

Pokrovsky's writings were repudiated by Stalin for their supposed 'vulgar sociologism' and insufficient appreciation of the role of great men in history, as well as for a lack of patriotic fervour. An official campaign of denunciation of Pokrovsky's alleged errors was initiated in January 1936. He had been dead for 21 years when the man claiming to be him appeared in the Cocktail Hall.

17. Beria was a Georgian like Stalin and was the longest serving and most influential of his secret police chiefs, wielding his most substantial influence during and after World War II. Beria administered the vast expansion of the Gulag labour camps. He rapidly fell from grace after Stalin's death, was arrested for treason and executed.

18. Kliment Yefremovich Voroshilov (1881–1969) was approved as Chairman of the Presidium of the Supreme Soviet a few days after Stalin's death. Nikita Khruschev became First Secretary of the Communist Party and Georgy Malenkov became Premier of the Soviet Union. Voroshilov, Malenkov, and Khrushchev brought about the arrest of Beria almost immediately after Stalin's death.

19. Semyon Mikhaylovich Budyonny (1883–1973) was a cavalryman, military commander, politician and a close ally of Stalin. He wrote a five-volume memoir, in which he described the stormy years of civil war as well as the everyday life of the First Cavalry Army. He was frequently commemorated for his bravery in many popular Soviet military songs, including *The Red Cavalry Song (Konarmieyskaya)* and *The Budyonny March*. The *budenovka*, a helmet-like winter felt hat worn in the Red Army, is named after him.

20. Vyacheslav Mikhaylovich Molotov and Kliment Yefremich Voroshilov were both ousted by Krushchev as he consolidated his grip on power.

21. Port Arthur and Dalny had been leased by Russia from China in 1897 and were lost to the Japanese in 1905 after the Russo-Japanese War. After World War II, the Soviet Union occupied the territory and finally ceded it to China in 1955.

22. In the early 1950s, the Party-approved doctrine of Socialist Realism still reigned supreme in the spheres of music, literature and painting. Guidelines formulated in 1934 stipulated that work must be: proletarian – art relevant to the workers and understandable to them; typical – scenes of everyday life of the people; realistic –in the representational sense; partisan – supportive of the aims of the State and the Party.

23. Aleksandr Laktionov (1910–72) was a very popular socialist realist painter, particularly known for his portraits and genre scenes. His *A Letter from the Front*, 1947, was particularly well known and loved by the public.

24. 'Varnished reality' was a term coined by the critic Vladimir Pomerantsev who, in December 1953, wrote a controversial essay in the literary journal *Novy Mir (New World)*, entitled 'On Sincerity in Literature (Ob iskrennosti v literature)'. The term 'varnished reality' was subsequently applied to the glossy, over-optimistic 'socialist realist' work of certain Soviet painters as well as writers.

25. *Literaturnaya Gazeta* was an influential weekly literary journal, though by the 1950s it had broadened its scope and contained political and social content as well. It was the official organ of the Union of Soviet Writers and as such carried the stamp of authority.

26. Imam Shamil (1797–1871) was a political and religious leader of the Muslim tribes of the Northern Caucasus. He was a leader of anti-Russian resistance in the Caucasian War.

27. The town of Komsomol-on-Amur, as its name suggests, had been built by Komsomol volunteers in the 1930s with the aid of forced labour from surrounding prison camps.

28. The series of amnesties in 1955 meant that many criminals as well as political prisoners were released. 'Among prisoners freed under the 3 September 1955 decree were 3,954 counter-revolutionaries, 2,721 murderers and about 10,000 recidivists': Jeffrey S. Hardy, *The Gulag after Stalin: Redefining Punishment in Khruschev's Soviet Union, 1953–1964* (New York, 2016).

Chapter 5 The Pushkin Museum of Fine Arts

1. 'Hostile whirlwinds': the quotation comes from the *Varshavianka*, a popular revolutionary hymn. The author of the original Polish text was the Polish socialist W. Święcicki, who composed its words while imprisoned in the Warsaw Citadel (1878–9). It was translated into Russian in 1897 by Lenin's companion in arms, Krzhizhanovsky, who was at that time in the Butyrskaya Prison in Moscow.
2. Every organisation with at least three Communist Party members had its own in-house Party Committee (*Partkom*), led by a secretary elected from among the regular staff of the organisation. Larger organisations had a secretary who was paid by the Party.
3. '*Samizdat*' literally means 'self-published'. As a way of circumventing the rigid censorship in the Soviet Union, underground, 'unofficial' and dissident literature was clandestinely produced and circulated among trusted groups, usually as typescripts.
4. 'The Führer's ... moustache': this striking aesthetic similarity between Nazi and Stalinist art was the starting point for Golomstock's book, *Totalitarian Art*, written many years later.
5. Khrych Poganich: 'khrych' means 'old sod' and 'poganets' a rascal, or, archaically, a non-Christian (pagan).
6. The Morozovs were a wealthy merchant family who had owned the splendid mansion on Kropotkin Street before the revolution and had a magnificent collection of modern art.
7. On 6 March 1948, a government resolution abolished the State Museum of New Western Art which was a 'breeding-ground of Formalist ideas and servility to the decadent bourgeois culture of the period of Imperialism' that had done 'great damage to the development of Russian and Soviet art'. Two weeks before the resolution was passed, the museum workers were given 24 hours to 'roll up the permanent exhibition', including several huge Matisse panels. The Pushkin Museum received 291 paintings and the Hermitage, 335. The list of works to be sold abroad consisted of the boldest modern paintings which most offended against the dogma of Socialist Realism. http://www.rusartnet.com/russian-museums-and-galleries/moscow/museum-of-new-western-art (accessed November 2017).

Chapter 6 The International Festival and Artists

1. The International Youth Festival (Vsemirny festival molodezhi i studentov) is also known as the World Festival of Youth and Students.
2. Anastas Mikoyan (1895–1978) was of Armenian descent. In 1935 he was elected to the Politburo and was among one of the first Soviet leaders to pay goodwill trips to the USA in order to boost economic cooperation. Mikoyan spent three months in the USA, where he not only learned more about its food industry, but also met and spoke with Henry Ford and inspected Macy's in New York. When he returned, Mikoyan introduced a number of popular American consumer products to the Soviet Union, including American

hamburgers, ice cream, corn flakes, popcorn, tomato juice, grapefruit and corn on the cob: Simon Sebag Montefiore, *Stalin: The Court of the Red Tsar* (New York, 2005), pp. 192–3. Mikoyan was Minister of Foreign Trade under Malenkov, and became First Deputy Premier under Khruschev.

3. Kirilenko and Kirichenko. Both are typical Ukrainian surnames. Alexey Kirichenko (1908–75) had been a favourite of Khruschev's, but he fell from grace in 1960 and was demoted to the position of the first secretary of the Party Committee of Rostov Oblast and retired in 1962. Andrey Kirilenko (1906–90) was the vice-chairman of the bureau of the Central Committee at the time of the *Art of Ancient Mexico* exhibition in 1963 so was presumably the high-ranking official who visited.

4. Dolberg was a friend from university who had made a daring escape to the West in 1956 and settled in London.

5. Dmitry Nalbandyan (1906– 93) was a Soviet Armenian painter. He was a member of the USSR Academy of Arts (1953), People's Artist of the USSR (1969), Hero of Socialist Labour (1976), and twice winner of the Stalin Prize. He was celebrated for his huge historical compositions. He was dubbed 'the first brush of the Politburo' because of his many portraits of Soviet leaders, including Lenin, Stalin, Khruschev, and Brezhnev.

6. Aleksandr Deyneka (1899–1969) was celebrated for works such as the monumental painting, *The Defence of Petrograd* (1928) and *Collective Farmer on a Bicycle* (1935); he also worked with mosaics, some of which can still be seen at the Mayakovsky metro station in Moscow.

7. 'Kukryniksy' was a collective name derived from the combined names of three caricaturists, Mikhail Kupriyanov, Porfiri Krylov and Nikolai Sokolov, who had met at art school in the early 1920s. The three began drawing caricatures under the joint signature in 1924.

8. Although the US State Department officially disapproved of American participation in the festival, regarding it as a communist propaganda exercise, contemporary American modernism was represented by a minor action painter, Harry Colman, who attended unofficially: Susan Reid *Art Beyond Borders: Artistic Exchange in Communist Europe (1945–1989)* (Budapest, 2016), p. 283.

9. George Costakis, 1912–90. Born in Moscow of Greek parents, Costakis worked for nearly 30 years in the administrative section of the Canadian Embassy in Moscow. He was a passionate collector of the Soviet avant-garde as well as buying the work of his contemporaries such as Zverev. When he left the Soviet Union in 1977, half of his collection was made over to the State Tretyakov Gallery. In 1997 the Greek State bought the remaining 1,275 works which now belong to the State Museum of Contemporary Art in Thessaloniki.

10. Vladimir Yakovlev, 1934–98. His work was exhibited in the Different Art exhibition, Moscow 1990 and he had a one-man exhibition at the Tretyakov Gallery in 1995. His work is now collected internationally.

11. Oskar Rabin (born 1928) was one of the leaders of the nonconformist/unofficial movement in Soviet art and one of the organisers of the dissident 'Bulldozer' Exhibition in 1974 which was forcibly broken up by police with the aid of bulldozers and water cannon. He emigrated to Paris in 1978. Dmitry Plavinsky (1937–2012) was an active member of the nonconformist movement who defined his style as 'Structural Symbolism'. Aleksandr Kharitonov (1931–93) was known for his religious subject matter and his techniques inspired by icon painting and Old Russian embroidery traditions.

12. The Vetlosyan camp in the Komi republic in the far north-west of Russia was for invalids whose health had been destroyed by the back-breaking forced labour they had endured.

13. **Author's note:** see Sinyavsky's article about this, 'The White Epos (Bely epos)' published in the collection *Apollon*, and my album *The Camp Drawings of Boris Sveshnikov* (*lagernye risunki Borisa Sveshnikova*), published in 2000 by Memorial, Moscow.

Chapter 7 The Sinyavskys, Khlebny Lane, the Far North

1. The Kadets or Constitutional Democratic Party (Konstitutsionno-Demokraticheskaya Partiya), also called the Party of People's Freedom (Partiya Narodnoy Svobody), was founded in October 1905 by the Union of Liberation and other liberals associated with the *zemstvos*, local councils that often were centres of liberal opinion and agitation. The party called for a radical change from the autocratic rule of the Tsars to a constitutional monarchy.

2. Aleksandr Gerasimov (1881–1963) was a leading proponent of socialist realism in the visual arts, and painted Stalin and other Soviet leaders. One of his best-known and countlessly reproduced works was the massive painting, *Stalin and Voroshilov in the Kremlin*, 1938.

3. The choice is between two contemporary novelists: the ideologically safe Semyon Babayevsky (1909–2000), who won the Stalin prize three times and is best known for his novel *Cavalier of the Golden Star* (*Kavalier zolotoy zvezdy*), or his much more daring contemporary Andrey Platonov (1899–1951), whose masterpieces, *The Foundation Pit* (*Kotlovan*) and *Chevengur*, both remained unpublished in the Soviet Union until the late 1980s.

4. Vladimir Vysotsky (1938–80) was a singer-songwriter, poet, and actor who achieved vast popularity throughout the Soviet Union. His fans ranged from the intelligentsia to the man on the street and his work had an enduring effect on Soviet and Russian culture. He became widely known for his unique hoarse singing style and for his lyrics, which featured social and political commentary in often humorous street jargon. He was also a prominent stage and screen actor and worked with the experimental director Yury Lyubimov at the Taganka Theatre. Though his work was largely ignored by the official Soviet cultural establishment, he achieved remarkable fame during his lifetime and after his early death thousands lined the streets as his coffin was taken to the famous Vagankovo Cemetery.

5. The historical Abram Terts was a notorious Jewish gangster from Russia's past and was the hero of an Odessa ballad. Sinyavsky himself was not in fact Jewish, but came from the landed nobility. In his autobiographical novel *Good Night!* he describes Terts as his 'shady double'. 'I can see him as if it were just yesterday – a crook, a cardshark, a real son of a bitch, his hands in his pants pockets, his moustache stringy, his cap snapped down over his eyes ...' Abram Terts (tr. by Richard Lourie, *Good Night!* (New York, 1989), p. 9). Sinyavsky continued to publish his fiction under the name of his alter ego Terts for the rest of his life, reserving the name Sinyavsky for his works of literary criticism.

6. The Mezen, one of the biggest rivers of European Russia, is 857 kilometres long. Its source is in the Timan Ridge in the Komi Republic, west of the northern Ural Mountains. It flows first south-west, then sharply turns roughly in a north-western direction. Its mouth is located in the Mezen Bay of the White Sea.

7. The five-walled *izba* (wooden hut) was divided into two living areas by its fifth log wall.

8. Old Believers are a break-away sect who maintain the liturgical and ritual practices of the Eastern Orthodox Church as they existed before the reforms of Patriarch Nikon of Moscow between 1652 and 1666. Those who remained faithful to the pre-Nikon rites endured severe persecutions from the end of the seventeenth century until the beginning of the twentieth century as 'Schismatics' (*raskolniki*).

9. Martyrologies: one of the most celebrated Old Believers who was martyred for her faith was Feodosia Morozova, a wealthy Boyar's wife and lady-in-waiting at the court of Tsar Aleksis. She refused to recant and was arrested in 1671, tortured and imprisoned in the underground cellar of a monastery where she is believed to have starved to death. Vasily Surikov's famous painting, *Boyarina Morozova*, 1887, shows the dramatic moment of her arrest. As the fur-clad noblewoman is hauled off through the snow in a rough-hewn sledge, she is shown defiantly making the sign of the cross in the Old Believer way, with two straightened fingers, to the onlookers who line the route.

10. The Solovky or Solovetsky islands were originally famous for the Russian Orthodox Solovetsky Monastery complex which was founded in the fifteenth century. By the end of the sixteenth century, the abbey had emerged as one of the wealthiest and most influential religious centres in Russia. The islands became a penal colony in later tsarist times and after the October Revolution attained notoriety as the site of the first Soviet prison camp, inaugurated in 1921, under Lenin. This was closed in 1939, on the eve of World War II. By the beginning of the war, there was a naval cadet training camp established there for the Soviet Northern Fleet.

Chapter 8 Dancing Around Picasso

1. Khruschev's report, 'On the Cult of Personality and its Consequences', was sharply critical of Stalin's rule, especially with respect to the purges of the Soviet Communist Party which had been particularly ferocious in the the late 1930s. The Khruschev report was known as the 'Secret Speech' because it was delivered at an unpublicised closed session of Communist Party delegates, from which guests and members of the press were excluded. Although the text of the Khruschev report leaked almost immediately, the official Russian text was published only in 1989 during Gorbachev's glasnost campaign.

2. Both Sinyavsky and Golomstock had ample opportunity to study Picasso's paintings during the Soviet Picasso Exhibition which opened in Moscow in October 1956. The 67 paintings on show included 35 from the Pushkin Museum's own holdings. See Marina Dmitrievna, 'The Riddle of Modernism in the Art Historical Discourse of the Thaw 2018 In memoriam Igor Golomstock,' in *A Socialist Realist History? Writing Art History in the Post-War Decades*, Editors: Krista Kodres, Kristina Jõekalda, Michaela Marek. (Köln, Weimar, Wien: Böhlau Verlag, 2018).

3. Picasso was in fact Spanish, but he spent most of his adult life in France.

4. Bulgakov's masterpiece, *The Master and Margarita*, was written between 1928 and 1940, but unpublished in book form until 1967.

5. Ray Bradbury's dystopian novel, *Fahrenheit 451*, was published in 1953. The novel presents a future American society where books are outlawed and 'firemen' burn any that are found. A band of resisters memorise and transmit to others the content of great works of literature.

6. The severe style: artists of the severe style 'sought to depict reality without the pomp or saccharine gloss of Socialist Realism. The focus of the severe style was not only on a new

form, but also on the discovery of contemporary Soviet men and women, the modern builders of communism. The artists travelled to remote corners of the Soviet Union, lived with geologists and workers constructing power grids, painted industrial landscapes in the far North and Siberia': Vladislav Zubok, *Zhivago's Children* (Cambridge, MA & London, 2009), pp. 176–7.

7. Gerasimov was the first president of the Soviet Academy of Arts from when it was created in 1947 until 1957. He was known in his later years for his hostility to innovation (see also Chapter 7, endnote 2).

8. Khruschev made a notorious visit to The Moscow Union of Artists' 30th Anniversary Exhibition at the Manege at the beginning of December 1962. He denounced some of the more experimental work in the earthiest of terms and this was the signal for a concerted campaign against formalism and abstraction in art.

9. Yekaterina Furtseva (1910–74) was one of the most influential women in Soviet politics and only the second woman to be admitted into the Politburo. She was Minister of Culture from 1960–74, a time remembered as the Age of Furtseva.

10. *People, Years, Life*: the first volume of Ehrenburg's memoirs had been published in *Novy Mir* in 1960 'after months of procrastination by the censor'. Ehrenburg's ambition was 'a monumental project to restore the heritage of numerous Russian artists, writers and intellectuals who had been forcibly erased from Stalinist public culture'. Zubok, *Zhivago's Children*, p. 166.

11. Ehrenburg's 1954 novel, *The Thaw (Ottepel)*, gave its name to the relatively liberal period which followed the death of Stalin.

12. Vladimir Kemenov had been head of VOKS the All-Union Society for Cultural Relations with Foreign Countries, 1940–8.

13. Vera Mukhina (1889–1953) was a famous Soviet sculptor, best known for the heroic Worker and Kolkhoz Woman monument which Mosfilm took as its logo in 1947. The bronze monument of Tchaikovsky in front of the Moscow Conservatoire is also by her.

14. 'The materially corporeal bottom': a reference to Mikhail Bakhtin's book on Rabelais in which he argued that 'the depiction of the grotesque body, the communal banquet and the carnivalesque exhibited a positive construction of the material body and its functions' (Rachel Webb Jekanowski http://offscreen.com/view/svankmajers_lunacy) (accessed November 2017). Mikhail Bakhtin (1895–1975) was a philosopher, literary critic, semiotician and scholar who worked on literary theory, ethics, and the philosophy of language. Although Bakhtin was active in the debates on aesthetics and literature that took place in the Soviet Union in the 1920s, his distinctive position did not become well known until he was rediscovered by Russian scholars in the 1960s.

Chapter 9 The Museum Again

1. Khruschev was apparently alluding to a 1910 exhibition in Paris when a painting made by a donkey, Lolo, with a brush tied to his tail, was included among the works on display. Lolo's painting forms part of the permanent collection at *l'Espace culturel Paul Bédu* (Milly-la-Forêt).

2. Aleksey Kosygin (1904–80) had been sacked by Stalin, but his political career revived under Khruschev and he became an official of the State Planning Committee in 1957, and

was made a candidate member of the Politburo. He was promoted to the State Planning Committee chairmanship, and became Khruschev's First Deputy Premier in 1960. He went on to become Premier of the Soviet Union, sharing power with First Secretary Brezhnev, after Khruschev was ousted in 1964.

3. Sasha Khalturin, from the KGB, had been one of Igor Golomstock's fellow students in the Art History Department. See Chapter 4, 'Finances and Romances'.

4. The founder of anthroposophy, Austrian-born Rudolf Steiner was a noted Goethe scholar who became involved with Theosophy in Germany in 1902, when he met Annie Besant, a devoted follower of Madame Blavatsky. In 1912 he broke with the Theosophists because of what he regarded as their oriental bias and established a philosophical system of his own, which he called Anthroposophy, a 'spiritual science' he hoped would restore humanism to a materialistic world. In 1923 he set up headquarters for the Society of Anthroposophy in New York City. Steiner advocated that education, art, agriculture, and science be based on spiritual principles and infused with the psychic powers he believed were latent in everyone. The world centre of the Anthroposophical Society today is in Dornach, Switzerland, in a building designed by Steiner. The society is noted for its schools.

5. Dekulakisation was the Soviet campaign of political repression, including the arrest, deportation and execution of millions of the better-off peasants and their families in 1929–32. The richer peasants were labelled *kulaks* (tightfists) and considered class enemies. More than 1.8 million peasants were deported in 1930–1. The stated purpose of the campaign was to fight the counter-revolution and build socialism in the countryside. This policy was accomplished simultaneously with collectivisation and effectively brought all agriculture and peasants in Soviet Russia under state control.

6. Many people in the Soviet Union who were disenchanted with Communism saw the Germans as possible saviours.

7. When people applied to emigrate they were automatically refused if they had been involved in secret work at any stage in their careers.

Chapter 10 VNIITE

1. The All-Union Agricultural Exhibition in Moscow was a permanent installation on a huge scale which finally opened in 1939 after several false starts. It was renamed The Exhibition of Achievements of the National Economy in 1959.

2. Oleg Genisaretsky (born 1942) is well known as a philosopher and art historian with interests in a wide range of topics including spirituality, ecology, anthropology and the psychology of creativity.

3. Vyacheslav Glazychev (1940–2012) became a highly respected urban-planning expert and architectural historian who fought to preserve Moscow's historical quarters.

4. 'Rhinoceros' is an absurdist parable by the Romanian-French dramatist Eugène Ionesco, first performed in 1959. During the play, the inhabitants of a small, provincial French town turn into rhinoceroses; ultimately the only human who does not succumb to this mass metamorphosis is the central character, Bérenger. The play is often read as a critical response to the upsurge of Fascism and Nazism during the 1930s. It explores the themes of conformity, culture, mass movements, philosophy and morality.

5. Father Aleksandr Men: see Chapter 15, 'Questions of Faith'.

6. Yury Artemyev: see Chapter 3, 'Moscow'.

7. Nikolai Fyodorovich Fyodorov (1829–1903) was a Russian Orthodox Christian philosopher, who was part of the Russian cosmism movement and a precursor of transhumanism. Fyodorov believed in radical life extension, physical immortality and even resurrection of the dead, using scientific methods.

8. Arnold Toynbee (1889–1975) was a British historian, philosopher of history, research professor of International History at the London School of Economics and the University of London. He is best known for his 12-volume *A Study of History* (1934–61), through which he examined the rise and fall of 26 civilisations in the course of human history. With his prolific output of papers, articles, speeches and presentations, and numerous books translated into many languages, Toynbee was perhaps the world's most read and discussed scholar in the 1940s and 1950s.

9. Bakhtin was exiled by Stalin in 1936 and spent some of his exile teaching in Saransk, the capital city of Mordovia, about 630 kilometers east of Moscow. Later, Bakhtin was invited back to Saransk, where he became chair of the General Literature Department at the Mordovian Pedagogical Institute. When, in 1957, the Institute changed from a teachers' college to a university, Bakhtin became head of the Department of Russian and World Literature. See also Chapter 8, endnote 13.

10. *The Aesthetic Character of Artistic Trends in Modern European Painting* (*Esteticheskaya priroda khudozhestvennykh techeniy v sovremennom zarubezhnom iskusstve*), was never published.

Chapter 11 Great Expectations

1. Lev Turchinsky was Golomstock's friend and colleague at the Pushkin Museum who kept a stack of clandestine literature in his book-binding studio see Chapter 5, 'The Pushkin Museum of Fine Arts'.

2. Nikolay Arzhak was Yuly Daniel's pseudonym.

3. *The White Book* (*Belaya Kniga*) by Yury Galanskov and Aleksandr Ginzberg – published in English as *On Trial: The Case of Sinyavsky and Daniel* – documented the Sinyavsky-Daniel trial using a copy of the closed-door court proceedings from the court stenographer. Ginzburg sent copies of the book to the KGB and the Chief Prosecutor's Office. The book also circulated in *samizdat* and was smuggled to the West. Galanskov and Ginzburg were arrested in 1967 and charged with anti-Soviet agitation and propaganda. Ginzburg was sentenced to five years' forced labour and Galanskov to seven. Galanskov died in the labour camp from medical neglect.

4. *The Price of Metaphor or the Crime and Punishment of Sinyavsky and Daniel* (*Tsena metafory, ili Prestupleniye i nakazaniye Sinyavskogo i Danielya*), by Nikolay Arzhak and Abram Terts.

5. The infamous Lefortovo was the remand prison where the KGB interrogated political prisoners.

Chapter 12 The Sinyavsky-Daniel Trial

1. **Author's note:** I am not going to describe the course of this shameful trial. The full court report and also the reactions to the trial inside the country and abroad are all set out in *The White Book* which came out straight after the trial. I will just record what I remember.

2. Article 70, Anti-Soviet agitation and propaganda, was the main instrument used to prosecute Soviet dissidents. It was defined as:

 (1) propaganda or agitation with the purpose of undermining or weakening of Soviet power or with the purpose of committing or incitement to commit particularly grave crimes against the Soviet state (as defined in the law);

 (2) the spreading with the same purposes of slanderous fabrications that target the Soviet political and social system;

 (3) production, dissemination or storage, for the same purposes, of literature with anti-Soviet content.

 The penalty for violating article 70 was from six months to seven years of imprisonment, with possible subsequent internal exile from two to five years.

3. 'Heavily tattooed driver': in those days in the Soviet Union being tattooed was a sign that you mixed in criminal circles.

4. **Author's note**: Recently Rozanova found the lieutenant's biographical details on the internet: *Ekonomtsev Igor Nikolaevich. Graduated from the classics department of the Languages and Literature Faculty of Moscow State University in 1963. From 2002 – archimandrite**. This must be the same man. I would like to think that he turned to the church at the promptings of his own heart, and not at the behest of his KGB bosses.

 * The title archimandrite, primarily used in the Eastern Orthodox and the Eastern Catholic churches, originally referred to a superior abbot whom a bishop appointed to supervise several 'ordinary' abbots and monasteries, or to the abbot of some especially great and important monastery. The title is also used as an honorific, with no connection to any actual monastery, and is bestowed on clergy as a mark of respect or gratitude for service to the Church.

5. Etlis was I. G.'s friend who had been arrested while a medical student in connection with the doctors' plot. See Chapter 4.

6. 'Parasites were exiled': in the Soviet Union, which declared itself a workers' state, every adult able-bodied person was expected to work until official retirement. Thus unemployment was officially and theoretically eliminated. Those who refused to work, study or serve in another way risked being criminally charged with social parasitism. In 1961, 130,000 people were identified as leading the 'anti-social, parasitic way of life' in the Russian Soviet Federative Socialist Republic. See: 'To inflict helpful fear' (Vnushit poleznyy strakh) (Yevgeny Zhirnov, *Kommersant*, 25 April 2011, https://www.kommersant.ru/doc/1618579 (accessed November 2017)). Charges of parasitism were frequently applied to dissident intellectuals. Since their writings were considered against the regime, the state prevented them from obtaining employment. To avoid trials for parasitism, many of them took unskilled (but not especially time-consuming) jobs (street sweepers, etc.), which allowed them to continue their other pursuits. Joseph Brodsky was sentenced to five years' internal exile for 'social parasitism' in 1964.

7. Before the advent of digital technology, printing was a labour-intensive industrial process involving manual typesetting. Lines of type were composed by assembling moulds, known as '*sorts*' of individual letters into a 'composing stick' to form words and sentences. Once a book had been printed the type would be broken up into individual *sorts* ready to be reassembled into a new work.

8. The tattooed Stephan Dudnik: The painter had been a persistent thief in his youth (see Karl Schlögel, *Moscow 1937* (Cambridge, 2012)). He had been orphaned in the

Civil War, and served time in the camps as a petty criminal. There he discovered a gift for painting and eventually rose to a high position in the Soviet art world. A tattooed snake twined along his right arm with the head appearing prominently on his hand.

9. Bukharin and Kamenev had been powerful allies of Stalin but fell out of favour. Kamenev was executed in 1936, Bukharin in 1938.

10. Aleksandr Tvardovsky (1910–71): As editor-in-chief of *Novy Mir* literary magazine from 1950–4 and 1958–70, Tvardovsky was one of the most significant figures among the Moscow intelligentsia. 'Tvardovsky and the circle of writers, poets and critics that emerged round *Novy Mir* challenged the regime's monopoly on defining what was true literature and what was trash.' Zubok, *Zhivago's Children*, p. 246. Tvardovsky had good relations with Khruschev (they shared a peasant background) and he obtained permission to publish the unknown Solzhenitsyn's *One Day in the Life of Ivan Denisovich* in *Novy Mir* in November 1962. This caused a sensation. 'People all over the Soviet Union besieged libraries [. . .] to read the *Novy Mir* volume': *Zhivago's Children*, p. 200. Tvardovsky was also celebrated for his titanic drinking bouts and was apparently recovering from one of these when he encountered Igor and friends outside the Union of Soviet Writers.

11. Vysotsky: see Chapter 7, endnote 4.

12. Bulat Okudzhava (1924–97) was a well-known Russian poet, writer, musician, novelist, and singer-songwriter of Georgian-Armenian ancestry. Vladimir Voynovich (born 1932) is a writer and former dissident. He is the author of *The Life and Extraordinary Adventures of Private Ivan Chonkin* (*Zhizn' i neobychaynyye priklyucheniya soldata Ivana Chonkina*) (1969), a popular satire set in the Red Army during World War II. Boris Balter (1919–74) is the author of the well-known novel *Goodbye Boys!* (*Do svidaniya, malchiki!*) (1963). Fazil Iskander (born 1929) is an Abkhaz writer, known for his descriptions of Caucasian life. Oleg Chukhontsev (born 1938) is a poet.

13. The Molodezhnaya station was opened in 1965 at the end of the line running south-west from Pionerskaya, so it was then on the very outskirts of Moscow.

14. Khruschev's attempt to solve the chronic housing shortage was to put up cheaply built and quickly erected tower blocks on the outskirts of large towns and cities. They were nicknamed 'Khruscheby' to rhyme with 'truscheby' (slums). Source: http://soviethistory. msu.edu/1961-2/the-khrushchev-slums/ (accessed January 2018).

Chapter 13 Dissidents

1. The forcible deportation of the Crimean Tatars from Crimea was ordered by Stalin as a form of collective punishment for alleged collaboration with the Nazi occupation regime in Taurida Subdistrict during 1942–3. A total of more than 230,000 people were deported, mostly to the Uzbek Soviet Socialist Republic. This included the entire ethnic Crimean Tatar population, at the time about a fifth of the total population of the Crimean Peninsula, besides a smaller number of ethnic Greeks and Bulgarians. A large number of deportees (more than 100,000 according to a 1960s survey by Crimean Tatar activists) died from starvation or disease as a direct result of deportation.

2. After the Prague Spring, a period of liberalisation in Czechoslovakia introduced by Alexander Dubček, the Soviet Union cracked down and invaded the country with troops from Bulgaria, Hungary, East Germany and Poland on the night of 20–21 August 1968.

3. 'Socialism with a human face' was the programme of political reforms put forward by Dubček during the Prague Spring. It was to be a process of mild democratisation and political liberalisation that would still enable the Communist Party to maintain real power.

4. *Tamizdat*: unofficial literature smuggled out of the Soviet Union and published 'tam' (over there) in the West.

5. In Russian, the name Yavas sounds like the start of a threatening expression 'Ya vas' implying 'I'll get you'. Mordovia still has prisons today where political detainees are held. Nadezhda Tolokonnikova, one of the members of Pussy Riot, was incarcerated there for 21 months. See https://www.dissidentblog.org/en/articles/gulag-alive-and-well-mordovia (accessed January 2018).

6. Undesirables such as released prisoners could be banned from approaching any large town by a 101-kilometre exclusion zone.

Chapter 14 Pen Portraits of My Friends

1. A play on the original by Plato: Socrates is my friend but the truth is dearer to me.

2. *What is to be Done? (Chto delat?)* was a political pamphlet written by Lenin in 1901. Its title echoed the title of the novel by the nineteenth-century Russian revolutionary Nikolay Chernyshevsky.

3. There is a pun in Galich's line: the Russian expression for 'first aid' is 'fast aid'.

4. *Hieronymus Bosch (Yeronim Boskh)*, under the pseudonym G. Fomin (Moscow, 1974).

5. The album was published as *Paul Cézanne (Pol Sezann)*, by Yevgenia Georgievskaya and Anna Barskaya (Leningrad, 1975).

6. Rostislav (Slava) Klimov (1928–2000) was a gifted editor at the publisher Iskusstvo, specialising in comprehensive books on art history.

7. Aleksandr Kondratov (1937–93) was a linguist, biologist, journalist and poet. He wrote many books on subjects as various as ancient and modern languages, history, mathematics and paleontology. He wrote a monograph about dinosaurs purportedly surviving into modern times.

8. Leonid Batkin, born 1932, is a literary and film critic who has written about Andrey Tarkovsky's films.

9. Nathan Eidelman (1930–89) was a Soviet Russian author and historian. He wrote about the life and work of Pushkin, about the Decembrists and about the historian Nikolay Karamzin.

10. Mikhail Alpatov (1902–86) was an historian and art theorist, notable for his contribution to the history of the culture of ancient Rus.

11. Lenin wrote in an article, 'Party Organisation and Party Literature (Partiynaya organizatsiya i partiynaya literatura)' (*Novaya Zhizn* 12, 13 November 1905), that 'One cannot live in society and be free from society. The freedom of the bourgeois writer, artist or actress is simply masked (or hypocritically masked) dependence on the money-bag, on corruption, on prostitution.': Source: http://www.marxists.org/archive/lenin/works/1905/nov/13.htm (accessed January 2018).

12. Lenin posited that any culture contains two cultures: the bourgeois and the proletarian or the conservative and the progressive.

13. Aleksandr Kazhdan (1922–97) – a distinguished scholar in Byzantine history.

14. *Cities and Museums of the World (Goroda i muzei mira)* (Iskusstvo: Moscow, 1967–90), was a very popular series consisting of 48 books; *A Concise History of the Arts (Malaya istoriya*

iskusstv) (Iskusstvo: Moscow, 1972 – 91), was a 10-volume set of lavishly illustrated art history reference books; *A Life in Art (Zhizn v iskusstve)* (Iskusstvo: Moscow, 1967 – 93), was a series of 120 biographies of artists and architects. See also Dramatis Personae; Yura Ovsyannikov.

15. Shimon Markish (1931 – 2003) was a literary and cultural historian and translator. The son of poet Perets Markish, Shimon was educated as a classical scholar. Markish left the Soviet Union in 1970, emigrating first to Hungary and then, in 1974, to Geneva. He dedicated the greater part of his life to Russian Jewish literature, a subject that he established, promoted, and enriched as a field of research Markish also compiled several anthologies of works by Russian Jewish writers (on Valery Grossman, Ilya Ehrenburg, and Isaac Babel, as well as the book *Rodnoi golos* (*Native Voice: Pages from Russian Jewish Literature*), 2001). See: Zsuzsa Hetényi and Alice Nakhimovsky, 'Markish, Shimon', YIVO *Encyclopedia of Jews in Eastern Europe*, 22 September 2011. http://www.yivoencyclopedia.org/article.aspx/Markish_Shimon (accessed 12 November 2017).

16. Lev Gumilyev (1912 – 92) was an historian, ethnologist, anthropologist and translator from Persian, who is known for his highly unorthodox theories of ethnogenesis. His parents were the poets Nikolay Gumilyev and Anna Akhmatova. They were divorced when Lev was seven years old, and his father was executed two years later by the Bolsheviks. The KGB used Lev as a pawn in their attempts to silence the powerful poetic voice of his mother, repeatedly arresting and imprisoning him. Emma Gerstein's Memoirs contain a poignant exchange of letters between the imprisoned Lev and his mother whom he often reproached for not doing enough to rescue him. Emma Gerstein, *Moscow Memoirs (Memuary)* (London, 2004), appendix 3. After Stalin's death he was rehabilitated and made a name for himself as a highly original and controversial scholar.

17. See Boris Bernstein, *Stary kolodets* (St Petersburg, 2008), p. 311.

18. Bernstein, *Stary kolodets*, p. 312.

19. George Roerich (1902 – 60) was a prominent Tibetologist.

20. 'Hokypoky': in James Joyce's *Ulysses*, Leonard Bloom, a secular Jew, is meditating on the Catholic rite of Holy Communion where bread is transmuted into the body of Christ. *Ulysses*, 5.357 – 62: 'Yes, bread of angels it's called. There's a big idea behind it, kind of kingdom of God is within you feel. First communicants. Hokypoky penny a lump.' 'Hokey-pokey' was originally an American term for cheap ice cream sold on the streets. The vendors would call out the rhyme: 'hokey pokey penny a lump, the more you eat the more you jump'. The rhyme passed from the USA to Britain and is part of a repertoire of well-known playground rhymes surviving from the Victorian era. Source: http://www.bookdrum.com/books/nights-at-the-circus/118412/bookmark/126322.html (accessed November 2017).

21. Yury Lotman (1922–93) was a prominent literary scholar, semiotician, and cultural historian, who worked at the University of Tartu. He was a member of the Estonian Academy of Sciences. He was the founder of the Tartu-Moscow Semiotic School and is considered to be the first Soviet structuralist.

22. 'We'll discuss this … in another place': this was a veiled threat that perhaps the KGB would get involved.

23. Vyacheslav Ivanov, born 1929, is a prominent philologist and Indo-Europeanist.

24. Miron Etlis: see Chapter 4, pp. 33 – 6 and Dramatis Personae.

25. *A General History of the Arts (Vseobshchaya istoriya iskusstv)* (Iskusstvo: Moscow, 1956–66); *Monuments of World Art (Pamyatniki mirovogo iskusstva)* (Iskusstvo: Moscow, 1967).

26. The Barbizon school of French painters was active from about 1830 to 1870. It takes its name from the village of Barbizon, near the Forest of Fontainebleau, where many of the artists gathered. Klimov's book, *A Theory of the Evolutionary Development of Art* (*Teoriya stadialnogo razvitiya iskusstva*) was published posthumously.

27. Koktebel is one of the most popular resorts in the Crimea, situated on the shore of the Black Sea. It is best known for its literary associations. The poet Maximilian Voloshin made it his residence, where he entertained many distinguished guests, including Marina Tsvetayeva, Osip Mandelshtam and Andrey Bely (who died there). They all wrote remarkable poems in Koktebel.

28. Thor Heyerdahl (1914–2002) was a Norwegian adventurer and ethnographer. He became renowned for his *Kon-Tiki* expedition in 1947, in which he sailed 8,000 km across the Pacific Ocean in a hand-built raft from South America to the Tuamotu Islands. The expedition was designed to demonstrate that ancient people could have made long sea voyages, creating contacts between separate cultures.

29. Yury Knorozov (1922–99) was a linguist and ethnographer who played a leading role in deciphering the script of the Mayans.

30. Andrey Kolmogorov (1903–87) was a mathematician who made significant contributions to the mathematics of probability theory, topology, intuitionistic logic, turbulence, classical mechanics, algorithmic information theory and computational complexity.

31. Nikolay Marr (1865–1934) was a Georgian-born historian and linguist who argued for the common origin of Caucasian, Semitic-Hamitic, and Basque languages. In 1924, he went even further and proclaimed that all the languages of the world descended from a single proto-language which had consisted of four 'diffused exclamations': *sal, ber, yon, rosh.* Later he fell seriously out of favour with his fellow Georgian, Stalin: see Chapter 4, p. 31.

32. 'Ud' is Russian slang for penis.

33. Eugen Varga (1879–1964) was a Soviet political economist of Hungarian origin. He was an adviser to Stalin in the 1930s and miraculously survived the purges. In 1946 he published *The Economic Transformation of Capitalism at the End of the Second World War*, which argued that the capitalist system was more inherently stable than had formerly been thought.

34. The poet and critic James Fenton describes the genesis of 'Conversation about Dante' (Razgovor o Dante) as follows: 'the 50-page prose work was reprinted recently as an appendix to *The Selected Poems of Osip Mandelstam*, translated by Clarence Brown and W. S. Merwin ... It was dictated by the poet to his wife, Nadezhda Mandelstam, sometime around 1934–5, that is, during the last phase of an itinerant life, written on a pile of grey forms provided by helpful acquaintances (there being no question of acquiring writing-paper).

 The poet's widow describes how, at a point when Mandelstam refers to Dante's need to lean on authority, she refused to write his words down, thinking that he meant the authority of rulers, and that he condoned Dante's acceptance of their favours. "The word had no other meaning for us," she says, "and being heartily sick of such authorities, I wanted no others of any kind. 'Haven't you had enough of such authorities?' I yelled at him, sitting in front of a blank, grey-coloured sheet of paper, my hands defiantly on my knees. 'Do you still want more?'"

 Mandelstam was furious with her for getting above herself. She was angry back, and told him to find another wife. But in due course she did what the circumstances required

during the Stalinist persecution: she learnt the essay by heart, in order to ensure its survival. It wasn't printed until three decades later, in 1967, when an edition of 25,000 copies appeared in Moscow and quickly sold out – the first of Mandelstam's works to appear after the thaw.' Source: https://www.theguardian.com/books/2005/jul/16/classics. dantealighieri (accessed November 2017).

35. The simple stone mounted on a plinth is officially known as the *Memorial to the Victims of the Gulag.*

36. The exact number of prisoners who went through the Solovky camp during 1923–39 is still unknown, but estimates range between tens and hundreds of thousands. It was the 'mother of the GULAG' according to Aleksandr Solzhenitsyn. He estimated that in 1923 there were 'no more than 3,000' prisoners, but that by 1930 the number had jumped to 'about 50,000'. Aleksandr Solzhenitsyn, *The Gulag Archipelago (Arkhipelag GULAG)* (London, 1975), p. 72.

37. Feliks Dzerzhinsky (1877–1926), nicknamed 'Iron Feliks', was a prominent member of Polish and Russian revolutionary movements. Dzerzhinsky is best known for establishing the Soviet secret police force, originally known as the Cheka, serving as their director from 1917 to 1926. The Cheka soon became notorious for mass executions, performed especially during the Red Terror and the Russian Civil War. 'Iron Feliks' also refers to the 15-ton monument of Dzerzhinsky, which once dominated Dzerzhinsky (now Lubyanka) Square in Moscow, It was built in 1958 by the sculptor Yevgeny Vuchetich and was a Moscow landmark during Soviet times.

38. 'Scion of Rurik': Rurik, a Varangian chief, founded the dynasty which ruled Kievan Rus and its successor states until the seventeenth century.

39. 'The life and extraordinary adventures of my friend Miron Etlis': this is a reference to Voynovich's famous satirical novel, *The Life and Extraordinary Adventures of Private Chonkin (Zhizn i neobychayniye priklyucheniya soldata Ivana Chonkina)*, 1969. For the previous adventures of Miron Etlis see Chapter 4.

40. 'The quota system': freedom of movement was strictly limited within Soviet Russia but shortages of unskilled labour in large towns meant that people were sometimes allowed to move to towns to take up such jobs.

41. 'Rehabilitation era': see Chapter 4, endnote 13.

42. In Russian, Miron's surname, Etlis, begins with 'э', the third from last letter of the Russian alphabet.

43. Miron was not rehabilitated but released under the amnesty: amnesty, as opposed to rehabilitation, did not entail any form of exoneration or the right to return to where you had previously lived. See Chapter 4, endnote 13.

44. The Anti-Party Group, consisting of Stalinists Kaganovich, Molotov, Shepilov and Malenkov, attempted an abortive coup against Khruschev in June 1957.

45. The Vagankovo Cemetery in Moscow is the equivalent of Père Lachaise in Paris, or Highgate Cemetery in London, containing the graves of many famous and distinguished people.

46. Aleksandr Skryabin (1872–1915) was a pianist and composer. In his later career Skryabin developed a substantially atonal and dissonant musical system, which accorded with his personal brand of mysticism. Skryabin was influenced by synaesthesia and associated colours with the various harmonic tones of his atonal scale, while his colour-coded circle of fifths was also influenced by theosophy.

47. Memorial (MEMORIAL: An International Historical, Educational, Human Rights and Charitable Society) was founded on 28 January 1989. It focuses on recording and publicising the abuses of the Soviet Union's totalitarian past, but also monitors human rights today in Russia and other post-Soviet states. Memorial also helps individuals to find documents, graves, etc., of politically persecuted relatives. As of 2005, Memorial had a database of over 1,300,000 names of such people.

48. In 1996, Neizvestny completed his *Mask of Sorrow*, a 15-metre tall monument to the victims of Soviet purges, situated in Magadan.

49. 'Yes, there are still women in Russian Villages': this is an adaptation of a famous line from Nekrasov's narrative poem, *Red-Nosed Frost (Moroz, Krasny Nos*, 1863). The poem celebrates the resilience, steadfastness and courage of peasant women.

Chapter 15 Questions of Faith

1. Orthodox Russophilia: for liberal opinion in contemporary Russia, 'Russophilia' is shorthand for excessive patriotism, shading into xenophobia and promoted by the Orthodox Church.

2. **Author's note:** in 1980 Father Dudko was arrested for anti-Soviet activity and while he was in prison he wrote a letter of repentance, was pardoned, and began to preach in the spirit of Orthodox Russophilia, even to the extent of declaring that Stalin was a Christian believer who had cared about Russia in a paternal way. When Andrey Menshutin was dying at the end of the 80s he refused to make his confession to this priest. 'I can't turn a blind eye to what he did', he said before he died.

3. The books of the Major Prophets are Isaiah, Jeremiah, Lamentations, Ezekiel, and Daniel. The books of the Minor Prophets are Hosea, Joel, Amos, Obadiah, Jonah, Micah, Nahum, Habakkuk, Zephaniah, Haggai, Zechariah, and Malachi. The Major Prophets are described as 'major' because their books are longer and the content has broad, even global, implications. The Minor Prophets are described as 'minor' because their books are shorter (although Hosea and Zechariah are almost as long as Daniel) and the content is more narrowly focused.

4. Aleksander Men (1935–90) eventually published many books. His major work is his history of religion, published in seven volumes under the title: *In Search of the Way, the Truth, and the Life (V poiskakh puti, istiny i zhizni)* (vols 1–6, Brussels, 1970–83; 2nd edn Moscow, 1991–2) and including as the seventh volume his most famous work, *Son of Man (Syn chelovechesky)* (Brussels, 1969; 2nd edn Moscow, 1991). The Brussels editions were published under a pseudonym as religious literature was severely repressed until perestroika.

5. 'Animals with cloven hoofs': in fact, according to the Torah, only animals that have cloven hoofs **and** chew the cud are kosher.

6. 'And he joined his own people': this formula is used in the Torah, with reference to the death of Abraham and his burial in Machpelah.

7. The 'True Orthodox', or 'Catacomb', or 'Tikhonite' Church claims to be the direct descendant of the Russian Orthodox Church as it existed before the revolution and in the first decade after the revolution under Patriarch Tikhon.

8. Men was murdered on a Sunday morning while walking along the wooded path from his home in Semkhoz. He was on his way to Novaya Derevnya, where he had served as parish

priest for 20 years, to celebrate the Divine Liturgy. Since his death, Men's works and ecumenical ideas have been seen as controversial among the conservative wing of the Russian Orthodox Church. Nonetheless, Men has a considerable number of supporters, some of whom argue for his canonisation. His lectures are regularly broadcast over Russian radio.

Chapter 16 A Waiting Game

1. Sinyavsky was sentenced to seven years hard labour. He was released in June 1971.
2. Aleksandr Mikhaylov (1938–95) was a philologist, literary critic and cultural commentator.
3. Aron Gurevich (1924–2006) was a mediaeval historian, working on the European culture of the middle ages.
4. Mikhail Gasparov (1936–2005) was a philologist and translator, renowned for his studies in classical philology and the history of versification, and a member of the informal Tartu-Moscow Semiotic School.

Chapter 17 Departure: An Obstacle Race

1. Yevgeny Pasternak (1923–2012) – literary critic and son of Boris Pasternak.
2. *Internatsionalnaya Literatura* was a monthly literary and political magazine published in the Soviet Union from 1933 to 1943. It had Russian, French, English and German editions. The magazine contained literary criticism of both Soviet and foreign literature, a chronicle of the international literary world, and the translated works not only of 'approved' authors, such as Romain Rolland, Ernest Hemingway, Heinrich Mann, Lion Feuchtwanger, William Saroyan and André Maurois, but also of more experimental writers such as Joyce. In their paper, 'Literary Translation and Soviet Cultural Politics in the 1930s', the authors posit several reasons for the surprising amount of freedom *Internatsionalnaya Literatura* enjoyed: 'for a number of reasons the journal was largely untouched by the welter of controls and restrictions that were developing in the literary sphere. First, the Union of Soviet Writers, which was founded in 1932 as part of the push to centralise the administration of all cultural activity, was still in the process of organisation. Second, for practical reasons the authorities could not make the same demands of foreign authors (or of correspondence and editorial work with them) that they could in relation to Soviet writers. Finally, virtually all Party decrees, decisions of the Union of Soviet Writers (including the promulgation of socialist realism as the 'sole artistic method' of Soviet literature), censors' standards, and other regulatory documents concerning literary activity targeted domestic literature specifically. The problem of how to apply these to translated foreign literature was left up to the discretion of the editorial board [of Internatsionalnaya Literatura].' In: 'Literary Translation and Soviet Cultural Politics in the 1930s: the role of the journal Internacional'naja Literatura', by Nailya Safiullina and Rachel Platonov, *Russian Literature* 72/2 (15 August 2012), pp. 239–69. https://doi.org/10.1016/j.ruslit.2012.08.005 (accessed November 2017). When first published in Paris in 1922 *Ulysses* was banned in the UK and USA for obscenity.
3. Graham Greene, *Getting to Know the General* (Penguin Books Ltd, 1985), p. 179.

Chapter 18 The Journal *Kontinent*

1. Axel Springer (1912–85) was a highly successful German publisher, who founded his company, Axel Springer GmbH, in Hamburg in 1946. In 1952, Springer started the publication of the best-selling daily newspaper, *Bild-Zeitung*, broadsheet in size but tabloid and right-wing in tone and content. He went on to acquire a string of newspapers and magazines and took over several other publishing houses.

2. Viktor Nekrasov (1911–87) was a writer, journalist and editor. He won the USSR State Prize for his first novel, *Front-line Stalingrad* (*V okopakh Stalingrada*), based on his own experiences serving in the Red Army in World War II. Later novels took a distinctly anti-Stalinist line and he was one of the first writers to call for a monument to be built at the ravine of Babi Yar, the site of a wholesale massacre of thousands of Jews by Nazis and their local Ukrainian collaborators in 1941. From the mid-1960s he signed numerous open letters protesting against Soviet policies and was expelled from the Communist Party in 1973 and emigrated to Paris in 1974.

3. Nahum (Naum) Korzhavin (born 1925) is a Russian poet of Jewish descent. His studies at The Gorky Institute of World Literature were interrupted when he was arrested in 1947 and incarcerated for several years. He was rehabilitated in the post-Stalinist thaw, completed his studies and began publishing his poems in journals. In the late 1960s he became involved in the dissident movement and was prevented from publishing although his work circulated widely in *samizdat*. In 1973 he applied to emigrate, citing as his reason 'lack of air to live'. He settled in Boston, USA.

4. The Ullstein Press had been a thriving Jewish publishing house in the 1920s. The business was seized by the Nazis in 1934 and 'aryanised'. After the war the publishing house was restored to the Ullstein family, but it struggled financially and was eventually taken over by Axel Springer.

5. Propyläen was founded in 1919 as an imprint of the Ullstein Press for non-fiction and particularly history and art history.

6. The Posev Press. See endnote 8, below, on the NTS.

7. The famous novelist and dissident was forcibly expelled from the USSR in February 1974. Solzhenitsyn initially settled in Zurich and at last collected the Nobel Prize he had been awarded for Literature in 1970 but been unable to collect for fear of not being readmitted to the Soviet Union.

8. The NTS (Narodno-Trudovoy Soyuz), known in English variously as The National Alliance of Russian Solidarists, The National Labour Alliance, or the People's Labour Union, was first established by Russian émigré students in European universities in 1930. Reacting against the perceived passivity of their fathers' generation of exiles, they wished to actively oppose and eventually overthrow Bolshevik ideology. They also opposed what they saw as the excessively rationalist and materialist tradition of much Western liberalism; their movement had a strong Christian ethos. *Posev* (Sowing) was the name of the journal through which they promoted their ideas, and also the name of their publishing house, Posev Press, which was based in Frankfurt.

9. 'The Literary Process in Russia' (*Literaturny protsess v Rossii*); Sinyavsky signed this article with his pseudonym, Abram Terts, see Chapter 7, endnote 5. The Russian title of Pyatigorsky's book, *Remarks on the Metaphysical Situation* is *Zametki o metafizicheskoy situatsii*.

10. The three Brodsky poems were: 'On the Death of Zhukov' (*Na smert Zhukova*); 'The End of a Beautiful Era' (*Konets prekrasnoy epokhi*); 'In the Lake District'(*V Ozernom krayu*).

11. Galich had been given 24 hours to leave the Soviet Union in June 1974 and initially settled in Norway.

12. For a dissident Russian, this would be the equivalent of having Leonard Cohen performing in your living room.

13. The full title of the 'lullaby' is: 'About how Klim Petrovich composed a science-fiction lullaby while rocking his nephew Semyon, Klavka's son, to sleep.' This was part of a long satirical song cycle, 'Episodes from the Life of Klim Petrovich Kolomiitsev, Workshop Foreman, Holder of Many Orders, Deputy of the Town Soviet' see Gerald Stanton Smith's translation of *Galich's Songs and Poems*. I. G. is quoting (somewhat inaccurately) from memory but gives the menacing gist.

14. Rhinoceroses – a reference to Ionesco's absurdist play *Rhinoceros* satirising conformism, in which all the inhabitants of a provincial French town (except for one independent-thinking man) turn into rhinoceroses. Maksimov later wrote his own story, *Saga about Rhinoceroses*, inspired by the play. See also Chapter 24, endnote 2.

15. The Black Hundreds was an extreme nationalist movement in Russia in the early twentieth century. Its members were staunch supporters of tsarist rule and were also notorious for their xenophobia, antisemitism and incitement to pogroms.

16. In Gogol's *Dead Souls*, Mizhuev is the brother-in-law of the flamboyant Nozdrev and tags along with him on various adventures. Boris Dralyuk has pointed out that the quotation, 'and the brother-in-law, Mizhuev, as well!' appears not in Gogol's original novel but in the stage adaptation by Bulgakov. Nozdrev is thrown out of the Governor's ball for his outrageous behaviour and the blameless brother-in-law is expelled for good measure.

Chapter 19 The Anthony Blunt Affair

1. The Cambridge Spy Ring had provided the Soviet Union with top secret information during World War II and the beginnings of the Cold War. Although the Soviet Union had been an important ally during World War II, it became an arch-enemy for the West after 1945.

2. According to his biographer, Blunt's confession was in fact made on 23 April 1964. Miranda Carter, *Anthony Blunt: His Lives* (London, 2001), p. 451.

3. 'Secret, even from the Queen': 'The Queen was also informed, according to her one-time secretary, Lord Charteris, and to Roy Jenkins, Home Secretary ...' Carter, *Anthony Blunt*, p. 448.

4. It was agreed that Blunt would receive immunity from prosecution and that the matter would be hushed up: 'there was a terror of scandal. Hollis [Director of MI5] and many of his senior staff were acutely aware of the damage any public revelation of Blunt's activities might do to themselves, to MI5, and to the incumbent Conservative government': Peter Wright with Paul Greengrass, *Spycatcher: The Candid Autobiography of a Senior Intelligence Officer* (Australia, 1987), p. 213.

5. Blunt's *Picasso's Guernica* was published in the UK by Oxford University Press in 1969.

6. The Apostles is a 'secret' society which was founded in 1820 and continues to exist today. The group has a membership of 12 undergraduates at any one time, mostly elected from Trinity College and King's College. Many members of the Bloomsbury Group were also

Apostles: Leonard Woolf, John Maynard Keynes, Bertrand Russell, Lytton Strachey, E. M. Forster. Ludwig Wittgenstein was an infrequent attender.

7. According to Miranda Carter, 'contrary to suggestions at the time of his exposure, there is no evidence that Blunt was the direct cause of any deaths': Carter, *Anthony Blunt*, p. 287.

8. John Lister Illingworth Fennell (1918–92) was Statutory Professor of Russian at Oxford when Igor taught there.

9. Each year, the British Academy elects to its Fellowship up to 52 outstanding UK-based scholars who have achieved distinction in any branch of the humanities and social sciences. The distinguished classical scholar, Sir Kenneth Dover, was president of the Academy in 1979 when the question as to whether Blunt should be expelled arose. According to his obituary in the Telegraph in 2010, Dover 'tried with only partial success to hold the ring between competing factions within the Academy but the problem solved itself when Blunt resigned. For Dover, who privately thought expulsion could be justified on the grounds that Blunt had transferred his allegiance to a government hostile to the pursuit of scholarship, the whole affair was "absorbingly interesting and therefore intensely enjoyable".'

10. The 'wise men' who were against Blunt's expulsion included Isaiah Berlin, A. J. P. Taylor and Ralf Dahrendorf. Carter, *Anthony Blunt*, pp. 491–2.

Chapter 20 Radio Liberty, Galich

1. In 1949 the United States government founded Radio Free Europe (RFE) to broadcast to Eastern Europe. A sister channel, Radio Liberty, was created in 1951 to target audiences within the Soviet Union. Both services, which merged in 1976, were covertly funded by the CIA until 1972. Their aim was to combat communist ideology by offering listeners in totalitarian regimes an alternative source of information. The broadcasts were subject to regular jamming by the KGB. Both stations had their headquarters at the Englischer Garten in Munich.

2. Vladimir Vysotsky, see Chapter 7, endnote 4. Bulat Okudzhava, see Chapter 12, endnote 12.

3. NTS: see chapter 18, endnote 8.

4. 'Nabokov-style emigration and Gazdanov-style emigration': see Dramatis Personae for the contrasting lives of these two writers.

5. The French inquest found that Galich's death was accidental but his daughter always believed that he had been assassinated.

Chapter 21 At the BBC

1. Solzhenitsyn uses the scornful term 'obrazovantsy', meaning mere degree holders (presumably as opposed to genuine thinkers who would agree with him!).

2. Seva Novgorodtsev – pseudonym of Vsevolod Levenstein – (born 1940) was a successful jazz musician who emigrated in 1975. He became famous throughout the Soviet Union as a DJ on the BBC Russian Service. According to the BBC, it is believed that in the 1980s he had audiences of 25 million people 'tuning in their short wave radios to hear Seva's crackly broadcasts of David Bowie, Queen and Michael Jackson'. http://www.bbc.co.uk/news/m agazine-34157596 (accessed 20 November 2017).

3. Ochagavia was known on air as Dr Eddie Lawrence.

4. The first assassination attempt on Pope John Paul II took place in Rome in 1981. The actual perpetrator was a Turk, Mehmet Ali Ağca, but the Bulgarian Secret Service and the KGB were strongly implicated. Cardinal Wojtyła of Poland had been elected pope in1978 and was a strong supporter of Poland's anti-communist Solidarity movement.

5. White Guards – an anachronistic reference to the anti-Bolshevik army which fought in the Civil War which followed the Russian Revolution. NTS: See Chapter 18, endnote 8.

6. *The Yawning Heights* is an allegorical satirical novel set in the imaginary Russian town of Ibansk. Circulated widely in *samizdat* within the Soviet Union, the novel was smuggled out and published in Switzerland in 1976. It was the first novel of the philosopher Aleksandr Zinoviev (1923–2006).

7. The Molotov-Ribbentrop Pact, also known as the German-Soviet Non-agression Pact, was an agreement signed in August 1939 by Joachim von Ribbentrop for Germany and Vyacheslav Molotov for the Soviet Union. As a result the Soviet Union did not enter World War II until 1941, after Hitler broke the agreement by attacking Soviet positions in eastern Poland during Operation Barbarossa.

Chapter 22 The Second Trial of Andrey Sinyavsky

1. See: *Teffi: A Life of Letters and Laughter*, Edythe Haber (I.B.Tauris, forthcoming) and *Russian Emigré Short Stories from Bunin to Yankovsky*, edited by Bryan Karetnyk (Penguin, 2017).

2. Diamond-shaped patches were sewn on the back of convicts' jackets so that they could be easily spotted and recaptured.

3. *Vestnik RSKhD* translates as Herald of the Russian Student Christian movement.

4. Khmelnitsky had appeared as a witness for the prosecution in the Sinyavsky-Daniel trial in 1966 (see Chapter 12).

5. The article 'From the Belly of the Whale' ('Iz chreva kitova') was published in issue no. 48 of *22* in 1986.

6. 'From the Belly of the Whale' was an angry riposte by Khmelnitsky to the final chapter of Sinyavsky's autobiographical novel, *Good Night!* In that chapter, called 'In the Belly of the Whale', Sinyavsky details his childhood and adolescent friendship with 'Seryozha' (clearly Khmelnitsky) and Seryozha's repeated treachery. *Good Night!* (*Spokoynoy Nochi*) had been published by Sintaksis in Paris in 1984.

7. Hélène Peltier Zamoyska (1924–2012), French Slavic scholar. Thanks to her father's position at the French Embassy in Moscow, she was one of the rare foreigners allowed to study at Moscow State University (MGU) in the late 1940s. At Sinyavsky's trial in 1966, she 'was named as the person who had illegally smuggled out his manuscripts'. Sheila Fitzpatrick, *A Spy in the Archives* (London, 2014), p. 238. Peltier Zamoyska played a role in bringing Pasternak's *Dr Zhivago* to the West. She had visited Pasternak in autumn 1956 and been given a copy of Doctor Zhivago: *Lettres à mes amies françaises* (Paris, 1994), pp. 20–1. She was part of the team of translators of the first French edition (with Michel Aucouturier, Jacqueline de Proyart and Louis Martinez).

8. Sinyavsky believed that once Hélène became a Soviet citizen by marriage she would be at risk of assassination by the KGB.

9. See Abram Terts (trans. Richard Lourie), *Good Night!* (New York, 1989), pp. 320–61.

10. Translation by Gerald Stanton Smith. The lines are from the poem 'Landscape', which is prefaced by a paragraph in which Galich explains how, while at a country club on the

outskirts of Moscow, he came across a Heath Robinson-like contraption for measuring the rising levels of sewage in the club's cesspit. This consisted of a post with numbered divisions on it, some string, a float and a weight. The watchman who explained it to him said it was called a 'govnomer' – a 'shitometer'. Alexander Galich, *Songs & Poems*, translated and edited by Gerald Stanton Smith (Ann Arbor, Mich., 1983).

11. From 'My Friends Keep Going Away' (dedicated to Frida Vigdorova), Stanton Smith, *Songs & Poems*.

12. *Kontinent* republished Khmelnitsky's article in issue 71, 1992, with additional commentary.

13. Natalya Gorbanevskaya (1936–2013) was a poet, journalist and translator. In August 1968 she was one of seven brave souls who made a protest against the Soviet invasion of Czechoslovakia in Red Square, pushing her three-month-old son in a pram. In 1969 she was arrested and held in a psychiatric hospital for two years. For a time Gorbanevskaya was a celebrity figure in the West. In 1976 Joan Baez released a song dedicated to her, called 'Natalia'. In 1975 she was given permission to leave the Soviet Union and moved to Paris, where she worked for *Kontinent*.

14. Yury Artemyev: see Chapter 3.

15. The Archive of the President of the Russian Federation was established in 1991 and is managed by the Presidential Administration of Russia. Despite early hopes and promises that it would be open to scholars and historians, it remains almost entirely classified and preserves records of the President of Russia and Presidential Administration of Russia, as well as documents of the highest organs of the Communist Party of the Soviet Union. See Robert W. Davies, *Soviet History in the Yeltsin Era* (London, 1997), p. 96.

16. The President's Special Commission on the Archives was set up by Yeltsin in 1992 to oversee the declassification of the historical archives of the Politburo and the personal archives of the General Secretaries of the party, including Stalin and of many leading figures including Trotsky and Maxim Gorky, and their opening to the public. Little of the promised access came to pass. Davies, *Soviet History*, p. 112.

17. The Fifth Chief Directorate of the KGB dealt with internal security. Created in 1969 to concentrate on combatting political dissent, it took up some of the tasks previously handled by the Second Chief Directorate. The Fifth Chief Directorate had special operational departments for religious dissent, national minorities, the intelligentsia and the artistic community, and censorship of literature.

18. Irina Ilovayskaya-Alberti (1924–2000) was a journalist and the editor of *Russkaya Mysl*, an influential Russian-language weekly newspaper published in Paris. She was a close associate of Solzhenitsyn and an admirer of Pope John Paul II. She was born into the Orthodox faith but converted to Catholicism.

19. *A Voice from the Chorus* by Abram Terts is composed of a series of fragmentary sections taken from the letters which Sinyavsky wrote to Rozanova during his incarceration. The 'chorus' is made up of snatches of dialogue from the voices of other prisoners.

20. Dolberg had been instrumental in collecting the 'ransom' money so that the Golomstocks could emigrate. See Chapter 17.

21. Dalstroy, also known as the Far North Construction Trust, was an organisation set up in 1931 by the NKVD (the predecessor of the KGB) to manage road construction and the mining of gold in the Russian Far East. Dalstroy created about 80 gulags in the Kolyma region and used the prisoners as forced labour to carry out construction work (see Chapter 2).

22. Rudolf Abel (1903–71) – real name Vilyam 'Willie' Genrikhovich Fisher – was a Soviet intelligence officer. He adopted his alias when arrested on charges of conspiracy by FBI agents in New York in 1957. He was sentenced to 30 years' imprisonment for his involvement in what became known as the Hollow Nickel Case. He had served just over four years when he was swapped for the American pilot Gary Powers.

23. Francis Gary Powers (1929–77) was an American pilot whose Central Intelligence Agency (CIA) U-2 spy plane was shot down while flying a reconnaissance mission in Soviet Union airspace, causing the 1960 U-2 incident.

24. Aleksandr Glezer (1934–2016) left the Soviet Union with several crates full of canvases by unofficial artists. The exhibition which he and Golomstock arranged, Unofficial Art from the Soviet Union, was held at the Institute of Contemporary Arts, in London in 1977. It was opened by Henry Moore and attracted widespread attention. A permanent home for the collection, Le Musée Russe en Exil, was established at Montgeron, near Paris in 1976. Golomstock later ceased to have any dealings with Glezer, whom he considered to be 'very calculating and overweeningly ambitious'.

25. *The White Book* was the verbatim account of the Sinyavsky-Daniel trial. Its compilers, Ginzberg and Galanskov, had been sent to the camps for producing it (see Chapter 11, endnote 3.)

Chapter 23 Politics versus Aesthetics

1. *Totalitarian Art*, see Chapter 5, endnote 4 for the genesis of this book.

2. Bukovsky had spent a total of twelve years in various psychiatric wards and labour camps. See Dramatis Personae.

3. 'Pestering the life out of … senators and congressmen': Bukovsky had met President Jimmy Carter at the White House in 1977, a meeting that was widely reported as a sign of the newly elected president's commitment to human rights.

4. Nikita Struve (1931–2016) was born in Paris to a Russian family of intellectuals exiled in France after the revolution. Struve was a translator, writer, publisher and strong supporter of the Russian Orthodox faith. He became a professor of Russian and founded and directed the French-language religious magazine *Le Messager orthodoxe*. As editor at YMCA Press in Paris, he was in charge of the publication in Russian of Solzhenitsyn's *Gulag Archipelago* in 1973 and consulted on the French and other language editions.

5. Sinyavsky's playfully irreverent treatment of Russia's national poet is neatly encapsulated in Catharine Theimer Nepomnyashchy's introduction to the English translation: 'Sinyavsky constantly breaches critical decorum, mixing lyrical effusions with colloquialisms and labour camp slang, playing havoc with chronology and allowing his narrative to be carried along by the flow of metaphors that stand the clichés of the Pushkin cult on their heads.' Catharine Theimer Nepomnyashchy and Slava I. Yastremski, *Strolls with Pushkin* (New York, 2017), p. 1v.

6. Mikhail Kuzmin (1872–1936) was a poet, musician and novelist. He was associated with the symbolists and then with the Acmeist group of poets that included Gumilyev, Mandelstam and Akhmatova. He was a friend of Akhmatova but later fell out with her. He was the inspiration for one of the villains in her 'Poem without a Hero'.

7. 'Galina Borisovna': a common euphemism for the (K)GB.

8. 'With the Saints give Rest, O Christ' (So Svyatimi upokoy) is traditionally sung during the Russian Orthodox funeral service.

Chapter 24 Sinyavsky's Last Years

1. Boris Yeltsin (1931–2007) became the first president of the Russian Federation after Gorbachev's resignation in 1991 and the dissolution of the Soviet Union. He wanted to transform Russia's socialist economy into a capitalist market economy and implemented economic shock therapy, price liberalisation and wholesale privatisation. Most of the country's national resources and wealth fell into the hands of a small number of oligarchs.

2. *Saga about Rhinoceroses (Saga o nosorogakh)*, 1982, is described by Maksimov himself as 'satire ... it has nothing to do with the West as such but with certain forces in the West, destructive forces, working – sometimes unconsciously towards the downfall of civilisation.' John Glad, *Conversations in Exile; Russian Writers Abroad* (Durham, NC 1993), p. 246.

3. On 21 September 1993 a power struggle between President Yeltsin and the Russian parliament came to a head. Yeltsin ignored the constitution and dissolved the Russian Parliament. His political rivals, the speaker of the Supreme Soviet, Ruslan Khasbulatov, and Vice President, Aleksandr Rutskoy, barricaded themselves inside Moscow's White House – the parliament – and voted to impeach the president. On 4 October the army stormed the White House on Yeltsin's orders and arrested the occupiers. Over a hundred people, possibly many more, were killed in street fighting between the different factions.

4. Pyotr Abovin-Yegides (1917–97) was a philosopher, writer and dissident who spent time in prison and a psychiatric ward. Between 1978 and 1980 he edited the *samizdat* magazine *Poiski (Searches)*. He was expelled from the Soviet Union in 1980 and settled in Paris.

5. *Sintaksis* 34 (1994), pp. 200–2, 206.

6. **Author's note**: I cannot resist having my say about the worldwide anti-smoking psychosis. Sinyavsky's case is not the only one I remember. The same thing happened to Boris Shragin: heart attack – ban on smoking – lung cancer. And the same thing happened to another person I knew. Nine years ago I myself had a serious heart attack. I argued with my hospital consultant about smoking. 'One cigarette will kill you', he said gravely. Once I got back home I decided to test this out and lit up a cigarette. I am still smoking – and still alive to tell the tale.

7. *A Journey to Chernaya Rechka* has been translated in English by Slava I. Yastremski and Michael M. Naydan with Olha Tytarenko under the title *A Journey to the River Black*. Chernaya Rechka (literally little black river) in St Petersburg was the site of Pushkin's fatal duel with D'Anthès on 27 January (old style) 1837.

Chapter 25 Perestroika

1. I. G. had been awarded a year-long research grant to work on his book, *Totalitarian Art*.

2. Yury Zlotnikov (1930–2016) was one of the pioneers of abstract art in the post-Stalinist Soviet Union.

3. Vasily Polenov (1844–1927) was a landscape painter associated with the Peredvizhniki (Wanderers or Itinerants) movement of realist artists who escaped from the strictures of the Imperial Academy of Arts by organising themselves into a co-operative which mounted travelling exhibitions.

4. Solovetsky Islands: see Chapter 7, endnote 10.

5. Feliks Dzerzhinsky: see Chapter 14, endnote 37. A year after the ceremony to inaugurate the Solovetsky boulder the BBC reporter, Martin Sixsmith, witnessed the following scene: 'I was in Lubyanka Square in front of the KGB's headquarters on 22 August 1991 as demonstrators toppled the statue of Feliks Dzerzhinsky, the organisation's founder. When a hawser was tied round Dzerzhinsky's neck and the 14-tonne colossus came crashing to the ground, it seemed the KGB's days were numbered.' http://news.bbc.co.uk/1/hi/world/europe/7257310.stm (accessed November 2017).

6. I. G. deliberately uses the archaic 'Chekists'. Cheka was the acronym for the first of a succession of Soviet secret police organisations. It was established on 20 December 1917 by a decree from Vladimir Lenin. Dzerzhinsky, the first head of the Cheka, explained in July 1918: 'We stand for organised terror – this should be frankly admitted. Terror is an absolute necessity during times of revolution. Our aim is to fight against the enemies of the Soviet Government and for the new order of life. We judge quickly. In most cases only a day passes between the apprehension of the criminal and his sentence. When confronted with evidence, criminals in almost every case confess; and what argument can have greater weight than a criminal's own confession.' Source: http://spartacus-educational.com/RUSDzerzhinsky.htm (accessed January 2018).

Chapter 26 Family Matters

1. Nomenklatura: the privileged elite – Communist Party and state functionaries – who ran the senior bureaucracy in the Soviet Union.

2. Aleksandr Litvinenko was a former officer of the Russian Federal Security Service (FSB) and KGB, who fled from Russia and received political asylum in the United Kingdom in 2000. On 1 November 2006 Litvinenko suddenly fell seriously ill. He died three weeks later, poisoned by radioactive polonium-210, believed to have been slipped into his cup of tea at a meeting with former KGB/FSB contacts. Litvinenko's revelations about FSB activities and his deathbed accusation that Russian president Vladimir Putin was behind his poisoning resulted in worldwide media coverage. A public inquiry into Litvinenko's killing concluded that President Putin probably approved his assassination.

3. The programme was actually aired twice but then banned and removed from the BBC website.

4. See Standpoint http://www.standpointmag.co.uk/node/3492/full for a detailed account by Masha Karp of what happened to her programme and the further consequences.

5. Lev Markiz/Marquis (born 1930) began his career as a virtuoso violinist, but then developed a career as a conductor, particularly associated with the music of Shostakovich and Schnittke.

6. Loshits is a town in the Lublin province of Eastern Poland. Jews first settled there at the end of the seventeenth century. Before the outbreak of World War II there were about 2,900 Jews in Loshits. The community was liquidated on 22 August 1942, when all the Jews of the town were deported to the Treblinka extermination camp.

7. The Bund or the Jewish Labour Bund was a secular Jewish socialist party in the Russian Empire, active between 1897 and 1920. Its aim was to unite all Jewish workers in the Russian Empire into a united socialist party, and also to ally itself with the wider Russian social democratic movement to achieve a democratic and socialist Russia. In 1902, a United Organisation of Workers' Associations and Support Groups to the Bund Abroad was founded.

8. The Soviet government had a project to resettle all the Jews in the USSR in a designated territory where they would be able to pursue a way of life that was 'socialist in content and national in form'. The Soviets also wanted to offer an alternative to Zionism, with its goal of establishing Palestine as the Jewish homeland. Socialist Zionists such as Ber Borochov were gaining followers at that time and Zionism was a rival ideology to Marxism among left-wing Jews. Birobidzhan, in the remote Soviet Far East, was eventually chosen as the site for the Jewish autonomous region. It was strategically important as a buffer zone against the border with China. It had a severe climate and harsh terrain: it was mountainous, covered with virgin forests and swamplands, and new settlers had to build their lives from scratch. To make colonisation more enticing, the Soviet government allowed private land ownership.

9. Nikolay Yezhov (1895–1940) was the notoriously ruthless head of the NKVD (1936–8), during the most active period of Stalin's purges. His time in office has become known as the 'Yezhovshchina', a term coined during the de-Stalinisation campaign of the 1950s. Eventually, Yezhov became a victim of the purges himself. He confessed under torture to a range of anti-Soviet activities, and was executed in 1940.

10. In the second Battle of Smolensk (7 August–2 October 1943) the Red Army successfully cleared the German presence from the Smolensk and Bryansk regions. Smolensk had been under German occupation since the first Battle of Smolensk in 1941.

Dramatis Personae

Iosif (Yuz) Aleshkovsky (born 1929) is a writer, poet, playwright and performer of his own songs. With no hope of being published officially in the Soviet Union, Aleshkovsky emigrated in 1979 and settled in Middletown, Connecticut, USA, where he was a Visiting Russian Émigré Writer in Wesleyan University's Russian Department.

Irina Antonova (born 1922) served as Director of the Pushkin Museum of Fine Arts for 52 years, reluctantly retiring at the age of 91 in 2013.

Sergey Averintsev (1937–2004) was a distinguished cultural scholar, a specialist in literary history and theory. From the 1970s to the mid-1990s, he worked as a senior researcher at the Gorky Institute of World Literature in Moscow. From the mid-1990s until his death, he was a professor of Slavic Studies at the University of Vienna.

Boris Birger (1923–2001) was a leading nonconformist Soviet artist. He was twice expelled from the Union of Artists and emigrated to Germany in 1991.

Andrey Bitov (born 1937) is a prominent Russian writer. Many of his works, such as *Life in Windy Weather* (*Zhizn v vetrenuyu pogodu*, 1991), *Pushkin House* (*Pushkinsky Dom*, 1978) and *The Monkey Link* (*Ozhidaniye obezyan*, 1993) have been widely translated into other European languages.

Larisa Bogoraz (1929–2004) came from a family of Communist Party bureaucrats in the Ukraine and trained as a linguist. She married the writer Yuly Daniel in 1950 and became a human rights activist after his arrest and imprisonment for publishing abroad. Bogoraz became well known in 1968 after she organised a protest in Red Square against the Soviet invasion of Czechoslovakia. For this she was sentenced to four years' exile in Siberia. Daniel was released while she was still in Siberia and eventually they divorced. Bogoraz continued as a courageous campaigner, writing innumerable protest letters against human rights abuses. She wrote an open letter to Yury Andropov in 1975, when he was head of the KGB,

demanding that he open up the organisation's archives. Her second husband, Anatoly Marchenko, a fellow-activist, died in a labour camp after a hunger strike in 1986. Shortly afterwards, President Gorbachev ordered the wholesale release of political prisoners. In 1989, Bogoraz joined, and subsequently became chairwoman of, the newly re-founded human rights organisation, the Moscow Helsinki Group. She acted as a bridge between the old guard of dissidents, and the new generation that were arising as the Soviet Union dissolved.

After the fall of the Soviet Union, Bogoraz continued her activism, visiting prisoners and holding seminars on the defence of human rights. She also became chairwoman of the Seminar on Human Rights, a joint Russian-American non-governmental organisation. She resigned from the latter in 1996, but continued to exert influence in human rights circles up until her death.

Joseph Brodsky (1940–96). Born and brought up in a Jewish family in Leningrad, Brodsky started writing poetry at an early age. He left school at 15 and worked at an extraordinary range of manual jobs while learning English and reading English and American poetry. When he was 20, he was taken up by the great poet, Anna Akhmatova, who recognised his abundant poetic talent. In 1964 he was sentenced to five years of exile in Archangelsk in the far north of Russia for 'parasitism' but his sentence was commuted after an international campaign. Four of his poems appeared in Leningrad anthologies in the 1960s but nothing more was officially published in the Soviet Union until perestroika, although his work circulated in *samizdat* and was widely published in translation in Europe. In June 1972 Brodsky was expelled from the Soviet Union and settled in the United States where he taught or was poet in residence at various universities. He was awarded the Nobel Prize for Literature in 1987 and in 1991 became Poet Laureate of the United States.

Vladimir (Volodya) Bukovsky (born 1942) was prominent in the Soviet dissident movement of the 1960s and 1970s and spent a total of 12 years in psychiatric prison-hospitals, labour camps, and prisons within the Soviet Union. In December 1976, Bukovsky was forcibly deported from the USSR and exchanged by the Soviet government for the imprisoned general secretary of the Communist Party of Chile, Luis Corvalan. He gained a Masters degree in biology at Cambridge University and has continued to work as a neurophysiologist and is an active and maverick campaigner for human rights. He is implacably opposed to Putin and attempted to stand

for President of the Russian Federation against Dmitry Medvedev in 2008 but his candidacy was turned down on various technicalities. At the Litvinenko poisoning enquiry in London he expressed his conviction that the Russian authorities were responsible for the assassination. In 2017 he was arrested in Cambridge on charges of having images of child pornography on his computer. His supporters believe he has been framed by the Kremlin. In February 2018 his trial was indefinitely postponed because of his failing health.

Valery Chalidze (born 1938) is a Georgian-American author and publisher. He studied physics in Moscow and Tbilisi. On 4 November 1970, Chalidze became one of the three founding members (together with Andrey Sakharov and Andrey Tverdokhlebov) of the Moscow Human Rights Committee. The Committee was among the first non-governmental organisations in the history of the Soviet Union and eventually became affiliated with the United Nations.

Yuly Daniel (1925–88) was the son of the Yiddish playwright Mark Daniel. In 1942 he volunteered to serve in the Soviet army although he was underage. He was badly wounded in 1944 and invalided out. He trained as a teacher and taught in schools in and near Moscow. He was an accomplished translator of poetry. Like his friend Sinyavsky, he was writing stories and novellas and smuggling them abroad to be published under the pseudonym of Nikolay Arzhak. He and Sinyavsky were arrested in late 1965 and stood trial the following February. The Sinyavsky-Daniel trial, as it was known, drew world-wide criticism and is considered to be the starting point of the dissident movement. After serving a five-year sentence, Daniel returned to Moscow where he was helped by human rights activists to make a living by publishing translations under a pseudonym. He refused to emigrate and settled in Kaluga, 150 kilometres south-west of Moscow.

Ilya Ehrenburg (1891–1967) was a prolific Soviet writer, journalist, translator, and a celebrated cultural figure. In the aftermath of the Russian Revolution of 1905, Ehrenburg became involved in illegal activities with the Bolsheviks. When he was 17 Ehrenburg was arrested by the tsarist secret police. He was eventually allowed to go abroad and chose Paris for his exile. There he continued to work with the Bolsheviks and met Lenin but subsequently became involved in the bohemian life in Montparnasse where he met Picasso, Modigliani and Diego Riviera. In 1917, after the revolution, Ehrenburg returned to Russia. As a friend

of many of the European left, he was frequently privileged by Stalin to visit Europe and to campaign for peace and socialism. In 1936–9, he was a war reporter in the Spanish Civil War. He was instrumental in enabling the exhibition of Picasso's paintings which was put on at the Pushkin Museum in Moscow and then at the Hermitage in Leningrad in the last months of 1956. Picasso's work had been banned as 'formalist' under Stalin. '[Ehrenburg] had known and liked Picasso since the 1920s, when they met in the bohemian circles of Paris. Ehrenburg played on the Kremlin's eagerness to reach out to the broader intellectual and artistic circles of Western Europe ... additional support came from many younger Soviet artists who in 1955 began to raise their voices against the complete subjugation of art to the goals of state propaganda.' Vladislav Zubok, *Zhivago's Children* (Cambridge, MA, and London, 2009), p. 95.

Yefim Etkind (1918–99) was a professor of philology and a translation theorist. In the 1960s and 1970s he was involved in the dissident movement, speaking out in defence of Joseph Brodsky in 1964 and supporting Solzhenitsyn. He was expelled from the Soviet Union in 1974 and settled in France.

Miron Etlis (born 1929) was a psychiatrist and gulag prisoner who became a prominent member of the Magadan branch of the Human Rights group, Memorial. He features at some length in Adam Hochschild's *The Unquiet Ghost: Russians Remember Stalin* (1994), where his name is transliterated as Atlis.

Aleksandr (Sasha) Galich (1918–77) was a much-loved Soviet bard-style singer-songwriter who accompanied his highly colloquial, satirical songs on the guitar. Born Aleksandr Aronovich Ginzburg, he created his pen name by amalgamating elements from his real name. Originally a highly successful and conventional playwright, Galich evolved into the musical spokesman for a generation of dissidents during the 1960s. His songs – often thematically linked cycles – circulated in *'magnitizdat'* (unofficial recordings which passed from hand to hand, the equivalent of *samizdat* literature). An increasingly subversive thorn in the side of the authorities, he was expelled from the Soviet Union in June 1974, settling initially in Norway, then Munich, where he presented programmes on Radio Liberty, and finally Paris. Even after his enforced exile, his songs were constantly broadcast back to Soviet listeners via radio stations such as Radio Liberty and the BBC Russian Service.

Gaito Gazdanov (1903–71) joined the White Army as a 16-year-old and was evacuated from the Crimea with the remnants of General Wrangel's army (see also Chapter 1, endnote 5). He reached Paris in 1923 where he worked as a labourer and later drove a taxi at night, enabling him to study at the Sorbonne and pursue his career as a writer. His 1939 novel, *Night Roads* (*Nochnaya doroga*), was inspired by his experiences as a taxi driver. His novels *The Spectre of Alexander Wolf* (*Prizrak Aleksandra Volfa*) (1947) and *The Buddha's Return* (*Vosvrashcheniye buddy*) (1949) brought him international success. He joined Radio Liberty in 1953 and continued to broadcast for them up until his death in 1971.

Aleksandr (Alik) Ginzburg (1936–2002) was a journalist, poet and human rights activist. In 1967 he was sentenced to five years in the gulag for publishing *The White Book*, an account of the Sinyavsky-Daniel trial. After his release in 1972, Ginzburg and Solzhenitsyn initiated the Fund for the Aid of Political Prisoners. Funded by royalties from Solzhenitsyn's book *The Gulag Archipelago*, it distributed funds and material support to political and religious prisoners across the Soviet Union throughout the 1970s and 1980s. He was a founding member of the Moscow Helsinki Group which monitored human rights abuses in the Soviet Union. He was arrested again in 1978 and given an eight-year sentence. In 1979, he was expelled to the West as part of an exchange for two Soviet spies.

Anatoly (Anatol) Goldberg (1910–82). Following the Russian revolution, he emigrated with his parents in 1918 and settled in Berlin, where he attended a French school, and later studied Chinese and Japanese at the Berlin School of Oriental Studies. When the Nazis came to power in Germany he and his wife emigrated to Britain, where he joined the BBC Monitoring Service, working in German, Russian and Spanish. He joined the BBC Russian Service as soon as it was formed in 1946 and rose to become its head, a position he was removed from in 1957, apparently under pressure from the Foreign Office where he was considered to be too soft on Communism. He continued as a revered commentator until his death in 1982.

Andrey Guber (1900–70) was the senior curator at the Pushkin Museum of Fine Arts from 1945 to 1970. He published a number of books and was one of the authors of the six-volume *General History of Art* (*Vseobshchaya istoriya iskusstv*) (Moscow, 1960).

Yury Kolpinsky (1909–76). Art historian and theoretician specialising in Western art and classical antiquity.

Lev Kopelev (1912–97) was a dissident writer who met Solzhenitsyn in the gulag while serving a 10-year sentence. He served as a model for Rubin in Solzhenitsyn's *The First Circle* and was instrumental in getting *One Day in the Life of Ivan Denisovich* published in the Soviet Union. Kopelev's book about the camps, *To Be Preserved For Ever* (*Vechno khranit*), aroused great attention when it appeared in the West in 1976. He was allowed to leave the Soviet Union with his wife, Raisa Orlova, in 1980 and settled in Germany.

Oleg Kudryashov (born 1932). Primarily a printmaker, Kudryashov has also produced sculptures, videos, performance pieces and three-dimensional reliefs constructed from his own dry point engravings. He lived and worked in London from 1974 to 1997 when he returned to Russia. His work is exhibited and collected all over the world.

Prince Aleksandr Lieven (1919–88) came from an illustrious family of Baltic aristocrats who emigrated after the revolution. Lieven served as head of the BBC Russian Service in 1960 and subsequently as head of the entire East European Service. His sons, Dominic and Anatol, are both distinguished academics and commentators on Russia.

Vladimir Maksimov (1930–95) – born Lev Samsonov – became a leading figure in literary and political circles in émigré Paris where he arrived in February 1974 after being stripped of his Soviet citizenship for his dissident activities. A powerful personality, he had survived a brutal, neglected childhood and two spells of forcible incarceration in psychiatric hospitals in the USSR.

Nadezhda Mandelstam (1899–1980) was a writer and teacher, and the wife of the poet Osip Mandelstam. Osip was arrested in 1934 for his poem 'Stalin Epigram' and exiled to Perm, near the Urals. Nadezhda went with him. Later, they were allowed to move to Voronezh in south-western Russia, but were still banished from the largest cities, which were the centres of artistic and cultural activity. After Osip Mandelstam's second arrest in May 1938 and his subsequent death at a Siberian transit camp that year, Nadezhda Mandelstam moved from place to place, trying to avoid the attentions of the secret police, working as a teacher of English and keeping her husband's work alive in her memory as it was too dangerous to write it down. She was allowed to return to Moscow in 1956 and wrote two memoirs of her experiences, published in English as *Hope Against Hope* and *Hope Abandoned* (Nadezhda means 'hope' in Russian) and devoted her life to the preservation and publishing of Osip Mandelstam's work. See Chapter 14, endnote 34.

Andrey Menshutin (c. 1925–88) was a colleague of Andrey Sinyavsky at the Gorky Institute of World Literature. He and his wife, Lydia, were part of the Sinyavsky–Golomstock circle in Moscow. In 1964 he and Sinyavsky co-authored *Poetry in the First Years of the Revolution (1917–1920)* (*Poeziya pervykh let revolyutsii (1917–1920)*).

Vladimir Nabokov (1899–1977) was the scion of a wealthy aristocratic family who emigrated after the revolution. Nabokov studied at Cambridge and then joined his family in Berlin where his father had set up the émigré newspaper *Rul*. His first nine novels were in Russian, but he achieved international prominence after he began writing in English. Trilingual since childhood, he wrote his masterpiece *Lolita* (1955) in English and himself translated into Russian (1967).

Ernst Neizvestny (1925–2016). His monumental sculptures in bronze or concrete, often based on the forms of the human body, are noted for their powerful plasticity. Khrushchev famously derided Neizvestny's works as 'degenerate' art at the Moscow Manege exhibition of 1962 ('Why do you disfigure the faces of Soviet people?'), but the sculptor was later approached by Khrushchev's family to design a tomb for the former Soviet leader at the Novodevichy Cemetery. Much of his art from the Soviet era was destroyed before he was forcibly exiled to America. In 1969, he was the subject of an influential book by John Berger, *Art and Revolution: Ernst Neizvestny, Endurance, and the Role of the Artist* (London, 1969). Although Neizvestny eventually settled in New York City and worked at Columbia University, he frequently went back to Moscow and celebrated his 80th birthday there. Neizvestny, whose surname means 'unknown', now has an international reputation. He was awarded the State Prize of the Russian Federation in 1996.

Mikhail (Misha) Nikolaev (1929–88) was brought up in an orphanage after his parents were shot in the purges in 1932. He served in the Red Army as a teenager and spent 15 years in the camps for his protests against various injustices. After his release he married the Tsvetaeva scholar Viktoria Schweitzer, and they emigrated to the USA where Vika got a teaching post at Amherst, Massachusetts, while Misha was employed as the warden of a student hostel. Igor Golomstock visited them at Amherst and saw that Misha (who had no paper qualifications whatsoever) was happy in a milieu where he could have learned discussions on equal terms with professors and where he was on close terms with the poet, Joseph Brodsky, also teaching at Amherst in the 1980s. Brodsky dedicated his poem *Performance* (*Predstavlenie*) to Misha. Despite Misha's settled existence in

America, his experiences in the camps continued to haunt him. On one occasion he was picked up by the police while walking back to Amherst late at night and rather drunk. Misha's reflex action was to throw himself into the bushes, whereupon the police handcuffed him and put him in a cell for the night. When Misha woke the next morning and found himself behind bars he panicked, throwing himself violently at the walls and door of the cell. I. G. thinks this incident may have contributed to his early death from a heart attack. Misha wrote a memoir of his childhood, *Detdom* (New York, 1985). Extracts from *Detdom* (*Autobiography of an Orphan*), translated by Robert Chandler, were included in GLAS, vol. 16 ('Childhood') (Moscow, 1998). http://journals.sagepub.com/doi/abs/10.1080/0306422900 8534989?journalCode=ioca&.

Yura Ovsyannikov (1926–2001) was a historian, art historian, writer and editor who produced a large number of books for the specialist art publisher, Iskusstvo.

Aleksandr (Sasha) Pyatigorsky (1929–2009) was a philosopher, scholar of South Asian philosophy and culture, historian, philologist, semiotician and writer. He knew Sanskrit, Pali, Tibetan, German, Russian, French, Italian and English. In an obituary in the *Guardian*, he was cited as 'a man who was widely considered to be one of the more significant thinkers of the age and Russia's greatest philosopher.'

Vasily Rozanov (1856–1919) was one of the most controversial writers and philosophers of the pre-revolutionary epoch. His views have been termed the 'religion of procreation', as he tried to reconcile Christian teachings with ideas of healthy sex and family life. Because of references to the phallus in Rozanov's writings, he was called the Rasputin of the Russian intelligentsia. Rozanov starved to death in a monastery in the hungry years following the Revolution. Recently his paradoxical writings have once again become available to Russian readers, and there has been a resurgence of sympathy for Rozanov's political views. Rozanov remains little known outside Russia, though some Western scholars have become increasingly fascinated by his work and his persona.

Maria (Maya) Rozanova (born 1929) graduated from Moscow State University in Art History and taught at the Gerasimov Institute of Cinematography and the Abramtsevo College of Design and Applied Arts. She was married to the writer Andrey Sinyavsky. The letters he sent her during his long incarceration for dissident activities formed the basis of several of his books. After their emigration to France she set up and was

editor-in-chief of the literary journal, *Sintaksis*. The journal ran from 1978–2001 and attracted many prestigious contributors. Rozanova was an energetic and indefatigable defender of her husband's reputation during the years of émigré quarrels.

Andrey Sakharov (1921–89) was instrumental in developing Soviet nuclear weapons, for which he received the Stalin prize. In 1968 he spoke out publicly in favour of nuclear disarmament and peaceful co-existence and was dismissed from all his posts. He became a celebrated dissident and was awarded the Nobel Peace Prize in 1975, although he was not allowed to collect it. From 1980 to 1986 he and his wife, Elena Bonner, lived in internal exile in the closed city of Gorky. He was rehabilitated by Gorbachev in 1986 and went on to be elected to the Congress of People's Deputies in 1989.

Viktoria (Vika) Schweitzer (c. 1930). Schweitzer's work on Tsvetaeva, which began in 1954 with the collection of rare and archival materials, resulted in *Tsvetaeva* (*Byt i bytiye Mariny Tsvetayevoy*), a groundbreaking biography first published by *Sintaksis* in Paris in 1988 and eventually published in two different Russian editions and in English, Dutch, Italian, and Swedish translations. She was active in the dissident movement in Moscow and in 1966 took part in organising the 'Letter of Sixty-Three', in which 63 prominent Russian and Soviet writers expressed opposition to the government's arrest and persecution of Andrey Sinyavsky. As a result of this letter, Schweitzer was sacked from her job at the Union of Soviet Writers. After emigrating to the USA in the 1970s with her husband, Misha Nikolaev, she taught in the Russian departments of Amherst and Mount Holyoke Colleges for 30 years.

Igor Shafarevich (1923–2017) was an internationally renowned mathematician and leading dissident. However, his reputation was tarnished by accusations of anti-Semitism and far-right, nationalist leanings.

Princess Zinaida Shakhovskaya (1906–2001) was the long-time editor of the Russian émigré newspaper *Russkaya Mysl* (*Russian Thought*). She belonged to the first wave of emigrants and fought with the French Resistance during World War II.

Varlam Shalamov (1907–82). The son of a hereditary Russian Orthodox priest, Shalamov had difficulties accessing higher education after the revolution because of his origins but eventually studied Soviet Law at Moscow State University. He joined a Trotskyist group and was imprisoned from 1929 to 1931. After his release, he began publishing stories and articles but was arrested again in 1937 and spent 15 years in the Kolyma

camps where his health was almost destroyed. Nevertheless he continued to write poetry and prose after his release. His acclaimed *Kolyma Tales* (*Kolymskiye rasskazy*), published in translation in the West in 1966 and in Russian in 1978, were only published in the Soviet Union in 1987. A small planet, discovered by the Russian astronomer Nikolay Chernykh in 1977, is named after him.

Georgy Shchedrovitsky (1929–94) was a Russian educational theorist who began studying theoretical physics but transferred to the Philosophy Department of Moscow State University where he focused on logic and the methodology of science. In 1962 he joined Vadim Sadovsky and Erik Yudin in creating the Interdisciplinary Seminar on Structural and Systemic Methods of Analysis in Science and Technology at the Commission on Cybernetics of the Academy of Sciences of the USSR. He developed the concept of the organisational-activity game – a kind of game designed to facilitate organisational change. The Schedrovitsky Institute for Development continues his work investigating philosophy and methodology.

Boris (Borya) Shragin (1926–90) was a philosopher, editor, political commentator and human rights activist. He left the Soviet Union in the early 1970s and worked for Radio Liberty before settling in USA. He wrote a book on the history of Soviet dissent, *The Challenge of the Spirit*, in 1978.

Aleksandr Solzhenitsyn (1918–2008) was a novelist, historian, short story writer and dissident. In 1945, while serving in the Soviet army in East Prussia, Solzhenitsyn was arrested for writing derogatory comments in private letters about Stalin's conduct of the war. He was sentenced to an eight-year term which he served in various camps. Through his subsequent writings he helped raise global awareness of the Soviet gulag system. He was allowed to officially publish only one work in the Soviet Union, *One Day in the Life of Ivan Denisovich* (1962), in the periodical *Novy Mir*. After this he had to publish in the West, most notably *Cancer Ward* (1968), *August 1914* (1971), and *The Gulag Archipelago* (1973). Solzhenitsyn was awarded the 1970 Nobel Prize for Literature. He refused to go to Stockholm to receive his award for fear that he would not be allowed to re-enter the Soviet Union. He was eventually expelled from the Soviet Union in 1974. He initially settled in Zurich and subsequently in a secluded estate in Vermont, USA, from where he continued to exert huge influence over émigré affairs in Europe. He returned to Russia in 1994 after the dissolution of the Soviet Union.

Natalya Stolyarova (1912–84) was born in emigration to a revolutionary family and returned to the Soviet Union in 1934. She was imprisoned in 1937 and shared a cell in the Lubyanka (the KGB holding prison in Moscow) with Yevgenia Ginzburg who wrote a famous memoir of her own 18 years in the camps, published in English as *Journey Into the Whirlwind*. After Stolyarova's release in 1946 she lived a hand-to-mouth existence for several years. She became Ilya Ehrenburg's secretary in 1956 and worked with him until his death in 1967. She was an important figure in dissident circles, supplying details of her imprisonment to Solzhenitsyn for his *Gulag Archipelago*, and helping smuggle the manuscript abroad.

Boris Sveshnikov (1927–98) was a nonconformist artist, graphic artist and illustrator who developed his highly individual style during his eight-year incarceration in the gulag. His work is now collected internationally.

Valentin Turchin (1931–2010) was a computer scientist and pioneer in artificial intelligence. He became active in dissident circles in the 1960s. By 1973, Turchin had co-founded the Moscow chapter of Amnesty International and was working closely with Andrey Sakharov. In 1974 he lost his academic post and was persecuted by the KGB. Facing almost certain imprisonment, he and his family were forced to leave the Soviet Union in 1977.

Boris Vipper (1888–67) was a distinguished art historian and scholar. He was a professor at the University of Latvia from 1924 to 1941; he then became chair of the Art History Department at Moscow State University and was a senior researcher at the Pushkin Museum of Fine Arts. He was made a Corresponding Member of the Academy of the USSR in 1962.

Prince Andrey Volkonsky (1933–2008) was a pioneer of the Early Music revival in Russia. One of his illustrious forbears was Prince Sergey Volkonsky, a high-ranking army officer who was exiled to Siberia after taking part in the liberal reformist Decembrist plot of 1825. His wife, Maria, chose to follow him into exile, even though it meant she would never see her children again. A number of literary works, including Pushkin's *Yevgeny Onegin* and Nikolay Nekrasov's poem *Russian Women* (*Russkiye zhenshchiny*) paid tribute to the steadfast loyalty and heroism of Maria Volkonskaya.

Aleksandr Voronel (born 1931), physicist and founder, with his wife, the writer Nina Voronel, of the Russian-language journal *22* which was published in Israel.

Aleksandr (Alik) Yesenin-Volpin (1924–2016) was the son of Nadezhda Volpin, a poet and translator from French and English and the celebrated poet, Sergey Yesenin, whom he never knew. A mathematician by profession, he was first held in a psychiatric hospital in 1949 for writing 'anti-Soviet' poetry. Several more arrests and detentions occurred but he was given an amnesty after the death of Stalin. In 1965, Yesenin-Volpin organised the demonstration at Pushkin Square demanding an open trial for Andrey Sinyavsky and Yuly Daniel. The leaflets written by Volpin and distributed through *samizdat* asserted that the accusations and their closed-door trial were in violation of the 1936 Soviet Constitution and the more recent RSFSR Criminal Procedural Code. He was one of the first Soviet dissidents who took on a 'legalist' strategy of dissent. He proclaimed that it is necessary to defend human rights by strictly observing the law, and in turn demand that the authorities observe the formally guaranteed rights. Yesenin-Volpin was again put in a psychiatric ward in February 1968 as a result of his protests against the trial of Alik Ginsburg and Yury Galanskov for publishing *The White Book*, an account of the Sinyavsky-Daniel trial. He emigrated to the USA in 1972 and carried on his mathematical research at Boston University.

Zinovy Zinik (born 1945) is a novelist and broadcaster who emigrated from the Soviet Union to Israel in 1975. He joined the BBC in 1976 and has continued to broadcast as well as writing many novels, including *The Mushroom Picker (Russofobka i fungofil)* (1986) and *The Russian Service (Russkaya Sluzhba)* (1987), both adapted for television.

Anatoly (Tolya) Zverev (1931–86) belonged to the group of 'unofficial artists' who rejected socialist realism. He only had his first one-man show in Russia shortly before his death in 1986 and his work was exhibited in small, underground galleries. Throughout his career he was harassed and persecuted by the Soviet authorities, especially as his international success grew. His works are now in many leading collections in Russia, Europe and the USA.

Appendix I

Simplified chronology of Soviet and post-Soviet leaders in Russia

Vladimir Lenin 1922–4

Iosif Stalin 1924–53

Georgy Malenkov 1953–5
(triumvirate with Beria and Molotov March–June 1953)

Nikita Khruschev 'the thaw' 1955–64

Leonid Brezhnev 'stagnation' 1964–82
(triumvirate with Kosygin and Podgorny 1964–7)

Yury Andropov 1982–4

Konstantin Chernenko 1984–5
(triumvirate with Gromyko and Ustinov Feb.–Dec. 1984)

Mikhail Gorbachev 'perestroika' 1985–91

Soviet Union dissolved 26 December 1991, the day after Gorbachev's resignation as president.
Formation of the Russian Federation.

Boris Yeltsin 1991–9

Vladimir Putin 2000–8

Dmitry Medvedev 2008–12

Vladimir Putin 2012–incumbent

Appendix II

Successive iterations of the secret police in the Soviet and post-Soviet era with their acronyms

Cheka All-Russian Extraordinary Committee to Combat Counter-Revolution and Sabotage 1917–22
Chairman: Feliks Dzerzhinsky

GPU State Political Directorate 1922–3
Chairman: Feliks Dzerzhinsky

OGPU Joint State Political Directorate 1923–34
Chairman: Feliks Dzerzhinsky 1923–6
 Vyacheslav Menzhinsky 1926–34

NKVD People's Commissariat for Internal Affairs 1934–41
Chairman: Genrikh Yagoda 1934–6
 Nikolay Yezhov 1936–8
 Lavrenty Beria 1938–41

NKGB People's Commissariat for State Security Feb. 1941–July 1941
Chairman: Vsevolod Merkulov

NKVD 1941–3
Chairman: Lavrenty Beria

NKGB 1943–6
Chairman: Vsevolod Merkulov

MGB Ministry of State Security 1946–54
Chairman: Viktor Abakumov 1946–51
 Semyon Ignatyev 1951–3
 Lavrenty Beria March–June 1953
 Sergey Kruglov 1953–4
KGB Committee for State Security 1954–91
Chairman: Ivan Serov 1954–8

Aleksandr Shelepin 1958–61
Vladimir Semichastny 1961–7
Yury Andropov 1967–82
Vitaly Fedorchuk 1982
Viktor Chebrikov 1982–8
Vladimir Kryuchkov 1988–91
Vadim Bakatin 1991

FSK Federal Counterintelligence Service 1991–5
Director: Viktor Barannikov 1991–3
Nikolay Mikhailovich Golushko 1993–4
Sergey Stepashin 1994–5

FSB Federal Security Service of the Russian Federation 1995 onwards
Director: Mikhail Barsukov 1995–6
Nikolay Kovalyev 1996–8
Vladimir Putin 1998–9
Nikolay Patrushev 1999–2008
Aleksandr Bortnikov 2008 incumbent

Select Bibliography

Art/Art History

Dodge, Norton T. and Jane A. Sharp (eds) *Painting for the Grave: The Early Work of Boris Sveshnikov* (New Jersey: Museum, 2008).

Dmitrieva, Marina, 'The Riddle of Modernism in the Art Historical Discourse of the Thaw 2018 In memoriam Igor Golomstock' in *A Socialist Realist History? Writing Art History in the Post-War Decades* Editors: Krista Kodres, Kristina Jõekalda, Michaela Marek. (Köln, Weimar, Wien: Böhlau Verlag, 2018).

Golomstock, Igor, *Totalitarian Art in the Soviet Union, the Third Reich, Fascist Italy and the People's Republic of China*, trans. Robert Chandler (New York: The Overlook Press, 2012).

Golomshtok, Igor and Alexander Glezer, *Unofficial Art from the Soviet Union* (London: Martin Secker & Warburg, 1977).

Golomstock, Igor and Boris Sveshnikov: *The Camp Drawings* (Moscow: Memorial, 2000).

Reviakin, Sergei and Igor Golomstock (preface), and Edward Lucie-Smith, *Oleg Kudryashov: Bridge to the Future* (London: Unicorn Publishing, 2017).

Life in the Soviet Union

Davies, Robert W., *Soviet History in the Yeltsin Era* (London: Palgrave Macmillan, 1997).

Ehrenburg, Ilya, *The Thaw*, trans. Manya Harari (London: Harvill, 1955).

———, *People, Years, Life, 1891-1921,* trans. Anna Bostock and Yvonne Kapp (New York: Knopf, 1972).

Fitzpatrick, Sheila, *A Spy in the Archives: A Memoir of Cold War Russia* (London: I.B.Tauris, 2015).

Galich, Aleksandr, *Songs and Poems*, trans. & ed. Gerald Stanton Smith (Ann Arbor, MI: Ardis, 1983).

Mandelstam, Nadezhda, *Hope Against Hope: A Memoir* trans. Max Hayward (London: Harvill Press, 1999).

———, *Hope Abandoned: A Memoir*, trans. Max Hayward (London: Harvill Secker, 2011).

Polonsky. Rachel, *Molotov's Magic Lantern: A Journey in Russian History*, (London: Faber and Faber, 2010).

Shalamov, Varlam, *Kolyma Stories*, trans. Donald Rayfield (New York: NYRB Classics, 2018).

Slezkine, Yuri, *The House of Government: A Saga of the Russian Revolution* (Princeton, NJ: Princeton University Press, 2017).

Solzhenitsyn, Aleksandr, *One Day in the Life of Ivan Denisovich*, trans. Ralph Parker (London: Penguin Classics, 2000).

Zubok, Vladislav, *Zhivago's Children: The Last Russian Intelligentsia* (Cambridge, MA: Belknap Press of Harvard University Press, 2009).

The Sinyavsky-Daniel Trial

Labedz, Leopold, and Max Hayward (eds), *On Trial: The Case of Sinyavsky (Tertz) and Daniel (Arzhak)*, (London: Collins and Harvill Press, 1967). A translation from the Russian of *The White Book* by Aleksandr Ginzburg and Yury Galanskov.

Selected Works by Andrey Sinyavsky/Abram Terts and Yuly Daniel/Nikolay Arzhak

Daniel, Yuly, *This is Moscow Speaking and Other Stories*, trans. Stuart Hood, Harold Shukman, John Richardson (New York: Dutton, 1969).
Sinyavsky, Andrey, *Strolls with Pushkin*, trans. Catherine Theimer Nepomnyashchy and Slava I. Yastremsky (New York: Columbia University Press, 2017) Edition also includes *A Journey to the River Black*.
———, *Soviet Civilization: A Cultural History*, trans Joanne Turnbull with Nikolai Formozov (New York: Arcade Publishing, 1990).
Tertz, Abram [Andrey Sinyavsky], *The Trial Begins and On Socialist Realism*, trans. Max Hayward (Berkeley, CA: University of California Press, 1982).
———, *Goodnight!* trans. Richard Lourie (New York: Viking, 1989).
———, *A Voice from the Chorus*, trans. Kyril FitzLyon and Max Hayward (New Haven, CT: Yale University Press, 1995).

Émigré Literary Life

Glad, John (ed.), *Conversations in Exile; Russian Writers Abroad* (Durham, NC: Duke University Press, 1993).
Haber, Edythe, *Teffi: A Life of Letters and Laughter* (London: I.B.Tauris, forthcoming).
Karetnyk, Brian (ed.) *Russian Émigré Short Stories from Bunin to Yankovsky*, trans. Bryan Karetnyk and others (London: Penguin Classics, 2017).
Matich, Olga, and Michael Henry Heim (eds), *The Third Wave: Russian Literature in Emigration* (Ann Arbor, MI: Ardis, 1984).

The Anthony Blunt Affair

Carter, Miranda, *Anthony Blunt: His Lives* (London: Macmillan, 2001).
Wright, Peter, with Paul Greengrass, *Spycatcher: The Candid Autobiography of a Senior Intelligence Officer* (New York: Viking Penguin, 1987).

Other

Koestler, Arthur, *Darkness at Noon*, trans. Daphne Hardy (London: Vintage Classics, 1994).
Orwell, George, *Animal Farm: A Fairy Story* (London: Harvill Secker, 2010).

Index